The Complete Drawing Book

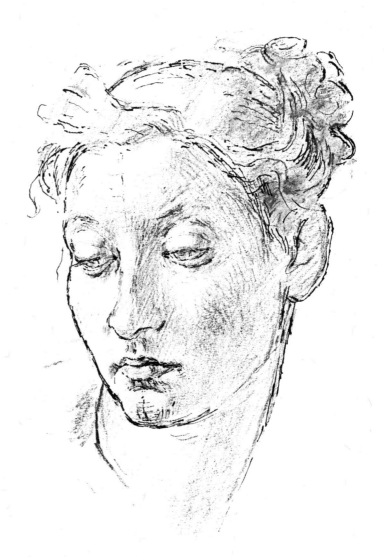

THE COMPLETE DRAWING BOOK

Edited by Peter Probyn

Watson-Guptill Publications, New York

(The arrangement of this collection is © Studio Vista 1970)
First published in London 1970 by Studio Vista
35 Red Lion Square, London WC1R 4SG
British ISBN 0 289 70052 3

First published in New York 1970 by Watson-Guptill Publications,
1515 Broadway, New York, N.Y. 10036
Library of Congress Catalog Card No. 73-121145
American ISBN 0-8230-0780-4
Reprinted 1973, 1975, 1978, 1979, 1980

Printed in U.S.A.

Contents

Acknowledgements
The drawings on pages 39 (below), 40, 44, 53, 54 (above), 55 (right), are from the *Radio Times;* on pages 48 (below), 53 (below), 58 (below), 59, 60 from the *BBC Schools Publication,* and on pages 52, 55 (top), from *The Listener.* On pages 48 (top), 49, from *Your Food* by P. Searle, Longmans, Green & Co. Ltd. On page 58 (above right), from *Norwegian Folk Tales,* Allen & Unwin Ltd. On page 50, from *Pearl and Sir Gawain,* Everyman, Dent Ltd. Page 56, from *A Child's Book of Composers,* Novello & Co. Ltd. Pages 39 (above), from *Portrait of Beach,* 54 (below), from *Kirsti Comes Home,* Methuen & Co. Ltd. Page 63, from *The Fisherman's Fireside Book,* Heinemann Ltd. Page 47, by permission of the British Travel and Holidays Association. Page 42, by permission of Unilever Ltd., and page 58 (above left), by permission of the Egg Marketing Board.

The drawings on pages 319, 320, 321, 322, 323, 324 (above), 324 (below), 328, 329, 341 (above), 341 (below), are reproduced by permission of *Punch.*

The drawing on page 343 (above, right), from *Destroyer from America* by John Fernald, is reproduced by courtesy of Jonathan Cape, Ltd.

Introduction

First and foremost the aim of this book is to inspire you to draw.

It is designed primarily for the beginner. Stage by stage, it offers guidance to the amateur artist of any age who wants to draw but is uncertain how to begin, where to begin, what materials to use, what to look for first, or how to approach so mysterious and romantic an activity.

So, for all its pages, for all its apparent scope, *The Complete Drawing Book* is essentially a simple, uncomplicated book. It is about the practice rather than the theory of drawing and it is free of the tedious jargon that all too often surrounds even the simplest statements about art. Above all it is practical. It faces squarely the countless problems that confront the beginner who simply wishes to record on paper, in pencil, chalk or ink something that he sees or discovers, or the expression of something he feels or imagines.

For convenience, and because the material in this collected edition first appeared under separate titles in a series now known in many countries, it is divided into sections by subject matter. We are, alas, somewhat conditioned to think in terms of 'life drawing' 'portrait drawing', 'animal drawing' and 'flower drawing'. Some we classify as pen and ink drawings, others as line and wash, or charcoal. But in fact there is only drawing. The good draughtsman can draw anything he sees before him, and the subject, combined with a certain common sense, will dictate the materials he uses. Nevertheless, like so many of us in these days of increasing specialisation, some artists tend to specialise according to his particular interests. It is to this kind of artist that we have turned for the material in this book. Each author/artist is widely recognised as an expert in his particular field, and it is this that gives the book its special authority, its quality, and its great variety.

The challenge that each artist has accepted is one of clarification and communication; to pass on to the beginner, by simple explanation, something of the essence of his technique and philosophy. And, in step-by-step illustration, to offer as much practical help and technical guidance as possible about the art of drawing in his own field.

It is surprising how consistently similar in attitude and approach each individual artist turns out to be. Only in small matters of emphasis do they differ. In this lies the major drawing lesson of the book. Whether one draws a single tree, or a wild, despairing landscape, a simple chair, a portrait, or a jug of flowers, the problems, the fine point of decision-taking, remain identical.

But what has emerged additionally as a wholly unexpected bonus — and perhaps it is more noticeable in this collected edition than it was in each separate book's original form — is the extraordinary amount of incidental information the text contains. Information about strange and obscure matters is part of the stock in trade of the artist. In this book it ranges gratuitously across such disparate phenomena as the behaviour of steel ships in heavy seas to the bone structure of the lesser primates; from the simple mathematics of perspective to the leaf arrangement systems of wild flowers.

Drawing would be a pointless exercise if it concerned itself only with superficial appearances. In fact it does much more than this: drawing is finding, exploring, imagining and creating; it has little to do with imitating, which is the camera's job. Just as a knowledge of anatomy helps the artist to draw the human figure, so a knowledge of the sea helps him to draw ships with greater authority, intelligence and awareness.

Indeed it is this continual curiosity about what lies behind mere surface appearances that marks out the artist from his fellows. Before we begin to draw we must first school the eye to see, *to really see*. And we must train ourselves to be curious and to question.

It is this that makes the practice of drawing both stimulating and enriching. As soon as the mind and the eye is opened by the act of drawing, the world about us becomes a great deal more exciting. We become aware of relationships between line and shape, form, texture and pattern. Everywhere we look we see things that went completely un-noticed before. And then we can begin to look *subjectively* at what we see, carefully analysing our own reactions to it.

This is why drawing is so complete a distraction from the chaos of everyday life. Wherever we are, whatever we are doing, the mind and the eye are absorbed, fully occupied in storing this and that for future use. This positive development of visual memory builds the confidence we need when at last we have an hour or two at the drawing board alone. Furthermore the therapeutic return we derive from so disciplining ourselves through creative craftsmanship, in a society that gloats increasingly over machinemanship, cannot be overestimated.

If you are led towards this kind of activity by the text and drawings on the following pages, if the illustrations help you towards achieving what you would like to achieve, and if the example of these sixteen artists inspires you to draw, draw and draw again, then this book will have served its purpose well.

Chalk and crayon

Kay Marshall

Willow charcoal on Ingres paper, 12'' x 14''. Fine lines can be drawn only on grained paper, and by turning the stick round to keep a sharp edge.

Chalks and crayons

Because of their covering capacity, chalks and crayons are the artist's fastest drawing materials. So it follows quite reasonably, that he can get into a muddle with them more quickly than with any other. Chalks react immediately to touch, so they should be used spontaneously. Pencil is the proper tool for a long, slow, probing search; chalk used in this way loses its vitality. Constant alterations, which can't be erased, soon destroy one's exciting inspiration. A chalk drawing must always be a summing up, never a long recital of facts, so think what you want before you start, and decide to eliminate everything that doesn't contribute to your idea.

I shall try, in this limited space, to separate the problems so that you can worry efficiently about one thing at a time. In this way it is easier to find out where you are going wrong, instead of feeling that the drawing is a hopeless muddle all over.

A drawing is divided into two parts: the vision, in which the brain sorts out what the eye sees, and the putting down, a purely physical thing which can be learned like hitting a ball. Don't confuse the two: your brain tells you what tone a line should be; your hand carries it out. An even line or tone is made with an even pressure; a free line with a free hand or arm movement; a tight line with the chalk held firmly; a quick line, quickly; a slow line, slowly; an incisive line is drawn with the point; and a less insistent one with the side of the chalk or pencil.

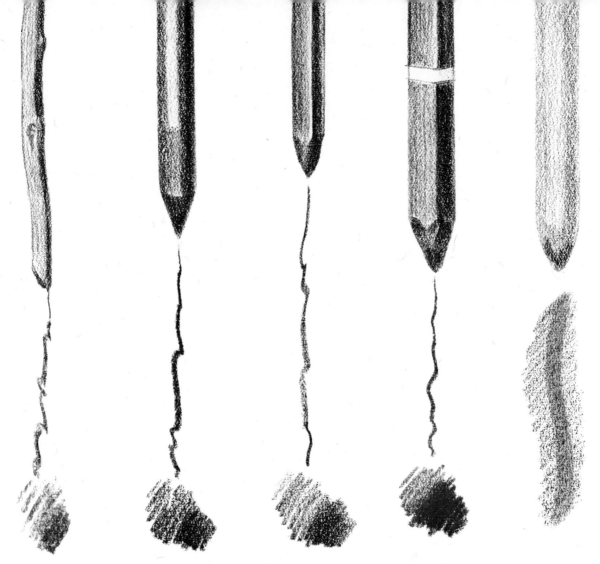

Charcoal. Compressed charcoal crayon. Conté crayon Carb-Othello chalk Blotting paper stump

The important thing in choosing your weapon is to find out which will give you the result you want with the least effort. Never strain your material, or you will get a forced drawing. Choose a soft chalk for a dark drawing, so that you don't have to go over and over your line and worry it. Choose a fine, hard one for delicate lines and greys, so that you can draw incisively. A soft chalk forces you to work so lightly that the drawing becomes anaemic.

The beauty of chalks is their granular texture; this should always be preserved. Let them sparkle against the paper; don't on any account rub them down to an eggshell finish, or you will finish with a dead drawing which is a bad imitation of a photograph. Chalks are broader than pencils, so draw bigger; learn the proper scale for each. Conté, which is fine and

even, will get lost on a very large drawing. Charcoal, which is soft and loose, will 'wool up' a small drawing in no time.

Chalks should be held under the hand, unlike the pencil, as this is the only way you can draw an easy, relaxed or rhythmic line. Never sit huddled over a drawing board, because this produces tense drawing. The bigger and broader your drawing, the more often you must stand away from it. Seeing it in reverse through a mirror is a great help in locating faults before you go too far. Standing at an easel will help you to work freely with the whole arm for large drawings and visualising; sitting down will give you more control over detailed work - but do sit as far from your board as possible.

All chalks are harder and grittier in pencil form, and produce a different tex-

ture. Stick to one at a time, work within its limitations, and you will get a much more unified drawing. Where lines and accurate details are essential, as in architectural drawings, use a pencil, combining it, if you like, with a simple chalk tone to indicate shaded areas. For large tonal effects of light and shade, use chalk to put in greys crisply and effortlessly. Never labour with fine close lines. Chalks should never be rubbed out, but a putty eraser can be used to pick off small errors.

Conté sticks

These are the hardest and finest of the crayons and need more pressure to get a full tone. Their fine, smooth texture, however, makes it possible to work into the tones without spoiling them. They don't rub easily, but can be sharpened to a good point; they are suitable for accurate work such as portraits, and are better on the finer grained papers. They are square and can be used flat on their sides to lay tones, which is particularly useful when one wishes to show the change of plane on the side of a building without using a line. They are usually sold in boxes of a dozen, but some shops will sell them separately. Black and white conté sticks are made in three grades, but sepia and sanguine (terra cotta) are only made in the medium grade. These are good for drawing anything which is generally light in tone, perhaps a fair haired, light complexioned person. You may find it easier to make a more unified drawing with them, as the range of tone values is limited.

Carbon pencils

This group bridges the gap between pencils and crayons. They are quicker to use, because the carbon part is wider than the lead in pencils and so gives a broader line. They range in 5 grades from H to 3B, and

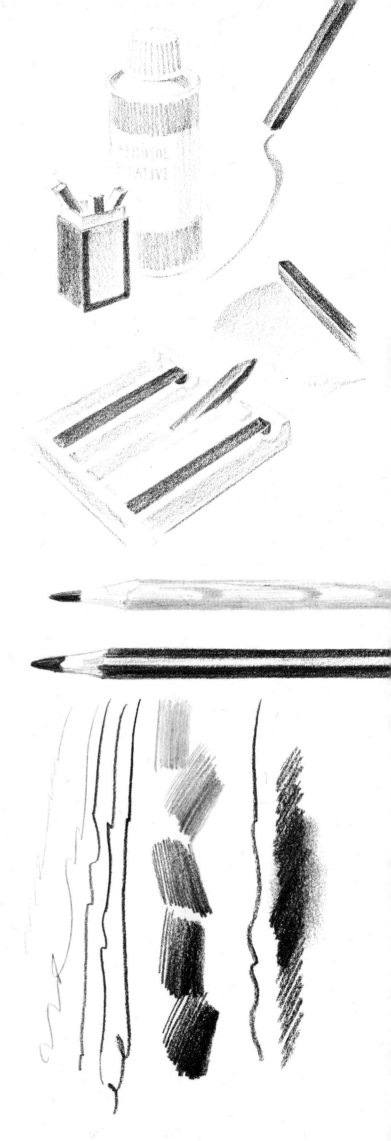

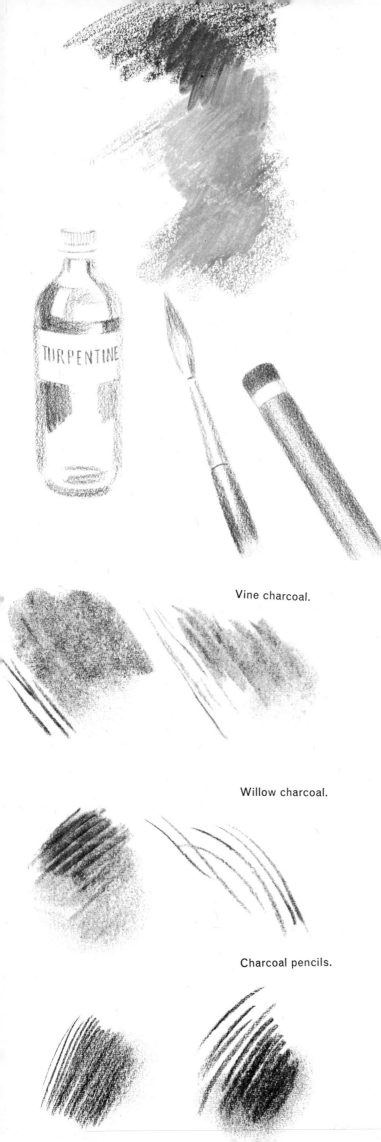

Vine charcoal.

Willow charcoal.

Charcoal pencils.

will maintain a fairly good point for some-time, according to the hardness. They are ideal for working drawings where accuracy and information are required.

Carbon pencils are not to be confused with the Carb-Othello pencils in three grades, of which No 1 is the softest. These are pastels in pencil form, and are much looser in texture and blacker. They will take on any kind of paper, and are especially good for large drawings because of their strength and ability to hold their own on really coarse grained paper. Carbon pencils will only rub down a very little, but Carb-Othello, because they are looser, can be rubbed well beyond the area they are applied to. They are ideal for subjects which require velvety darks which you want to apply freely and quickly.

Oil pastels

These are fairly recent additions to the artists' materials, and should not be confused with chalks and crayons, as they have few of their qualities. Their main virtue is that they do not rub off; their great disadvantage is that they do not rub in. Pressure is needed for application and care must be taken, for the colour tends to build up in unsightly patches. Be prepared to spend some time experimenting, because they call for a well disciplined hand. The Carb-Othello coloured, square chalks are as firm in texture as oil pastels, but they are easier to handle and will give a wider range of colour, for they blend easily. The time spent in fixing pastels is negligible, compared with the extra time needed for controlling oil pastels. No doubt they can produce interesting results, but they cannot be used in the same free way as chalks and crayons.

Charcoal

This is the softest material of all, and can be rubbed into large areas of velvety grey

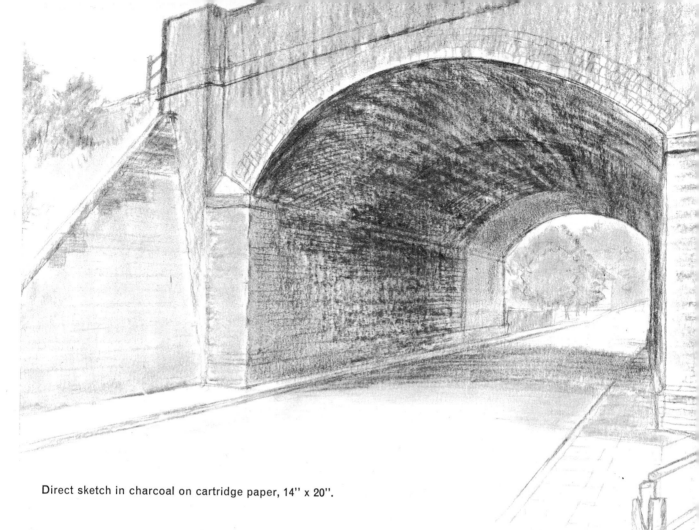

Direct sketch in charcoal on cartridge paper, 14" x 20".

tones in a matter of seconds. This makes it invaluable for quick sketches, compositions and tonal schemes. On smooth paper it can be flicked off time and again for alterations; on any surface it must be fixed at various stages, as the slightest touch from the hand or a sleeve will rub it off. Willow charcoal sticks are thin or moderately thin, and are stocked at most art shops. Vine charcoal, thicker and suitable for larger work, is only stocked by specialist shops. Charcoal is a loose, untidy material, easier to control when used quickly and decisively. It is apt to become blunt or wander off course without warning, so avoid using it for precise line work.

For precision work, charcoal has been made into pencils, in three degrees of softness. Various firms make these and they all vary slightly, the cheaper ones being grittier. Conté make an extra soft, thick pencil, and Faber pencils are very finely ground but less black. You can also buy Faber's compressed charcoal crayons

in seven grades. They are firm, finely ground, comfortably thick to hold and do not wear down too quickly. The pencils and the crayons are decidedly granular and blacker than the sticks, both in line and tone, but when rubbed with a stump they produce the same velvety grey as the stick tones. The crayons and pencils do not rub off so easily, but it is possible to rub out the worst of one's mistakes from a smooth paper. Rubbing out any chalk on a grained paper has the same result as using a stump, it rubs the chalk or pencil into the grain. Smooth, matt surfaced papers are the most suitable for charcoal sticks, as grained papers blunt them down so quickly.

Large general effects should be aimed at, rather than precision. More even tones can be made by rubbing a wide stick down to a wedge, than by using the point of the stick. I find it better to leave the tones rough as long as possible; they are easy to soften, but difficult to liven up once they have been rubbed

15

down. The use of a blotting paper stump is a purely personal matter. It is much quicker to use the finger, and I think that tones made this way are more lively.

The bridge on p. 15 interested me chiefly because of its size and the strong perspective inside it, so I only used thin charcoal sticks where necessary and for the rest, larger pieces and a very wide piece of vine charcoal, rubbed flat, for the large surfaces. These were drawn to show the planes, vertically for the front of the bridge, across the road, in perspective inside the bridge and on the supporting wall. This sloped back, so I rubbed it roughly in that direction. Where the bricks were smooth inside the bridge, I rubbed them and tried to show, with a few quick lines, how the bricks ran diagonally across the arch, making a secondary movement. I wasn't interested in the bushes on the bank or the trees at the end, so I scribbled them in lightly without any attempt at detail.

The importance of paper

Before discussing paper, I must stress the importance of working on a pad of several layers of smooth paper, to prevent the grain of the drawing board spoiling one's drawing. This cushioning also makes for more sensitive drawing and softer tones. A permanent pad can be made by tearing 7 or 8 sheets (still stuck together) from a layout pad. For smaller drawings, a child's thin drawing book with the covers removed is more convenient.

There is such a variety of papers to choose from, that it is better to have some idea of how different surfaces react to crayons, before spending money needlessly. First, never buy shiny paper; it won't take chalk. The smoother the paper, the more quickly the crayon will travel over it and the more even the tones will be. The line, however, tends to become too smooth and uninteresting. Layout pads, good for doodling and composition, come into this category. The paper has the advantage of being semi-transparent, so that a sheet can be laid over an unsatis-

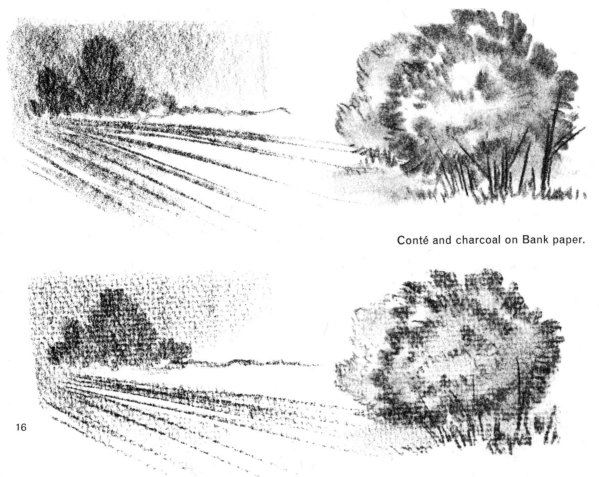

Conté and charcoal on Bank paper.

16

Conté and charcoal on Swedish Ingres paper.

Rapid variation on a theme of dark railings against a lighter background.

factory drawing and alterations tried out, without redrawing the whole thing. Smooth paper with an absorbent surface is also quick, but gives a less slick line. The soft surfaces act as shock absorbers on tones, making them grey rather than black. It is easier to draw details on this kind of paper, and so it is good for quick chalk drawings of animals. Cheap scribbling pads often contain smooth absorbent paper and are suitable for experimental work with animals, as one has to abandon so many starts.

Tinted papers in various colours are also absorbent but vary in surface; some are rough without having an interesting grain, and on the whole they are for coarser drawing. Soft coloured paper, known as 'sugar' paper, is very good with chalks, as the tones are never harsh and one can choose between using the smooth or grain side.

A grain breaks up lines and tones:

the fine grains only a little; the coarser ones quite a lot. This breaking up gives chalks and crayons their vitality. Instead of a still, dead grey, an optical grey is made by the fusion of white or toned paper with black specks of chalk. It is 'live' rather than dead because of the rapid movement from white to black. A slow tone, on the other hand, moves gradually from white to black and there are no surprises. A fine line would be lost in the breaking up process of a coarsely grained paper, so a broad, rapid stroke would be necessary. This makes coarsely grained paper useless for fine detailed work, and as tentative lines are useless, it is better to use it only when you know exactly what you want, and have done enough preliminary work to be able to put your drawing down boldly and leave it alone.

Just as an absorbent surface deadens a tone, so a hard grained paper brings it to

17

life, immediately giving a black, granular tone which is exciting and akin to the texture of stone. The Ingres paper group comes between the smooth and the rough, with the exception of Swedish Ingres, which has a slightly woven grain. They are 'ribbed' papers and come in a wide range of tints and greys. French Ingres has a firm, even surface, gives beautifully soft but lively tones and adds a texture to the lines. It is more suitable for subtle, unhurried drawings. German Ingres is similar, but has a more woolly surface. Italian Ingres has a hard, very close rib, which breaks the drawing into fine vertical or horizontal lines. This is definitely a paper to be used after forethought. Softer chalks or pencils must be used with the grained papers. Choose your paper for what it does best, and don't 'worry' it into doing work for which it is not intended.

Charcoal on blotting paper, 7'' x 13''. No alterations are possible on blotting paper. The lines have to be put down boldly and without subtlety.

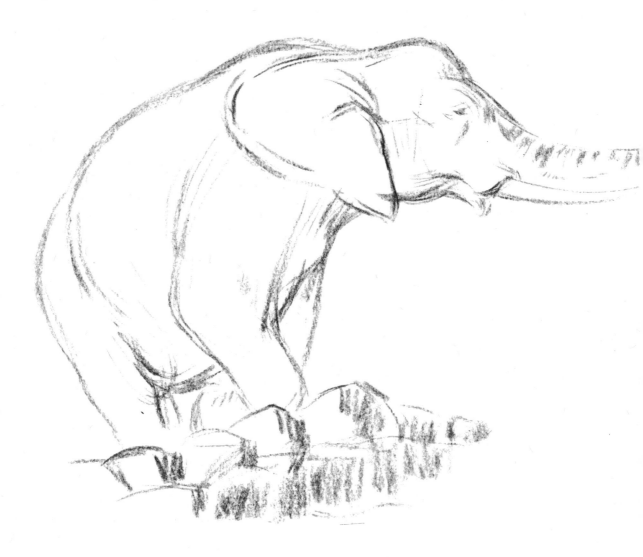

(1) Tone laid quickly with side of conté crayon.

(2) Tone laid in lines.

(3) Even tone built up gradually.

The handling of tone values

Tones are colours translated into a scale of greys, as in a photograph. To the untrained eye, searching for detail instead of seeing the subject matter as a whole, they can be a great worry. Start quite simply by ignoring local colour, leaving the paper to represent the light side and laying a simple tone on the shaded side. In rounded objects, this light and shade will be linked by a middle tone. If you like, darken the tone on the darker objects. An even tone is made by even pressure on the crayon. The traditional way of shading, is to draw more or less parallel lines at 45°, using the side of the pencil to make them softer and blunter. The angle prevents confusion with the vertical and horizontal drawing lines, and makes it clear that the lines indicate tone values. Lay tone on the light side, and tone plus shade on the shaded side. On dull days, the difference between light and shade is slight; objects can be seen as a whole shape. In strong sunshine, the tone values become lighter on the light side

and darker on the shaded side, so that the big shape is still divided into two definite areas of tone.

The easiest way to see tones is through half closed eyes, as this eliminates detail. Bright colours often appear lighter than they really are. An easy way to tell if one colour is lighter than another, is to hold up one hand so that the colour appears between two fingers, then move the hand quickly to see the other colour in the same way. You will be able to tell immediately which is lighter in contrast with the fingers. Simple tone can be put in quickly by rubbing a finger in some chalk dust and applying it where you want to show a turning form. Remember that a tone is darker after rubbing it lightly, and almost twice as dark after using a stump, because the granules cover up all the white spaces.

An object has texture when it is composed of a series of changing planes catching light or casting shadows. Decide on the general tone and represent it with lighter and darker marks.

(4) Crayon dust rubbed on paper with the finger.

(5) Tones laid in directions of planes.

(6) Tones laid as texture.

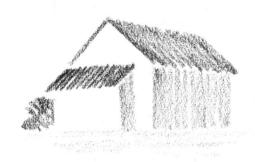

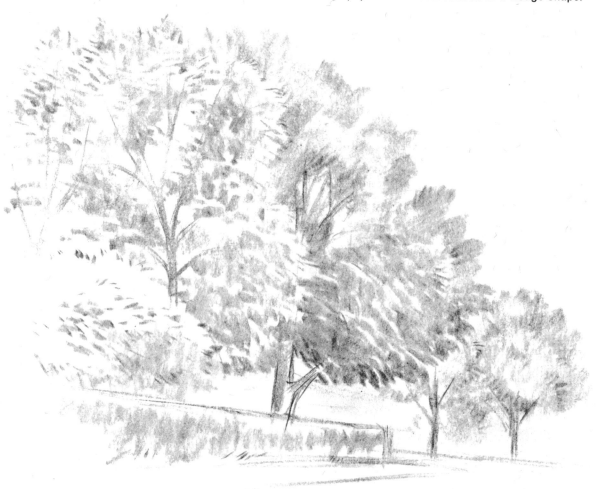

Landscape in charcoal

Charcoal should only be used where there are large trees, tree masses or buildings in the foreground and middle distance. It is not suitable for defining smaller groups on the horizon. Avoid subjects which rely on light shining through leaves and small branches, because charcoal is too rough to do them justice. I find smooth sketch books most suitable, as errors can be easily erased or wiped off, and quick sharp touches can be put in to suggest branches and clear edges.

Landscapes can be approached in several ways: as movements of land and tree masses, as light and shade patterns, or as a record of facts to be used as a background in an illustration. The trees above were jotted down in a few minutes and drawn small, about 6" x 9", with a stick about $\frac{3}{16}$" wide, rubbed down to a wedge. They were drawn directly, with only one or two areas lightly rubbed down

at the end.

Where strong light and shade effects are aimed at, put them in at one time, not as each item is drawn, because the light changes too rapidly for them to hold together when drawn separately. Adjust your technique to the scale of your drawing and the time you can spend on it. When a clear record is needed, draw clearly from the start after a very light, general layout. For working drawings, think of the landscape from a constructional angle, mark in the general proportions, then plan the ground plane with any definite slopes, and plot the trees and buildings on this. For drawings which may have to be translated into another medium, add pencilled notes such as 'tree trunks darker or slightly darker than leaves','rough texture here' and so on. Once away from the subject, it is very difficult to remember everything you may need at a later date.

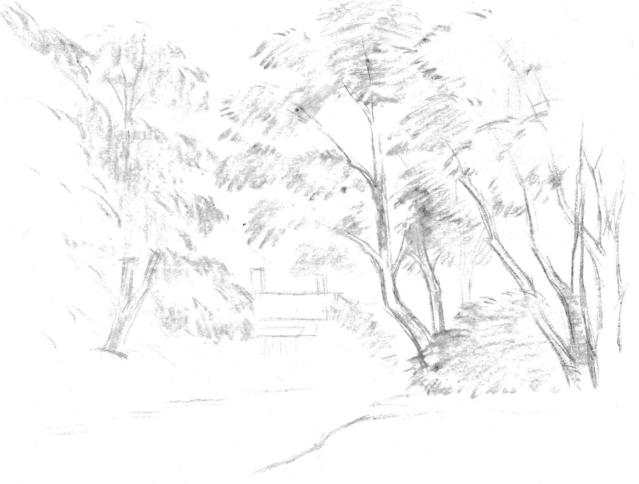

(1) Here the central tree was drawn in first as a circle, and areas of tone were added to suggest foliage. Next, the trees on the left and right were put in with another light tone and a few strokes to indicate the main directions of structure and growth.

(2) As the light was changing rapidly, this remained a quick impression. Some darker accents were added, but little further detail because of the small scale (9'' x 12'', on cartridge paper) of the drawing.

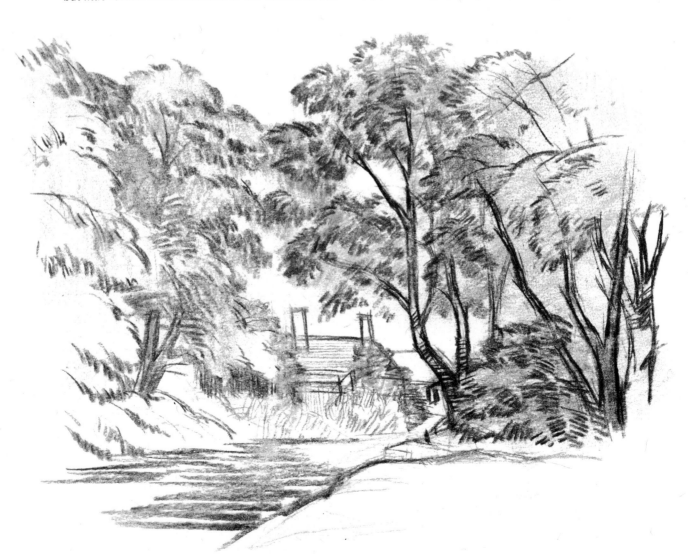

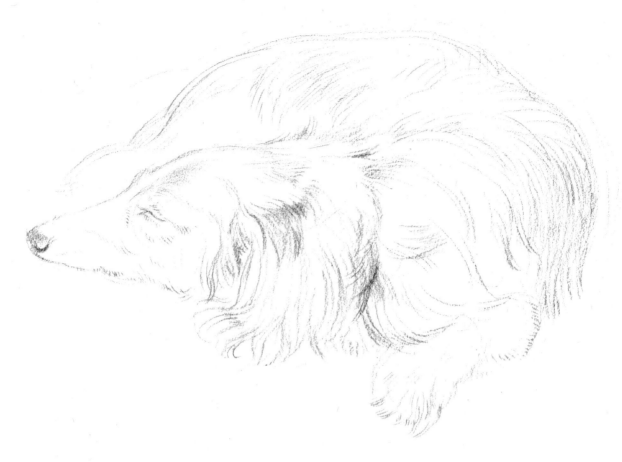

Sleeping dog. B conté pencil on cartridge paper, 6" x 9".

Animals in chalk

Animals are always a problem, because they rarely stay still long enough to draw more than a few rough lines - the end of a morning's work can leave you with a collection of worthless scribbles. Concentrate on quick sketches of feet, legs and the head when an animal is particularly restless, so that you have useful information to fill in the gaps when you try to sketch the whole animal. Always assume that it will move - don't begin a large-scale drawing which you cannot possibly finish. Use a cheap sketch book or scribbling pad with a matt surface, and fix it to your board with spring clips. Smooth hard chalks or pastels are the ideal material. Carb-Othello make them in square sticks which you can buy separately in many colours. For sharp details and fine drawing, buy them in pencil form. There is never time for subtle colour grading, so choose two or three which are of the

approximate colour and tone. Practice will tell you what information you need for re-drawing from your rough sketch. So if there isn't time to finish, mark in the colour and definite markings lightly, and draw in small areas in texture, showing the type of hair and how it grows. Then add information about how the ear grows out of the head, how the neck fits on to the shoulder, the way the hair grows between the front legs and so on. In short furred animals, use the way in which the hair grows to explain the construction. Constant observation and practice are essential. A file of photographs cut from papers and magazines is invaluable for reference, and drawing from memory is the quickest way to find out how much you don't know and what to look for when you next start. A well stuffed animal can be a great help in sorting out shapes and lines and textures.

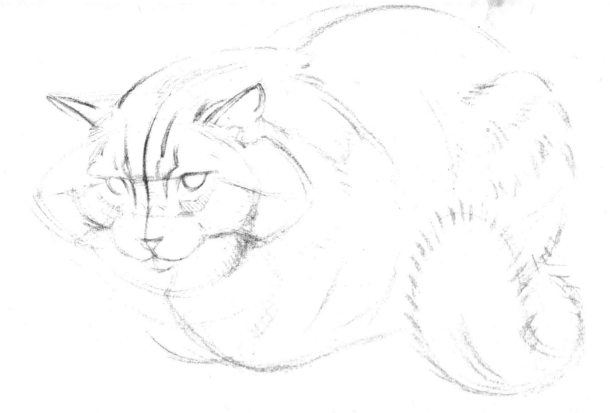

Cats never sit for more than a few minutes, so they have to be drawn without any attempt at detail on whatever paper is available at the time. Smooth cream sugar paper was ideal in this instance, as it was the colour of the lighter fur, the rest being soft shades of ginger. The eyes were drawn in No 1 (blackest) Carb-Othello pencil, and the rest of the body in No. 3. This is the hardest pencil, draws grey on absorbent paper, and rubs out quite easily.

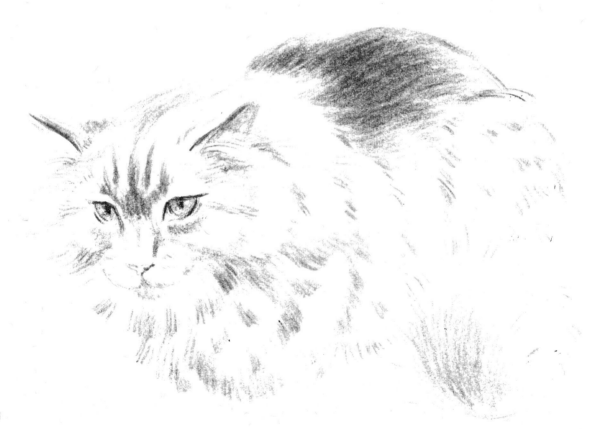

First I marked in the main constructional lines. These were a great help at the next stage. The markings on the head were particularly useful in conveying the underlying form.
There were no sharp edges anywhere, and the fur divided into flakes on the under parts, which were drawn with blunt strokes. A light grey Carb-Othello chalk was rubbed into the back and tail and any other areas which needed to look soft and downy.

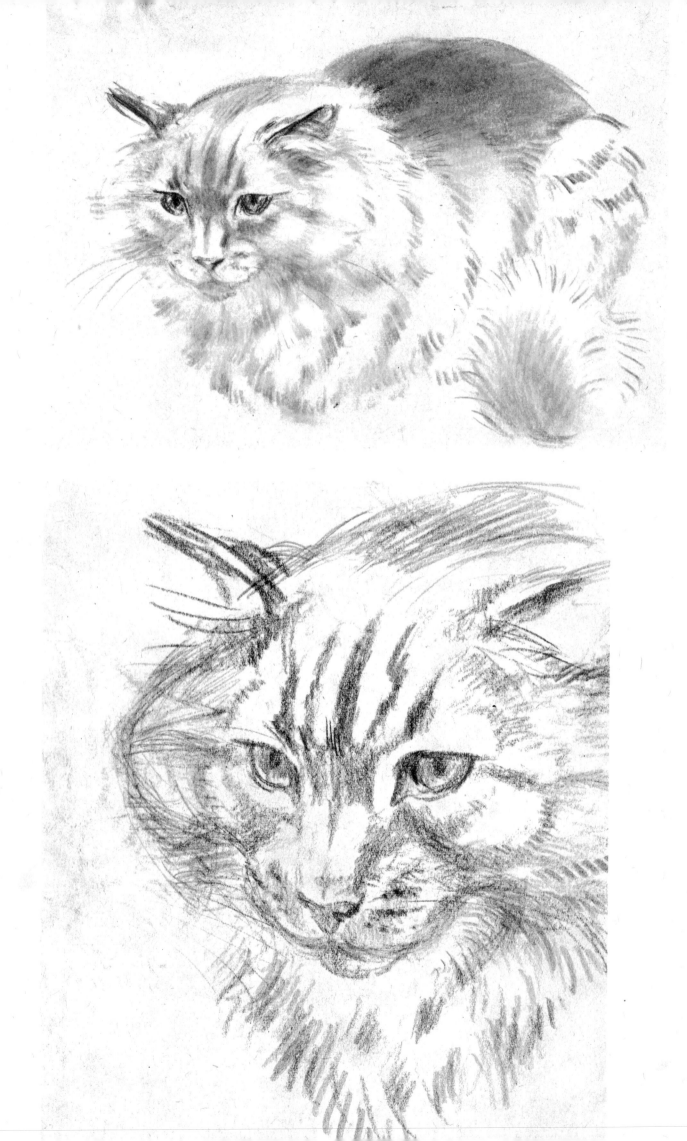

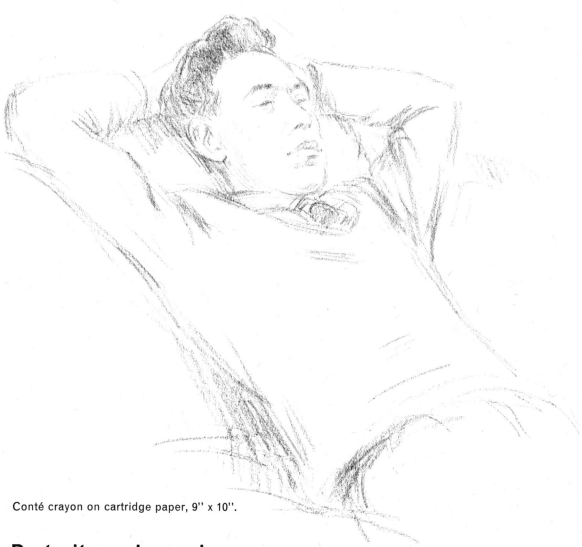

Conté crayon on cartridge paper, 9" x 10".

Portraits and people

Portrait drawing depends both on your model and on what you want to say. Quick sketches often catch a likeness which gets lost in a more ambitious drawing. Prolonged drawing tends to modify rather than clarify, if you are unsure what you are doing. If this happens regularly, allow for it by exaggerating the main proportions slightly at the outset. A quick impression in charcoal, emphasizing the points that interest you most, is very helpful, and acts as a useful check on fussing over details. Serious drawing with a pencil, trying to understand the form, will help with any chalk drawing. Only when you really understand a thing, can you put it down simply and well.

A chalk portrait should never be rubbed down smooth to imitate a photograph.

Leave this to the camera. You are recording *your* impression of the sitter. Finely ground pencils and crayons are most suitable for portrait work; paper without a rough grain will allow for sensitive drawing round the eyes and mouth. Expression can only be caught with light, swift touches. When in doubt about how best to treat a certain part of the drawing, try it out at the side of the paper or on a spare piece, rather than spoil what you have already done. Take time trying to see what is needed, instead of rubbing out and altering. Draw the tones in such a way that they do not compete with the features. Hair and clothes should be treated as simply as possible. Outlines are more satisfactory if left to the last and drawn in with a light touch.

25

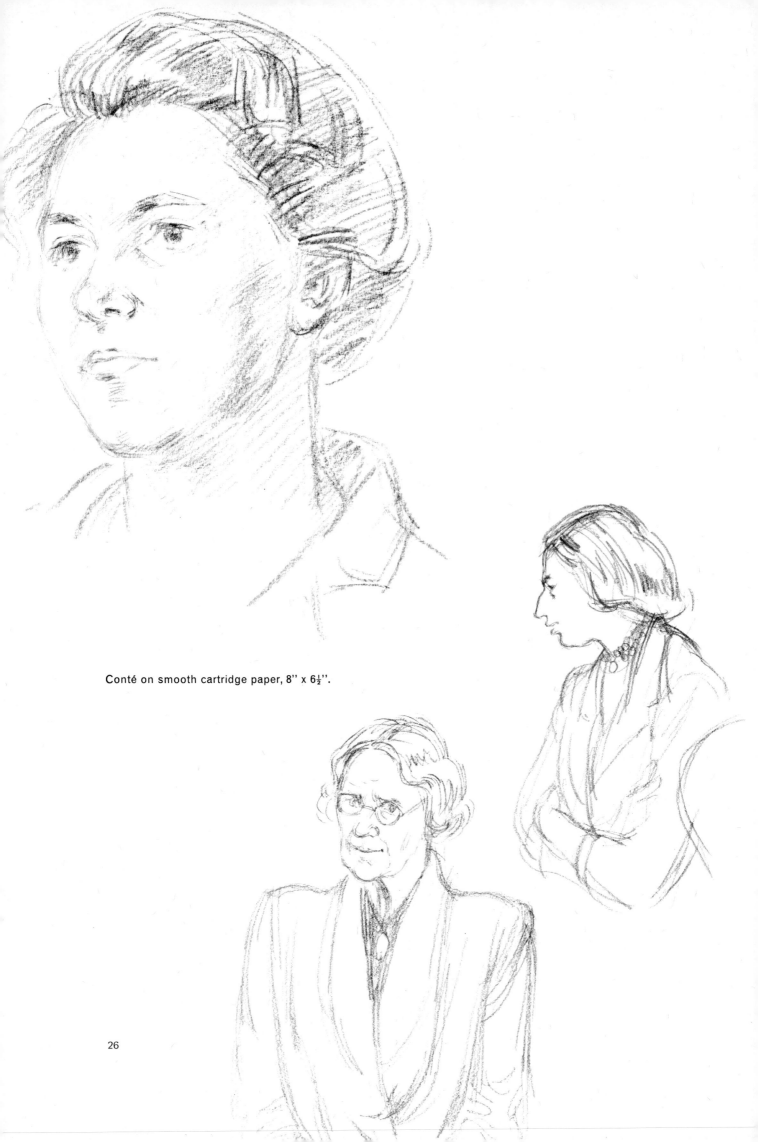

Conté on smooth cartridge paper, 8'' x 6½''.

26

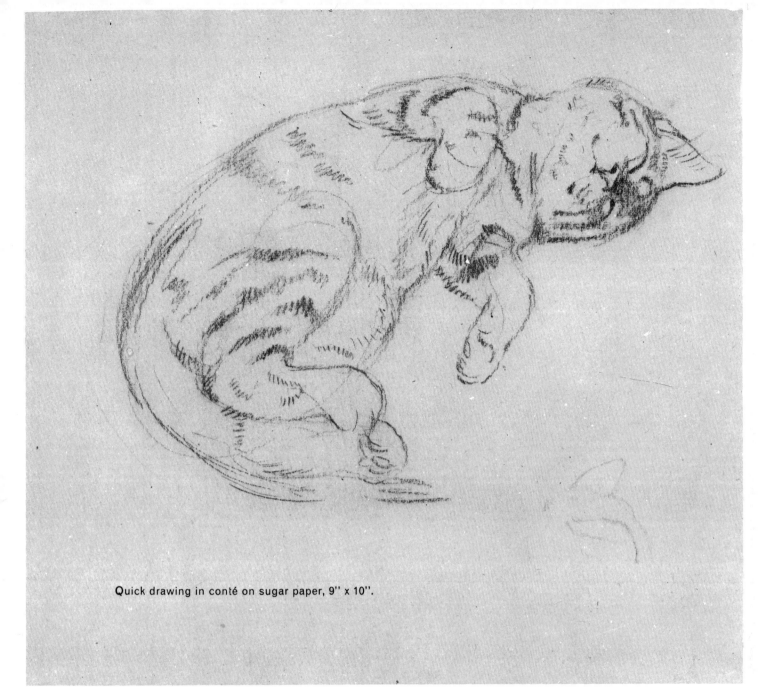

Quick drawing in conté on sugar paper, 9'' x 10''.

Working on toned paper

Timid starters will enjoy this, as mistakes are less noticeable when the contrast between chalk and paper is reduced. The nervous habit of rubbing out 'starts', can only be cured by a firm decision to tidy up at the end, not at the beginning. Carefree doodling is the best way to get acquainted with your weapon, and to convince your self that it will not blow up in your hand if fired inaccurately.

Toned paper is a heartening background for coloured chalks, saving a lot of time when drawing anything dark in tone, especially in large work, and when sketching animals quickly. When there is only time to put in the main lines, the area in the middle can look incredibly bare on white paper. Theoretically, black on grey should lose much of its impact, but none of the grey papers is an exact mixture of black and white; most of them have a bias toward a warm colour such as yellow, green, brown or pink. It is this colour which provides contrast.

Lines and tones have to be clearer on darker papers, and a white conté crayon

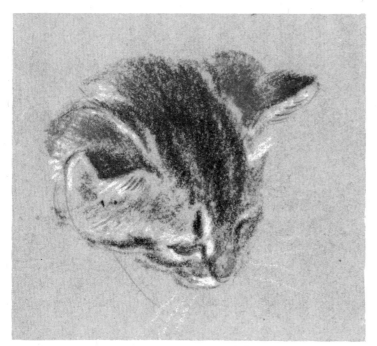

Hard pastels on coloured paper, 4'' x 3½''.

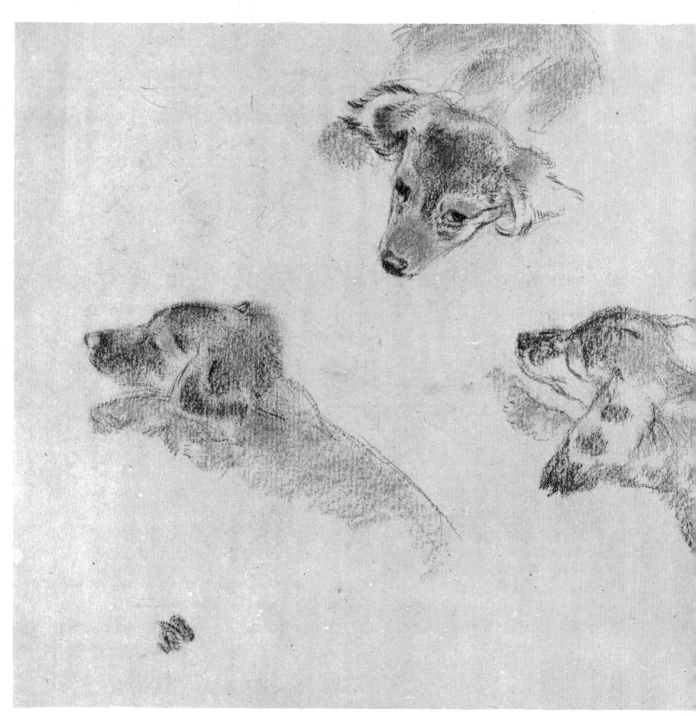

Hard pastels on coloured paper, 10" x 18".

or light chalk may be necessary if the effect is too sombre. Tinted paper can suggest the general atmosphere of a subject or landscape: a warm colour for sunlight, a cool dark one for night, a neutral one for architectural drawing. A beautiful paper is Ingres, made in a wide range of greys and colours.

Limited tone range is easier to control than unlimited white to black - the darker the paper, the simpler the drawing need be. The simpler the drawing, the more it must say in a few lines; the fewer the lines, the more each one must be considered.

Drawing on toned paper is restful. The eye is not shocked by black against white, and the movement from tone to tone is never too rapid. Background colour makes lost and found edges easier, and understatement more subtle. Not putting in everything leaves something to the imagination, for most things are robbed of mystery when subjected to harsh light. Toned paper hints at things half seen.

Two approaches to the same problem: lost and
found edges in pencil above, in charcoal below.

Lost and found edges

A study of these helps to make any drawing much more interesting. A poster which is designed to catch the eye, must be simple, so that it can be understood at a glance. A drawing which has to be lived with, cannot afford to be so obvious. Lost and found edges provide the quiet surprises to which the eye can return with enjoyment again and again; things half hidden, or partially stated, create an air of mystery, and give some escape from being faced eternally with bare facts.

A 'found' edge is one which shows in contrast to its background - it shows very clearly if the tones are at the opposite ends of the scale. In a line drawing, it can be stated by a clear sharp line; in a tone drawing, by black suddenly against white. 'Lost' edges are rounded edges, as in an egg, or where an edge is seen against something of the same colour or the same tone. There is an infinite variety of half-seen edges, and the more subtly you can mark them, the more interesting your drawing will be.

Focus and impact

Think of your drawing as being in or out of focus. This will help you to decide how clearly or sharply you wish to draw each part. In imaginative drawing, the part to which you wish to draw the eye must be more in focus than the rest, so draw it more clearly. A landscape seen as a whole needs things nearest to the eye more sharply defined. Do this either by drawing in more detail, by using darker shades, by drawing more sharply with the point of the crayon, or by combining all three.

A sharp line drawn with the point, because it is quite clear, is always in focus. Turn the pencil or crayon more on its side for lines which are less important or farther away, so that the line loses its sharp definite edge.

Movement draws the eye, and a quick movement in line makes the eye follow where you wish it to look. Movement from light to dark does the same. The speed can be regulated by spreading tone over a large area for slow movement, or concentrating the transition for a quick one. In a calm peaceful drawing, merge the tones slowly from one to another, and draw the lines without speed or urgency. Breaks in a line, lighter and darker accents, or a line composed of a series of smaller lines, draw attention because they create movement. Avoid jagged lines on objects which you wish to keep quietly in the background - a light continuous line is sufficient to suggest smaller groups or details in the distance, sharp touches only bring them into focus.

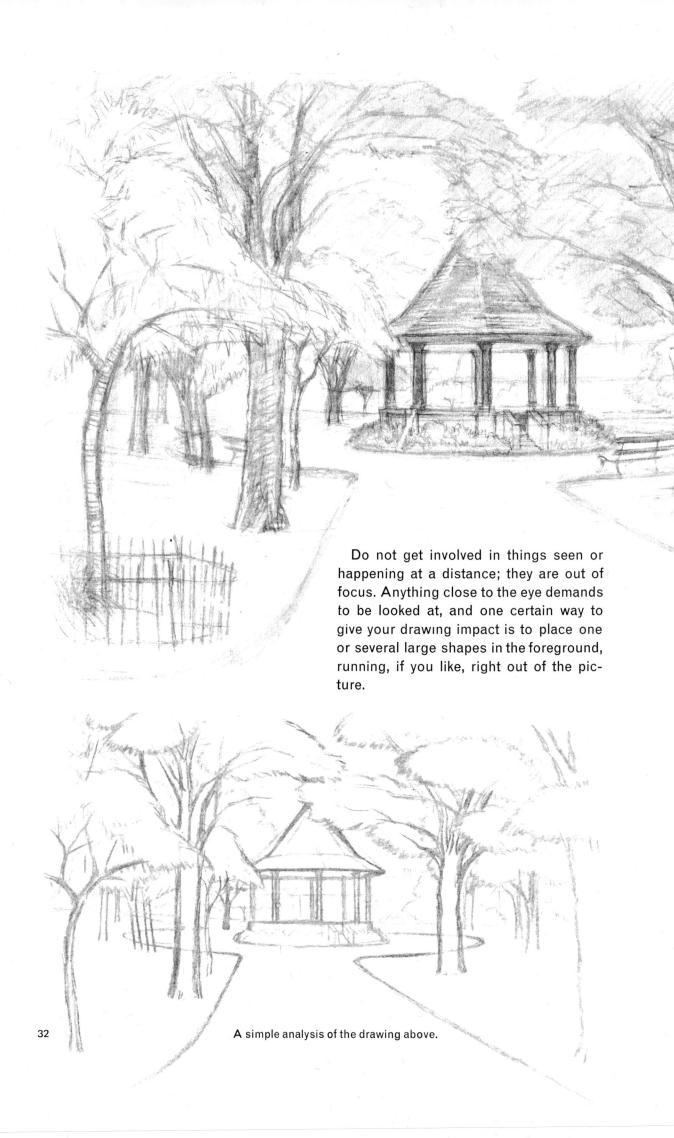

Do not get involved in things seen or happening at a distance; they are out of focus. Anything close to the eye demands to be looked at, and one certain way to give your drawing impact is to place one or several large shapes in the foreground, running, if you like, right out of the picture.

A simple analysis of the drawing above.

bits added, a hedge is a wall with texture, a row of trees a wider, rougher hedge high above ground level. Trees in their perfect state are regular in shape, like long, round or flat toadstools or mushrooms. Put them in like that, and break bits off where they are irregular. Eliminate fussy little branches which spoil your basic shape. Try to draw only the things which contribute to your drawing as a whole. Draw things which make it immediately clear what they are; things seen in foreshortened or contorted positions call for a great deal of drawing skill and a good knowledge of perspective. When things don't look quite right or explain themselves, try to make them look right in your drawing. You are not taking a photograph or making a record of facts.

In drawing the big shapes, consider the shapes between them. This helps to put them in the right place. Sometimes a long narrow strip of white paper left between objects has an unpleasant effect; a simple tone may help to break it up. Tones should be considered as shapes within the larger shapes, so avoid strong contrasts of light and shade until you are very sure of your drawing. Highlights are tempting but difficult to control, and should only be used to 'explain' some surface like glass. Animals are better drawn as studies unrelated to their surroundings - their shapes and patterning are usually exciting and interesting enough in themselves. Avoid using cast shadows, and use tone only to explain where the form turns, and in such a way that it does not become confused with tone used for local colouring.

The big shapes

The first consideration in any kind of drawing must be the big basic shapes, so spend time on getting them right. Your first rough drawing should say quite clearly what your subject is; if it doesn't, no amount of details will put it right. Objects at a distance can be seen quite clearly as shapes; try to see things close at hand in the same way, ignoring details. Basically, most buildings are boxes with

Finding faults

Never let your failures depress you to the extent of not wanting to try again. Find out why a drawing died, before burying it discreetly. Diagnose it quickly by diagrams. 'Artistic' drawing wastes time and confuses the issue. Lay a piece of layout paper over the drawing and work round the big shapes with charcoal. If there are no big shapes, you have found the fault immediately. Make some by grouping smaller parts together. Never go on to stage two, until stage one looks right without further explanation. Work on the composition until you are satisfied, and try to get some interesting movements inside the drawing. Decide whether you want one to predominate and play the others down, or whether there is to be movement and action in several places.

Fix it when it looks right, and pin another piece of paper on top. Plan the tones on this in broad flat areas, no rubbing down or subtleties. From this you will see whether they explain what you want to say; whether the objects in the foreground are really in front; which shapes are awkward. A further line drawing of the objects helps you to concentrate on their construction, and to decide where the focus and sharp lines should be. It is easier to think clearly when one problem is not confused with another, for co-ordination only comes with experience.

Over or under emphasis may be the result of uncontrolled pressure. Poor drawing and composition are always the results of unclear visualising, so concentrate on improving major faults first, as details are always minor.

Sketch in conté on absorbent, slightly grained paper, 6'' x 7''.

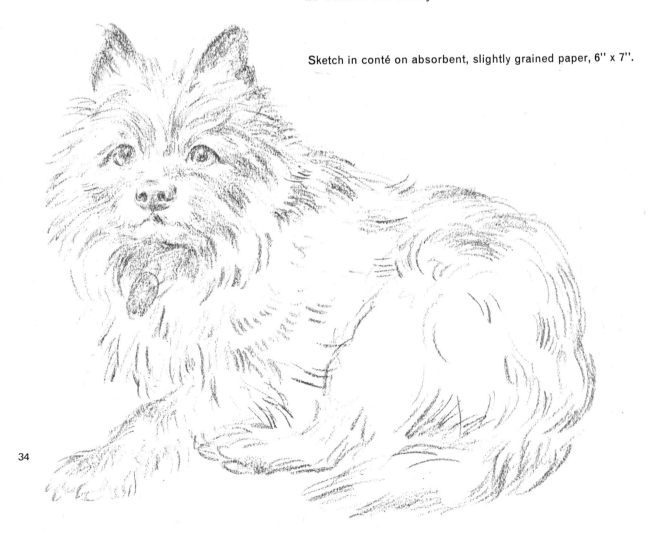

34

Mount cutting and presentation

A mount protects a drawing and adds greatly to its appearance, so it is well worth the time it takes. For most drawings, a simple white mount with a vertical cut is adequate, but for an important one you might prefer a grey or tinted mounting board, and go to the trouble of cutting a beveled edge, made by holding the knife at an angle. This looks better, but it takes longer and requires some practice before starting on the finished article.

The board supporting the drawing should be firm enough to prevent it from bending. The top mount will depend on how much you can afford to spend on it. A large mount dwarfs the drawing; too small a mount is niggardly. The size can be determined by laying the drawing under a sheet of layout paper, marking the space to be cut, and the outside dimensions, remembering to leave more space at the bottom to give better balance. Cut out the supporting mount the same size as the outer dimensions, using a T-square or setsquare. For cutting, you will need a hard surface such as metal or Formica, a steel ruler and a Stanley knife. Its wide handle gives a firm grip, and the blades are replaceable, which is important as a sharp blade is essential. Cut the top mount exactly the same size as the lower one, and draw lightly in pencil the space to be cut out, making sure that it is parallel to all sides. In cutting, place the ruler on the edge of the line for a vertical cut, further back for a bevel edge. Always place the ruler on the *outside* of the part to be cut, for the knife may run off the line. Hold the ruler firmly and make your cuts as clean as possible, taking care not to go over the corners. Do not pull out the centre until all lines are cut cleanly

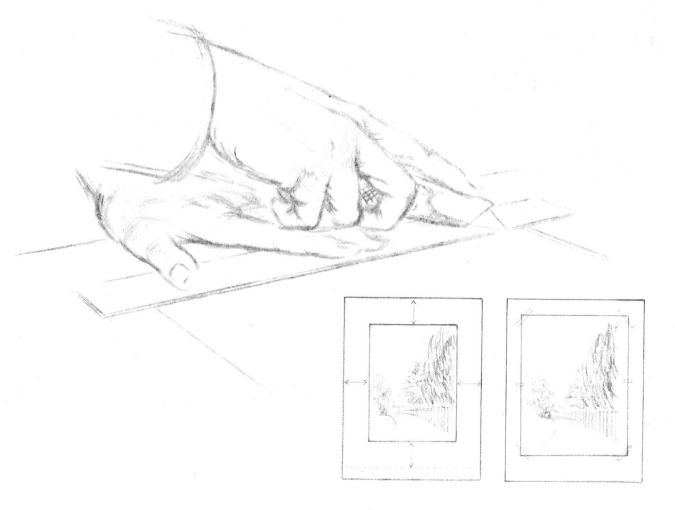

through. Position the drawing by laying it on the under mount and laying the other mount on top. Fix the two mounts at the corners and sides. If the drawing is not to be framed, protect it with layout paper cut to the same width, but long enough to be turned over at the top and stuck down. Stick the upper and lower mounts together at the corners or all round, or hinge at the top before attaching the protective piece of layout paper.

Summing-up

At the beginning I said that one can get into a muddle more quickly with chalks than with any other material. There is one kind of failure which recurs so frequently that every precaution should be taken to guard against it. It invariably follows a flying start when everything seems to go right. Ambition soars to great heights and you simply can't stop because there isn't time to put down everything that excites you. When eventually you do stop to draw breath, you find to your horror that the excitement has gone and the drab drawing in front of you bears no resemblance to your first bright vision. There is a simple reason for this. The longer you look at anything, the more you see, and quite naturally you want to put it all down. You add subtleties to middle tones which are already full strength, and confuse them with shadows; you find all kinds of differences in the light areas, and turn them into light middle tones. You are left with a series of tones moving slowly into each other, blunting contrasts, nibbling into the big shapes that are no longer recognisable. Standing back frequently or going right away from your drawing for a few minutes, is the only way of avoiding this kind of disappointment. Stop the minute you find that you are 'filling in'; avoid the temptation of finishing a sketch if you have nothing more to say.

Failure will also follow trying to draw like someone else, because the way you draw is the way you think. Trying too hard to make a good drawing causes tension, and prevents you from enjoying it. The question of success or failure rises at this point, and a lot depends on your reasons for drawing. When you draw for fun or relaxation, the drawing is less important than whether you have enjoyed it or not. When you draw to express something about what you see, you start a search or series of searches, and each drawing must be judged on what you have discovered or been able to say clearly. A very unpleasant drawing can be a success, if you have found out what *not* to do and learn to avoid it in future. Drawings hardly ever come up to expectations, so making the finished drawing an end in itself is asking for disappointment. When you know what you want but haven't enough experience to put it down, settle for the next best thing and continue your search over a period of time. The answer, or a good substitute, often turns up in the most unexpected places.

Try to look at chalk drawings by the great artists; most of them are very beautiful but simple studies for paintings. Use your drawings as studies in clear thinking, and it is more than likely that you will be pleased with some of the results.

36

Pen and ink
Faith Jaques

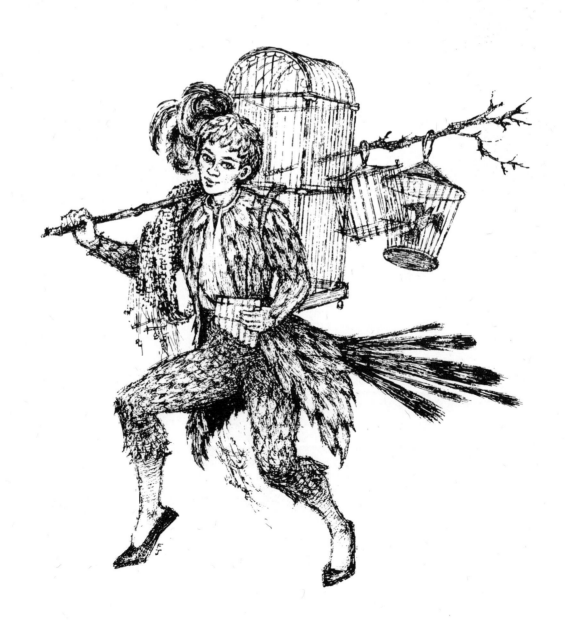

Drawing with a Pen

The basic thing to understand about drawing with a pen is that you are using a precise and pointed instrument; it differs from other media, such as a crayon or a brush, in that a range of tone can only be obtained by detached lines, not by a general spread of shading put down in one stroke. Therefore the artist who uses a pen must have a fairly clear idea at the beginning of what he wants his drawing to look like - where the dark and light areas are, for example, and the general pattern it is going to make, since, although your effects can be achieved quite freely, you need to be clear in your mind quite early on as to how you are going to

build up the various ranges of tone. It requires a more logical approach than most media, chiefly because the actual laying of tone takes longer than it would with, say, a brush - it is better to think first and get it right than spend a long time on a drawing only to realize it is wrong, and have to start again. This is not to say that you should think too mechanically about your effects - you will soon find that you can 'feel your way' into a drawing as easily as you can with a pencil; but a pencil mark is easily erased, whereas a pen mark is sometimes only too definite.

At first you will probably find a pen a

rather hard and rigid instrument to use, and you will quickly realize the mental discipline this rigidity imposes. In the early stages one tends to use the pen to make an outline and then fill it in with varying tones and patterns. This is a suitable process for some purposes, but it does tend to produce over-mechanical results; therefore it is much better to learn to handle the pen freely as soon as you can, so that you can think less about *how* you are using it, and more about *what* you are using it to express.

So practise using a pen as much as you can; use a fountain-pen for drawing in your sketch-book (to save carrying a bottle of ink), and you will find that by constantly using a pen for direct drawing you will soon get confident enough to use it as freely and easily as a pencil; this way you will be really *drawing* with a pen, not just using it to fill in areas with patterns.

Materials

1 The Pen

There are many varieties of pen available. You will see a few examples opposite, but there are many others that you can investigate yourself. There is no need to feel too traditional about what sort of pen and nib you use – for centuries pen drawings were made with a quill, but hardly anyone uses one now, and there are any number of new ideas about, such as a felt pen, or 'drawing stick', which allows great freedom of expression. I have even seen excellent drawings achieved with a sharpened matchstick or the wrong end of a brush!

There are too many types of nib to list them all, but basically they fall into three groups: *a)* metal nibs sold separately from the pen-holder; *b)* fountain-pens;

c) types which are not exactly pens, but which can be used in very much the same way, such as ball-point and felt pens.

Metal nibs come in a great range of shapes and sizes. The smallest, a crow quill or mapping-pen, is a very delicate instrument which is difficult to use with freedom - unless each line is carefully considered and put down very deliberately it will scratch and splutter, and I would not advise it for beginners. Then come a range of nibs made by such well-known firms as Mitchell or Gillott; experiment among these and find what suits you best. For instance, among the finer nibs a Gillott 170 gives a fine line but is quite firm and sturdy to use, whereas a Gillott 290 gives an even finer line but is rather

40

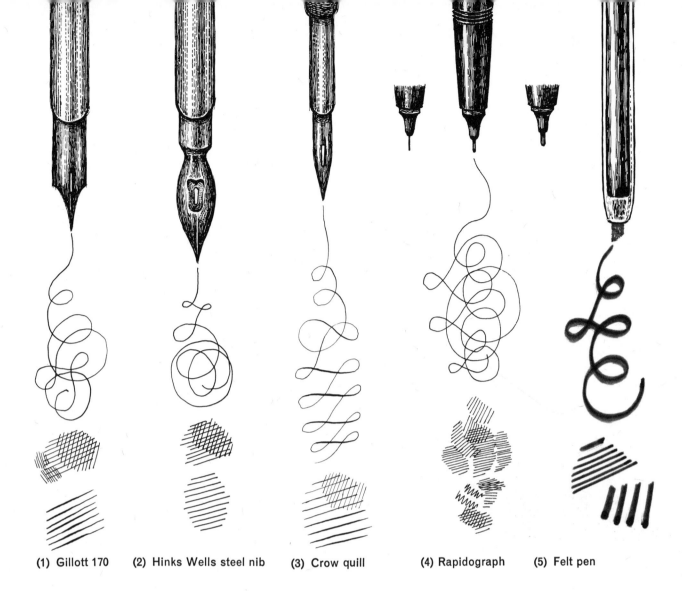

(1) Gillott 170 (2) Hinks Wells steel nib (3) Crow quill (4) Rapidograph (5) Felt pen

more flexible, which you may find makes it a little more difficult to control. To begin with I think a strong, fairly large nib is advisable, because it is firm to use; a small flexible nib is all right for slow careful work but it is tricky to manage at speed because it tends to catch in the paper if much pressure is applied. All the main manufacturers make large steel nibs; a good one is made by Hinks and Wells - it is very firm and seems to hold more ink than most. Some nibs have a reservoir attachment for holding ink and some pen-holders have a similar arrangement.

There are many *fountain-pens* specially made for drawing, in a great range of sizes. I have illustrated here the Rapidograph, whose nib is like a rigid steel rod; it gives a firm, somewhat wiry line which does not graduate in thickness. You can also buy Graphos pens which have interchange-able nibs varying not only in size but in shape, some being round, some square, and so on. The makers sell special ink for use in these pens, and they should be cleaned with special cleaning fluid. Cheap-er fountain-pens, such as Osmiroid, can also be bought with interchangeable nibs; these are very useful because you can bend the nib to suit yourself. Writing ink should be used in these.

I have already referred to *felt pens* or drawing sticks. In price they range from very cheap to fairly dear. There are many varieties, some of which are obtainable with differently shaped 'nibs' - square, chisel, etc. Ordinary *ball-point pens* are quite useful for sketching, but the ease with which they slide over the paper can lead to a very slick line. I find it is better to hold them vertically, rather than at a slant, as this produces a more sensitive line.

A fountain-pen or a ball-point is ob-viously a very useful instrument to use

for sketching as you do not need to have a bottle of ink at hand. For elaborate drawings a pen-holder and a selection of nibs is preferable, as you may need several different ones for one drawing. Have a good look at everything available, not only at your art shop but at a stationers' too, and find out what suits you best.

The drawing above was done with a medium-sized Rapidograph fountain-pen, though a Gillott 290 nib was used for the finer details of the face and hands and the woodwork graining. The Rapidograph is not a very sensitive pen and even in its smaller sizes does not give as fine a line as most ordinary nibs do. But for a fairly large drawing requiring a coarse open treatment, with strong blacks and plenty of white space, it is very suitable.

The drawing was made on Ingres paper, which is intended for use with pastels, not the pen, but it has a slight grain which can provide an attractive surface for the heavier nibs. Here it proved to have just enough 'bite' in the surface to make the line a little ragged; the undeviating thickness of the Rapidograph line sometimes has a rather mechanical effect, and a paper with a slight grain can off-set this by making the line look a little more loose and coarse. But the grain in Ingres paper, and all watercolour papers, is too much for a fine and flexible nib as it will cause it to scratch and possibly even break.

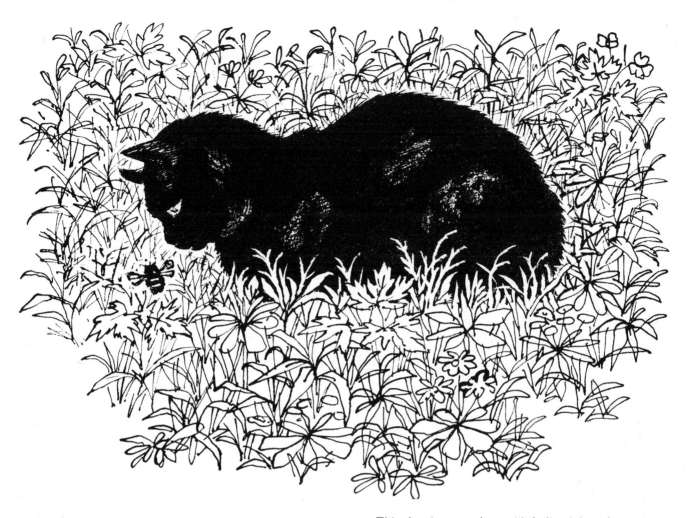

This drawing was done with Indian ink on Ingres paper, using a thick steel nib. To get the nearly solid black on the cat, broad scribbled lines were laid down and quickly smudged with the finger while still wet.

2 Inks

When you are drawing in your sketchbook it does not matter what coloured ink you use, but when you are making a finished drawing it is best to use black ink as it is more definite and gives you a chance to get the maximum possible range of tone.

There are many black inks available for use in ordinary pens, the most free-flowing one being black writing ink. This is not waterproof, which means that if you want to make an area of tone you can do it with a brush and water. Indian ink, which you buy at your art shop, is 'fixed', i.e. waterproof when dry. Inks vary in density - the more dense the black the greater the carbon content of the ink, and therefore the more it will clog the pen.

For fountain-pens such as Rapidograph and Graphos use the special inks provided by the makers, and clean the pens as instructed with cleaning fluid. Always wipe ordinary nibs clean after use.

You will find by experiment which inks suit you best. Different sorts suit different purposes, but for general use an American one, Higgins', is very satisfactory, as it is sufficiently dense yet remains free-running. This last point is very important - if the ink does not flow easily the pen will scratch and you will get very irritable.

If you want a smudged line you can use any ink satisfactorily as long as you do it while it is still wet. It works best in papers with a grain.

3 Papers

You can draw with a pen on almost any surface. Even blotting paper (see (1) below) can produce a line with a character all its own. There is no need to spend a lot on expensive sketchbooks or special papers - lay-out paper and typing paper are cheap, and you can buy a large sheet of newsprint very cheaply. If you want something a little firmer, try Imperial sheets of cartridge paper, or some other student-grade, large white drawing paper; it is cheaper if you buy it by the yard. You must draw as much as possible and therefore you do not want the worry of economizing over paper, so buy the cheaper ones. For elaborate finished drawings, though, you may require a special surface, such as smooth Bristol board, which is obtainable in inexpensive foolscap (17x13 inches) sheets. It comes in 2-sheet, 3-sheet, and 4-sheet thicknesses, the thinnest being the cheapest, and has the advantage that it is very stable and will take any amount of hatching and loading with ink, as well as plenty of scratching-out. If you make a mistake on one side you can turn over and use the back. There are heavier boards available, with one working side only. They have the same surfaces as the strong watercolour papers; hot-pressed (smooth), hot or cold (medium rough), and rough, but they are rather expensive. You may prefer to use the papers, but they will not keep as flat as the boards, and are not much cheaper. I have mentioned Ingres paper on page 42: it comes in white and several pastel colours, and it does well for smudged drawings.

(1) Blotting paper

(2) Smudged line on Ingres paper

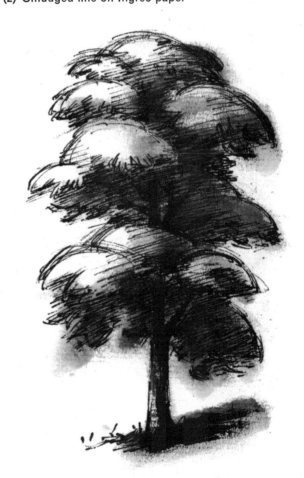

44

4 Pencils and India Rubbers

You will need a soft pencil, say 2B, for quick thumbnail sketches to indicate the masses of light and dark in your drawing; and a fairly hard one, say H, for use in drawing the design out carefully before inking-in. Do sharpen them to a long point - a pencil with a stubby point is clumsy in the hand and leads to scruffy drawing. If the point is long you will not have to sharpen it so often. You can use a knife for sharpening your pencils - your local art shop will stock the most useful sort which has interchangeable blades - but a stiff, single-edged razor-blade is better, and is also useful for scratching out on a drawing. A sandpaper block for keeping the pencil point sharp costs 2s. 11d (1$).

Use a soft white india rubber - I have suggested in (4) below that you cut it diagonally; this gives you a point so that if you have spent a long time drawing a design carefully you can rub out a small error accurately without taking away the surrounding drawing. A typist's eraser is also useful for rubbing out ink lines. Wipe all nibs, and wash your brushes after use, and keep these and pencils in a mug or old jam jar, so that the points do not get damaged.

Ordinary grade pencils cost about 1s. (60 cents), better quality ones about 1s. 3d. (75 cents). It is preferable to have the better ones if you can afford it as they are easier to sharpen.

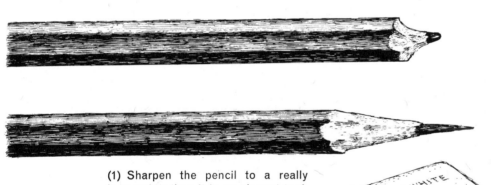

(2) Use a single-edged, stiff razor-blade for sharpening the pencil.

(1) Sharpen the pencil to a really long point; then it is an elegant tool, an extension of the forefinger, and you will draw with pleasure and accuracy.

(4) A soft white india rubber is best for erasing pencil lines; cut it diagon- ally to provide pointed ends for accurate rub- bing-out.

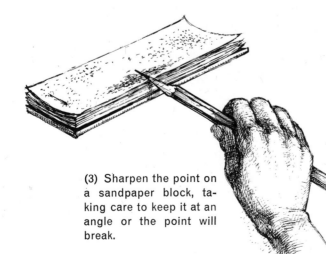

(3) Sharpen the point on a sandpaper block, ta- king care to keep it at an angle or the point will break.

(5) Typist's ink eraser

(6) Keep everything in a jar so the points do not get damaged.

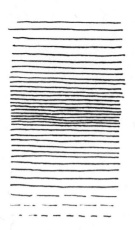

(1) Tone darkens when lines are put closer together

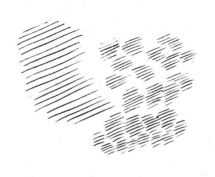

(2) Simple direct shading

(3) Cross-hatching, each layer at an opposing angle

(4) More layers of tone approaching solid black

(5) Pen used freely for scribbling - but tone still controlled

(6) Stipple and dot - too laborious for frequent use

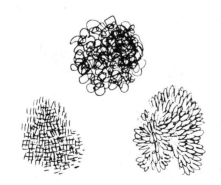

(7) Other loose textures

(8) Smudged line, and line drawn on damp paper

Applying Tone

You will find that the only way of increasing the tone is by putting the pen lines closer. There are, of course, hundreds of patterns you can make with a pen, but these examples show not patterns but the most basic ways of laying a tone, in a manner that is free enough for you to build on it naturally without having to think about it too mechanically.

In (1) you see how the tone darkens when parallel lines are put closer together; (2) shows the most natural form of shading (if you are left-handed it will go the other way), and in (3) and (4) succeeding layers of tone are laid in slightly opposing directions, building up to a tone that is almost solid black. (5), (6) and (7) are just a few of the innumerable ways of making marks. (8)

shows, first, the effect of smudging the line while it is still wet, and secondly, the thick, rather blurred line you get if you dampen the paper first. (For a small area lick your finger and dab the paper with it.) The drawing below needed an effect of a light figure standing out against a dark background. The details of the dress were inked in with a fine nib and then refined by working up to and across them with a fine brush and white gouache. The background required a general dark tone with heavy shadows, but enough definition for the chest to be clear. This was achieved by cross-hatching in several different directions, building up to an almost solid black in the cast shadows.

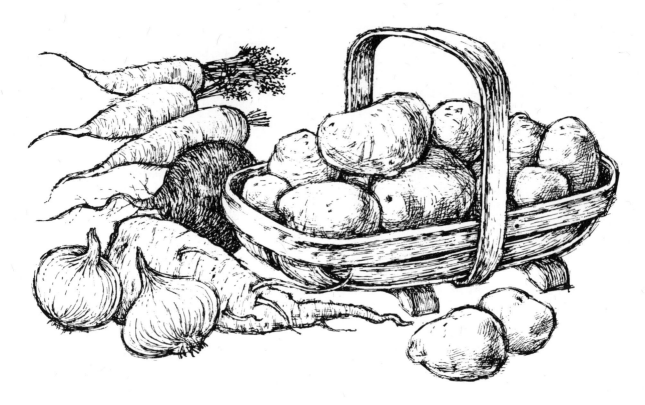

No effect of mood or emotion was required for the above. It was for a practical cookery book, and the drawings needed to be a reasonably accurate representation of fruit and vegetables and familiar cooking utensils. So it was kept generally light in tone, the only dark accents being on those objects which are themselves dark in tone, such as the beetroot. Otherwise shading was used only to define the shape and textures of the objects, with no attempt to portray cast shadows.

From the drawings on this page you will see that certain drawings have different purposes and therefore require different techniques. If your picture is to be decorative - that is, effective chiefly as a pattern in black and white, like the cat drawing on page 43 you will have to map out fairly carefully the actual shapes and tones, with due regard for the pattern. This sort of drawing does not attempt to take you into a scene so much as to decorate the page. However, some pictures, like those in the chapter 'The Heart of the Matter', have to give a greater feeling of reality, and convey a suitable emotional flavour. So here it is better to keep your penwork loose and fluid, so that you can convey subtle tones and less defined shapes. This sort of drawing, being rather more free in execution, is frequently drawn rather larger than the size you see in print.

Stage by Stage

On the next few pages you will see two drawings, each shown in various stages. The two finished drawings were intended for different purposes: the first is an illustration, the second really a decoration. The first drawing shows a situation - a knight approaching a castle on a bleak winter's day. A suitable approach here is to start by making a quick thumbnail sketch in soft pencil, roughly positioning the main subjects, and indicating the darkest and lightest areas, all the while bearing in mind the required mood of the drawing. This will 'set the scene', so to speak - it can be helpful at this stage to think of it as though it were a scene in a film. From here progress to a further rough in which you work out the general design and pattern a little more carefully. Then go on to the next stage, drawing out the design quite carefully and establishing the perspective and detailed drawing of the subject-matter. It is useful

to do these stages on lay-out paper, which is slightly transparent, so that you can lay each rough over the previous one and trace through. When you start the final inking-in try to work freely over the drawing from side to side, not filling in outlines but going for the strong directions in the design; it is best to 'feel your way in' on the darkest areas as these will be the 'key' to which to adjust the other tones. If you are working on a more decorative design, like the one on page 51, little can be left to chance because everything depends on the resulting pattern, so you need to have fairly tight control of the drawing right to the end. Therefore the method of working has to be rather more mechanical. Start with a quick sketch to establish the subject-matter and general pattern. Follow this with a reasonably detailed pencil drawing. Check whether the shapes you put in (and those you leave out) are pleasing and re-draw where

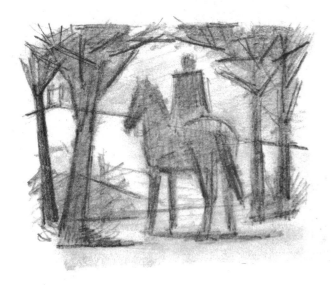

1

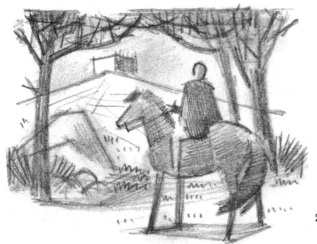

2

necessary. Finally trace it on to a good working-surface and ink it in carefully. 1 shows the first quick sketch to establish the subject-matter, the areas of tone indicated by soft pencil smudged with the finger. The idea in my mind was simply of a horse and rider framed by trees, with a castle on a distant hill. In stage 2 I started to reorganize the design to make a better and more 'readable' pattern. I dropped the left-hand tree as it made the design a little too symmetrical, and brought the castle into clearer view in the centre background. I altered the horse to a more profile view as it seemed a more interesting shape, and brought it right into the foreground, pushing the trees back. This gave a better feeling of distance. I kept the strong verticals of the tree-trunks as steady sides to the design, and also the pattern of branches at the top.

Stage 3 shows the design with the details now drawn in more carefully. I tried to express the structure and form of the rocks and the horse and rider, and the pattern made by the drapery of the rider's cloak. I left the pattern of the branches only roughly indicated so that when I started inking-in I could work freely with the pen and not feel tied down. Having lightly inked in the darkest parts - still *drawing* with the pen rather than filling in outlines - I went ahead on the final stage, working all over the drawing quite loosely, building up the darkest tones first and then adjusting the middle tones to them, until the drawing was complete. I used Ingres paper and two pens, a medium-sized Radiograph fountain-pen and a Gillott 290 nib for the finer lines.

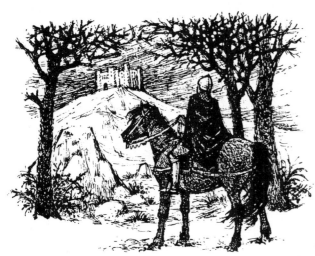

3

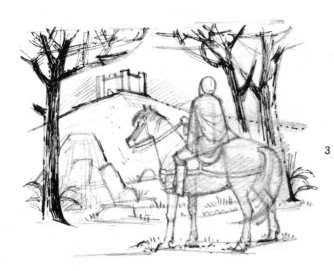

4

Stage 1 First rough, partly inked in, of a decorative cover for a magazine

Stage 2 Accurate pencil drawing, evolved from the rough drawing above, ready for tracing

51

In the two earlier stages of this drawing, shown on the previous page, you will see how the pattern was the main consideration. The first rough in soft pencil was partly inked over to see the weight of the blacks against the delicate drawing of the flowers (this tone was lightened later). The figures were then re-drawn to improve the design and this accurate drawing was then traced on to Bristol board and inked in. You see the final drawing below.

On the left you see how the treatment of the figures was altered in the final version. Details of clothes and stance were changed and the general tone was kept lighter, without so much solid black, as it was found to be too strong for the flowery pattern surrounding the figures.

The Heart of the Matter

So far we have been concerned with *how* you draw; now it is time to consider the importance of *what* you draw. Remember that although *you* need to be concerned with the technique you use to achieve your results, everyone else will be more concerned with what your drawing expresses than how you did it. And what it expresses is the all-important part, not just the subject-matter but the emotion or situation that is also part of it.

If you have two figures in a drawing we want to know something about them; are they old or young? happy or sad? do they like each other or hate each other? Your drawing does not always have to show a particular action taking place, but it does need to convey a mood or a feeling. Of course if you are illustrating a passage from a book the author has already conveyed his meaning in words and it is up to you to interpret him and translate his words into pictures. But if you are drawing something you have seen, even something inanimate like a building or a flower, your drawing should have a character all its own; if five people are drawing the same thing the results will all be different because each artist - often subconsciously - is putting something of himself into that drawing. So when you look at anything to draw do not think only of its shape, but think also of what you feel about it. Is there something you can convey that goes beyond its external shape and form, right through to what you feel is the

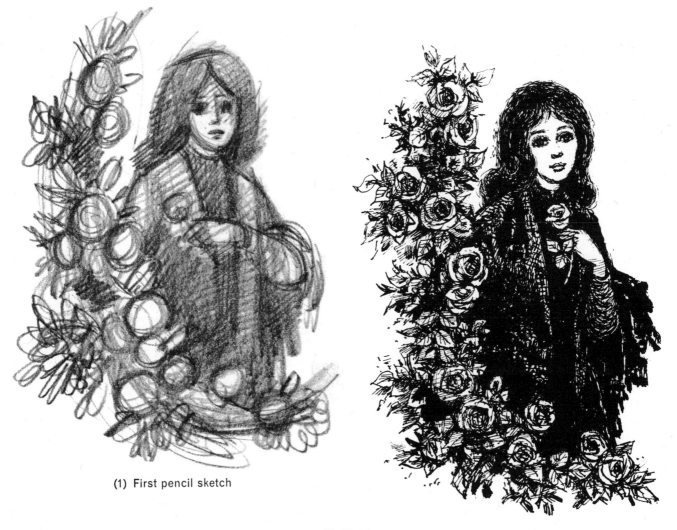

(1) First pencil sketch

(2) Finished pen drawing

essential character and individuality of it? Here, and on page 53, are several drawings all concerned with mood. The rough of 'Flower of Killarney' on page 53 shows how the first quick scribble is a vital attempt to catch the feeling of an idea before worrying about details of drawing. Below you see a child looking wistfully at pictures of her parents, and then the same child, now rougher and wilder in appearance, playing happily in the country. All these characters must be recognizable not just as being 'a child' or 'a young girl', but as a person expressing something. The same applies to a scene - if you do a drawing of, say, a few trees and a skyline, try to tell us more: is it a bleak and lonely scene, or a tranquil, happy one? restless or still? is the scene really what it appears to be at first glance, or are there sinister undertones to it? In other words, look at what you see not only objectively, studying the shape and form, but subjectively, carefully analysing your reactions to it.

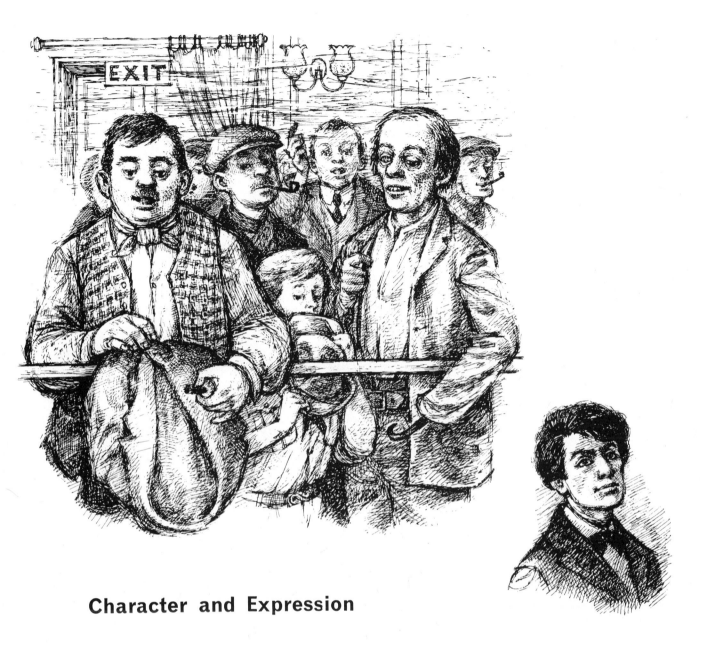

Character and Expression

From the previous chapter you will have understood the importance of making your characters convincing, so you will realize that you should be studying people all the time, and drawing them constantly - in the bus and train, at home and at work, at your club or school or wherever you are. If you see, for instance, two old men together, analyse the things that make them different from each other, and think what characteristics you would select from each to show these differences in a drawing. It is useful to think of the way an actor attempts a characterization: suppose he is to play the part of an elderly clerk in an office; will this clerk be frail and bent, longing for retirement perhaps? Cross by nature, or amiable? He might be sad and subservient or waspish and aggressive. Whatever his character it will show in his appearance, in his facial expression and in his posture, and an actor will study all these traits and develop them in his imagination to make a convincing portrayal of the character. You will need to study people in the same way. Examine the importance of tiny details to make a character look convincing: how would you place the eyebrows, for instance, in a face that was to express, say, bewilderment? It needs close observation to convey people and their expressions.

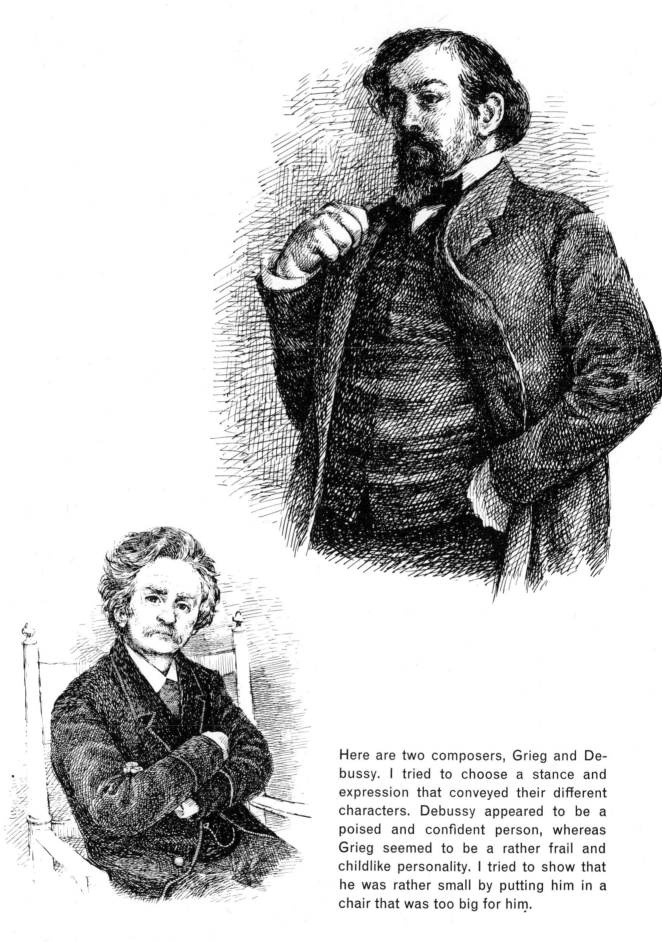

Here are two composers, Grieg and Debussy. I tried to choose a stance and expression that conveyed their different characters. Debussy appeared to be a poised and confident person, whereas Grieg seemed to be a rather frail and childlike personality. I tried to show that he was rather small by putting him in a chair that was too big for him.

Fantasy and Imagination

Sometimes you will be drawing familiar scenes - things that you have observed and want to put down on paper. But there may be times when you want to draw out of your imagination; your jumping-off point may be just an idea in your head that you want to try to put down in visual terms, or it may be a passage from a book or a poem that you want to illustrate. The field of children's literature provides a rich source of exciting pictorial ideas. Here one can find the most satisfying subjects because one is released from demands of factual explanation, leaving the imagination to run free in a world of make-believe. If this world of giants and witches and other fantastic creatures appeals to you, then think of some well-known myths or legends, shut your eyes and try to form a picture in your mind of the scene you want to show; then scribble around freely with a soft pencil and see what you can produce. Children's nursery rhymes are also full of wonderful ideas for imaginative pictures. But remember that the fantasy-world has its own laws which are just as practical as those of the real world: a giant must look like a giant, very big compared with his surroundings, but he must still look like a man too. The subjects nearly always need to look just as real as in a normal drawing, but the context is changed - things are upside-down, or much smaller or larger than usual - so exaggerate these characteristics to help the feeling of fantasy.

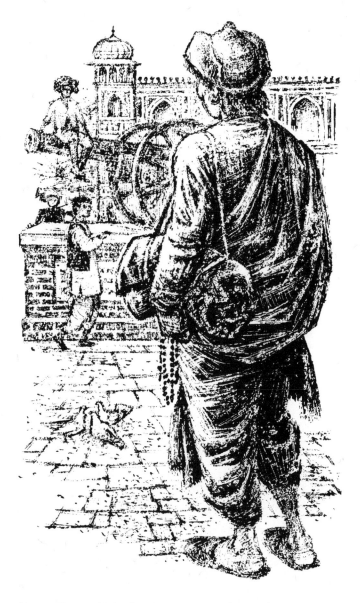

Sometimes it is better not to show the face of an important character; if we see his face then we can learn a lot about a person. But in this story the character was a mysterious new arrival on the scene - although he was to become important later on nothing was known about him at this stage; so it seemed better to portray him as just a figure seen from the back - a symbol, almost unknown and undescribed with no expression showing to help us form an opinion about him.

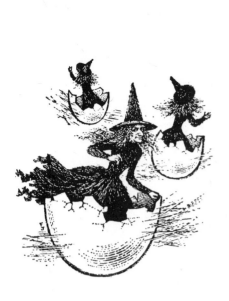

A giant is only a man on a very large scale - but it is important to have something near him to show he *is* larger than usual. Is it possible to show a giant - or a dwarf - if there is nothing else nearby of normal size to relate him to? That would be a subtle problem. Anything is possible in the world of fantasy - witches can fly in eggshells as long as they are the right size to fit into them. Everything works as long as you do not ignore the practicalities.

Settings and Atmosphere

This is where the importance of your sketchbook comes in. If you have been drawing constantly in your spare time, you should have sketches and studies of buildings, country views, trees and plants, gates and doorways and so on. These studies will stand you in good stead when you want to make finished drawings from memory. In earlier chapters we have seen the importance of feeling and atmosphere in a drawing, but however fantastic or poetic you want your picture to be, it will not look convincing unless you have clearly understood the form and structure of the things you want to show. Even though some things in the drawing may be only faintly suggested, you will still need to know their structure if only so that you can select what essential parts to show and what unnecessary parts you can leave out. For instance, if you are drawing a tree you cannot possibly show

every leaf - you must search out the essential form of growth of the tree, find the masses and general planes and construct it - in fact you are not just drawing what you see but what you *know* about what you see. If you want to portray a group of trees looking melancholy and windswept, it is possible to do this with only a few lines and no definition of the branches at all; but it will only work successfully if you have understood their structure both individually and as group. Adding an 'effect' to a drawing which does not have this sense of structure will only produce slick and artificial results. Suppose you had to draw these everyday things from memory: a lamp-post, a letter-box, a stair-case with banisters, the house opposite yours in the street where you live - could you do this? Although you see them every day of your life you might be surprised to find how little you knew

about them. Suppose you had to draw a house entirely out of your imagination - if you understood its construction you could do it quite convincingly. But you will always need to draw the ordinary objects and scenes around you, both to provide references and to train your observation.

Decoration and Christmas Cards

Do you ever want to design your own Christmas cards, or special greetings cards to give your friends to celebrate some particular event? There are all sorts of decorative ways of doing this and it is not at all difficult.

Suppose you want to design a Christmas card. First, think of some of the ideas associated with Christmas, such as Christmas trees and their decorations, holly and mistletoe, Christmas stockings, traditional food - there are hundreds more. Decide on a few with decorative possibilities. Choose an area for your card that seems suitable to your subject - if you want to have a Christmas tree then it would be sensible to work in an area that is taller than it is wide, but if you are going to have several subjects then choose those that are roughly similar in shape. You can place your single subject, such as a tree or stocking filled with toys, simply on this area, making sure that its shape relates well to the edges, leaving reasonable

space, and add a border if you wish. But if you want to use several subjects, such as tree decorations, a robin, and dishes of food, divide up the whole area of the card into the number of spaces you need for your separate subjects, making a sort of grid into which you now put your drawings. The divisions between the areas can be made into patterned borders, if you like, or sprays of holly and ivy, or perhaps fir branches. The card below was designed in this simple way.

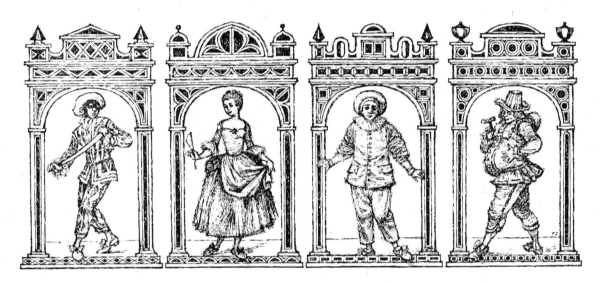

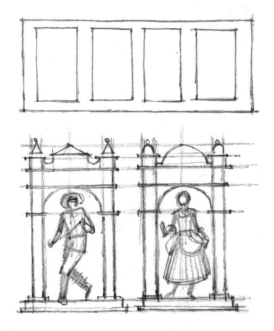

Here is the simple application of the principle of dividing up the area according to the number of subjects. I wanted to use the four characters from Harlequin and Columbine, so I chose a wide card and placed four equal shapes on it. I wanted each motif to fill the same area so I decided to put each figure in a little architectural 'folly', and devised these so that each had the same height and width and number of divisions, changing only the details of the tops, and the patterns on them, making four variations on one basic design. You will find books on decoration and ornament useful for ideas.

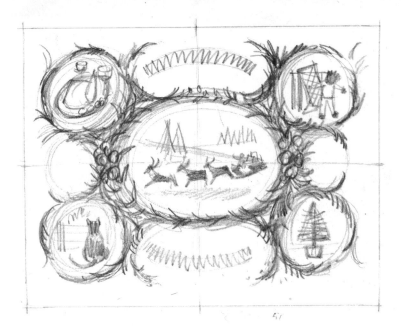

You see above the first scribble which was later developed into the finished design below, applying the principles which I stated earlier. I decided on one main subject - the reindeer and sleigh - and four subsidiary ones, with two words for the message taking up one space each. Then I divided the card into a symmetrical arrangement, with the main scene in the middle, the four smaller ones in the corners, and the words top and bottom centre. This left slightly awkward spaces left and right, so I put stars in these, and

then built up the lines dividing the areas into leafy borders. The result is rather elaborate and Victorian but it does not need to be; the same principle could be applied to achieve quite a simple design if you prefer. You could easily just divide the card into three upright strips and put, say, a Christmas tree in the lefthand strip, a stocking filled with toys on the right (both being similarly tall and thin) and something contrasting like a bunch of holly and mistletoe in the middle space. Then link them all with ruled borders.

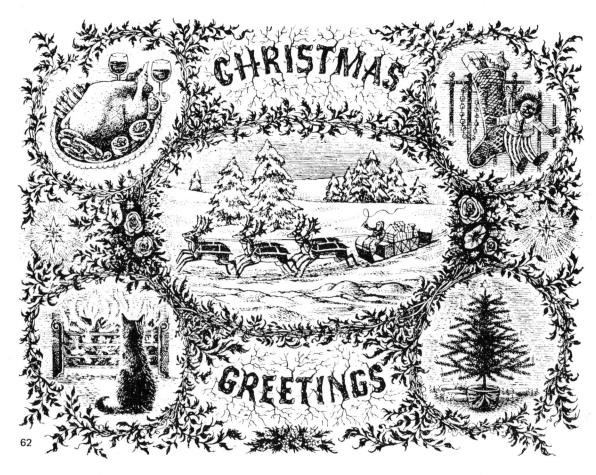

62

Designing Ornaments

These little historical ornaments, called cartouches, are very useful for all sorts of things, such as the cover of a school magazine, a notepaper heading, or on a small poster. They were first used in the 16th century, on architecture and later on title-pages, so look in reference books on these subjects for ideas. There are many variations of them and you can easily adapt a basic design to include whatever is relevant; the one opposite was for a book on fishing, but it could easily do for, say, gardening, by the addition of flowers instead of fish in the spaces. Find a suitable basic shape from a book, work out half of it in detail according to how much space you need in the middle for the title and what surrounding spaces for the other subject-matter, and then trace this half across to the other side. The principle for designing them is the same as for the Christmas card - work out what spaces you need and then design a symmetrical ornament to go around them. You may find some examples of swags and ornaments on the older buildings in your town - see if there is one above the main entrance of your Town Hall.

Wanting small posters for a jazz club meeting, or a concert - you could use long musical instruments above and below the centre, and shorter, more compact ones left and right. For a Harvest Festival poster you could use sheaves of corn and fruit and vegetables; for a Sports Club you could have racquets and bats and balls and golf clubs. Just take care that you place everything to make a good pattern; draw it out carefully in pencil and look at it through half-closed eyes, regarding it almost as though it were a map, and check that the shapes *between* the objects are interesting too. Then ink it in.

(1) First scribble to establish shape and spaces

(2) Rough idea of ornament and subject-matter

(3) Draw out forms carefully on one side and trace over

63

(4) Ink in final drawing

In Conclusion

I have suggested earlier in this section that you use a pen as much as possible for direct drawing in your sketch-book, not just for elaborate finished drawings. If you do this you will soon get confident enough to express your ideas as freely as with a crayon or a brush. As your observation and ability improve with experience, so will your confidence increase, and eventually your work will have a particular individual quality called style. This will come naturally when you are experienced enough to find your own particular methods of expressing your ideas. It is always helpful to study and analyse other artists' work, but if you try to impose their manner on your own work it will only result in a secondhand imitation. Your style really arises from what you are and what you see, and by constantly experimenting a personal manner will come naturally. So do not worry too much about the mechanics of technique, but do spend your time analysing everything you see and trying to express it on paper. Just as a writer expresses himself in words, and a composer in music, so you must express yourself in pictures, whether mere scribbles or finished drawings and paintings.

If you are really interested then you are certain to enjoy yourself as well. But sometimes everything on your drawing seems to go wrong; when this happens it is better to leave it, go away and do something else and then come back and start again. But do learn to analyse your work ruthlessly to find the mistakes - there is no point in starting a drawing again unless you understand why it went wrong. When an artist is working in pen and ink he is terribly involved in his work; a painter stands back and often works from quite a distance, but a pen-and-ink artist tends to crouch over his work, using his arm for small cramped movements, with his eyes often only a few inches away from it. Try to get back a little - sit fairly upright and try to keep your mental attitude, as well as your pen strokes, free and open. You may find that it is better to have your drawing on a board sloping from the edge of the table on to your lap, rather than flat on the table surface. This stops you crouching over it, and your back can be supported against the back of the chair; it also enables you to see your work at a better angle. If you have worked a long time at a drawing and find you are stuck, put it on the mantelpiece and stand right back from it, and you will be surprised how much more easily you can analyse it; bending over it too long means that you are only seeing the details and not the whole. For the same reason it is often helpful to look at it through a reducing glass, or hold it to a mirror as this will make you see it through fresh eyes.

Above all, enjoy yourself and never despair! From every drawing you make you will learn a lot, not only about your work, but also about yourself and everything you see in the world around you.

Nudes
Paul D'Aguilar

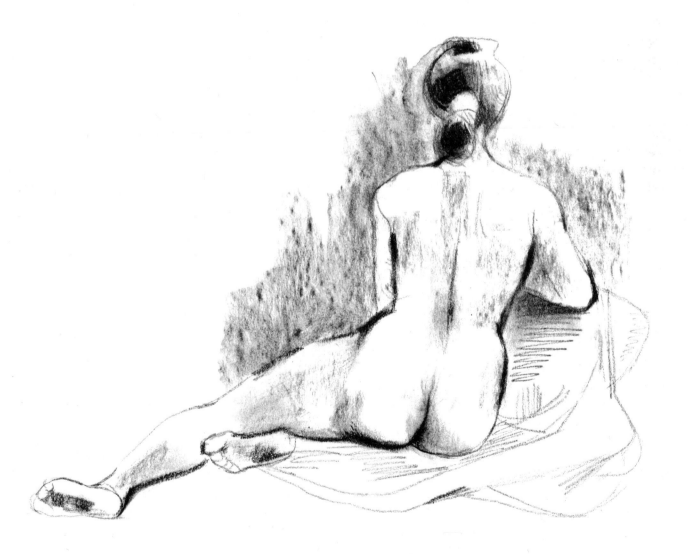

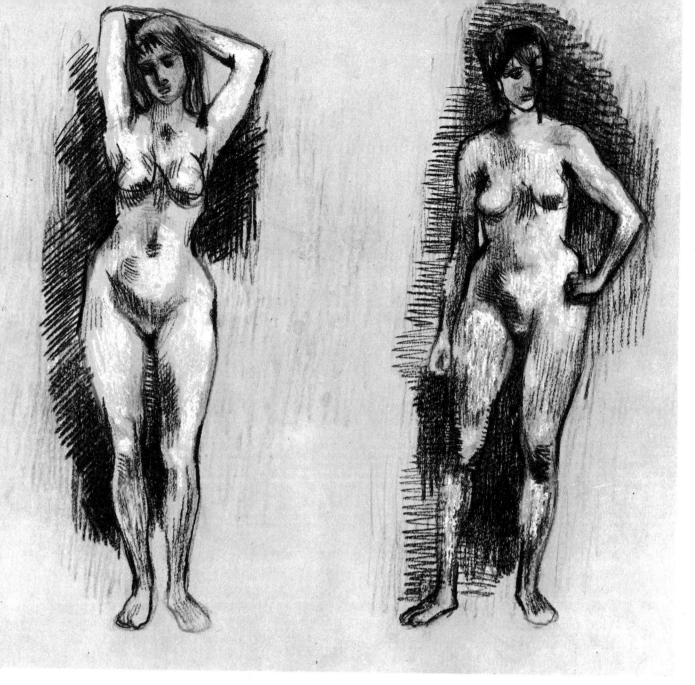

The nude figure has played a part of great importance in European painting. Its cult had already been perfected in Greek sculpture, and with the Renaissance it was revived in painting and drawing, with an added interest in anatomy which, for the first time, began to be studied scientifically.

As a *raison d'être* in creative design, it has held the interest of painters over a period stretching from Masaccio to Picasso. It has been humanism's chief means of expression, but realism, romanticism and expressionism would not have developed very far without it, nor would that analytical study of form, cubism. As a subject it has been the perennial starting-point for almost every movement in figurative art. The simple representations of Adam and Eve of Gothic times had led eventually to a type of figure full of movement and bursting with muscular energy, whose limbs had been twisted by inner conflict. This was the image of Michelangelo and his followers, and it led to an approach to the subject dominated by individuals: Rembrandt, El Greco, Velazquez, Delacroix, Ingres, Courbet, Renoir, Cézanne and Picasso, among many others.

The body is tremendously expressive. It can be idealized or distorted; represented with stark realism or caricatured; shown in full detail or simplified to a few lines or forms. It can be seen as a garment for the senses or a cage for the soul. It can be forceful, voluptuous, graceful, pathetic,

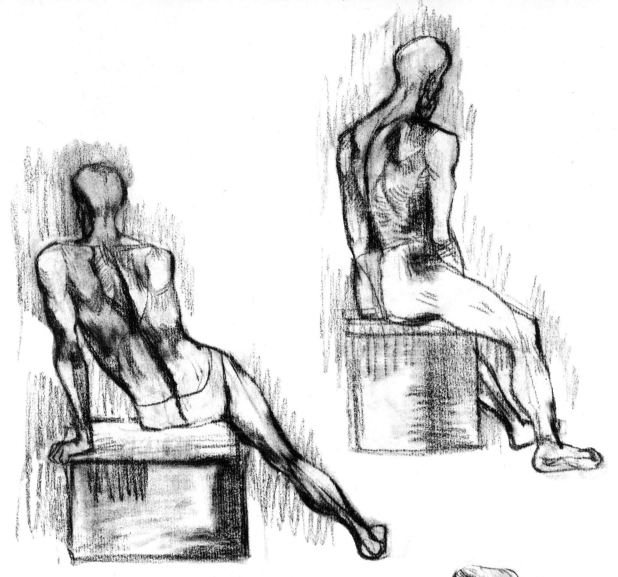

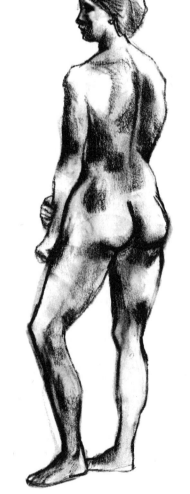

logical or evocative.

These different approaches should be studied in the work of other artists, but one's own attitude should be formed by making frequent drawings from the living model.

A good plan is to sketch the same figure in several different action poses which, because they follow one upon the other, are likely to be related. These sketches are done deliberately on one sheet of paper so that they can be seen together at a glance. This is not a new idea, but something that has been a well-established practice, and, for some unknown reason, seems to have been neglected in our art classes.

The body, like the face, has its own character. Peculiarities such as the varied shapes of hands, feet, etc., in different individuals should not be ignored, however; structure should come before detail, and, where detail is used, it should be as an aid

to form and expression, and not merely as a description of facts which may have no interest in themselves.

A point that should be kept in view is that the study of the individual figure, which is the concern of this section, is not so much an end in itself as an aid to the grouping of such figures to make a composition.

The model is not a lifeless mechanism, but living flesh and blood, and this should be shown from the very beginning. In your efforts to strike a balance between the all-over structure and the detail, the movement and flow of parts which are alive, as against the architecture of something that is solid, you will find that it is quite easy to work a drawing to death. When this happens, no amount of hocus-pocus will bring it to life again. The only remedy is to abandon it and start again, this time varying the pose.

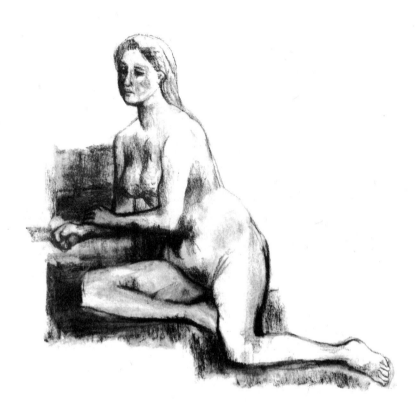

Making a start

How to begin? Some people start by drawing, say, an arm. They will then work it, rub it and worry it until it would fall off - if there were any body from which it could fall! It may be a very small arm, shining out in lonely isolation against a vast sheet of cold, white paper! Then, at length, the rest of the body begins to follow; it is, of course, out of proportion to this arm and out of scale with the surrounding paper. This is not the best way to make a start, although something like it may be useful in the second stage of work.

Of the many ways of starting, three can, perhaps, be summarized as follows: - (a) drawing from the centre of a form out- wards towards its margins; (b) drawing by outline; (c) drawing by a combination of the first and second methods so that the modelling and the flow of the outline can each be given due importance.

I would begin my drawing by roughing in the general shape, giving a simple foun- dation for proceeding to more detailed work, and establishing the right balance and movement from the word go. I would then look for points of accent within this frame- work. They occur wherever the shadow is concentrated: in the bend of an arm or leg;. under the armpits; under the chin etc. There are certain points in the body where the underlying structure is clearly visible at the

surface, and these should also be used: the ankle bones; the knee-caps; the pelvic ridges of the hips; the xiphosternum or end of the rib cage in the chest; the ends of the clavicles or collar-bones; or the triangular shape made by the sacrum in the small of the back; the ends of the scapula bones or shoulder-blades, etc. Before the drawing has taken any definite form, it may be helpful to connect these points by lines as a guide to the direction of the limbs,

carriage of the weight of the body and so on. After a time the lines can be left out as their direction will have been visualized.

Beginning, then, at any convenient point of accent and using rather a faint line, which should be kept soft and varied, the outline is followed to the next point of accent. The proportion of the lines is assured because they are related directly to the other lines and points nearest to them.

By this means the more usual method of measuring with the pencil becomes unnecessary, as the drawing and measuring are done together and as part of a single operation. In this way we can avoid that laborious business of holding the pencil at arm's length and trying to squint at it myopically.

Now let us take an example of drawing from the centre outwards. Suppose we want to draw the upper portion of an arm. Firstly, let us draw or imagine a central line, following in this instance the humerus bone. This will be our measuring-rod and we start to draw a line in relation to it from the armpit to the elbow. This will be the margin of the inner side of the arm, and referring to it and to our central line once again we

can now draw the outer margin of the arm. In this way we can build up and solidify the forms.

The points of accent and key points in structure that I have mentioned are very useful, as they enable us to build up a drawing quickly and at the same time with reasonable accuracy. If necessary, the general shape can be shown by using very faint lines to connect the points diagrammatically. Every effort should be made to get out of this stage as quickly as possible. and to dispense with it altogether as soon as enough confidence has been gained. Unless such a rough diagram is kept very faint, it will mislead rather than help, giving the drawing a very unpleasant, wooden appearance.

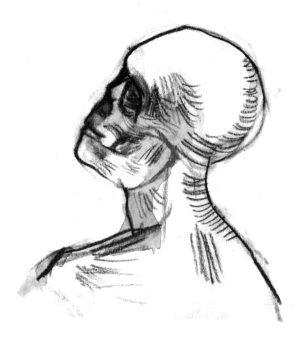

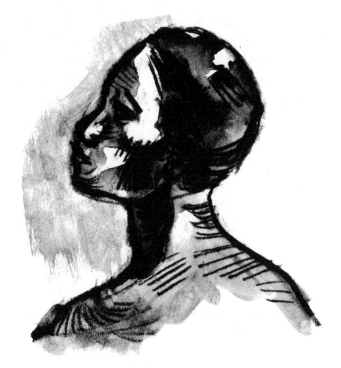

When drawing in detail, it is best not to work over and over again with many lines. Extra lines should be used to show where shadow falls and to soften and darken contours.

A line should be lost and found. In places it almost disappears, in others it thickens to a rich, dark accent. By means of a line the volume of an object can be shown even without any shading.

Accents occur wherever two solid surfaces come together as, for instance, between the fingers, under the arm-pits, at the back of the knee, etc.

When roughing in the outline, a kind of map can be made of the structure. If the figure is in a running position, for instance, where do the bones of the leg come, and where are they attached to the body? How does the movement of the arms complement that of the legs? How do the arms fit on to the body? What is the position of the skull, etc.?

Structure and simple anatomy

A detailed knowledge of anatomy is hardly necessary in order to make a good drawing, painting or piece of sculpture from the nude. Some familiarity with the structure, however, and a rough idea of how the mechanism works, will be found helpful, in addition to practice and intelligent observation.

The body is finely balanced like a crane, consisting of rigid pieces, the bones, articulating one upon the other and held in place and worked by the muscles. This

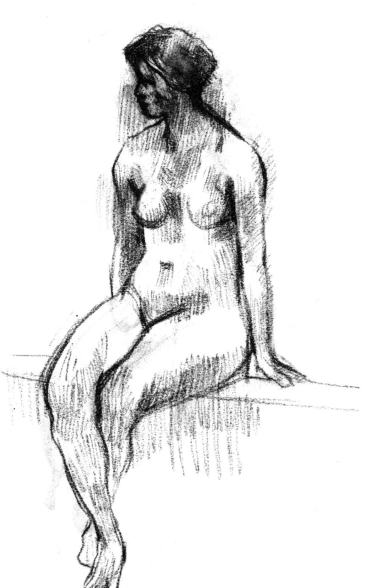

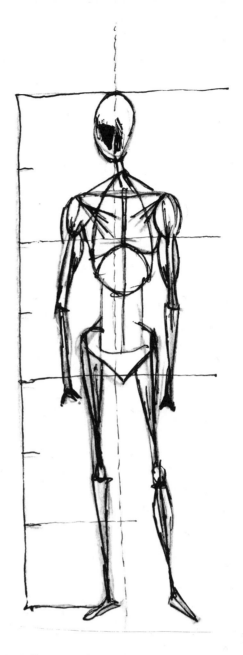

balance is seen at its best in movement, but is difficult to sustain for any length of time, from which we see that models by their very nature tend to sag and loose their equilibrium . . . a fact which, although sad, must be accepted! Again the answer is speed ּ to work as fast as possible without carelessness or faking.

To prevent one's figure from falling over, it is often helpful to draw an imaginary line of support. In an erect, standing position this plumb-line will fall from the centre of the neck to the inside of the ankle. If, as is usually the case, one leg is carrying the weight of the body more than the other, the line will pass through this supporting leg to a point just in front of the heel.

Of course a similar, but shorter line can also be used for seated figures.

If a standing, adult figure is divided for the purpose of measurement into four quarters, there will be a line touching the top of the head, another passing through the nipples, a third just above the point of division between the legs, and a fourth below the knee-caps. In the case of a child, these lines will cut through different points, since the head is larger in proportion to the body. The number of head measurements that will go into the height of the figure will vary with the individual, but it is usually seven in the case of an adult, and four, five, etc., depending on the age, for a child.

If we look analytically at the figure, we see that it consists of a head, a trunk or central portion and extremities. Starting with the trunk we notice that it is supported by a backbone or vertebral column, a rod

73

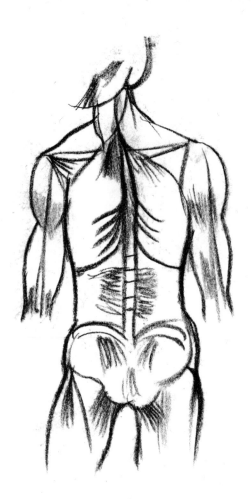

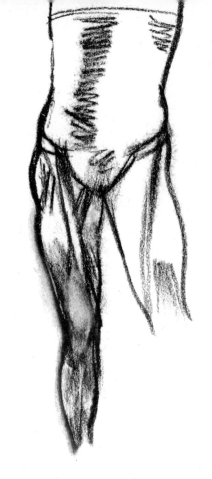

made of short, rounded bones, the verte-brae, which are strapped firmly together so that they form a gentle curve, rather in the manner of a figure S. The lower portion or sacrum is welded into a solid piece, and from this springs the pelvic girdle.

This is like a bony wash-basin standing on its two legs, and in it lie the entrails and soft organs of the abdomen. They are held together in a cylindrical sack. Next comes the thorax with its rib cage tied firmly to the vertebral column, and acting as a sort of protective dishcover for the

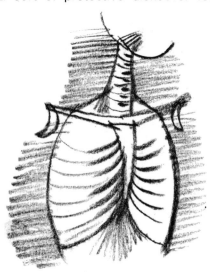

heart and lungs. To this are attached two sets of coat hangers, the long, thin clavicles in front, and the spade-shaped scapulas behind, and from these the arms hang. The vertebral column continues into the cervical region of the neck, a short stick upon which the head is balanced and to which it is firmly strapped.

The trunk, then, can be divided into several regions, the cervical in the neck, the thoracic in the upper and the lumbar in the lower part of the back, and the sacral in the area of the loins. Each of these regions has its external character. The neck is like a short cylinder containing a number of muscular straps which tie the head to the body and cause it to move up and down or to rotate. The thorax is characterized by the fairly free movement of the arms on muscles wrapped over the cage of the ribs. The lumbar region is soft and subtle in shape and therefore quite difficult to draw.

In contrast, the hips, at least in the male model, are strong and boldly marked. In the male chest the pectoral muscles form a characteristic pattern which is more pro-nounced in some models than in others.

In an athletic type the muscles of the ab-
domen can be contracted to form a ridge
running from the chest down to the front
part of the loins. In the female model the
whole trunk is quite different in appearance.
It is soft and curvilinear in outline, and
forms three main swelling shapes consist-
ing of the breasts and rounded abdomen.
The shoulders are curved and graceful and
their muscles are far less conspicuous than
they are in the male. The back part of the
thorax, however, is fairly similar in the two
sexes. The flat, muscular area between the
shoulder-blades gives a triangular shape
and this is repeated in a lower and smaller
version by the sacrum. When the arm is
bent the elbow, seen from the back, also
makes a triangle, with the olecranon pro-
cess and the internal and external condyles.
When the arm is held straight it forms an
inverted horse shoe. In the back the verte-
bral column makes a central line down the
trunk which is useful to the draughtsman.

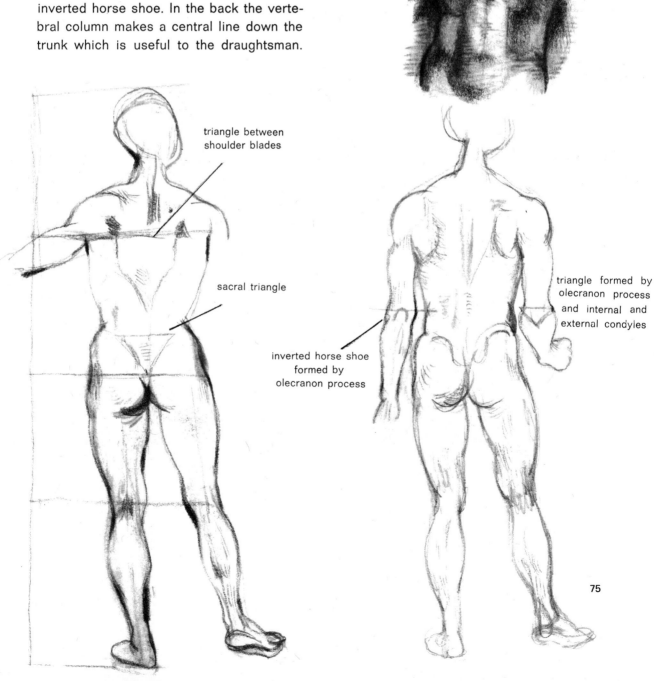

triangle between
shoulder blades

sacral triangle

triangle formed by
olecranon process
and internal and
external condyles

inverted horse shoe
formed by
olecranon process

75

The structure of the head

Heads are rather like animated eggs. The only bony part that really moves is the lower jaw, or mandible. Expression results from the movement of muscles, and, as I expect you will have noticed, is centred mainly around the eyes and mouth. It is so subtle that one can look away for an instant, then look back to find that it has changed utterly. There is only one thing to do about this: map in the head, indicating the features very softly, then capture the expression, if you can, in one *coup*. The shape and fall of the hair also gives character to the head. It does not hide the form of the skull beneath it as much as one would think, however; all one's powers of detection will be needed to follow this form and find it as it passes under a lock of hair and re-emerges.

Because noses are difficult to draw in perspective they are often neglected, their place being taken by a blur or two dots. They are easier to draw when the face is seen three-quarters on, than full face. Look for the shape and position of the nostrils and the muscles which surround them, which cast deep shadows. If these are well drawn, the central portion of the nose need only be indicated softly.

Eyes are essentially balls in sockets and should be modelled in perspective. Notice carefully how they fit under their lids and pay attention to the shape of the sockets. The pupils of the eyes move quickly and should be drawn quickly. Do not try to finish one and leave the other till later or you will never get them well-matched, but draw them both as part of one operation. The shape of the eye-ball itself is fairly uniform and drawing it is largely a matter of good construction. It is the area around it that gives individual character to the eye.

The cheek-bone is also important since it forms a connecting ridge between the ear and the corner of the eye. This ridge comes roughly within the central area of the head in profile.

When the head is seen from the side, the ear also makes a good measuring-point, especially with regard to the eyes, nose and mouth. When the head is held level, the base of the ear is on a line with the base of the nose, the top part of the ear with the eyebrow. If the head is gradually tilted backwards, these relative positions change, until the top of the ear is on a level with the base of the nose. If the head is lowered, of course, the reverse is the case. The ear is also useful in measuring the relationship between the head and the rest of the body. For instance, when the head is held back, the base of the ear is closer to the upper part of the shoulder than it would be if the head were held level.

The line of the jaw is soft in some places and hard in others. Its base line runs down from the ear in a gentle curve. This is flesh and thin muscle, and underneath it lies the more angular shape of the bone itself. This is formed rather like the letter L. The point of this L is almost on a level with the corner of the mouth, and is useful for making measurements. Its position can be felt by running the tips of the fingers along the line of the jawbone.

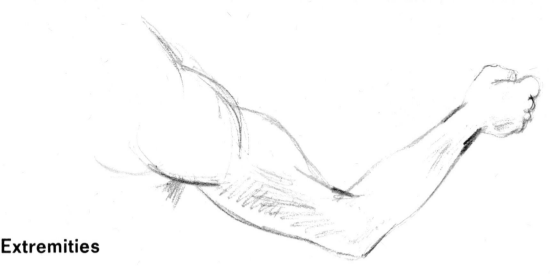

Extremities

Arms and legs follow a consistent pattern. They are divided into two halves with, in each case, a single bone in the upper and two bones in the lower portion.

The shoulders are padded by the shapely deltoid muscles. In the upper part of the arm the biceps are conspicuous, and bulge even more noticeably when this limb is bent. At the back, and rather higher up, the triceps make a gentler swelling. In the forearm the two bones, the radius and ulna, can be twisted so that the palms of the hands can be turned outwards or inwards from the body.

When the bones are so turned, a ridge is formed that flattens out towards the wrist. This, made up of a complex of small bones strapped firmly together, shows as a strengthening of the outline. From it the metacarpus bones spread out like a fan, forming the wide, flat body of the hand and continuing into the fingers. When the hand is clenched, the ends of the knuckle-bones show as a ridge and special attention should be paid to this, since the drawing of the hand depends upon its shape.

Notice the position of the thumb in relation to the other fingers. Try to summarize the outline shown by the fingers when they are resting together, and show the correct relationship between the hand, wrist and forearm.

Legs are naturally adapted for supporting weight and are made for strength. Their upper bone, the femur, is attached to a deep socket in the pelvis. When the figure is in a standing position and the bones of the leg have to support the weight of the body, they form a column which is not absolutely vertical, but one that dips somewhat in-

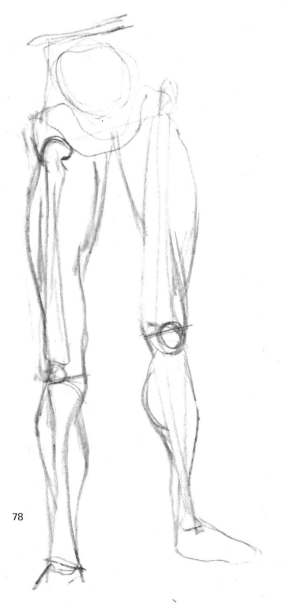

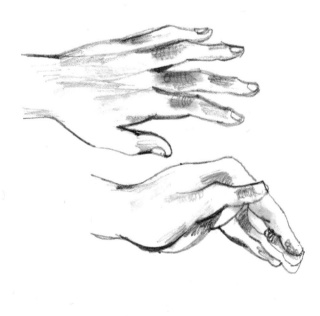

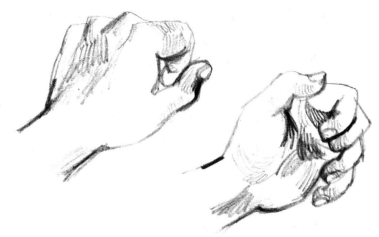

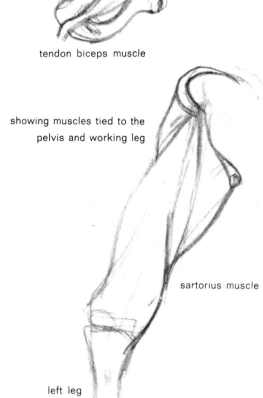

tendon biceps muscle

wards towards the knee, and is thrust outwards towards the hip. This column is steadied by a long, strap-like muscle, the sartorius, which stretches from the outer side of the hip to the inner side of the knee. When the leg is raised, a deep indentation is formed by this, together with other muscles in the same region. At the knee, the knob-shaped ends of the leg bones are clearly visible, even under their cushioning of muscles. Further down, in the calf, the gastrocnemius muscles make a powerful curve which runs down to the well-marked Achilles tendon in the heel.

showing muscles tied to the
pelvis and working leg

sartorius muscle

left leg

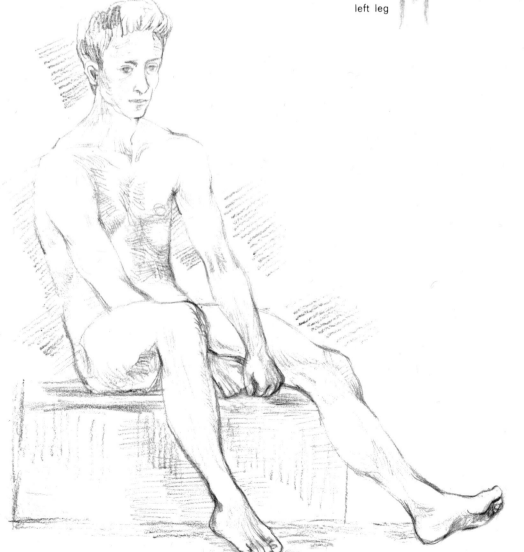

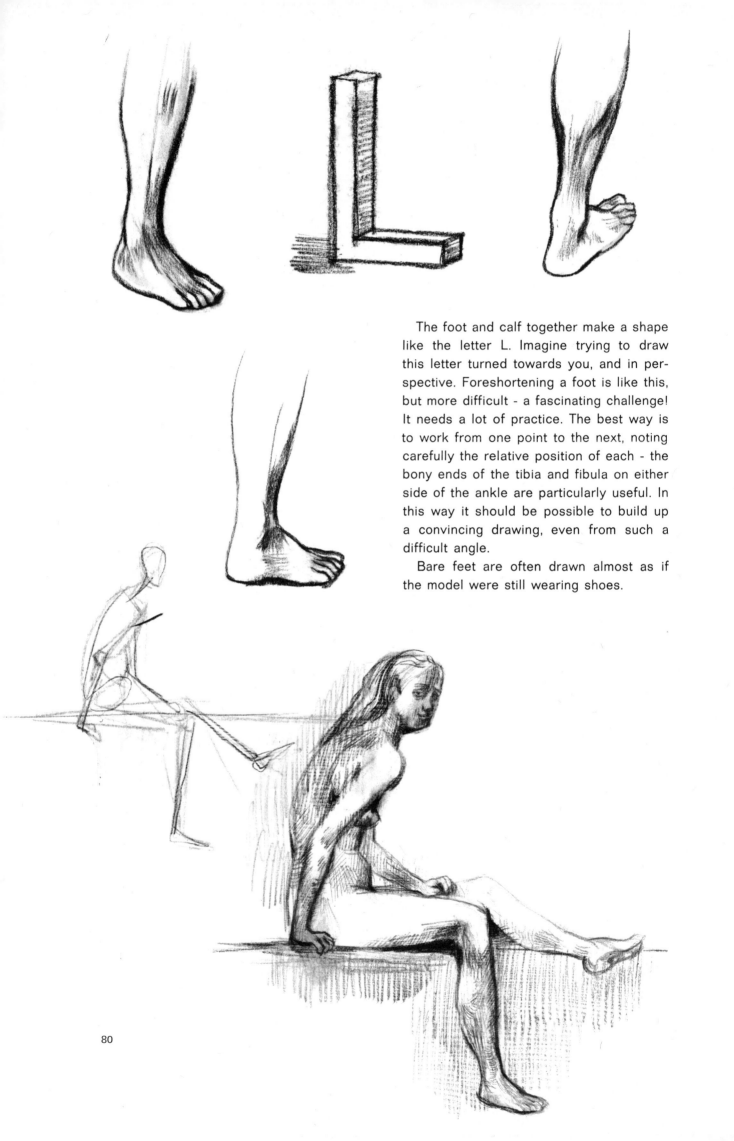

The foot and calf together make a shape like the letter L. Imagine trying to draw this letter turned towards you, and in perspective. Foreshortening a foot is like this, but more difficult - a fascinating challenge! It needs a lot of practice. The best way is to work from one point to the next, noting carefully the relative position of each - the bony ends of the tibia and fibula on either side of the ankle are particularly useful. In this way it should be possible to build up a convincing drawing, even from such a difficult angle.

Bare feet are often drawn almost as if the model were still wearing shoes.

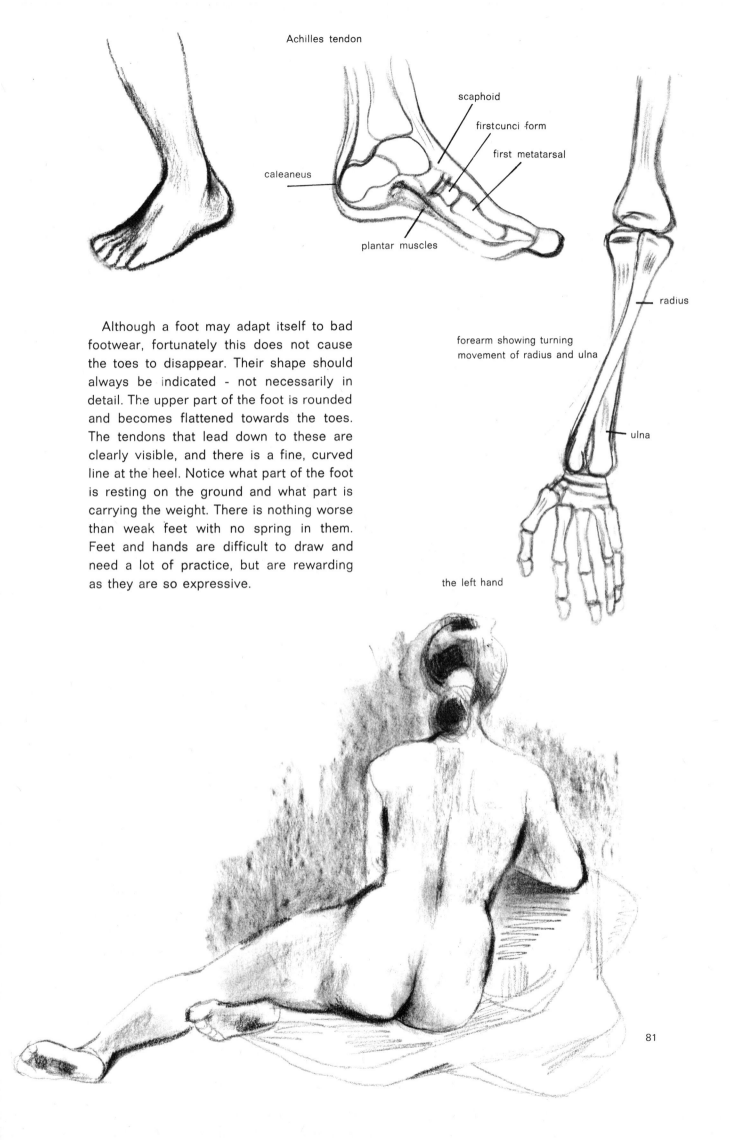

Achilles tendon

scaphoid

firstcunci form

first metatarsal

caleaneus

plantar muscles

radius

forearm showing turning
movement of radius and ulna

ulna

the left hand

Although a foot may adapt itself to bad
footwear, fortunately this does not cause
the toes to disappear. Their shape should
always be indicated - not necessarily in
detail. The upper part of the foot is rounded
and becomes flattened towards the toes.
The tendons that lead down to these are
clearly visible, and there is a fine, curved
line at the heel. Notice what part of the foot
is resting on the ground and what part is
carrying the weight. There is nothing worse
than weak feet with no spring in them.
Feet and hands are difficult to draw and
need a lot of practice, but are rewarding
as they are so expressive.

81

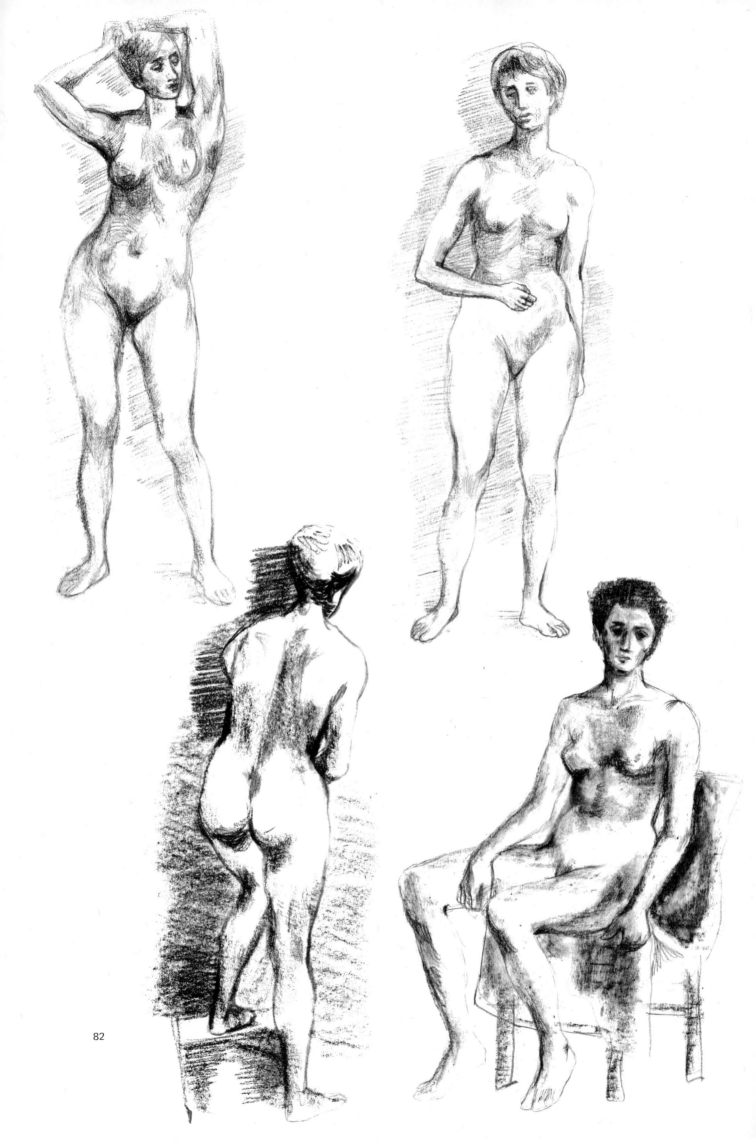

82

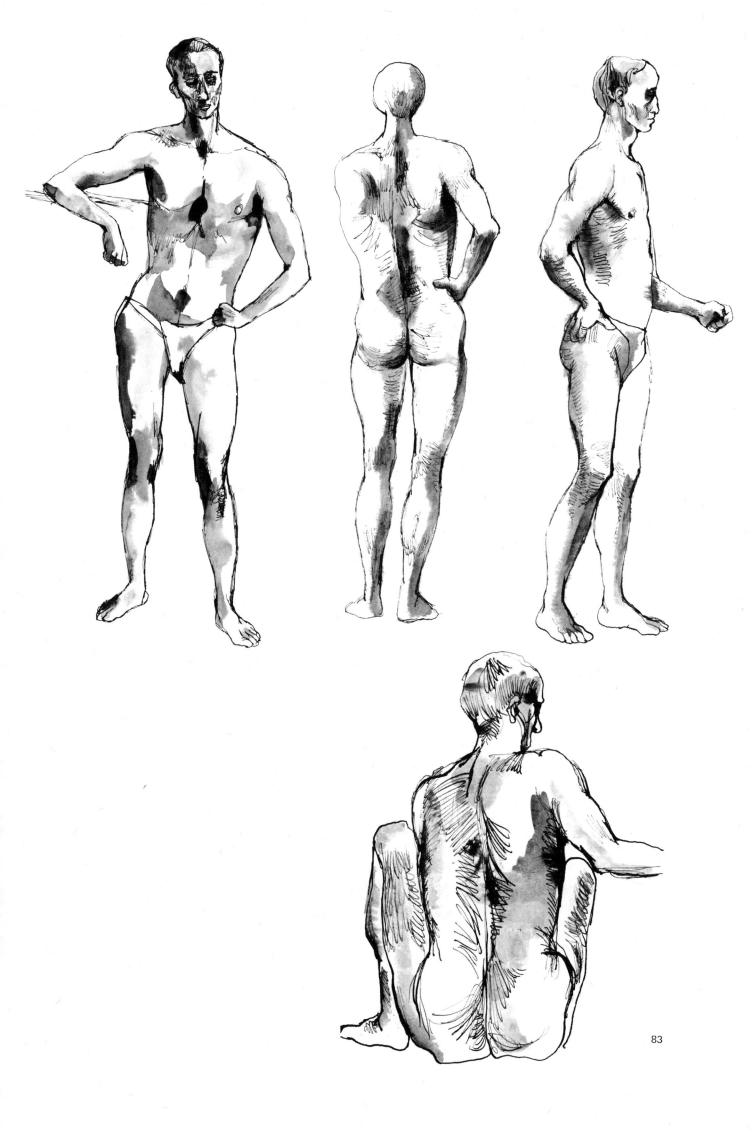

83

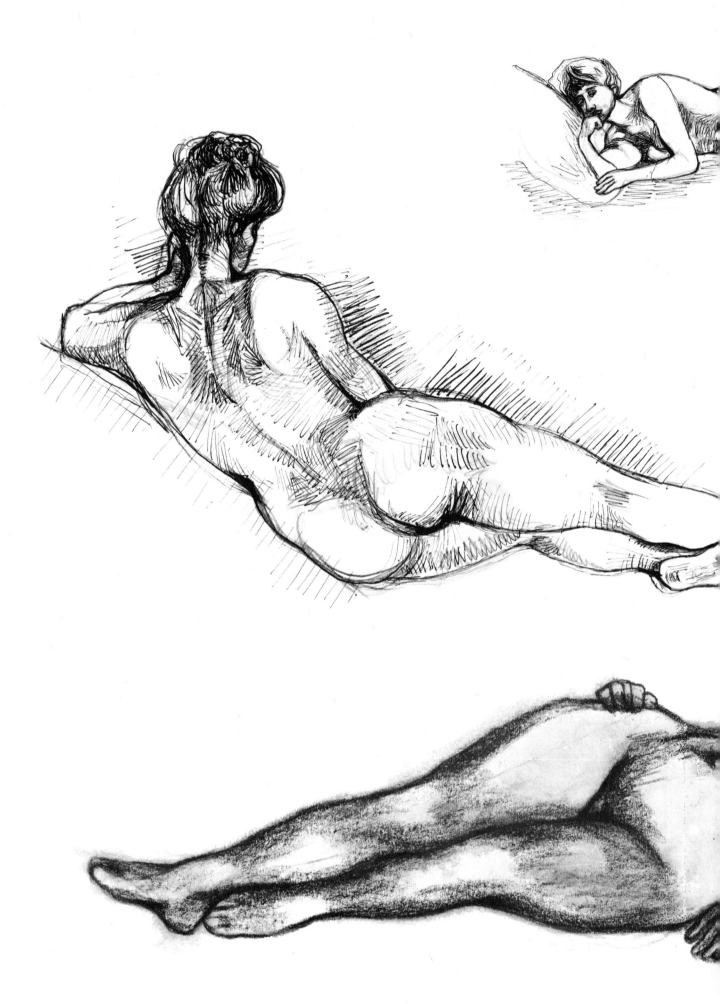

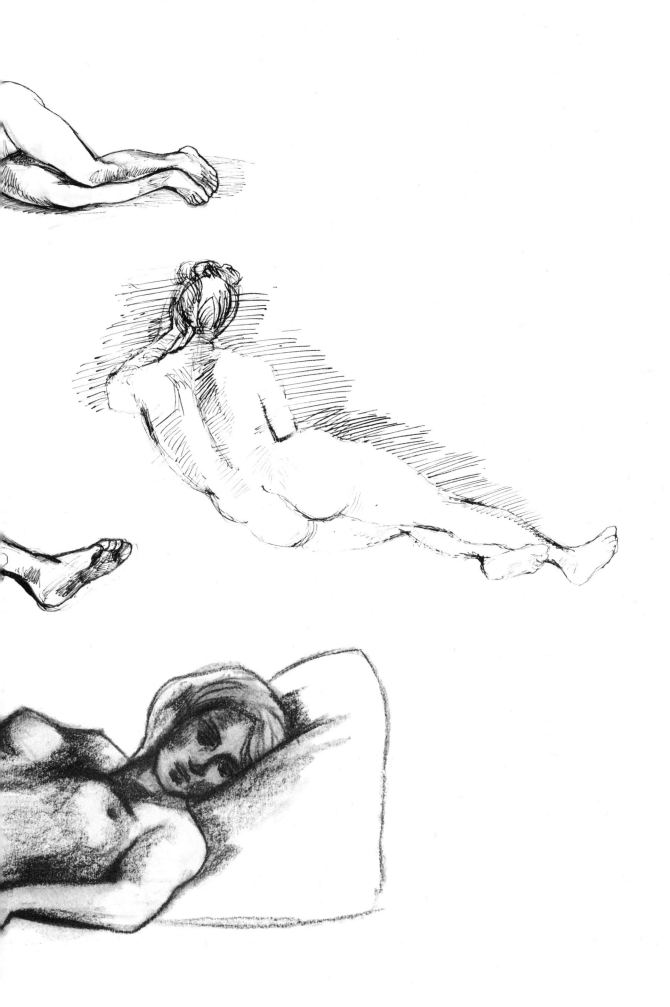

Movement

Every part of the body is intended for movement, and even when the pose is a stationary one the limbs should look as if they were alive and ready for action. Something can always be done about a figure that has been badly drawn, but for one that has become wooden there is no remedy but to start all over again, quite freshly and from a completely new beginning. Do not even try the same pose again; at least leave it for a bit, and come back to it again later.

The representation of movement in an art that is, by its nature, stationary is largely a matter of identification. It is like an actor playing a part. When drawing a man running, one should feel that one is onself running. If the model is bending over, for example, one should feel the effort, the straining muscles, the heavy breathing. In this way movement can be summed up quickly, and its continuity suggested by association.

Try to visualize movements in sequence.

What would an arm hanging limply at the side of the body look like if it were suddenly raised? What would happen to the bones of the forearm if the hand were turned round the opposite way etc.?

There are certain positions that are determinate and others that are vague. The three-quarter view of the face, for example, is determinate. The features, nose, mouth and eyes, all have a definite shape, which makes them easy to draw. A full face, however, is a different story. Here the features have a vague, indeterminate shape and can only be mastered after a certain amount of study. The body also has its determinate and vague aspects. A foot seen from the side, for instance, is more determinate than one seen full-on. The determinate positions are those that best suggest the characteristics of movements, and should be studied with this in mind. This, of course, excludes actual foreshortening.

Try drawing a seated figure. See if you can show the weight of the body, movement of the arms and legs, etc. Now find out how much you can remember about these movements. Draw another figure from imagination, seated in a slightly different position, and see if you have been able to capture the change in movement. Always draw a lot from quick action poses, and try to draw them really quickly and accurately. Watch your own movements in the mirror. This is especially useful for drawing faces, studying the various expressions, etc., but it is also effective from the point of view of the whole figure.

Hints and summing up

If you are posing the model yourself and do not need some special position, the best thing is to let him, or her, move around and watch out for a good attitude. As soon as this has been determined it is held, and the work can begin. Professional models tend to adopt one of a series of conventional and well-tried poses that are not usually very pleasing. Non-professionals, on the other hand, although they naturally tire much faster, have a certain awkward freshness that is much more likely to produce a good drawing. If anything goes seriously wrong, give yourself and the model a rest before starting again. Use plenty of paper and do not be afraid to discard work. A lot of time is wasted in working over things that have gone seriously wrong. I am not suggesting, of course, that a drawing should not be worked up properly, nor is it a bad thing to continue to work on a drawing which has been going well until you spoil it. This is quite distinct from working over

mistakes or attempting to revive work that has become dead.

A good principle is to move from soft, indeterminate materials which can be used slowly, towards those that are stronger, more determinate, and require faster and more expert working.

Look always for a balance between the outline and the underlying structure. Show movement with the aid of memory and association as well as by structure, proportion and outline.

See how the old masters and the more recent painters tackled their problems, and learn from them how best to handle the techniques of your preference.

If any part cannot be drawn properly, make a separate study of it on a separate piece of paper, then draw the whole again.

Keep your work simple, but do not despise the little accidents and subleties of nature - it is these that give us most of our visual pleasure.

Figures
John Raynes

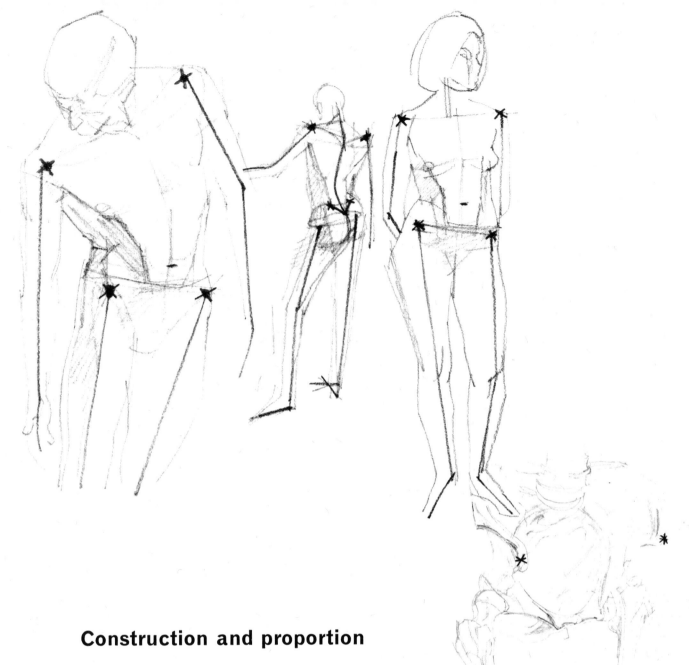

Construction and proportion

In this section I will try to help you to draw
people sufficiently well to populate your
pictures with groups or single figures,
and start you on the way to an understand-
ing of the human figure. You will never
achieve a *complete* understanding, of
course, nobody can; there is always
something new to learn. But if you look
long and often and draw and draw and
draw, you will find yourself acquiring a
store of visual knowledge from which you
will be able to predict the shapes your
figures will make, and you will also
be able to see the simple fundamentals
more clearly when you look and draw
again.

Which brings me to the first thing you
must learn: to look for the basic structure
of the figure. One must try to look past the
details and see the figure in terms of
simple basic solids. Numerous ways of
breaking up the figure into blocks and
cylinders have been suggested, but I am
going to suggest a slightly different one
from usual.

Although in the bony structure the
chest (thorax) and the hips (pelvis) are
only joined by the backbone (vertebral
column), I have found that it is misleading
to think of them as separate solids linked
by a flexible rod. In the live human being
there is so much tissue and muscle linking
them and contained by them, that I prefer
to think of the whole torso as one solid
form. Of course the torso can be bent in a
variety of ways, and there are several

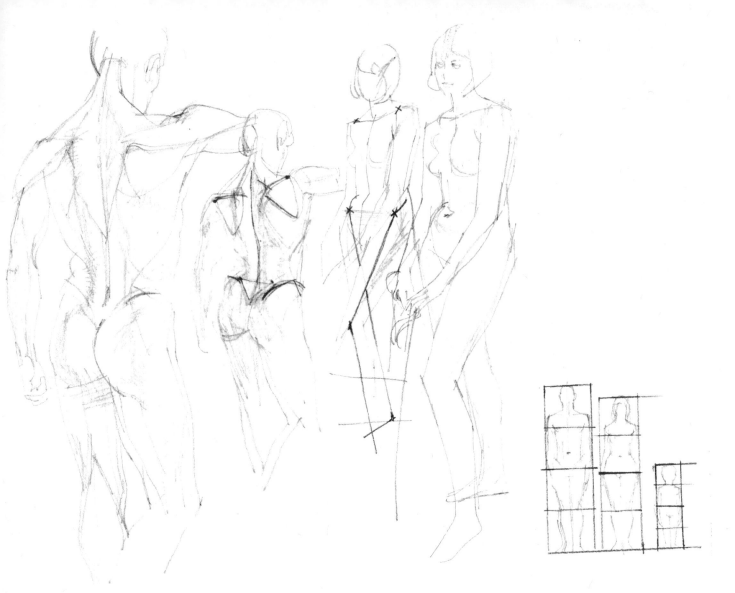

landmarks to help us to set up the figure accurately.

I suggest that for the moment you simplify the figure as I have done on page 91. The landmarks that you should especially look for are those marked with crosses. From the front the two top ones are the outer ends of the collar bones (clavicles), and from the back the outer ends of the wing of the shoulder blades (scapulae). The lower ones are: from the front, the points of the hips (pelvic ridges) and from the back, the two edges of the hipbones (pelvis) and the triangle of the base of the spine (sacrum). The left-hand drawing above shows this clearly.

Use single lines drawn from these points for the limbs. These will represent the general direction of the limbs, not either edge; and in the case of the legs, the line goes to the ankle, just in front of the heel, because this is where the weight

of the figure is transmitted to the arch of the foot, the heel taking the bulk of the weight in most balanced positions.

There are two remaining lines that will help you. From the front, the centre line of the torso, and from the back, the line of the backbone, which continues at the top as the neck. The head can be thought of as approximately egg-shaped, and sitting on the neck slightly tilted, so that the point of the egg is the chin, as on page 91. All that remains is a short line along the centre line of the sole of each foot, and similar lines for the hands.
With these simple elements we can construct figures of great vitality and endless variety.

The drawings reproduced above show the normal relative proportions of a man, a woman and a small child. Naturally there are great deviations from these 'norms' in real people, but they give a general

guide. Notice that in an adult, the legs account for almost half the height, and the length of the head goes about 6½ to 7 times into the height of the figure. In very young children, the head is relatively much larger and the legs comparatively short. As children grow into adolescents, the legs account for more of their height, the head for less.

One thing must be emphasized at this stage: there is no substitute for drawing from life. The simplifications I have outlined are to help you to separate the essentials from the trimmings, but first you must look for these vital elements in live people. Draw yourself in the mirror if need be.

Of course, when you come to making a complete study of a figure from life, there are many other subsidiary forms to be considered and other landmarks which help. On the drawing on the right, I have indicated in pen and ink some other important structural forms that you should look for. You will notice that many of these lines are *within* the outer edges of the figure, and this is important. It shows that it is not only the edge of something which tells you what shape it is. A drawing of the edges alone would be a silhouette, and would not necessarily tell you much about the *solid* shape. So do not draw a silhouette and then fill in the 'shading'!

Everything must grow together. It is much better to end up with a lot of straight lines, ticks and smudges in which you can see a properly proportioned, balanced figure, than to have a smooth, prettily-shaded figure drawing which looks as though it is made of cotton wool with no bones.

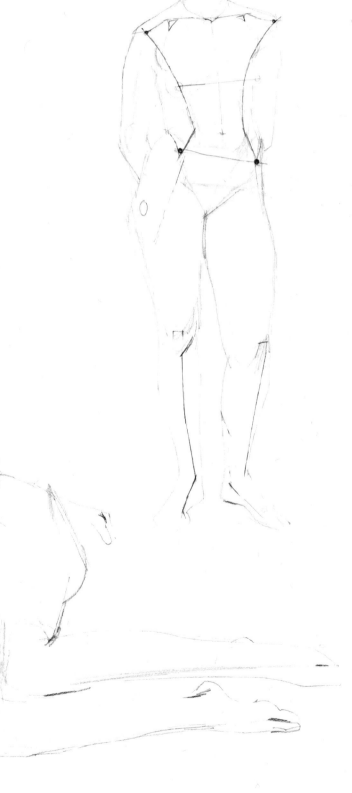

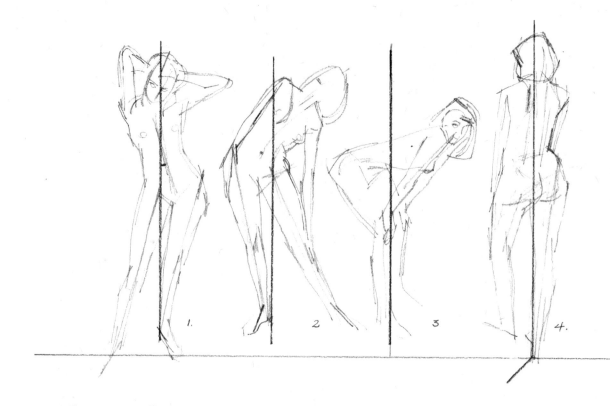

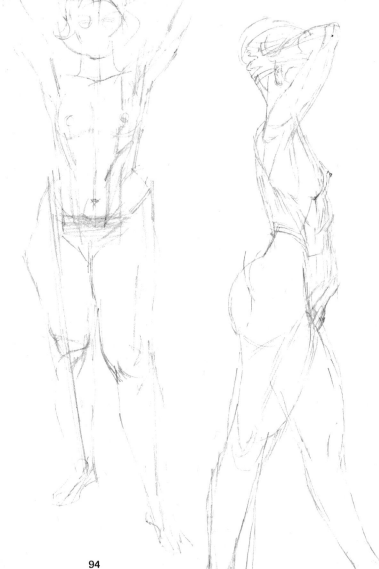

Balance

A good figure drawing stands well. It is balanced. It is obvious that a figure standing at attention is upright and balanced, but so also is a bending, reaching, twisting or stretching figure. The human body is splendidly mobile, and even when the only contact with the ground is the soles of the feet, a large variety of actions and poses can be executed with ease and perfect balance. Try standing up straight with your arms by your sides and heels together, then raise your arms in front of you. If you are to remain comfortably balanced, you will find that your body will swing back a little to compensate for the weight of your outstretched arms. Stand with your feet slightly apart and try to lift one foot. First, of course, the weight of the body must shift until it is over the foot which is to remain on the ground. Such compensations are made countless times every day by a normal human being,

without thinking about it. We, as artists, must study these automatic efforts of the body to remain in balance.

Look at people around you and see how their weight is taken on the toes or the heels, or on one foot or the other. Mentally draw a vertical line from the point on the floor where you think the main weight is being taken; then see where it goes relative to the head, for instance. In most relaxed standing positions, you will find that the head is exactly above the weight-taking foot, and this fact alone is a very great help in drawing people so that they look convincing.

The drawings at the foot of page 94 are of the same model in the same pose. It is a good thing, when someone is posing for you, to move round and draw the pose from several angles. You will understand better just how balance is being achieved.

All the figures at the top of page 94 are in equilibrium. See how in the first drawing, the body has swung in order to have equal weight each side of the vertical line from the weight-taking foot. The model's right leg is doing all the work here, and the other leg is just relaxing. The figure in drawing (3) has the weight taken equally on each foot, but since the head and upper part of the body are so far forward, the weight of the hips and the legs has shifted an equal distance to the other side of the imaginary vertical line over the ankles.

The weight of a seated person, of course, is taken on the thighs and buttocks, as well as the heels, and consequently the problem of remaining upright is not so acute. In a seated person, the feet are probably only taking the weight of the legs (unless the upper body is being supported by elbows or knees), so the main weight of the body is on a part of the pelvis called the ischium. Look carefully at people sitting in all types of chairs, without arms and with arms, and note carefully how the spine balances and supports itself.

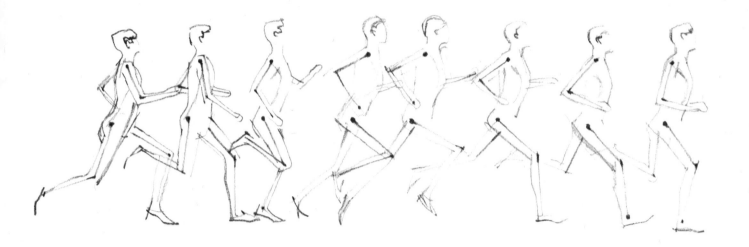

Simple movement

Until now I have been dealing with static equilibrium. A person walking or running is in a curious state of mobile balance. Unbalance is immediately followed by recovery and then by unbalance again, and so on until the final step, halt, and equilibrium again.

To take the first step from a standing position, one leans forward out of balance and one leg, say the right leg, moves forward, knee first, ready to take its turn at supporting the body. The leg straightens, the heel makes contact with the ground, and for a moment one could probably stop. If one continues, the weight of the body pivots over the supporting foot, the opportunity to stop is past, and the body falls forward, the left leg passing the right one preparatory to taking *its* turn.

Running is the same sort of thing, except that the runner is so overbalanced in the direction that he is moving, that it is possible for the legs to work like pistons and push against the ground to propel

him forward. The drawings above show this sequence, and also the way in which the left arm swings forward with the right leg and vice versa. This helps to counteract body roll and swing, in order to achieve side to side (or lateral) balance.

If something happens to interrupt this sequence of events, for example if one trips, then the body is in *uncontrolled* off-balance and emergency action is taken. The leg not in contact with the ground is brought forward immediately, in an attempt to stop falling and restore balance.

To draw action convincingly, you will find that it is usually best to draw a moment of off-balance. The more off-balance, the more dramatic it will be. The runner opposite will certainly fall unless that right leg comes forward, and the basketball player will have to re-adjust his position in the air if he is to land without falling.

At the top of page 98 is an analysis of active figures from a photograph. There is nothing against using photographs in this

97

way, especially for very active figures, where your eye does not give you much information. Be sure, however, that you *use* the photograph, and do not *copy* it. Choose a photograph which you really feel expresses the action well, and which will amplify your own observation. Lastly, remember that your draughtsmanship will only be tested and improved by drawing from life, so be careful not to become too dependent on photographs.

Persuade a friend to walk slowly to and fro in front of you. Watch carefully and try doing very simple drawings of three or four stages in the action. Add a line to each in turn. The first lines will be difficult, but once the four stages are established, you will be able to amplify them to a surprising degree, and you will learn a lot about the walking figure.

The drawings on page 96 were done in this manner; the model never stayed still. Do not try to halt your model in mid-action, so that you can see it more clearly. It just won't look right, and your drawing will be static.

Drawing clothes

In this chapter I want to deal at some length with the figure as a clothes hanger. Just as one has to think of the underlying structure in the nude figure in order to get the surface right, in the same way, clothing is an outer surface which can only be drawn convincingly if one is continuously conscious of the body within the clothing.

Of course most clothing doesn't fit as well as our skin, but however loose a garment may be, it has to touch somewhere, and it is the points from which clothing hangs, and the areas where it is under tension, which reveal the figure to us.

Although cloth seems at first sight to fall into haphazard folds, many of these are, in fact, predictable. Given a similar construction, the stresses and resultant folds in one sleeve will be similar to another. This predictability of the shape of

garments on the human figure can be called the *anatomy* of clothing. I think it should be thoroughly understood, if one's drawings of people are to have conviction.

Let us consider the sleeve of a man's jacket. Usually such a sleeve is set in, i.e. there is a seam around the arm-hole. The sleeve and armhole are cut and joined in such a way that when the arm in it is hanging straight down, there are no folds, and the sleeve is very near to being a tube. Now if the arm is raised (as drawing above), there is not enough cloth on the lower side of the arm, and so it is stretched and under tension. On the top side of the arm, however, there is now too much cloth, as the distance from the shoulder pad to the wrist has shortened. The sleeve cannot shrink in itself, so it has to go into folds, and since it is from the armhole that the taut side of the sleeve is stretched,

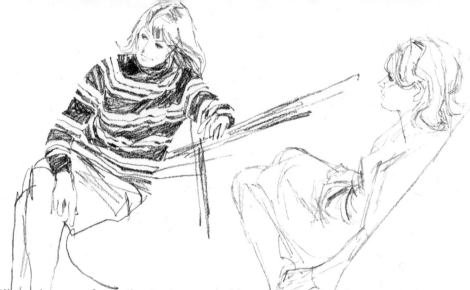

the creases will tend to run from the taut seam across to the slack side of the sleeve. This is a typical pattern and any set-in sleeve, and to a lesser extent any other sort of sleeve, will follow this pattern when the arm is raised.

Now suppose that the arm is bent, as when the hand is placed on the hip. Then the arm above the elbow will be the same as if the arm were raised straight. The cloth on the upper side will be slack and folded and that on the under side taut. But bending the elbow has reversed the situation for the rest of the sleeve. Now the elbow is pressing through the sleeve

and lengthening the distance that the cloth has to cover, and there are lines of tension radiating outwards from this new point of stress. The spare cloth in the bend of the arm becomes folded, of course, and the tension of the under side of the upper arm may be relieved and some of the taut folds disappear, although not all. The drawings on page 99 and below will show you what I mean.

Men's trousers, too, since they consist mainly of two tubes of material, fold in much the same way. When the figure stands straight and upright, folds are at a minimum, and the trouser legs would be like tubes, except for the long, straight creases which are ironed or stitched in. But when the man steps forward, all sorts of stresses and resultant folds immediately occur. The thigh of the moving forward leg will have swung from the hip, and at one stage the knee will be slightly bent. Thus the cloth at the top of the thigh, and behind the knee, will be slack and folded, while the buttock, and to a greater extent the knee, will have stretched the cloth, and taut folds will radiate from them. From this emerges a clear pattern of points of tension with stressed folds radiating from them, leaving islands of crumpled, loosely folded material.

Two things should be noted at this stage.

(1) Everything that I have said so far applies to relatively closely fitting garments. Looser fitting clothes are not always quite so predictable.

(2) When I said that a sleeve is cut to hang virtually without folds when the arm is

straight down, this only applies to freshly pressed or new clothes. The continual folding and stretching of sleeves and trouser legs on a living human figure, soon leaves a pattern of creases which remain even when the garment is not being worn. The tighter the garment, the more creases of this sort it is likely to acquire. Look in the mirror at yourself in those old blue jeans!

The position of the torso, which is the key to every pose, is revealed by clothing too, if you look carefully. Tight clothing, of course, is like a second skin, and the silhouette is therefore very similar to the nude figure. But even with the closest fitting clothes, there are usually some folds and tension which help to express the pose. A very loose sack-dress may hang straight down from a woman's shoulders, hardly touching the figure at all. Indeed most fashionable clothes are designed to have a shape of their own, which is evident whoever wears them. Nevertheless, however disguised the figure is, we know it is there - a dress on a clothes hanger looks quite different - so we must look for clues to the underlying pose. Never draw legs sticking out from beneath a skirt without some idea of where the pelvis is and the direction of the backbone. Sometimes, where there isn't a fold to be seen, the whole shape of the clothing, if carefully observed and drawn almost as a pattern, will seem solid and convincing, but the balance must be right. The position of the head relative to the arms and legs must convince the observer that they all belong to the same person.

I am not going to try to analyse the mechanics of all clothing in detail, but I hope that what I have said will serve to convince you that there is always a good reason for every fold you see in a clothed figure. If you try to understand what is happening to the cloth, instead of just copying the light and shade, you will find that you are able to sort out the *important* shapes and lines, those which express the character and pose with the greatest economy and vitality.

Another way of suggesting the form of the clothed figure, is by the use of a printed or woven pattern on the material itself. The sweater on page 100 is an example of pattern used in this way. Stripes are ideal to describe form as they function as contour lines, and the distortion of other regular patterns can be used effectively to show shape and form.

There is another sort of pattern that you should be looking for too: the pattern that your drawing makes on the page; the way that some lines are close together in an enmeshed texture while others are wide apart. The white areas, the accents of black - all these make a pattern. It should be a good one. If you look carefully at nature you will find marvellous patterns, but they have to be looked for and sorted out. If you are receptive to them, you will find them everywhere; some of the most marvellous, are formed by human figures and groups of figures.

When drawing the clothed figure, try not to be misled by superficial details. For example, a button on a jacket can be considered of secondary importance if it is not fastened and therefore not functioning - but if the same button is in its buttonhole, stretching the cloth and producing a tense crease that tells you something about the pose of the figure,

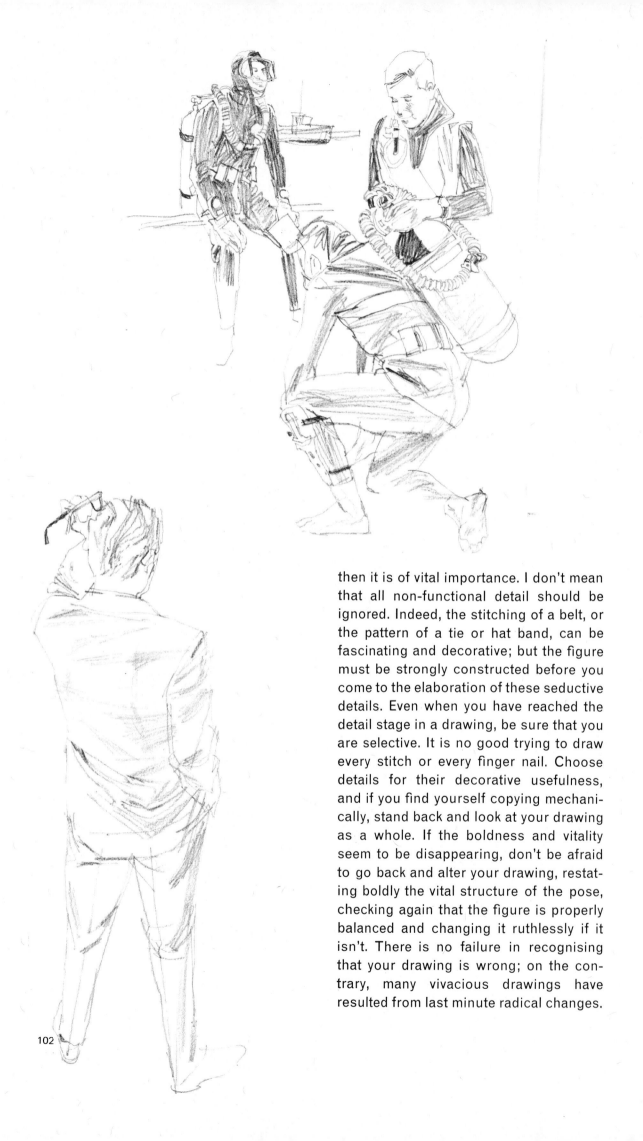

then it is of vital importance. I don't mean that all non-functional detail should be ignored. Indeed, the stitching of a belt, or the pattern of a tie or hat band, can be fascinating and decorative; but the figure must be strongly constructed before you come to the elaboration of these seductive details. Even when you have reached the detail stage in a drawing, be sure that you are selective. It is no good trying to draw every stitch or every finger nail. Choose details for their decorative usefulness, and if you find yourself copying mechanically, stand back and look at your drawing as a whole. If the boldness and vitality seem to be disappearing, don't be afraid to go back and alter your drawing, restating boldly the vital structure of the pose, checking again that the figure is properly balanced and changing it ruthlessly if it isn't. There is no failure in recognising that your drawing is wrong; on the contrary, many vivacious drawings have resulted from last minute radical changes.

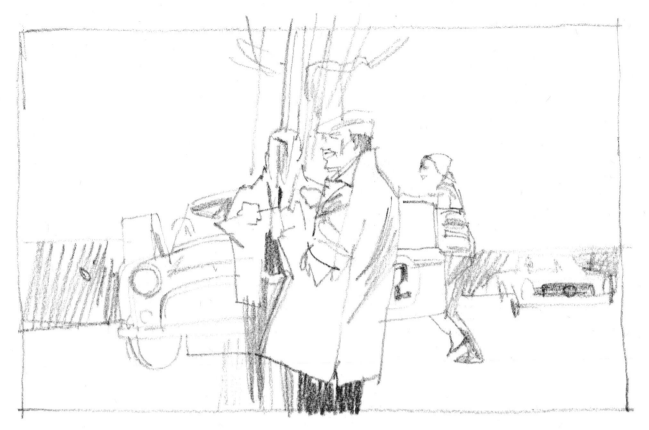

Composition

All good pictures are, in one sense, abstracts. The artist always spends a certain amount of time arranging his picture in terms of squares, rectangles, triangles, circles, etc. At this stage, it is truly an arrangement of shapes with no subject matter, and the pattern is all important - just as in an abstract painting. However realistic you want your final drawing to be, you must first consider the arrangement of the shapes and the patterns they make within the boundaries of the picture. This is composition.

Perhaps the simplest and most basic composition is a rectangle divided horizontally or vertically into equal parts, which is balanced but not very interesting. Move the division a little to either side of the centre, and put a little black square in the larger rectangle. Now the balance is more precarious, but more interesting. See illustrations above.

It is virtually impossible to lay down rules about what should or should not be done in composition. Whenever any authority states that one must never do something or other (for example, cramming the interest of the picture into the top third, and leaving the rest almost blank), some very good artist is found to have done it, with great success. Nevertheless, there are certain risky compositions that it is as well to avoid at first, although paradoxically, some of the most exciting compositions are those that very narrowly avoid being badly out of balance.

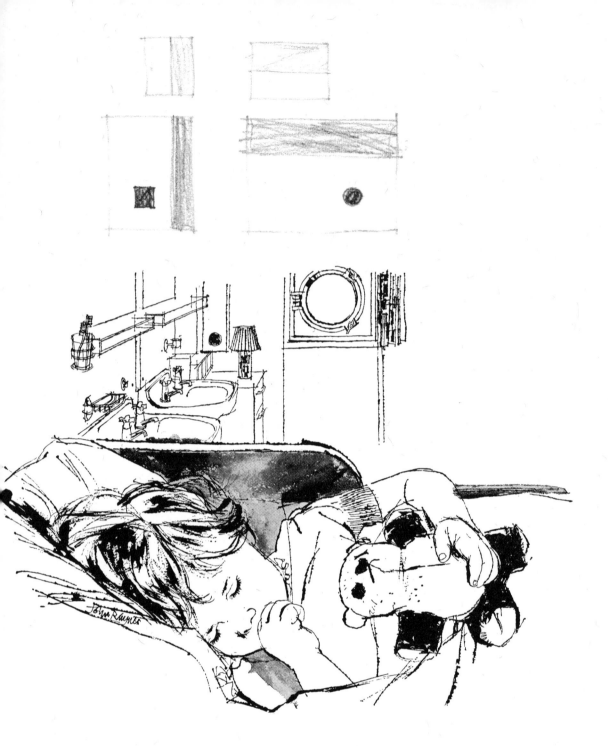

Most pictures have a centre of interest, a place where the eye naturally alights first. It is better generally not to put this area right in the middle of the picture, or too near to the edge. If, however, you decide to have a group of people near the edge, make sure that it is firmly cut by the edge or well clear of it. It looks uncomfortable to have a figure just touching the outer rim of the picture. This applies to heads and feet at the top and bottom of the picture too.

Apart from the positioning of the figures within the picture frame, the placing of two or three, or more people in relationship to *each other* must have very careful consideration. Look about you at people, and try to see the shapes they make when they are sitting, standing, working or playing together. Look at the complete group first as a single abstract shape. Then look within it at the accents, perhaps in the form of a coloured tie, an intricately creased sleeve, or a triangle of striped sweater showing under a jacket.

This sort of seeing and organizing of shapes is more important compositionally

than considering the actual pose of each individual figure. Indeed, when you come to analyse the separate poses, it is surprising how often one or more figures in even a small group are nearly totally obscured, with only an arm and head perhaps as evidence of the complete figure. Don't be afraid to draw people like this; people don't stand in rows all facing the audience, and your drawing will be more exciting for its authenticity. You can of course arrange your people as though they were on a stage, but a classical, formal type of composition will result. Analyse the figure composition of great painters whenever you have the chance. Piero della Francesca produced very beautiful paintings which depended on very formal, calm abstraction of his figures, and in contrast, Degas and Toulouse-Lautrec made great use of the accidental, split-second groupings. Experiment all you can, and you will soon develop a sense of the intrinsic 'rightness' or otherwise of a composition.

Materials

When deciding what materials to use, there is, in my opinion, one important overriding factor. Whatever paper one draws on, one must feel that there is plenty of it, so that there is no fear of spoiling it. For this reason, I suggest a pad of thin, smooth white paper. Medium and soft pencils are very pleasant to use on this, and you can be beautifully extravagant, covering sheet after sheet with bold experimental work.

If you want something finer and more opaque, cartridge paper in many grades and thicknesses is cheap and easily obtainable.

More expensive, but pleasant to draw on, especially with pen and ink, are the hand-made papers. These are made in various weights and textures. Anything less than 60lb is fairly thin, and should be stretched if water colour is to be used on it. (I will tell you in a moment how to stretch paper.) An average weight paper is 72 to 90lb and 140lb and over is quite thick and can be painted on without mounting or stretching.

To stretch a piece of paper for a water-colour or pen and wash drawing, you will need the following:

(1) A drawing board which is at least an inch larger all round than the sheet of paper.

(2) A roll of gummed brown paper.

(3) A sponge.

Immerse the paper in clean water until it is thoroughly soaked; then lay it on the board and sponge off the surplus water. Now cut generously long strips of gummed paper for the four sides; wet them thoroughly and tape the paper on to the board, making sure that there is plenty of gummed strip in contact with the board. Sponge off again and leave to dry. As it dries, the paper contracts and becomes absolutely flat and taut, and you will find that very wet watercolour can be used freely without any buckling. When you have finished the painting, release it from the board by slitting the gummed strips around the edges. If you don't want the bother of stretching paper, you can buy it already mounted on cardboard, which is ideal, but much more expensive.

Of course, many other surfaces are pleasant to draw on. Wood, plaster, canvas, etc. have all been used, and can be interesting to experiment with. However, since paper is readily available in such great variety, it is natural for most artists to choose it.

Pencils, pens, chalk and brushes are the usual tools for drawing with, although a palette knife, sticks of wood, the edge of a ruler and even fingers can produce interesting marks on occasions.

For making studies from life, I advise you to use a pencil of medium hardness, i.e. HB or F. Very soft pencils can give a superficially suave and impressive effect, but they are harder to control; and if you are trying hard to *discover* something about the figure you are drawing, as you should be, then it is all too easy to end up with a smudgy black mess.

For pen and ink drawings, use a big, strong nib which will allow you to make bold marks by pressing hard, and fine lines if used more delicately. Any ink is all right unless wash is to be added, in which case the ink should be waterproof. Chalks, pastels and charcoal are for broader, simpler techniques. Conté crayon is made in several grades of hardness, and can be very similar in use to a soft pencil. Pastels and charcoal are usually very much softer, and can be easily smudged, accidentally or intentionally! When finished, pastel fixative must be sprayed on to prevent further damage.

Sable brushes are best for drawing. A good No. 3 or 4 will have a nice sharp point and yet hold a fair amount of paint or ink. For putting on washes, however, you will need a larger brush - an ox or sable mixture is fine for this, and cheaper than pure sable.

A Figure Composition
Stage by stage

I am now going to describe the progress of a figure composition from rough idea to finished drawing, so that you can see how construction, balance, technique, etc., can be employed in practice.

Above are some of the ideas that I was putting down very roughly to try to find an interesting arrangement of people sitting relaxed listening to music.

This was to be a calm situation, so I didn't want the composition to be too 'busy'. Horizontals and verticals tend to produce calm; strong diagonals or tilted verticals and sharp angles generally suggest movement and drama.

The situation is just one dreamed up for this exercise, so I have had to search for satisfactorily expressive shapes. It could happen the other way around, i.e. by seeing the group, thinking how interesting it looked and then drawing it.

On this page is the composition that I decided on and worked out in more detail. Some of the lighter tones have been put in very freely. Much of this may be overpainted later, but it is good to leave parts of the first painting untouched if they happen to be right.

White is the lightest tone you have, and if you look carefully at the tones of a complete figure, you will find that pure white occurs very rarely. The light part

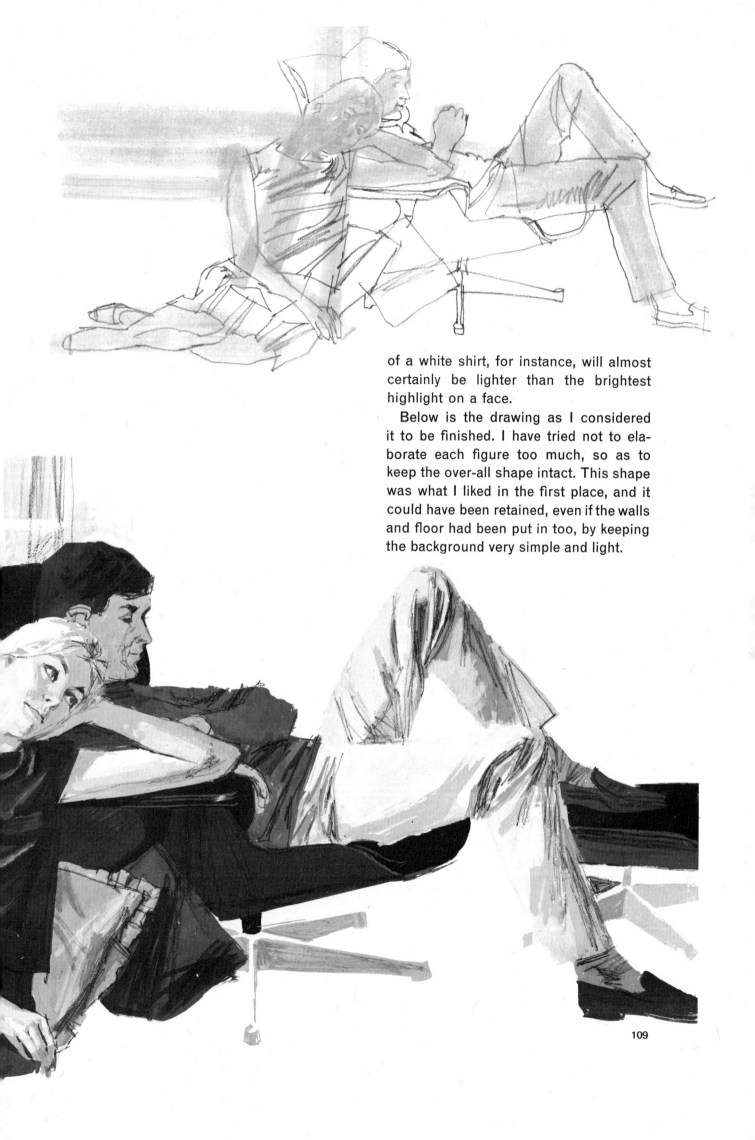

of a white shirt, for instance, will almost certainly be lighter than the brightest highlight on a face.

Below is the drawing as I considered it to be finished. I have tried not to elaborate each figure too much, so as to keep the over-all shape intact. This shape was what I liked in the first place, and it could have been retained, even if the walls and floor had been put in too, by keeping the background very simple and light.

Emotion and character

Until now, I have talked about an anonymous figure, the hypothetical *normal* human being. Of course he doesn't really exist - everyone is unique. It is this 'uniqueness' that I have in mind when I use the word 'character'. When you consider how many millions of human faces there are, all arranged more or less the same, it is really astonishing how easily we can recognise, with absolute certainty, the face of a friend or relative.

Even the face of someone met only briefly, will probably ring a bell if seen again among hundreds of others. Stranger still, if asked to describe what it is about a particular face that one recognises, one finds it very difficult, and trying to draw even one's parents' faces from memory is usually almost impossible. I believe the reason for this is that what we retain in our visual memory is the *pattern* of a face, the precise abstract relationship of the parts, which although difficult to reproduce, is instantly recognisable. So if we are to capture the character of a person in a drawing, we must above all get this pattern right. The most beautifully drawn eyes, nose and mouth, set in a face with the wrong spaces or shapes between them, will *not* look like your model. Of course the shape of the individual features has to be right too, but it is their *position* that has to be established first. This principle also applies to the whole figure.

You will have noticed, I am sure, how someone that you know well can be recognised even when they are so far away that no detail can be seen. All you have to go on is their general shape, or way of standing or walking. Now, it is this unique 'something', this particular shape that is different from any other, that you must try to find.

In the same way, if you want to draw a person who is sad, or happy, it is not sufficient to turn the corners of the mouth up or down and pucker or smooth out the forehead. The *whole* figure should express the mood. Watch the changes in posture

that accompany different moods - they are frequently more expressive than facial expressions.

The human face is fantastically mobile, however, and capable of expressing a great range of emotions. The split-second vision of the camera, coupled with your own careful observation, should help you gradually to pin down more and more of this bewildering range.

Costume

Specialised dress can be fascinating to draw, and even in this age of standardization there is a great wealth of costume designed for a particular purpose.

I have drawn examples on this and the next page. As always, it is ideal to have someone pose in the appropriate uniform, but this is sometimes impossible. It is possible, however, to imitate a costume approximately drawn from your model and add the authentic details from a photograph or museum. For example: a blanket could be thrown across the shoulders for a nurse's cape; a fairly tight jacket with a belt around the waist and another across the chest could suggest a military uniform. The odd peaked cap, laboratory coat, overalls, etc, plus standard clothes, a walking stick or two and some ingenuity, can produce very useful imitations of the real thing.

When to stop

The easiest thing in the world is to ruin a drawing by going a little too far and losing the first bright idea in a mass of conflicting details. Never lose sight of the whole picture, even when you are struggling with one small part. When you find yourself mechanically adding details and in a vague way 'finishing' the drawing, stop, stand back, and try to see it again as a whole. It may be that it *is* finished. It is not easy to tell when to pronounce a drawing complete, and obviously it is, to a certain extent, a matter of personal taste.

I think a drawing is finished when it is 'right' - when one has stopped making changes and everything seems to hold together in a convincingly complete way. Regardless of the odd incomplete fingernail, if it is right, then it is finished. I am very suspicious of pictures of artists putting 'finishing touches' to their work. I think perhaps they should be finishing sweeps!

People in action
Nigel Lambourne

Movement

The following pages are intended to encourage the student in attempting to draw people in natural movement. Not necessarily violent action, but the changes of position in body, arms, and legs which constantly occur in the activities of our every day life.

It is important for you to recognise the many ways in which a movement is repeated. As you compare them, probably other similar rhythms will come to mind. Many of them you may see and go through yourself every day. In fact, it is often helpful to make the gesture that you are attempting to draw.

Of course, it is more difficult to draw the real spirit of these things than it is to merely see how they repeat themselves in our lives. This book tries only to show you a few *general* ways of seeing and doing.

For instance, a camera cannot 'see' or 'do'; it can arrest and 'freeze' forever the most violent action. Yet for all its clearness and sharpness of shape, the print is without that very spirit of life in action. It may, from time to time, help you to understand the 'works' of a movement. But it will never help if you try to copy the photograph. This is because a true draughtsman, an artist, will capture the movement as it came, as it is at one moment in time, *and suggest what is to follow*.

A drawing has a life and movement of its very own: even apart from its subject. It is free from dull facts and unnecessary details.

You should aim always at an impression, an appearance of reality. Not 'reality' as we know the camera offers it to us. To try to do this, it must first of all be your concern to see the whole. The whole of the *movement*, irrespective of detail,

because a long nose or big ears in your drawing will never affect the essential spirit of action. When a bird skims through the air, you see no feathers only the strong flashing swoop of wings. To do otherwise we would need a 'camera' eye with one focus for the whole and another for the feathers. Be content with the wholeness, because it is the overall 'map', the first vivid impression which must start you in the act of drawing.

The force, the drive behind the first attempt at a subject becomes ever harder to keep up the longer we work on that same drawing; trying to 'improve' it we often think. Whereas in fact, we are doing little else than slowing down the movement, the spirit, and cluttering it up with details which add nothing to the excitement we are trying to put down. One way which may help you to avoid this is to draw constantly over the previous attempts. Lay thin paper over the last shot and see

how much you may now leave out in the fresh drawing. A sketch book or layout pad—*not smaller than 10″ × 8″*—which has a thin tough paper, transparent enough to see through to the under drawing, is excellent.

Whenever you are lucky enough to have someone willing to 'model' a movement for you, try to draw as much as you can with the person going slowly through the action, and only 'freezing still' occasionally. Then always re-create, draw from your memory afterwards and compare them with the drawings made on the spot. You may find that by combining the spirit of the earlier shots with the attempts from memory you produce a more complete but still lively drawing. Work swiftly from top to bottom. Strike out boldly over the figure which you are drawing in action. Your most obvious mistakes will stand out more quickly this way. At the beginning of your drawing, let the chalk or charcoal (both are excellent) drift quickly and *lightly* over the whole of the movement as it seems to be. Make these cobweb-like light lines set your approximate limits, and suggest the general directions and proportions. Gradually, as the sense of the action becomes clearer to you, draw over more and more boldly and avoid the fussy habit of rubbing out half an arm or a leg as you go along. This usually results in merely improving a tiny detail instead of improving the big, smooth rhythms. In other words, the whole again, will have been neglected. This is where the practice of drawing over the top of previous work, on thin paper, may assist you.

Work at the drawing only as long as you are sure of what to put down next. Not an instant longer. If you are standing at an easel, then walk back from it constantly; if sitting at work, then push the drawing at least to full arm's length from you. More will be learnt from your mistakes in working swiftly and boldly with frequent pauses to look at the whole effect, than an hour's hard scrubbing at the drawing, whilst your nose is a few inches from the paper.

To be discouraged is so easy. But also remember that if we are keen to draw better and ready to practise at every opportunity, we are probably not satisfied to simply do the things which we *can* do. We must always try to draw something too hard for us. It is the constant attempt which matters most. Finally, no amount of reading about 'doing' will improve your drawing. It was man's first (and probably his only) language, and to read about a drawing is as exciting as eating the recipe for an apple-pie. The more attempts you make at drawing movement, changing movements, then the more your own, particular way of using this language will develop.

Line

As you look at the various drawings in this section, notice that it is the *line* or the lines *through* and *across* the figures which assist the movement.

They are mostly drawn with a similar kind of line. The drawings of arms for example.

These have a kind of 'core' and swing, it is a fast, lively action.

First you may find it helpful to set up the vertical and horizontal lines. Simply as very general guides to give you confidence to build on; from which to swing up and down and across.

Move out lightly with spidery lines in all the directions in which the figure seems to move.

Repeat this loose 'map' of lines and make sure you are *thinking* of the *whole* movement each time, and that you are also understanding it a little more.

In my study of the orchestral conductor, there is a long swing which comes from the central 'core' of the body line and shoulders. It is the most important thing about the movement. The thrust comes from the vertical and horizontal lines which you see in the rough drawing.

Compare this with the similar half-length figure of the girl. The arms swing out and thrust up as do those of the conductor. In fact if he were drawn from the back, as she is, there would still be no difference in the method of setting about it.

Try to follow how the same swooping-up rhythm grows in each of them. This will happen again and again in so many of the actions which you draw.

It has been said by some great artists, that with one true vertical line and one

118

true horizontal, any drawing can be constructed. You may find some truth in this if you look carefully at different artists' drawings of movement. You will find there must be a 'peg', a foundation for your drawing. No movement can possibly *look* right without it. Instead of *one* starting point, it would be wonderful to have our left and right hands moving their pencils together with our eyes and brain. One hand moving through the action one way, the other hand tracking out somewhere else. We could then keep the whole of the movement going at once in the drawing, instead of fitting one bit on to another rather painfully. But as this is impossible, one can at least *think* a little in this 'all-over' way.

Try to see, in advance as it were, whereabouts on the paper the main parts of the figure may come. Try to find where the 'limits' of the action might be; feet and hands, for example, even before those first few lines go down on the page.

It does not matter in the least if the first shots are a bit wild and woolly. Go across, up and down the shape. Make the lines, *all* lines of action in the beginning. Right or wrong.

In the mesh (and mess) of lines we hang on the first construction, you may feel you are losing all the drawing of the action. It can soon be found again. Suppose you are drawing from memory of the model or fleeting figure—lay another sheet over the first drawing, think carefully and re-draw. If it is a very vigorous movement such as the boxer (page 122), move right through the figure, from the thrust of the *back* leg to the angle of the punching arm.

Never go back to fill out the character of the person until you are satisfied that the very best of action has been achieved. To add touches of character such as big ears, long noses, bootlaces (or whatever) at this stage would be as ridiculous

as painting the front door of a house which had not had its roof built.

Remember also, when you are working from memory, to try to go through some of the action yourself. To *feel* the movement can be a great help. Apart from standing back (very often) from your work, look at it in a mirror. Mistakes stand out very suddenly and clearly this way.

Look again at the other drawings in the beginning of this section. The map or frame of the movements of the skipping girl, and the band conductor, have a repeated shape. Whether seen from the back, or above—the rhythm, the swing is there. Emphasize these lines: leave them in your drawing. Never attempt to rub-out those very lines of direction which are the heart of the action because you feel they make the work look 'messy'. They can be absorbed gradually into the work, as you become more sure, more accurate in your *placing* of the lines.

The skipping figure has most of the 'map' of the lines of movement still showing. They sometimes assist the impression of speed: sometimes of slow smooth action. But if you place them surely and firmly, they will always remain lines of direction which help the impression of the various actions.

It is always a good thing to avoid making your drawings on cramped little scraps of paper. Keep your drawing pad or book with you as much as possible. Fast, lively movement is best attempted broadly; 8 or 9 inches high or across at least, will give you a better chance to feel the span and spread of the action. Feel the shape as big, and as broadly as possible right from the start. But apart from this general guide, do not worry that your work is too big or too small. Only by drawing *every day* will you feel what is a natural size for your hand, and gradually you will feel complete freedom to move your lines about in all directions without being cramped.

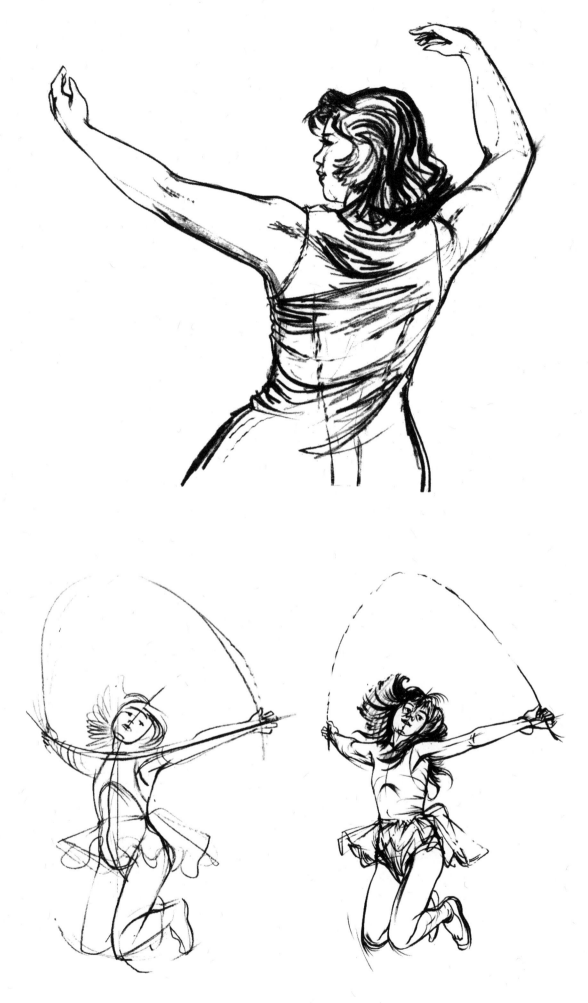

In the drawing of a boxer, the impression was one of 4 or 5 very quick shots at the movement, made in a gymnasium.

If you think of the compact way in which the body of the boxer moves, you might compare it with the half-figure of the man carrying a heavy load on the left shoulder opposite. (This happened to be the dead weight of clay wrapped in plastic.) The load carried by this character also makes the *body* appear compact. One arm compressed, heaving up the weight. The other swung out in a *fast* movement to balance him.

The little dancer opposite has a more 'casual' kind of movement as she bends down. It is a complete contrast to the boxer or the man with a package.

This action has something of geometry in its set-up. The shapes *inside* the arms and legs have been made strong, to help the straight up and down thrust. They have been exaggerated on purpose.

Here again it is the *line* which carries the movement from the feet on the floor, up and over the back and down the arms, to the floor. A 'through' swing, which was drawn several times to 'feel' the way.

Line itself has many jobs to do: it can be used to help us send a leg or arm away in space as well as come forward. It must be the first stroke of direction across a back, across the *section* of a body; it is used in great thickness, to suggest force or thrust as compared to a slight, thin stroke of less importance.

It is the very grammar, the heart of the language of drawing. Shading and shadow can never exist alone, but line can and must.

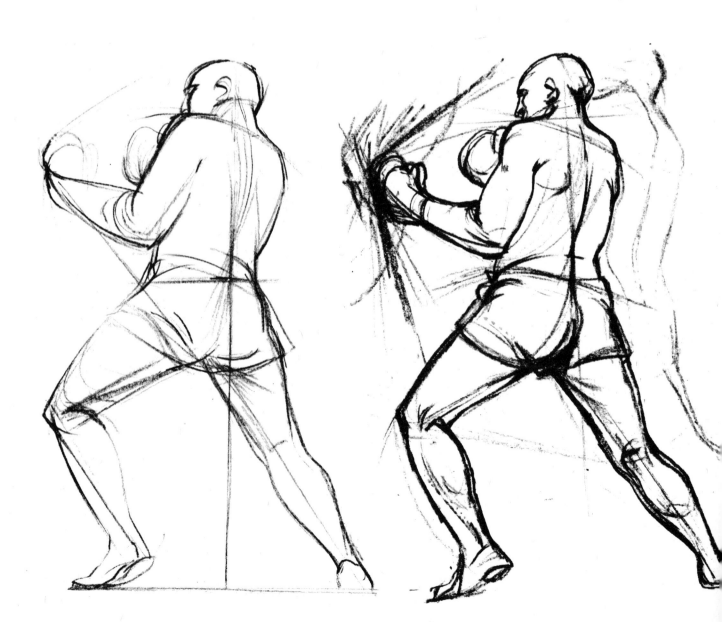

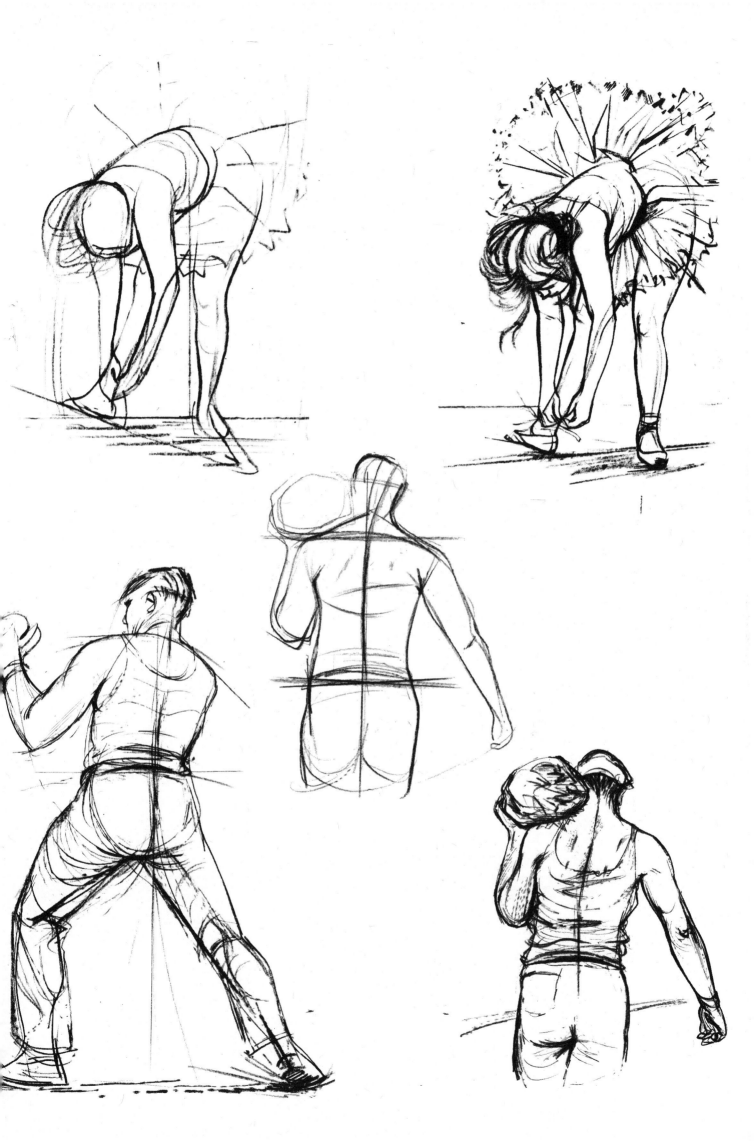

Rhythms

These consist of the various ways in which people move into compact or spread-out actions.

 The bunched-up, crouching 'chunk' of the girl is first seen as a broad oval swing of lines. Compact, with a central 'core', a strong through line from the head down the back and up to the knees and arm.

 It is the basis of a tilted, egg shape.

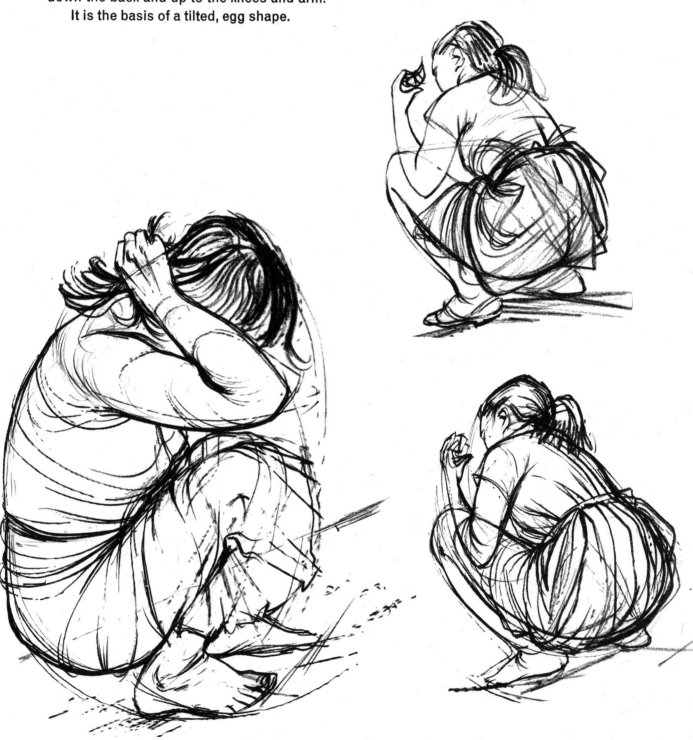

The drawings of the same movement were made within a few moments, on the sea shore. It is an enclosed kind of movement which you may see in sculpture. Study carefully the crouching figure tying her hair opposite; the rhythmic lines.

It can be easily compared with the drawing of the little dancer bending to tie her shoe. They are very similar in *rhythm* in the way in which they both form a compact whole.

In these drawings, the essential simplicity of the lines of construction remain. Little detail has been added which affects the first impression, and they remain brief, slight notes from a sketch book. Nevertheless, they are ready to be carried further in detail. If you crouch in front of a mirror, you may see more easily the way in which the rhythm of your back and legs moves in one long, continuous line. Repeat this kind of action, with variations a few times. It will teach you a lot about drawing a compact mass, a 'self-contained' shape.

The drawing of a dancer at practice above is quite the reverse rhythm.

This is a spread, extended movement which has something in common with the spread, raised arms of the characters in the last section. Only this is a complete movement as vigorous and thrusting from the ground out to the hands, as the boxer. The 'speed' of the lines through the legs, the body, the arms is identical with his. In this dancer the body is thrusting forward, moving up from the leg, to the arms. *One* long smooth line guides the whole of this action.

The twisting away of the dancer's right leg is the angular, broken rhythm which is the balancing angle of the pose. In the rough diagram you may see how important this is, in setting up the 'all over' first shot; both feet must touch some kind of floor level *and* also be placed in relation to each other from the start.

A through line; floor to head, to arm. Back through to knee, to right foot, to left foot, to finger tip, to head. There is no order or drill about it, but simply thinking *all* the time *all* over the shape.

Remember next that there is another direction also. The direction of the body twisting away from you in space, in much the same way as the further leg twists away from you.

Notice here how a kind of line, a section like ring, has been jotted down through the limbs as they move and twist. This will become very important to the way in which you think of shapes moving in space, as you learn more and experience more in what you draw. It is yet another kind of rhythm.

Study this carefully.

Much of what has been said about the dancer is very true of the acrobat also. Here the swing and span of figure is almost at its greatest. She supports herself, not from floor level, but from thrusting out each leg into trapeze rings.

Follow the big rhythms in this original, constructional kind of drawing, which was made whilst watching several repetitions of the swing. Later it developed as you see.

In my drawing of an athlete jumping, below, the body has pulled the long legs up into a broken, angular rhythm. It is a combination of a spread out thrust up the back into the arms, and a compact, taut body line.

This kind of movement is one of a swift passing of all the limbs in space; often the figure 'caught' in this instant must seem to be off balance. You should attempt to convey only the *essential effect* of such violent action. The least attention to detail will slow it down.

Clothes

The drawing of a golfer gets much of the action from the 'drag and pull' of the clothes across the body.

You need not study the complicated ways in which different kinds of clothing (heavy or thin), crease and fold, as a *separate* thing from drawing the figure. But you must learn to use and understand how the big, general movements of clothes can help the action.

The man bending down at a wheel (overpage) is 'explained' and given the impression of sudden action, simply by having the taut tugging of the shirt folds emphasized.

Whenever you can, draw a bending arm from the shoulder to the elbow and on to the wrist, wearing different kinds of dress yourself; drawn as you glance in a mirror. At first you will usually find it difficult to make up your mind which are the *big* important folds, those giving the best explanation of what is going on *underneath* as it were. It is excellent practice.

Looking back at several of the drawings already mentioned, you may begin to see how much of the movement through the whole figure comes about because of a few important lines of the clothing; they should always be part of the figure. If too many of them are shown, if one becomes fascinated by them, the action will be lost just as surely as if you had tried to finish the head before drawing anything else.

The particular dress of a matador, because it is tight-fitting, is a good example of taut folds following the action underneath. Notice particularly the way in which sections, or ring-like lines, go round the spread out arms and stiff legs. They do

129

130

two jobs at once. Helping the impression of tight cloth and at the same time showing the shape of the limbs as they come towards us or recede. Even in the first drawing, the construction has begun to be affected by the general 'pull' of the jacket and tight trousers.

Whilst the 'costume' is an ordinary dress, it is free and swinging enough to almost suggest a dancing step by itself.

This drawing was one of a series of the flowing, swaying *spiral* action which as you can see, is still kept in the figure at this stage. It is 'finished', in the sense that it is complete, with no more details at the top than it has at the feet. In many movements, the 'through' lines which you must see and use to give your drawing life, are of course imaginary lines. All the same, the pulled folds of coats, or shirts or trousers, will give you an enormous amount of help in the way of clues to explain what is happening.

131

Gradually you will be able, by the process of re-drawing, to select and eliminate *everything* but the essentials. In the drawings here, clothes have been deliberately used to give the various actions the speed of *sudden* stooping, turning and swinging in space. But never attempt to 'fill-in' with more lines than you can understand. You cannot easily fool yourself (or other people finally!) with 'effects such as whizzing lines coming off the body as are sometimes used in comic strip characters.

Remember once again, that drawing the clothes must never be more important than the figure itself. They are only part of the person in movement and echo, or reflect that action. It is so easy to slow up and even freeze into a statue an exciting gesture, simply by over-stating the heaviness of folds in a garment.

Practice and Memory

It is of course likely that you will already have had some practice at still figures, and portraits of people; some of your shots will also no doubt have been quite successful. There is much to be learnt from such drawings. In fact you should be constantly making careful studies in a notebook, of the heads of people, the twist of their shoulders and turn of the back. These 'stills' play a large part in your drawing experience when you come to people moving quickly.

Seeing an action repeated is of the greatest importance. Whenever you are attempting to work from 'life' probably out of doors, wait for the *same* movement, for example someone stepping off a kerb and looking about them. You must get down as much of the character (fat, or tall or lean) at one time as possible; their movement you will always be able to re-construct. Both from life and from your memory. Yet remember that you will only be able to use your memory if it is kept up to the mark. Only if you watch very closely, and constantly. To *imagine* a person doing some active job is only possible if your memory has been trained each day to hold the facts. Therefore, to make a start on the drawing of that person, the particular way in which *they* moved must still be in your mind. Because in spite of the similarity of many everyday actions, there is a 'personal' kind of manner of movement, as you may have noticed when drawing members of your own family.

The skater for instance was drawn, after watching for a long time the way in which she turned and spun. She was re-drawn several times to fix the image as one might speak of fixing the mechanical image on a camera film. All the same, she was drawn from *experience;* in other words, practice.

Swimmers, both in the water and diving, are difficult but very worth-while subjects. Their movements are quickly repeated and the rhythm of arms and legs are often those which you can easily feel for yourself.

Sometimes it will be only half of the figure, the back, shoulders and arms which you are able to put down, but this can be a complete action in itself. Concentrate then, on the whole of the spiral twisting lines of the back and out through the arms to the palms of the hands. Once again, remember to compare many of the thrusts of the arms with those of dancers.

At sports events, perhaps at school competitions, you will be able to quickly jot down the leaping away of the runners. On the spot drawings, no matter how wild your shots are, will usually have caught some life, some spirit of the thing. As in my drawing made on the spot, the final effect came about through watching several races. Drawings of athletes are quite often more successful when made from 2 or 3 different shots, the final one containing the spirit of the whole. A selection of the most convincing actions, re-drawn into a single unity later. Memory and practice are once again of the greatest importance in this kind of re-creation of a scene.

A figure climbing, above. Watching this powerful kind of muscle pull and drag, the body will usually be moving up and away from you. When you watch this happening (perhaps people climbing ladders as well as rocks), remember that the person will gradually appear to become more compact. A kind of expanding and contracting rhythm.

In several of the drawings, the first shot was made on the scene.

This particular action with which you must be very familiar, combines a great deal of the spiral-like twist and turn, with the clothes helping to tell the story. But above all, it is the *line through* and round the figure which keeps the movement going. This is as true of all these drawings as it is of those at the beginning of the section.

When you find yourself without drawing materials, watch as much as possible the everyday actions of people climbing stairs on the bus, at the station, turning round as they walk or run across the road. Then, as soon as you can get to a notebook, try to draw upon the memory. You will be very disappointed at first perhaps, because so little of the proportion and their manner remains in your mind. Better still, never be caught without a sketch-book and pencil.

It is, by the way, a most important part of your training to keep a balance, a proportion to all figures. Not merely a kind of formula, but a *sense* or instinct for the compact shape of trunk and, as in the drawings of athletes for example—an extended 'leggy' quality. Your memory may play you tricks here.

Yet when you attempt to draw scenes from memory, remember it is always a little more convincing if you are able to *exaggerate,* to overstate the long flying legs, the swinging arms or twist of a head. A person dancing or skating appears to be drawn with more truth and excitement if they are throwing themselves into the action with really strong (and *simple*) lines.

It is not very much help to be able to construct a standing figure, quite still, according to the proportions of an anatomy book, unless you are able to realise that those 'ideal' proportions will sometimes appear fantastically different in vigorous action.

Some of my drawings here are fairly clear examples of the importance of *line* in movement, *line* to give the *impression ;* they gain their vitality from an *impression,* as you read in the beginning of the section. The moment your drawings of vigorous action begin to accumulate lines going nowhere and facts or details, they will resemble a dictionary. Instead, you must tell a story. Surely that is one of the best reasons for wanting to draw.

Your memory cannot be a store house unless you keep the hand in constant, almost daily practice. Use a brush, a pen, charcoal, pencils, and remember they are the tools; combine them sometimes because in that way you will discover quite soon which is the most pleasant to move rapidly in all directions. Perhaps you might think about the act of drawing sometimes, as if it were the act of running or leaping. It is something that is moving in *all* directions. You cannot run or jump in bits and pieces, so never try to draw in that way.

Children
David Ghilchik

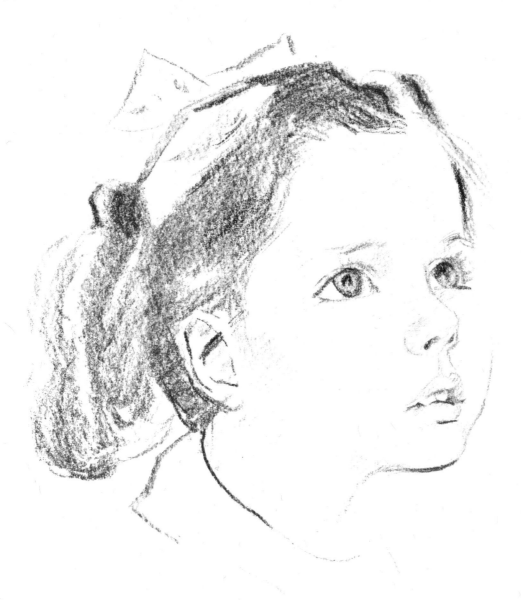

Making a Start

This section is primarily intended for the young artist.

Those of you who would like to draw your friends at school or your brothers and sisters at home, will I hope get some sound advice in these pages on how to set about it.

But as the same principles apply to drawing no matter what age the artist, it is possible that your elders will also find this section of some interest; they too may be fired with the idea of jotting down swift notes of their children or grandchildren in their various activities. To young and old I would suggest that it is a good idea to keep these drawings in sketch-book form, each one dated. Such a book will be most interesting to look through in the years to come—and much more 'alive' than any photograph album. Start your first sketch book now; fill it with drawings— either rough sketches or more finished studies—and write down the names of the children involved, the date you drew them, and possibly a description of the subject, with any comments that occur to you. You will find such notes, details of colour, and such-like, of great value when perhaps later you are looking through your sketch-book for material that will provide you with inspiration for a full-scale picture. One of the main functions of the sketch-book is the collection of information and details that you can make use of in picture making. Your sketch-book should be a reference library of all kinds of interesting visual material.

Let us get ourselves in the mood to start drawing.

It is fun to sit and watch a lot of children romping in a park playground, isn't it? They play with such gusto; on the swings, the see-saw, the chute, and all the other objects put there for their enjoyment. Or they hurl themselves with complete absorption into games of Cowboys and Indians, 'bang-banging' and 'biting the dust' very realistically.

If you have a notebook and pencil with you, you will soon find yourself making swift jottings of their antics, an occupation that will take hold of you completely.

Or you may think that your new brother or sister looks such an angel asleep and it would be fun to record this in a drawing. Perhaps it will occur to you that your best friend would make an interesting portrait? If so why not persuade him, or her, to sit for you?

If you have ever felt the urge to put pencil to paper, to record such things as I have mentioned, it is for you that this section is written.

Yet after the first surge of inspiration, difficulties arise. You may find your drawing doesn't convey what you had in mind and you wonder where you went wrong. Or perhaps you realise where you went wrong but don't know how to put it right.

Do not be discouraged; improvement comes with practice; and progress is definitely more rapid with a little guidance. If you are keen, I would be happy to think these pages have helped you to produce better drawings, shown you what to look for, what to avoid and helped you to select those facts which must be put down first because they are most important, and suggested those which are not

so important and can be included later. Also what details don't matter and can be left out altogether. I hope I can show you how to decide which are the essential things to look for and seize on, and in what order.

If you find the restlessness of young models worries you, it is possible you might decide it is easier to work from photographs. I would strongly urge you not to do this. Making a copy by hand of what a camera lens does more accurately and swiftly can teach you very little, and the result is bound to be dull and uninspired. Art, after all, is not a mere 'copy' of nature, but an intelligent interpretation of things seen, and it is what you yourself *feel* or *think* about your subject that matters. Real life is more inspiring than photographs, much more 'alive', in fact, and by correct guidance at the start and constant practice, you will be able to show this more and more in your drawings.

True, in the hands of an experienced artist a photograph can be a useful aid on occasion. I have, for instance, now and again been given the job of painting a portrait of someone I have never seen. At such times a photograph or two, preferably with a guide to the colour of hair, eyes, etc., is indispensable. But for learning to draw, I say definitely no photographs. When drawing it is not so important to get complete accuracy of line as to make your lines *expressive.* You will find you lay unconscious emphasis on the things that catch your eye in the subject; it might be the tilt of a head or how the wind blows the hair forward, or the twist of a body as a cricket bat is wielded; and it is this emphasis that makes good drawing so interesting. If six children, each with a camera, were to take somebody's photograph at the same moment, all six results would look alike; and before you had looked at the sixth one you will have become a little bored. But if all six children

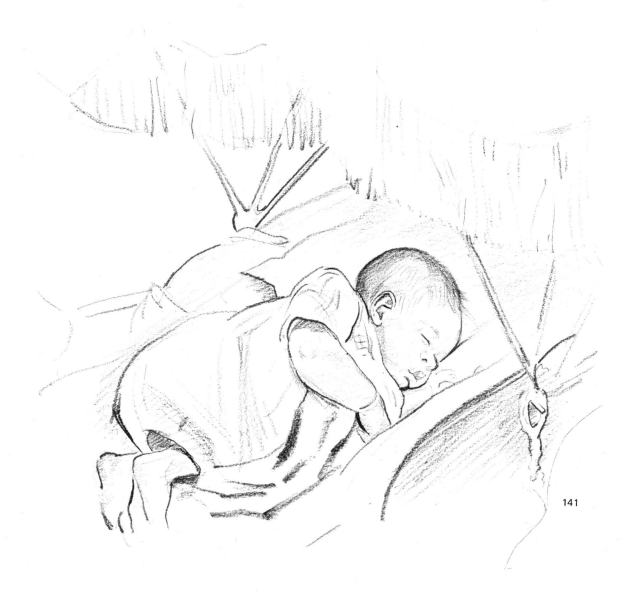

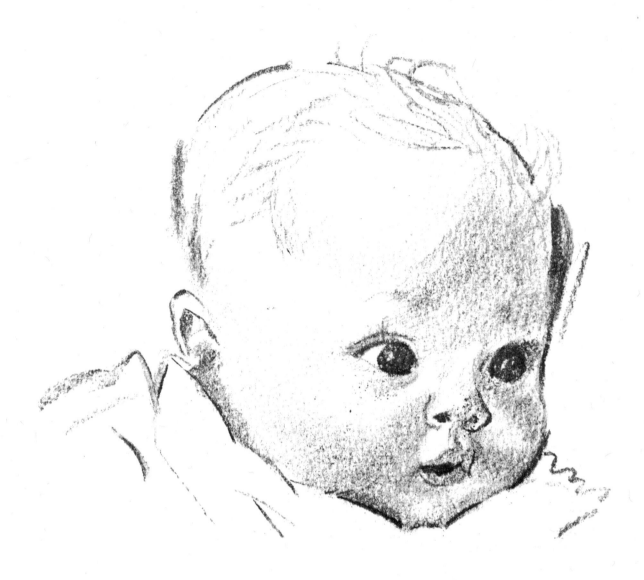

had a sketch book and drew the same person, each result would look different and therefore vastly more interesting. The development of personal style is therefore very important.

Now there are good and bad styles in drawing, and it is very easy to get into bad habits. The chief bad habit is that of 'scribbling'. 'I am only just sketching it in' I have often heard people say as they rapidly make several marks by hasty wrist movements of the pencil. I also say I compare their scribble-scribble-scribble with someone who stammers and stutters every time he speaks. How much better, and easier to listen to, it is when the talker thinks first what he wants to say and then says it deliberately and clearly. The same principle applies to drawing, which when you come to think of it is also a form of saying something, but with lines instead of words.

Therefore, avoid being a scribbly 'stammerer' by never drawing from your wrist but *from your shoulder*. Hold your pencil (or brush, pen, crayon if you happen to be using one of these) firmly between forefinger and thumb, keep your wrist—in fact your whole arm—steady but not rigid, your elbow fairly bent, and draw from the shoulder. You have to keep well away—almost at arms' length—from your paper to do this. Getting your face and body too near your drawing encourages 'wrist-scribbling'.

By drawing in the way I recommend you will have perfect control of your pencil. Your arm is like a well-oiled machine that can propel your pencil in any direction; you can draw straight lines up, down, across (from left to right or right to left) at any angle; or curves, ellipses, circles, anything.

You may have heard the well-known story of Giotto, the Italian painter of the 13th century who, when the Pope sent an emissary to bring back a specimen of his work, picked up a brush and drew a perfect circle. Well, Giotto couldn't have drawn his circle with one careful line if he had been a 'wrist-scribbler', but only by working from the shoulder. Try it. Carefully and deliberately, draw the nearest thing you can to a circle; then draw straight lines in every direction; to left, to right, up and down, and at all angles. You need not do too much of this, but it is good fun and valuable practice.

The bad 'scribble' style I warn you against is not the same as correcting inaccuracies as you go along. You will notice on many of my drawings in this section that some lines—the first ones—show although I have afterwards corrected them. You will also notice that they appear rather lightly. And this brings me to an important point in drawing.

Whatever medium you are using—pencil, pen, crayon, charcoal—no matter how thick or strong a line your medium *can* make—start your drawing with as fine and light a line as possible. If you have any corrections to make or any points that need emphasising, you can always go over these preliminary lines and, if you wish, alter them, and make them stronger and darker; it is much easier to do this than to try to lighten a line that is too dark. I cannot sufficiently emphasise the importance of this point.

If you can't do without an eraser altogether, use it as sparingly as possible. If your first lines are fine and faint enough, you can leave them even if you wish to introduce alterations; they will help one to follow your 'thought process' from first impression to the final correction. Often of course your first, lightly drawn impression is quite adequate and need not be corrected. And how attractive a drawing done in a few, free, light lines can be!

Do you know what a paradox is? I suppose you can say it is a statement which is really true but sounds topsy-turvy. I am going to state a paradox now. Sometimes we do 'on the spot' drawings direct from life and sometimes draw from memory; yet even when we are drawing from life we are drawing from memory! Just think a moment. How *do* we draw from life? We keep looking up at the figure we want to depict, then down at the paper as we actually draw. This means that really we are drawing from memory something we observed a second earlier. Has this thought ever struck you? It is really the same process as remembering something you saw a day or two ago, and drawing it from memory—only in that case your memory has to last a little longer!

It is a good thing to train your memory by practice. It comes in useful when you want to draw someone in action. If it is someone repeating the same action several times, like a child on a swing or children on a see-saw, you can safely memorise a bit at a time because you know your model will keep coming back to the same position. But in cases where the action only happens once—say when someone is running past you, or diving or doing a cartwheel, don't attempt to draw it at once; study it hard and try to remember all you can, then draw all you have remembered when the action has been completed. Training your memory is a very important part of drawing.

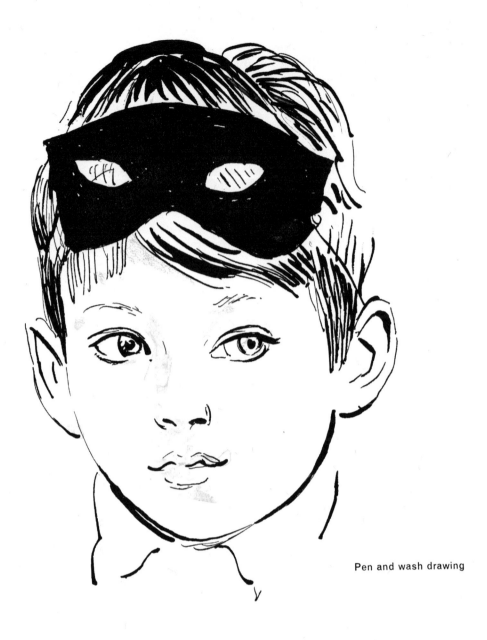

Pen and wash drawing

144

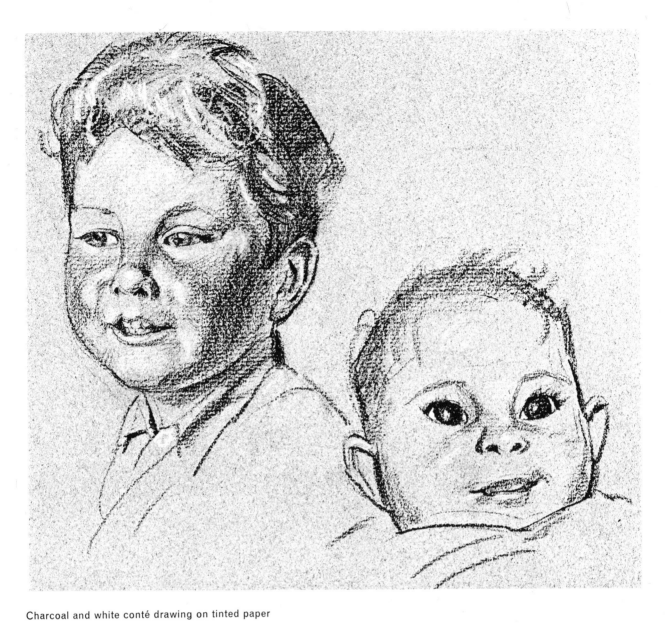

Charcoal and white conté drawing on tinted paper

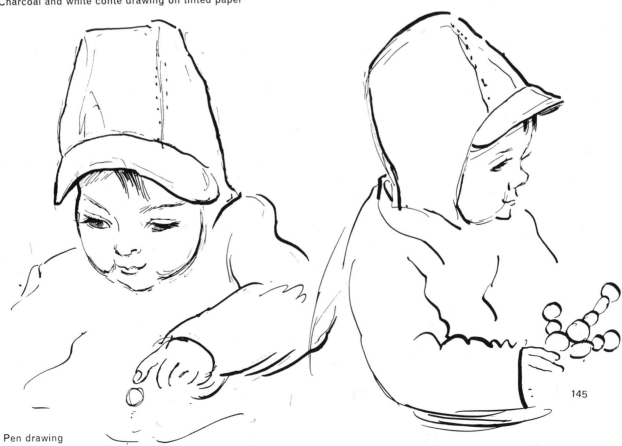

145

Pen drawing

Constructing your Figures

First of all, what does an artist mean by 'construction'? He means the expression by a system of lines of the 'build' of a figure, paying particular attention to those basic lines that suggest its action and its proportions.

As regards proportions, there cannot be hard and fast rules, as children vary so. Some are tall, some stumpy, there are thin ones and plump ones, long-legged ones and long-bodied ones, and so on. One of the most important things to get right as regards proportion is the size of the head compared with the body. Here, too, children vary—according to age, for one thing.

One may note as a rough guide that the head of a baby is about one-quarter the height of its body. This proportion gradually changes from baby to teenager. On an average, one might say that a two-year-old is 4½ heads high, a seven-year-old 6 heads, a twelve-year-old 6½ heads, and a nineteen-year-old 7 heads. You can measure how many times the head goes into the body of the child you are drawing by holding up your pencil with your arm straight out and adjusting your thumb as you measure the head with a length of pencil before seeing how many times it 'goes into' the body. You might have seen artists at work doing this, usually with one eye closed.

In drawing the construction lines of a standing figure, take care that it doesn't look as though it is falling over. Usually a person stands with the weight on one leg. An imaginary line drawn from the centre of the neck should come perpendicularly down to the inside ankle of the leg the weight is on, otherwise the figure will appear to be toppling sideways. Also note that on the side taking the weight, the hip is pushed up.

Foreshortening is another problem which calls for much observation and practice. Take a baby's arm which is raised towards you. That arm appears much shorter than when it is hanging to the side of the body. And note how things like the creases in the wrist look more circular to show the roundness and thickness of the arm.

We have noticed how a young child's head is larger in proportion to its body than the head of an older child. This, of course, is by no means the only point of difference. A child often has more back to its head when it is young; also a greater proportion of the head is covered with hair. In the very young the mass of hair is larger than the face. In a lad of four the hair grows well down on the forehead, and keeps more or less like this well on into the teens. In later life the hair goes on receding from the forehead or goes thin generally, and in some men it disappears altogether from the top of the head. Baldness, of course, is a problem which does not concern us when we are drawing children!

Badly drawn feet can easily spoil a drawing, so do pay particular attention to them. Children's feet are beautifully shaped, and it is a pity that so often after they have grown up they lose some of this early beauty. Carelessness in the choice of shoes can bunch toes together, and it is a wise parent who chooses sensible shoes for the child, thus keeping the toes well-formed, as Nature intended. Children stand and walk correctly by instinct. Have you ever seen pictures of natives walking? They walk with their feet turned ever so slightly in. Thus their little toes do their share in giving the feet leverage to move, and children find it natural to walk like natives. To walk with the toes pointing right and left, as so

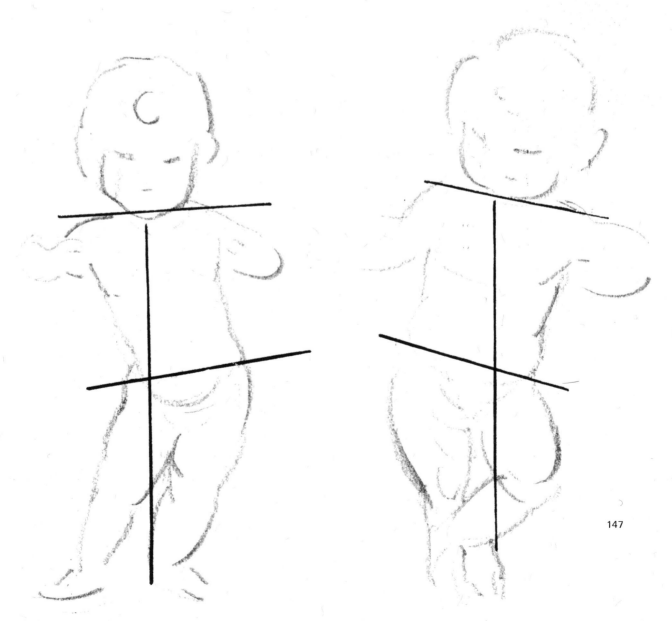

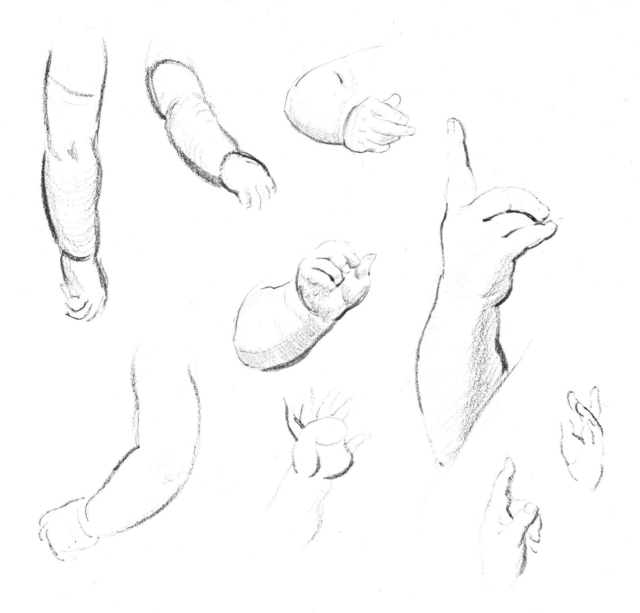

many grown-ups in civilized countries get into the habit of doing, makes the big toes do all the leverage and the little toes none, and does a lot to spoil the shape of the foot. So watch for these comparative points when drawing young children toddling about barefoot.

And notice in a child's foot how the ends of the toes are in a curved line, and how the big toe is usually a bit shorter than the second one.

149

Constructing a Face

We know that a face has two eyes and ears, a nose, and a mouth. But eyes are more than just two spots in a face, and the mouth is not just a slit separating the upper from the lower jaws. They are wonderfully constructed features as are the nose and ears.

Take the eye: this consists of the eyeball and eyelids. The eyeball rests inside a socket in the head. The eye-sockets are on each side of the bony part of the nose.

A good tip when drawing an eye is to think of it as an orange. Imagine the actual eyeball is the part of the orange you eat. The eyelids are the peel, with a bit cut away when the eye is open, to leave a portion of 'orange' showing. Thus, you see, the lids fit round the eyeball just as the peel fits round the orange. If you think of this it will help you to get the *roundness* of the eye.

And while we are on the subject of eyes, have you noticed how very bright the eyes of babies are? This is because the pupil of the eye is proportionately larger compared with the size of the eyeball in a baby than in a grown-up. To create that look of baby-hood it is important to make the pupils large and liquid. Of course, when the child is laughing the eyes don't look so round, as they get 'screwed up'.

Another important thing to notice is that in the average child, the eyes are set wide apart on the face. If you get them too close together you will give a monkey-like look to the head.

A. Eyes of a 3 months old baby. Notice the large and bright pupils and that the eyes are set wide apart

B. Eyes of a 6 year old

C. Eyes of a 12 year old

D. Eyes of an adult, included for comparison

A.

B.

C.

D.

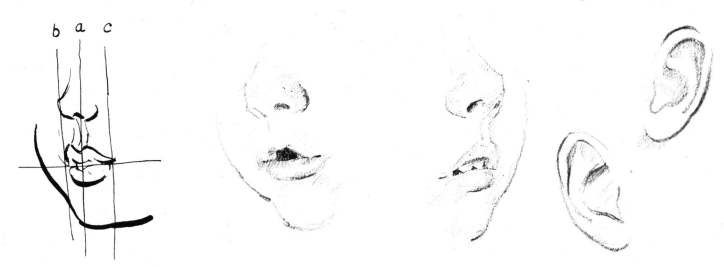

The mouth, too, you must set in its right place on the face. From that part of the nose which separates the nostrils, two lines come down to the centre of the top lip. This establishes where the centre of the mouth comes, and if you get this right the whole mouth will be correctly placed. This is a particularly useful way of establishing where to draw the mouth when the head is turned away in a three-quarter view. The side of the mouth nearer to you would of course be wider than the half that is turned away from you.

Ears, I find, are often just sketched in without much attention to detail. This is a pity, because they are beautifully formed. The lobes form an ellipse, and inside this ellipse is that shell-like curve which gathers in the sounds we hear. If you draw them carefully you will notice how delicately shaped they are. And notice how they are placed on the head. Normally, the tops of the ears are level with the line of the eyes, the bottoms with a line drawn across the cheek from the base of the nose. When the head is turned upwards the ears come lower. And of course when the head is tilted sideways one ear comes higher and the other lower. You might think all this is too obvious to mention, but it is surprising what errors one can make owing to a little thoughtlessness or lack of knowledge; and also I must remind you that when the head is tilted to one side, the eyes, nose and mouth get tilted with it!

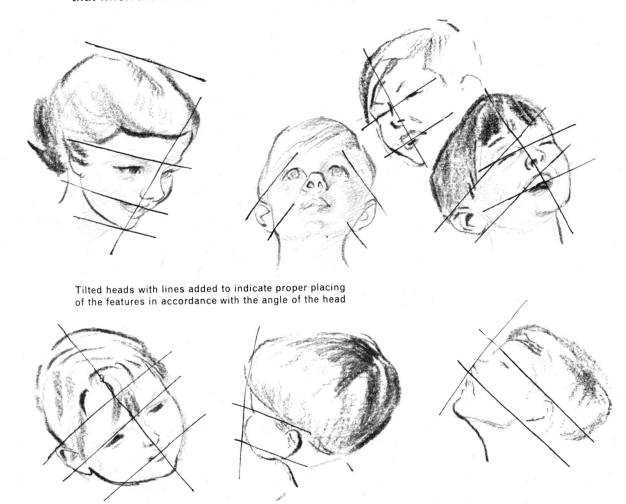

Tilted heads with lines added to indicate proper placing
of the features in accordance with the angle of the head

Drawing a Portrait

Try and get your friends to sit for you. When drawing a portrait you can, if the sitter is helpful, take more time and get more finish into the drawing than when you are sketching someone in action. But it is very hard to keep still for long and your sitter will probably get a little restless, so do not be too hard a 'taskmaster'. Give your model frequent rests; if he keeps still for too long he is apt to become unnaturally stiff and stilted and this will show in your drawing. Encourage your model to relax; chat a bit as you draw (if this does not distract you too much).

You might come to the conclusion that it would be less worrying to draw a portrait from a photograph, but—as I said earlier—I do not advise this. It is a very dull and unrewarding way to learn how to get a likeness. It is also very good practice to draw *yourself* in the mirror. Many artists do this quite a lot; I have used myself as a portrait model time and time again when a student, and still do occasionally when I can find the time. This is not vanity, I assure you. There are so many advantages in being your own model. For one thing, you are always available when you want yourself! Then, you know exactly the position you require so you don't move much. You can even draw your own profile—or even the back of your head if you wish!—by using two mirrors. The main principle to observe when drawing a self-portrait is to set a mirror the same height as your face, and at right angles to the surface on which you are working. This will give you an excellent three-quarter view. Then you simply glance from mirror to paper, paper to mirror until the drawing is finished. This is exactly the way in which Rembrandt worked, and he drew and painted perhaps more self-portraits than any other artist.

In drawing a portrait, first of all indicate very lightly the shape and tilt of the head, and how it sits on the shoulders. Then indicate, also very lightly, where the

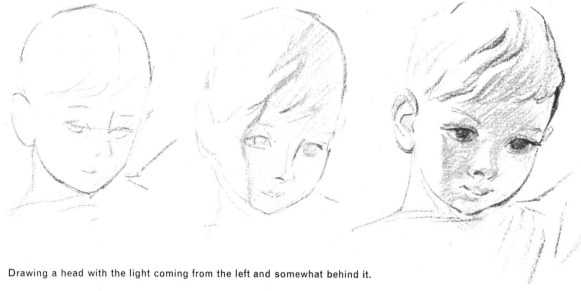

Drawing a head with the light coming from the left and somewhat behind it.

Stage 1. Indicate tilt of the head and also angles of features.

Stage 2. Draw in the features with a little more detail, also a line which shows which part of the head is in shade. This is called the *line of transition*, and is very important in drawing a head or other rounded objects in strong lighting.

Stage 3. Draw more details and also indicate the light that is reflected in the part of the face that is in shade. These reflected lights must never be as strong as the side of the face which catches the direct light. Soften but do not lose the *line of transition*.

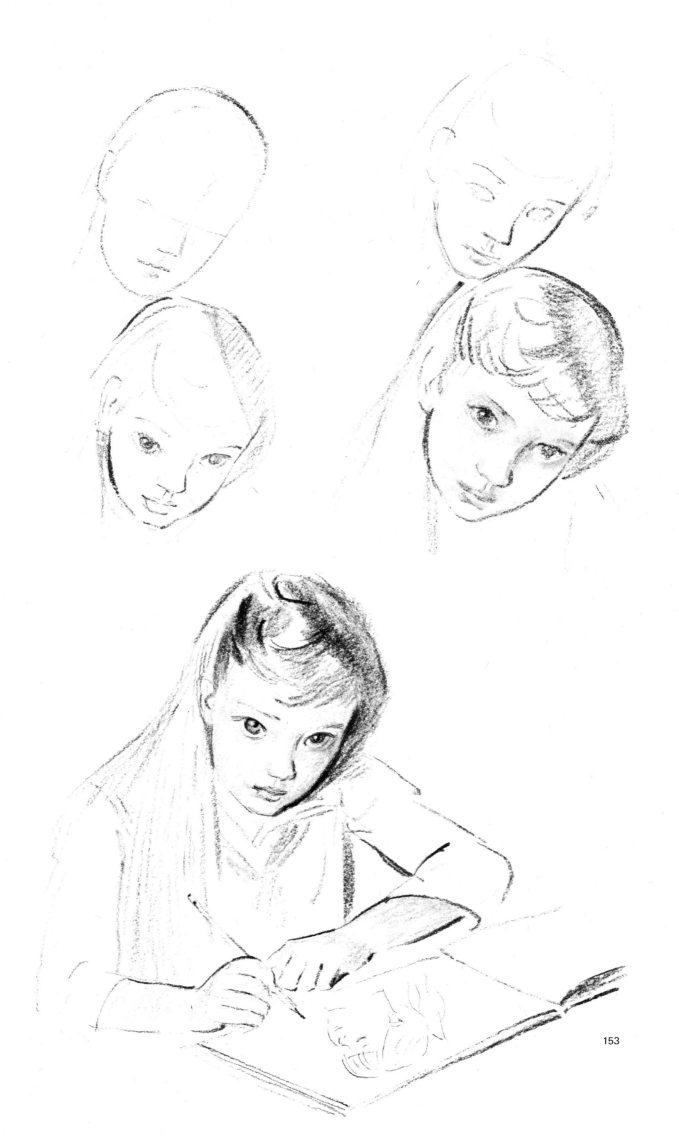

153

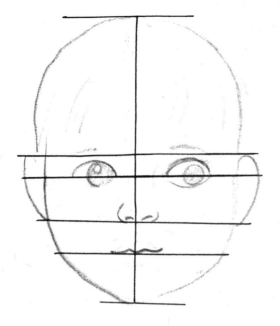

First stage of drawing a head.

The ruled lines are to show the tilt of the head and the angles of the features. Note that the eyes come about half way down the head.

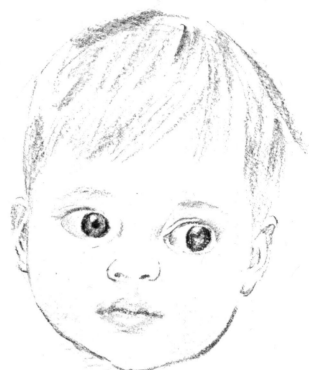

The finished drawing

features come *before* you start drawing them in detail. I know one or two portrait painters—and I must say they happen to be jolly good ones—who can start a portrait by painting in an eye and then putting in the rest of the face feature by feature. From your point of view I think the first method is by far the best.

That is why it is better to indicate the tilt of the whole head first; it will then be easier to get the eyes and other features at the correct tilt to go with it. So, to repeat my advice, indicate the position of the whole head first, then fit in the features accordingly.

Try your model in one or two different positions before starting. Some children have particularly interesting profiles; some, especially 'animated' types, come out best full face, looking right at you. Others provide an interesting aspect in a three-quarter view.

Get your sitter in a good light. Usually if the light comes from one side you get interesting modelling. If you place your sitter against the light (not a good idea except perhaps for special 'dramatic' effects) you should have a secondary light reflecting into the features; a large sheet of white paper, or even a light wallpaper close at hand, might be sufficient.

Study your sitter's most typical expressions. Keep up a little conversation; this will help to make the result more animated. Nothing looks more dismal than a portrait with a bored expression.

A portrait need not be just a head staring into space. You can have your sitter doing something—say, reading or sewing, or making something. Or, if you are lucky enough to have a friend who is as interested in drawing as you are, you could sit opposite and draw each other.

Drawing Groups of Children and Composing Pictures

Well, having drawn children in action and in repose, having drawn their faces in detail while attempting portraits, and having got into the habit of carrying sketchbook and pencil with you wherever you go, you might find yourself growing more ambitious and eager to draw completed pictures perhaps using some of the sketches you have made.

In picture-making, you must first of all draw your setting—say a park, a field, a street, or a playground. Then you must place your figures in the setting so that they look natural. This is not easy, as separately drawn figures can seem so unrelated. There will be an artificial look in the way you group them, as if you were arranging a shop window display piece by piece.

How do you get over this? Well, let us assume you have had some practice of drawing children in action. Now try something more elaborate: draw whole groups of children at once. Notice how they unconsciously 'arrange' themselves when they are playing together. You couldn't possibly 'invent' the 'unexpected' way their attitudes blend. One head or figure half hides another; a figure stands a pace away; two or three children may sit together but each one in a different position, and so on. As with the quick action notes you have made, indicate the main lines first—details can be put in later—if you have the time! A 'natural' group, thus jotted down, is excellent raw material for a picture.

Children in a classroom often group themselves very interestingly. So draw groups of your classmates at school whenever you get the chance.

Other factors and problems come into picture-making, such as perspective and the principles of composition; but I will barely touch on these here, as in this

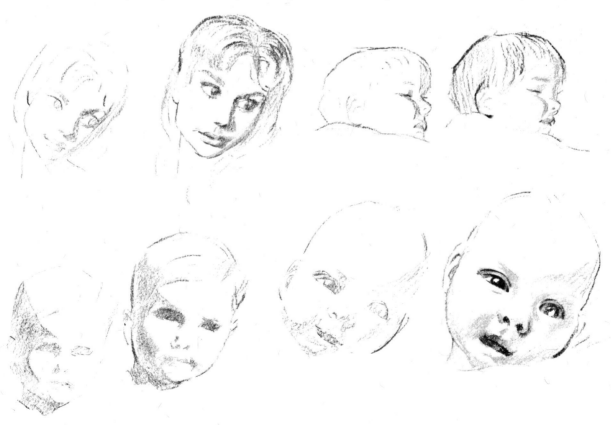

Heads in strong lighting. These are shown in two stages; first with the tilt of the head and corresponding angles of the features indicated, and with the light and dark parts suggested by drawing in the *line of transition* from light to shade. Secondly, the more finished drawing, with extra shading.

155

section I am concerned only with telling you how to draw children. The obvious thing to remember in perspective is that the figures further away appear smaller than those near to you. So far as composition is concerned, make sure that the eye of the spectator can find a point of maximum interest well in the picture, but not at the centre; balance (asymmetrically; symmetry is dull) a mass on the left with one on the right; and never divide your picture, either vertically or horizontally, into two equal halves.

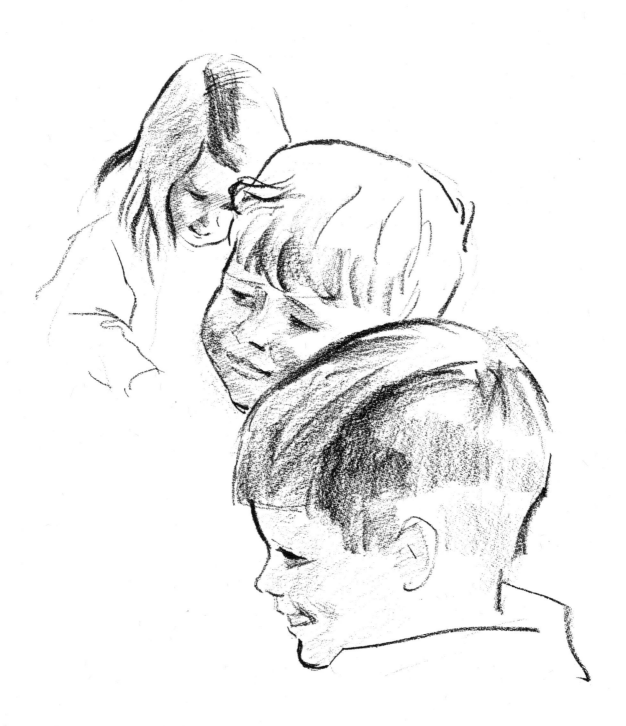

Portraits
Henry Carr

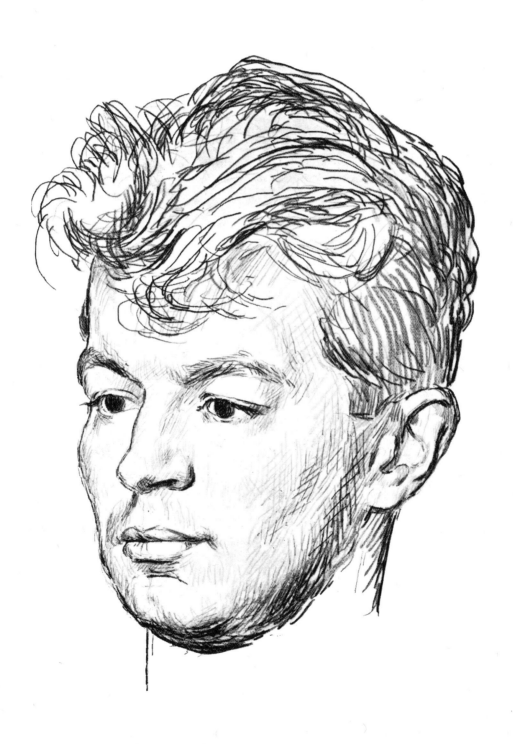

Introduction

In that old cookery book by Mrs. Beeton in the recipe on Jugged Hare she says, "First catch your hare".

So in portrait drawing, first catch your sitter. Seat him or her in a chair and see that it is comfortable and that the sitter is at ease. The light on the face should be such as is interesting to you, the artist. There is no rule regarding this, Rembrandt always had his sitters in a concentrated light which threw strong shadows; Holbein on the other hand, enjoyed a diffused light with the slightest contrasts of tone.

The distance you sit from the sitter depends to a great extent on how large you want the drawing to be. If the drawing is to be large, then you need to be close up to your subject. If it is to be a small head, then get further away. Again, there is no rule as to how big the drawing should be, it is purely the artist's decision, and may be influenced by what you want the drawing for. Few of the drawings by old Masters were done for their own sake. They were done to paint from, and the amount of detail in the drawing depended on what was needed for the finished painting.

Having made a decision on the distance from the sitter, the next thing to decide is, how to fix yourself in the most comfortable position in order to draw. Some people just sit on a chair and use a drawing pad or sketch book on the knees, but I should advise another chair, a kitchen chair with paper pinned to a drawing board leaning up against the back of the chair so that you have the seat on which to put your materials, pinning the paper on the board at what is the most convenient height for your hand and eye. You don't want the arm to get tired by drawing at too high a level, nor do you want your back to get tired by bending down to do the drawing.

All this is very simple stuff, nevertheless, it is important. The mind should not be distracted by bodily discomfort. To do the drawing is difficult enough without the distraction of a gymnastic display to do it.

You are now comfortable and so is the sitter, and if the sitter is to remain comfortable and not begin to look terribly grim, it is advisable to have frequent rests. This is not always easy to do, as the artist gets so concentrated on the work

that the sitter is too often forgotten and it undoubtedly is an effort to stop for a few minutes. However, difficult though it may be, I strongly advise it. Sitters have one characteristic in common, they get more and more grim the longer they sit, and in the final moments of a long sitting they hardly resemble the person who sat down some time before, and neither will the drawing.

Also one of the difficulties an artist faces in a long sitting is that he gets used to the faults of the drawing. Having made one little error in the beginning, other errors accumulate round it, so the drawing can become quite fantastically wrong. Invariably, the moment the artist's concentration is broken, these errors can be seen at once. The absurdities which students can do by concentrating for too long a period have to be seen to be believed, and the students themselves when they finally relax and look at the drawing are the most amazed. So, giving the sitter frequent rests cuts both ways and once the habit has been formed it is not difficult or disturbing.

It is probably too much to suggest that some conversation during the sitting would help to keep the sitter looking fresh and alert. It is a technique to be gradually developed. As a professional portrait painter, I find it essential. An effort now and then would not come amiss.

When one is young, and so aware that the drawings done are not masterpieces, there is some shyness in getting somebody to sit for any length of time.

Be tough. Be quite firm right from the start and insist on the time you want. Remember that some artists have taken forty or fifty sittings of two or three hours a time to paint a portrait, so don't be shy. The firmer you are on insisting on real co-operation from your sitter, the more co-operation you will get.

However young you are, you must be the boss while you are drawing a head. Believe it or not, the one thing that a sitter likes, is to feel that the artist knows his own mind and to be told exactly what he has to do. Be kind, but don't shilly shally.

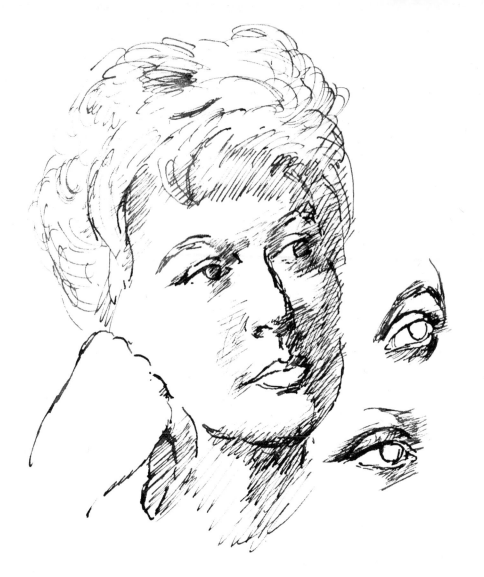

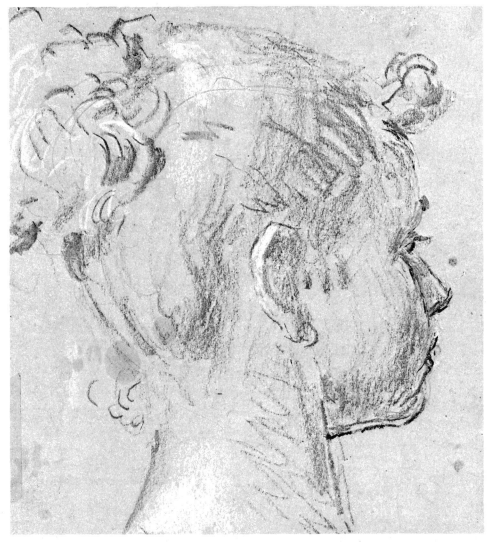

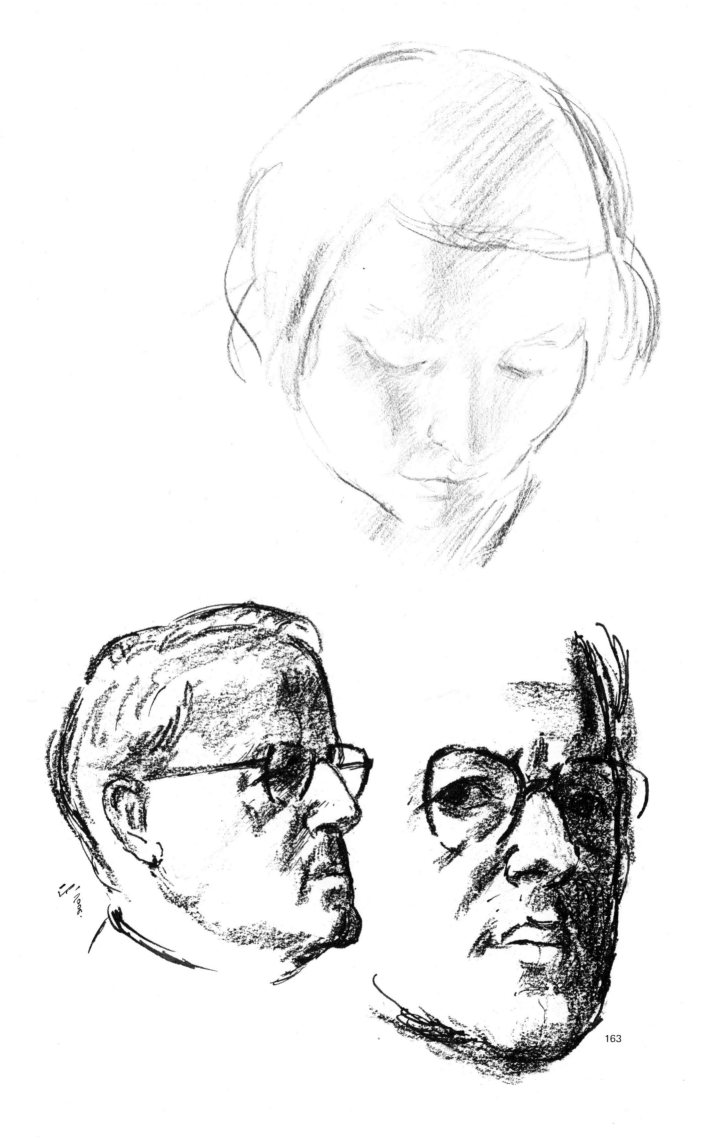

163

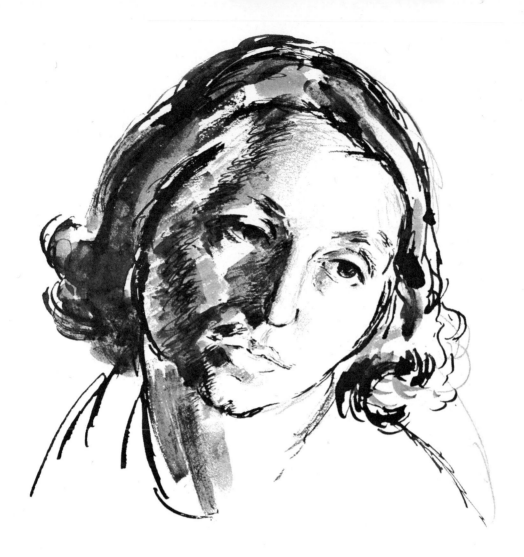

The Right Approach

Many people have said to me during my life that to paint or draw portraits you must have a gift, a special talent. Now, there are some students who have a natural ability of hand and eye that is undoubtedly beyond the average. But from long experience it is clear that these are not necessarily the ones that eventually succeed. In fact, the very ease with which they draw can be a danger. Not having to work so hard at drawing they tend to become superficial.

I would go as far as saying that the ability to draw easily in many cases is because the student is only seeing the superficial surface of things. The really important thing in order to succeed in anything, is to have an overwhelming interest. An interest that will not flag after disappointments and failures. The ability to overcome the many difficulties of drawing will undoubtedly come in time if the interest in what one wants to do persists.

If emotion and feelings are aroused by the subject for a proposed drawing, then it becomes difficult indeed to just record the surface appearance. Don't be dismayed. Things that have to be acquired by great effort are sweeter than free gifts.

To do good portrait drawings, you must be fascinated by faces. You must be disturbed, intrigued. Let us discard the idea that beauty is skin deep. There is nothing further from the truth. Real beauty spreads outward from the innermost recesses of the mind, and the characteristics of any human being are discernible

in how they look, how they walk, how they talk, how they write, in fact, in everything they do and in everything they become. So, in drawing a face you can be sure that if you get the forms and shapes, and the relationship of the forms and shapes right, you are getting the character of the sitter. But, of course, one must be fascinated by these things. They must intrigue and interest you enormously. If they do, then you can be sure of doing a drawing that will have interest if not mechanically accurate which is the last thing you want anyway.

This then is the first thing. The second is what sort of person *you* are. For just as surely as the sitter's mind develops his look and all his movements, so does yours control your hand and your mental attitude to portraiture.

Do you draw boldly, or do you draw gently, do you like pleasant, pretty faces or are you interested in queer, odd appearances? Are you sympathetic or maybe a little cruel? Do you like quiet, unobtrusive qualities, or do you like loud and ostentatious qualities? What you like, you will draw. So much depends on you.

The point I wish to make about this fact is that you must accept what you are like and draw in a manner that is natural to you. If you were to draw in somebody else's style and not be true to yourself, then you will not draw so well. In so far as you accept your own way of drawing, it will have individuality, for you are an individual, and in so far as nobody is exactly like you, so your drawing will be unlike anybody else's drawing.

No set methods. Allow your style to develop itself. When one is young, it is natural to find that one is very influenced by an enthusiasm for some master of drawing. It may be of course that this particular master comes the nearest to your particular interests; maybe, too, when one is young, moods change more easily and a student draws in one style one week and another style the next week.

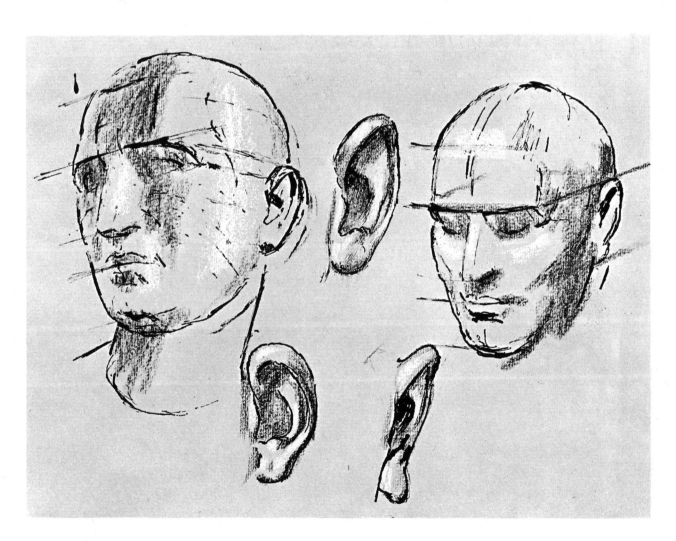

Principles and Hints

It is often argued that in learning the actual mechanics of drawing, the beauty of drawing can be lost for ever; that it is dangerous to spend.time and thought on the essential principles of drawing.

Let it be stated now that all great draughtsmen know these principles inside out. In such a thing as portrait drawing, it is impossible, in my opinion, to escape from the effort required to learn and master the principles of drawing.

If you want to be a pianist, you must master the technique of the piano. If you become too interested in the brilliance of your technique so that you play with no feeling whatever, then that is your fault, not the fault of the piano.

If you become so interested in the technique of drawing that it becomes your main interest and the subject of your portrait drawing is forgotten in an effort to show how well you can draw, then, again, that is your fault. A fault of character and understanding. In drawing, the only thing that can be taught, that can without any qualification be demonstrated, is the actual mechanics of drawing.

Perspective and light and shade. The understanding of these two essential things is very simple, but the ability to apply your knowledge to the complicated forms of a head requires practice and effort and a great deal of knowledge and ability in these two simple sciences can be acquired by drawing other things than heads. Draw simple things like chairs, tables, draw the corner of a room with the furniture, the picture on the wall, so that your drawing shows the tables and chairs really standing on the floor and in correct relationship to each other, the pictures looking as if they were hanging on the walls.

Draw things like plant pots, where you have to master the perfection of an eclipse, for if you can't draw a foreshortened circle, you won't be able to draw a head. For the basic shape of the head is that of an ovoid with the cross section of an ellipse. Do all this sort of thing as a task, don't worry about making a superb drawing. All you want out of it is knowledge and information. Use rulers to get straight lines if you want. It is surprising how quickly the general understanding of perspective will come and having got it, you need never worry about it again.

If you draw a head absolutely front view, then perspective does not come into it very much, the form would have to be explained by light and shade. The precise placing of the features and the precise drawing of these features would be an essential. The same thing applies to a profile.

In a way, and contrary to what most people think, the drawing of full face or profile is more difficult than drawing a three-quarter view, as one only has light and shade to suggest form, while in the three-quarter view the form of the head is partly suggested by the perspective.

If you drew a cube in such a position as to only see one face of it, there is no possible way of showing it is a cube. If you see a little of the top as well as one face, then there is some suggestion that it might be a cube, but if you show three faces, two sides and the top or the bottom, then there is no doubt whatever about it being a cube. The effect would be considerably increased by light and shade. One face in full light, one face in half-tone and one face in full shadow.

So it is with a head. In drawing a head full face, it is only possible to indicate

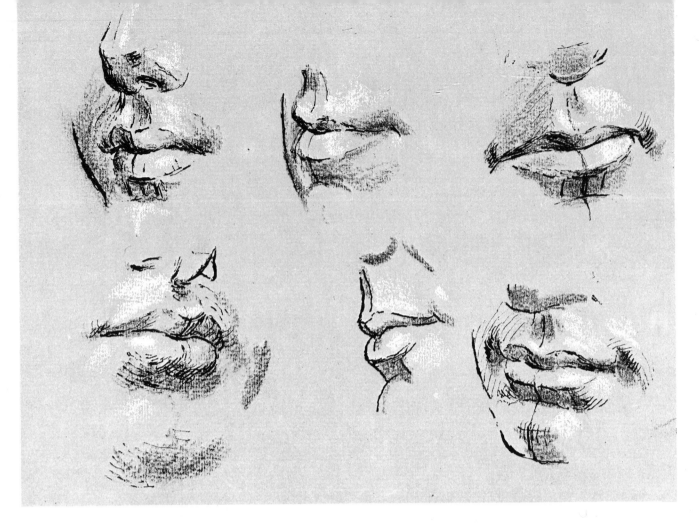

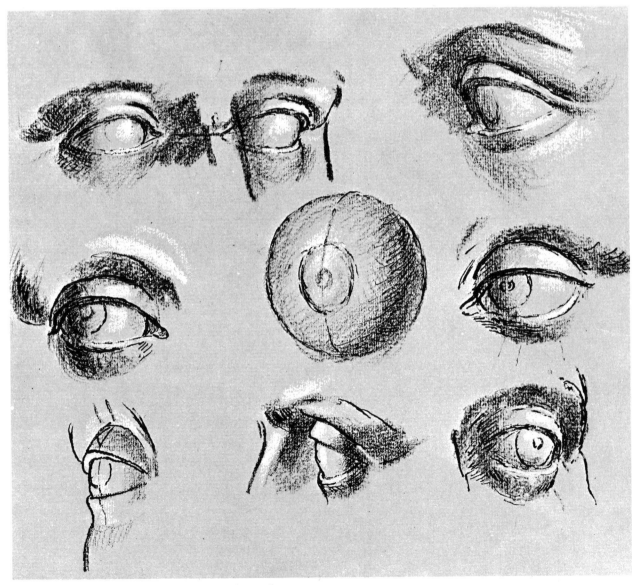

the angle of the nose in relation to the forehead by light and shade, but in a three-quarter view it is possible to indicate it precisely by simple perspective, just as the way one eyebrow is foreshortened in relation to the other will show how the forehead goes round. The way one side of the mouth is foreshortened in relation to the other side, will explain exactly how the mouth is curved. Add to this light and shade, and it is possible to see from the drawing, the modelling of the head as a whole, and also the modelling of its details. Begin your portraits by drawing the basic ovoid shape, then fit the features into this, either in full, profile or three-quarter view. And remember that the cross section is an ellipse. Think of an egg with the top cut off and you will have a good idea of the basic shape and form of a head.

The theory of light and shade is nothing more than that as surfaces turn away from the direction of light they get darker and when they reach a point more than 90° to the direction of the light, they are in full shadow.

As there is always some light reflecting back, the use of this reflected light will help to show the form in the shadows which would otherwise look flat.

One of the real dangers is in making an effort to copy the tones of the light and shade as you see it, in the hope that an accurate copy of these tones will show the form. It wouldn't. The difference in colour of parts of the head adds complication to the tone caused by light and shade.

What has to be done, is to try to draw the form and to use your knowledge of perspective and light and shade to express that form. To keep the eye, and mind, on the form. It is not just the shape of the head against the background and then an accurate drawing of the eyes, the nose and the mouth that you have to draw;

the actual surface form of the forehead and of the cheeks and chin must be followed and explained on the paper.

When Charles I wanted a bust of himself in marble, he got Van Dyck to paint three portraits of himself all on one canvas. One full face and two profiles. This painting was sent to Bellini in Rome who did the marble bust.

Van Dyck could have done drawings instead of paintings and Bellini would have been as able to see the form of the head equally well. It is this possibility of seeing the form in a drawing sufficiently well to do a modelling or carving from it, that is the acid test of what has to be achieved by a good portrait draughtsman.

It may be that some drawings which can be classed as excellent, show little form; they possibly have a spirit, a vitality, a design of shapes, that is fascinating. Nevertheless, the chances of doing good drawings in this vein are small indeed if the essentials of drawing form are not mastered in the first place.

Once these principles of perspective, and light and shade, have been mastered, one's imagination can take wing and eventually the actual mechanics of drawing will become instinctive. The beauty, the character of a portrait drawing does not depend on its mechanism, nevertheless, I strongly advise you to master the principles of drawing from the very outset.

What must be realized in drawing a head is that the shape of the skull is the essential feature. It is not enough to draw eyes, nose, mouth. The back of the head is as important as the front and the shapes of skulls are as varied as noses. No drawing can look good unless the mass of the head as a whole is right. What must be realized too, is that this mass of the head as a whole is most revealing as regards character. Also, of course, the way it sits on the column of the neck, and the neck on the shoulders. Eyes, noses, mouths are in a way secondary.

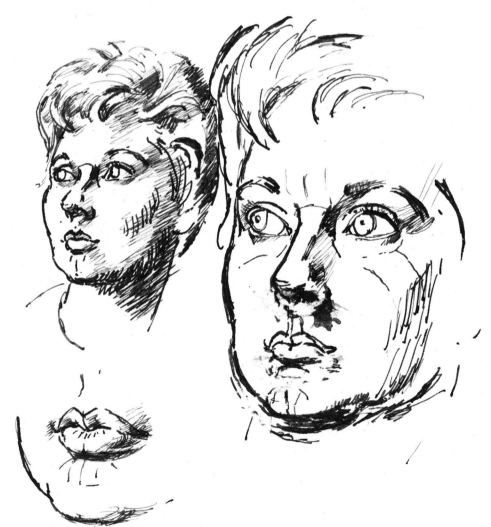

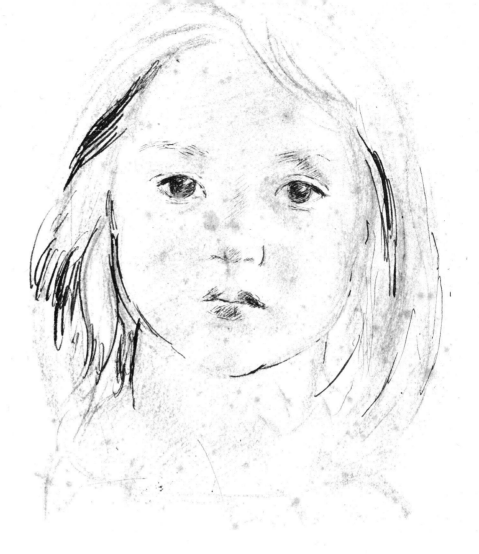

What must be observed is the shape of the forehead and the angle of the nose jutting out in relation to the front plane of the forehead. Observe the alignment and character of the jaw bone. The depth of socket of the eye, the form of the mouth. Then come the eyes themselves, the nostrils and the lips.

In modelling a head this would be the order of work, but the technical processes of drawing do not as a rule allow one to proceed in this fashion.

When modelling one starts with a lump of clay which can then be knocked about and built up and it is only natural that the details of eyes, mouth, nostrils and ears are the last things to be dealt with, but in drawing, the first mark is a line and though it is wise to get a general shape of the head immediately, one must very quickly fix the position of the eyes and extend upwards, sideways and downwards, building up the shape of the skull on the same line. This is the great difficulty of drawing, to be able to concentrate and draw in detail one part, and at the same time to be thinking of its place, proportion and form in relation to the rest of the drawing. The obvious failing is to draw each part without seeing the head as a whole.

It may be that the quality of a quick sketch is delightful, but don't limit yourself to quick sketches. Always draw as carefully as you can even if you have a very limited time to do the drawing. It has been said that after drawing as carefully as possible, the result looks like a sketch, but if you try to do a sketch, it looks like nothing at all.

It is advisable to always have with you a small sketch book and do drawings at odd moments. Now and then you will see somebody with an interesting head and maybe there will be an opportunity to do a drawing. After all, the really essential

factor in becoming efficient in drawing is to draw all the time. Teachers, books, may give you some useful information, but without continuous practice in the job itself, they can't help much.

A good tip regarding drawing heads when there may be little time, is to do them very small, thumb nail size. It is easier to get proportion right in a small drawing than in a large one. The characteristics which are interesting are easier to deal with since the fact that the lines are thicker in relation to the size of the drawing all helps to give a more satisfactory result.

When one starts to draw, one of the obvious difficulties is to get the proportions right. There are all sorts of dodges that artists have used to get over this difficulty. Sir William Rothenstein, who was my professor, and who had some justifiable fame for his portrait drawing always had t-squares, plumb lines, a whole lot of gadgets to make sure he got his proportions right and the angle of each line he tested with mechanical precision.

Sickert, a man of great talent often spoke of drawing the shapes of things in relation to the background, and I knew an artist who put a frame of vertical and horizontal wires at the back of the head, so that it was easier to see the precise angle of every part of the outline of the head in relation to the verticals and horizontals.

My opinion is that if you start using any mechanical means to get your drawing correct, you begin to rely on them; if you don't use them at the outset you will never need them.

There is no doubt whatever, and I am writing on the authority of a long experience in teaching, that though proportion is so often a difficulty at first, it is quickly mastered. It is not a thing to worry about.

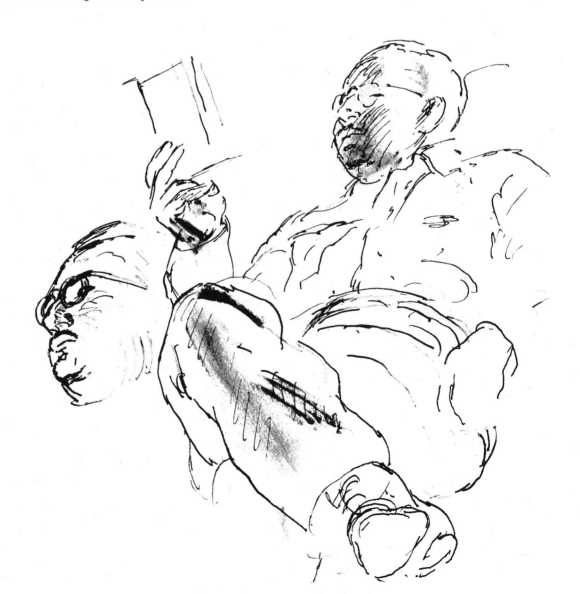

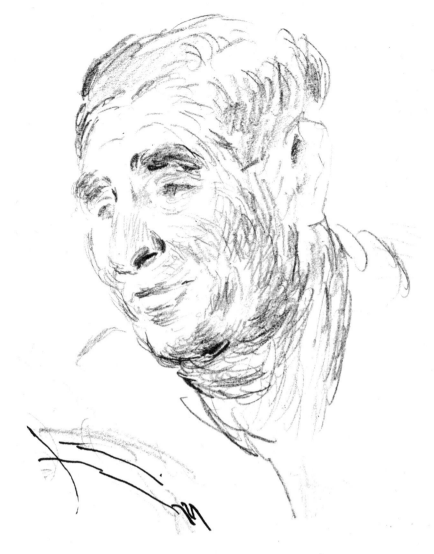

Another thing that is rather a puzzle, is what to do about the colour and tone in a head. Should the tone of the eyes, the tone of the hair, be indicated, and if the sitter has very rosy cheeks what about that? The lips too, are invariably darker than the rest of the skin.

The general rule is that in a drawing, *the main interest is the form* and if the colour and tone is going to interfere with the form, then they have to be ignored. But there is no rule in drawing that cannot be broken and, if you, the artist, feel that the tone of the eyes or the hair are an essential, then they have to go in. What must never be forgotten is that the artist makes his own laws as to what he does, and how he does it. But you can only make these laws on the basis of a solid mastery of the principles I have already outlined.

In writing comments about drawing or painting, the fact must be faced that there is always somebody to whom the advice given doesn't apply.

When one talks about perspective, and light and tone, it should be accompanied by demonstration. It is impossible to explain these things by words alone and so I have done a few drawings for this section with the idea of producing simple demonstrations that should be easy to understand.

The rest of the drawings have been done over a very long period of time and vary considerably in the materials used. Some in pencil, some in ink, charcoal and ink, chalk and ink, some with white chalk for the high lights, and some possibly with all the mediums available.

They also vary in mood and in purpose. Mostly they have been done to paint from, but a few have been done for their own sake.

In some the form is thoroughly worked out, in others just suggested, but on

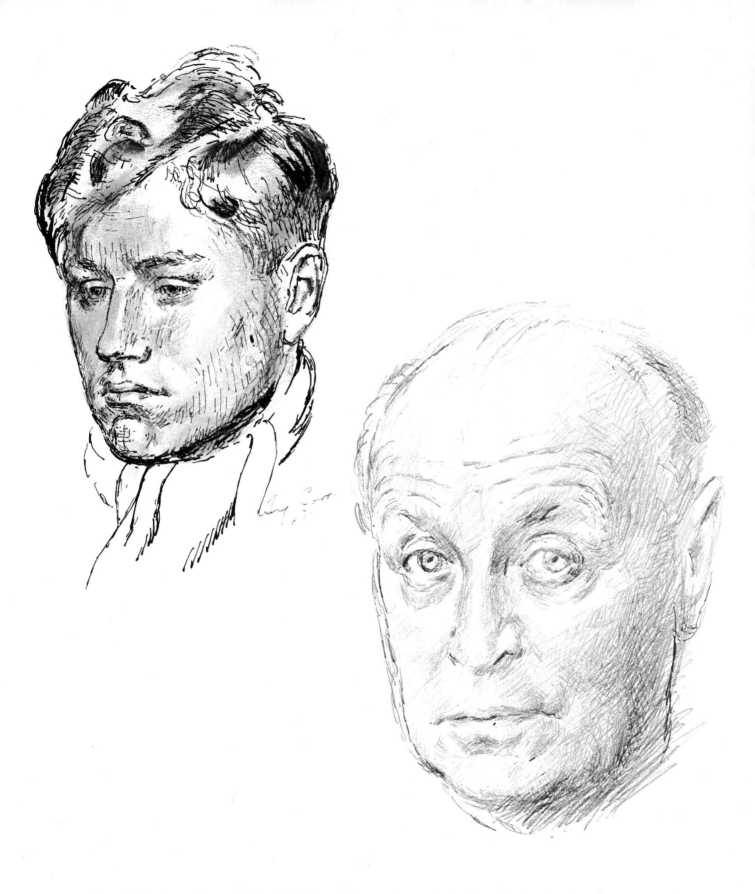

the whole, it can be seen that the interest in working out the form is the dominant idea, together with a fascination for shapes and the relationship of shapes and forms.

But the best drawings are those where the characteristics of the person drawn come out without undue stress on the mechanics of the job. To work towards this final idea is, I think, the right approach.

174

175

Wild flowers
Edith Hilder

This is a study of a hedgerow in
Autumn, drawn with an ordinary
ball point pen on typing paper.
These are simple materials, very
easy to obtain; easy to carry about
with you, no water to carry or ink
to spill.

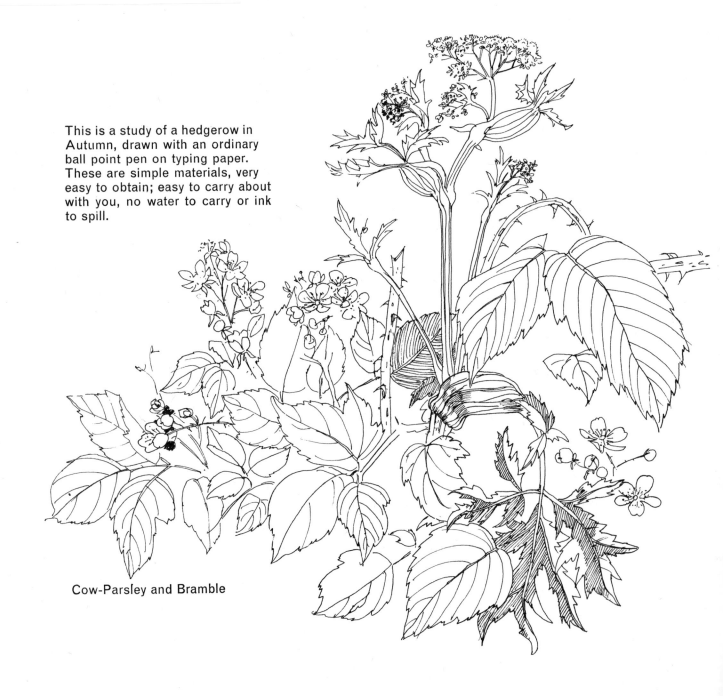

Cow-Parsley and Bramble

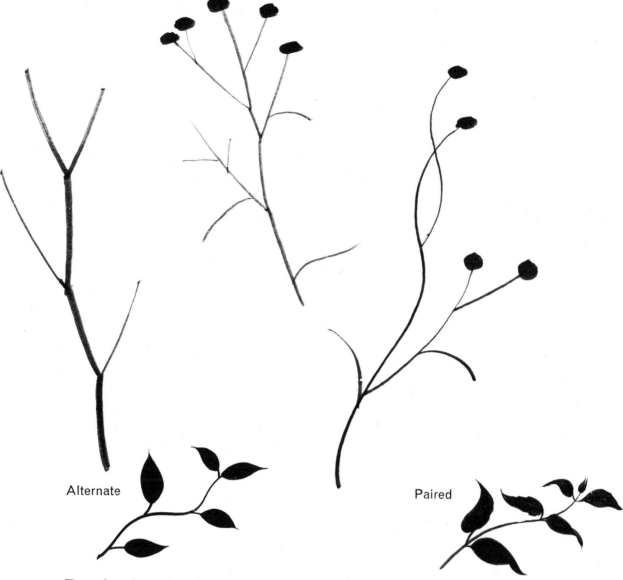

Alternate

Paired

Begin by looking

The drawings in this section are of the common wild flowers; those easily found while on almost any country walk.

The first pages are devoted to the study of the simple botanical structure of plants and flowers. A knowledge of botany, however slight, is valuable to the artist, and will most certainly help in making a convincing drawing. Constant observation and drawing trains both eye and hand; style grows with confidence and conviction. One learns to draw by constant practice; the best way to learn is to carry a sketch book and to make drawings and sketches whenever possible.

There are many excellent books on wild flowers and their habitat. Having dipped into a few of these books you will soon know what flowers to look for on various soils - for example, if you wish to find wild orchids, you will learn that they are to be found on chalky soil.

I have commenced the instructional part of this section with simple diagrams showing the basic structure of plants.

The six diagrams above show that the natural line of growth is not stiff or unyielding; that the plant has a natural 'live' rhythm, also that there is always a degree of curve - even in the apparently straight stem. Notice, for example, when a small stem branches off to the right, the main stem will compensate by curving to the left and vice versa. The same principle can be seen by observing the branches of a growing tree in relation to its trunk: the thickness of a stem or trunk is reduced every time it throws out a branch. This principle continues right up to the apex.

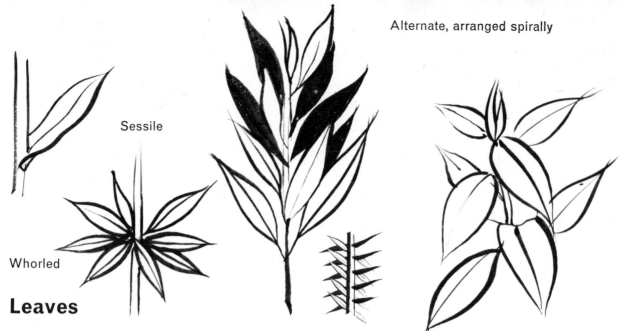

Sessile

Alternate, arranged spirally

Whorled

Leaves

Simply, plants have *systems* of leaf arrangement.

First, let us consider the *Alternate* system: here the leaves grow at right angles to the stem. In some cases the leaves are arranged spirally.

Next, the *Opposite*: here the leaves are paired at right angles; two leaves grow from the stem at the same level.

Thirdly, the *Whorled:* here two or more leaves grow from the same level. This principle is not very common; Herb Paris,

Pinks and Sweet Woodruff are good examples of this arrangement.

Fourth, the *Sessile:* here the blade of the leaf grows directly from the stem, as you can see, for example, in bulbs.

The leaf-like appendages attached to the base of the leaf where it joins the stem (as in the rose) are called *Stipules*.

I have named the leaf forms, but the real object of this exercise is to understand the fundamental differences in structure of the various systems, as this

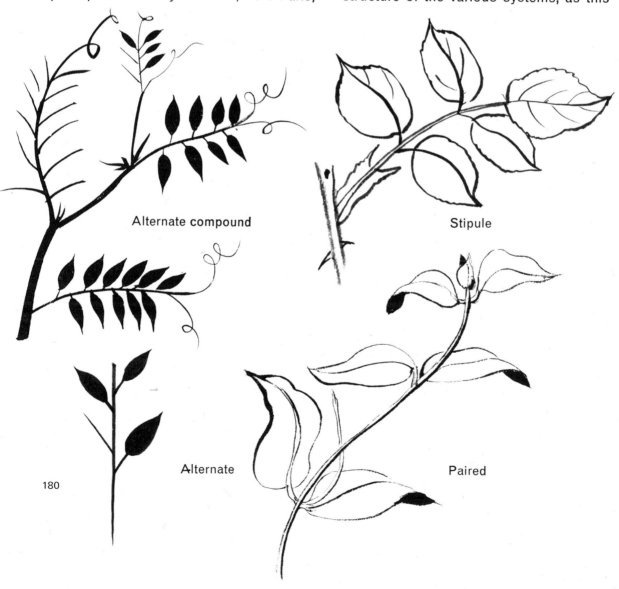

Alternate **compound**

Stipule

Alternate

Paired

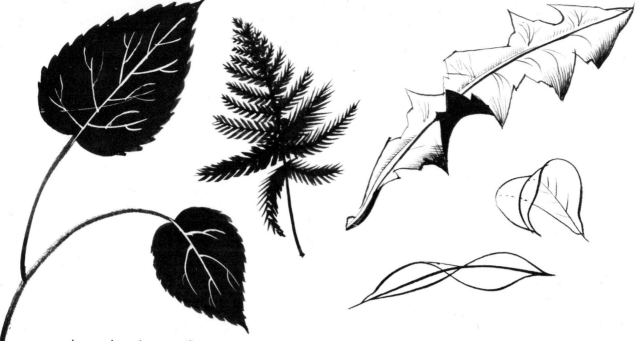

has a bearing on the construction of your drawings. If you begin by lightly drawing the main ribs and veins of a leaf, you will have an excellent guide to its shape and position in relation to its stem.

First draw the midrib of the leaf to give its direction - remembering not to get it straight and stiff; observe the curve. Where you have a plant where the leaves grow upright on the stem draw the lower leaves first and fit the higher ones later. Notice where the leaves spring from and

understand their structure; it is not enough to put the plant up and attempt to copy its superficial appearance.

If you have a plant where the leaves droop downwards from the apex, it is better to begin drawing from the top.

When drawing a leaf in perspective, it will help to get its main direction by first drawing the continuous line of the midrib, then the veins as they spring from the midrib. Practise drawing a single leaf in many different positions.

Silhouettes of flowers

Flowers are subject to the same laws of arrangement as leaves. Here are some simple silhouette diagrams which will help you to understand the structure of more complicated forms of flowers. They show, for instance, where the flower stalk branches; and the position of the head of the flower on the stalk.

Here are some brief notes relating to the more usual flower arrangements.

Spike - a long simple axis bearing flowers close to the stem, e.g. Verbena, Agrimony, Heather and grasses.

Raceme - differs from *Spike*, having flowers distinctly stalked, e.g. Hyacinth.

Corymb - the lower flowers are raised on longer stalks than the upper ones so as to bring them nearly on a level.

Umbel - formed by a number of single flowers on stalks of nearly equal length

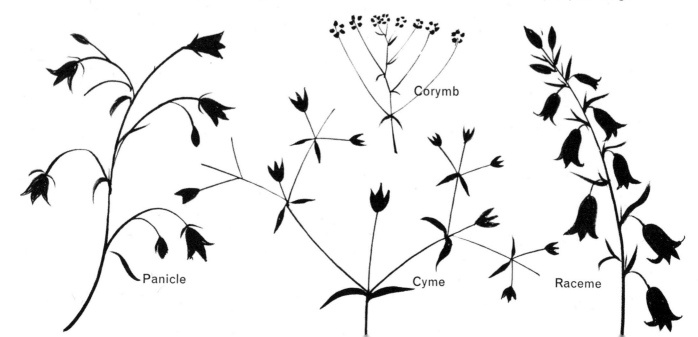

Panicle

Corymb

Cyme

Raceme

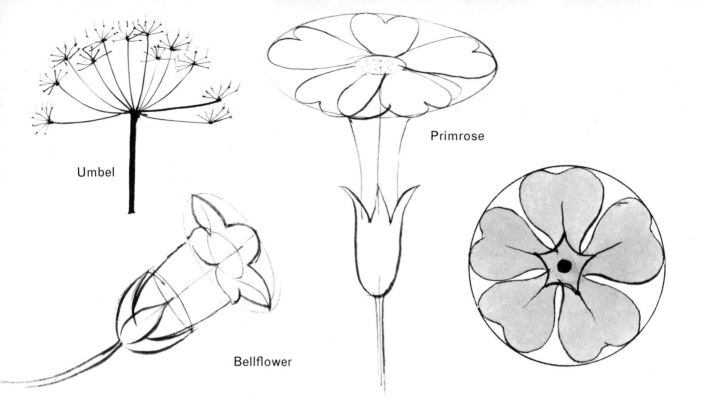

Umbel

Primrose

Bellflower

arising from one point, e.g. Wild cherry, Cowslip.

Compound Umbel - Wild carrot.

Capitulum or Head - a convex, flat, or concave surface crowded with a number of *Sessile* flower heads, e.g. Dandelion.

Solitary Flowers - a simple form, e.g. Tulip.

When drawing a flower it is important to get it placed correctly on its stalk. An imaginary line continued up from the stalk would mark the centre of the flower. Most flowers grow in regular circles - i.e. from the central pistil, the circle of stamens, then the petals and on the outside of the petals - the bracts. Knowledge of this helps when drawing a flower. With composite flower heads, like Daisies, the petals or florets radiate from the centre.

I have shown the construction lines of flower heads. The beginner could draw these lightly in charcoal. The charcoal can be dusted away, leaving a faint image which will serve as a guide.

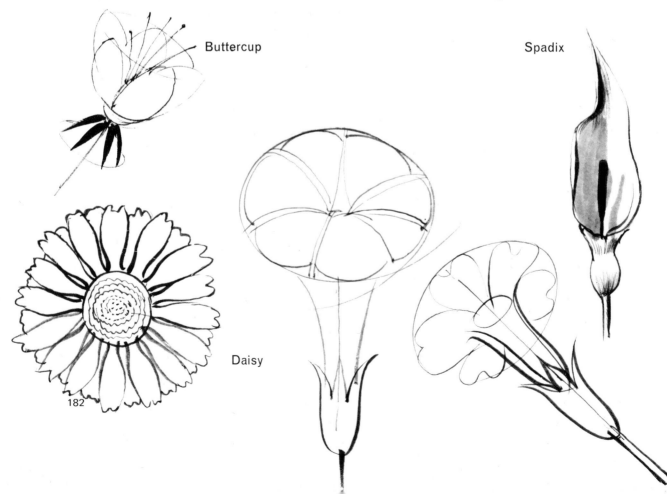

Buttercup

Spadix

Daisy

182

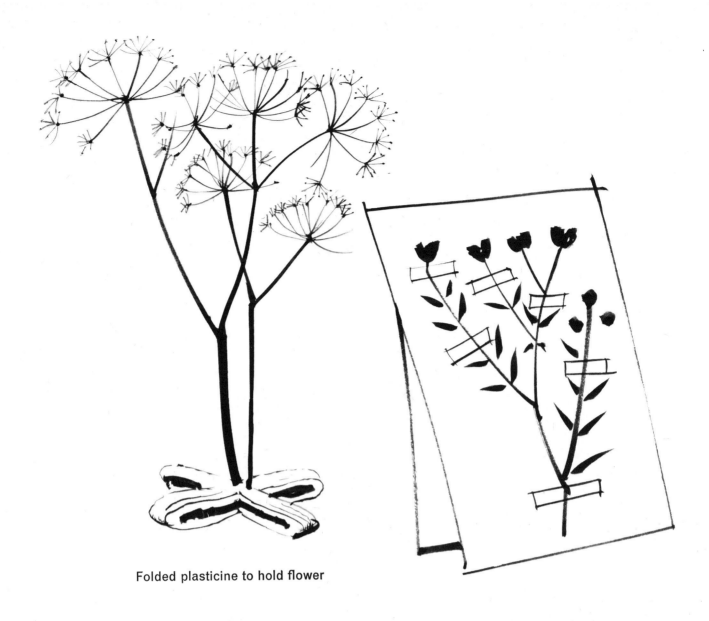

Folded plasticine to hold flower

Collecting wild flowers

Having decided to draw wild flowers, you will almost certainly want to pick them so you can make studies at home. You will come up against the problem of 'bringing them back alive'. Wild flowers, so lovely and delicate, are notorious subjects for drooping and wilting; in some cases they lose their shape within half an hour of being picked. To guard against this it is essential to put them into an airtight container as soon as they have been picked. An ordinary square biscuit tin is most useful for this purpose. A polythene bag, tied at the top to make it airtight, is excellent, as it is light and easy to carry when walking. Flowers brought home in airtight containers remain surprisingly fresh, and if kept in the container will remain in reasonable condition for several days.

Now you have collected your wild flowers you will want to begin making drawings. You will be faced with the problem of how to arrange the flowers and how to support them in a way that allows you to study them with ease.

I have found the following ideas most helpful: if one wishes to make a study of a single flower or a single spray, an ordinary milk bottle is ideal for long-stalked flowers such as foxgloves, or rosebay willow herb. To deal with a plant like 'Old Man's Beard' (Wild Clematis), which is essentially a climbing plant, and needs supporting if it is to look at all natural, use a piece of soft beaver board in con-

junction with a milk bottle. Stand the board on the mantle shelf with the bottle or container close to it. Secure the stem to the board using ordinary pins; with a few adjustments the plant can generally be secured in the position you want. Instead of pins you can use strips of clear sello-tape. Climbing plants may also be held by an ordinary bulldog clip, hung from the top of a simple improvised stand. The clip holds one part of the plant, while another part is fixed to a soft board with pins. This simulates the effect of a plant growing out of doors in its natural sur-roundings.

When making studies of Teasles, Cow-parsley or any other of the dried rigid autumn hedgerow plants, plasticine can be used to make an excellent support, simply by sticking the rigid stalks into a fair-sized lump modelled to stand on a flat surface.

Plasticine can also be moulded to take a small test tube which makes an ideal waterholding container for small wild flowers. Plasticine can be pinned with ordinary drawing pins to a surface at any angle and the tube adjusted to stand up-right, bringing the flower very near to you as you work.

While plasticine makes an excellent support for dried plants, one also needs a support that will contain moisture for fresh ones. When making a study of, say, Convolvulus, a small pot of moist sand makes a successful holder. Place this in an elevated position so that the stems and leaves trail down quite naturally near your work.

I have suggested these ideas as they deal with the problem of supporting plants which cannot be easily viewed when they are put into the conventional everyday flower vase. You will meet many such problems; I am sure you will think of ways of dealing with them as they arise.

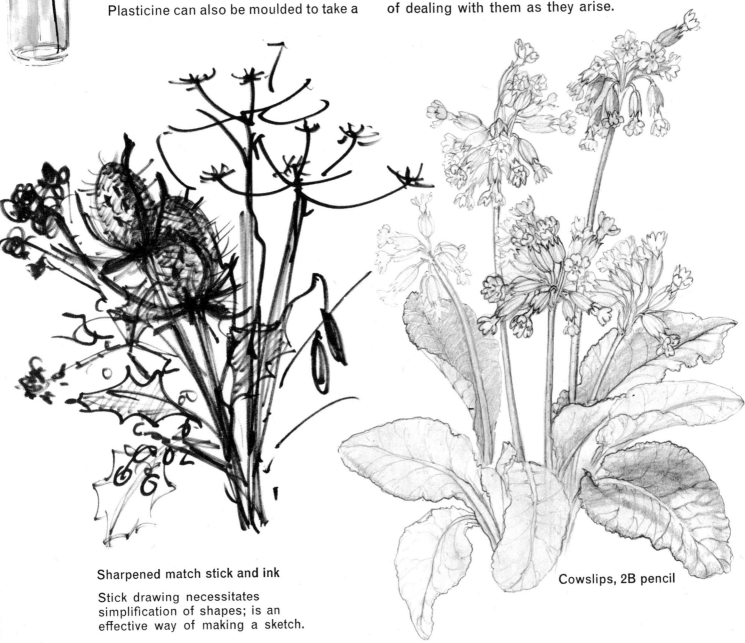

Sharpened match stick and ink

Stick drawing necessitates simplification of shapes; is an effective way of making a sketch.

Cowslips, 2B pencil

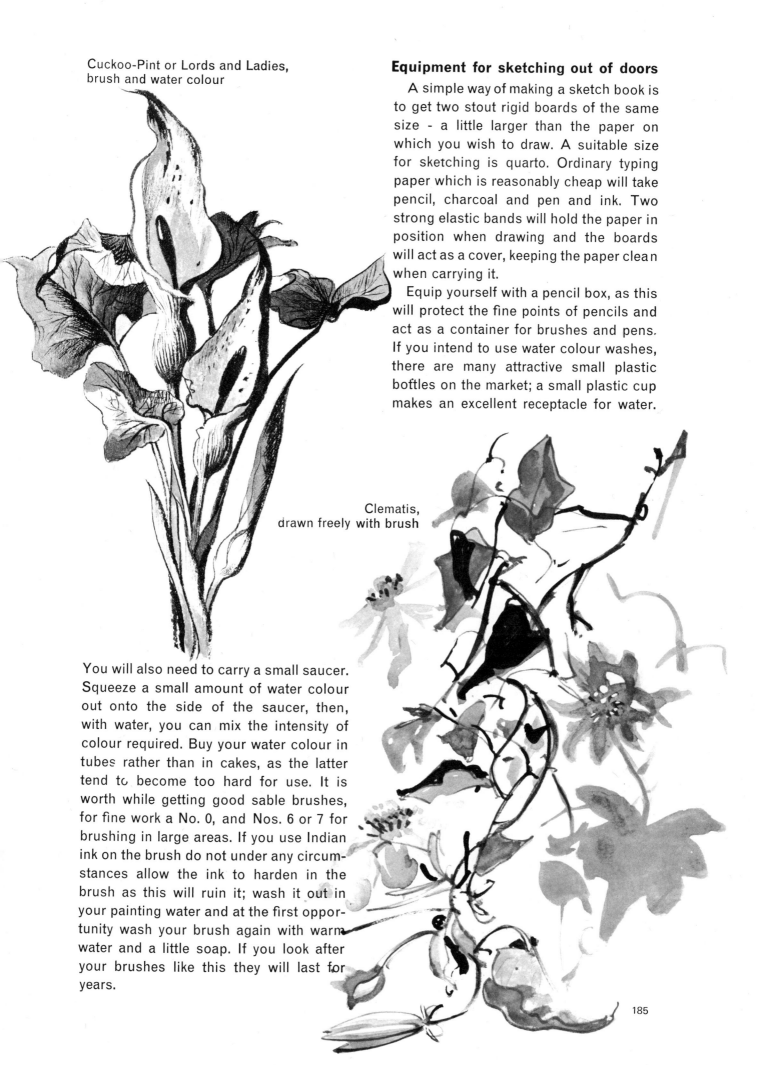

Cuckoo-Pint or Lords and Ladies,
brush and water colour

Equipment for sketching out of doors

A simple way of making a sketch book is to get two stout rigid boards of the same size - a little larger than the paper on which you wish to draw. A suitable size for sketching is quarto. Ordinary typing paper which is reasonably cheap will take pencil, charcoal and pen and ink. Two strong elastic bands will hold the paper in position when drawing and the boards will act as a cover, keeping the paper clean when carrying it.

Equip yourself with a pencil box, as this will protect the fine points of pencils and act as a container for brushes and pens. If you intend to use water colour washes, there are many attractive small plastic bottles on the market; a small plastic cup makes an excellent receptacle for water.

Clematis,
drawn freely with brush

You will also need to carry a small saucer. Squeeze a small amount of water colour out onto the side of the saucer, then, with water, you can mix the intensity of colour required. Buy your water colour in tubes rather than in cakes, as the latter tend to become too hard for use. It is worth while getting good sable brushes, for fine work a No. 0, and Nos. 6 or 7 for brushing in large areas. If you use Indian ink on the brush do not under any circumstances allow the ink to harden in the brush as this will ruin it; wash it out in your painting water and at the first opportunity wash your brush again with warm water and a little soap. If you look after your brushes like this they will last for years.

185

Drawing a simple wild flower: Periwinkle

(1) Begin by placing the flower on a white board and carefully fix in place with sellotape.

(2) State simply in charcoal the growth and direction of stems, position of leaves and flowers.

(3) Dust off surplus charcoal with a soft cloth and in pencil work out the flower elipses and perspective of the leaves.

(4) Using a B pencil draw in the detail and add modelling in a softer pencil, such as a 2B or 4B.

Drawing a complex wild flower: Tansy

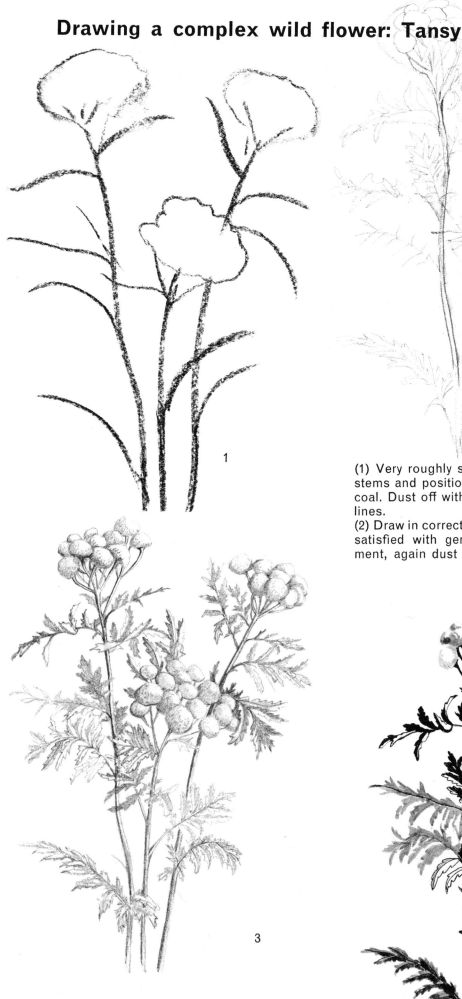

(1) Very roughly sketch in main direction of stems and position of flower heads in charcoal. Dust off with a soft cloth, leaving faint lines.

(2) Draw in corrections in charcoal, and when satisfied with general shape and arrangement, again dust away surplus.

(3) Now take a 2B pencil and draw in details of stems and leaves; take a harder pencil (HB) and draw in flower heads.

(4) Or, as in fig. 4, work directly in pen or brush over faint structural lines.
Finally dust away surplus charcoal.

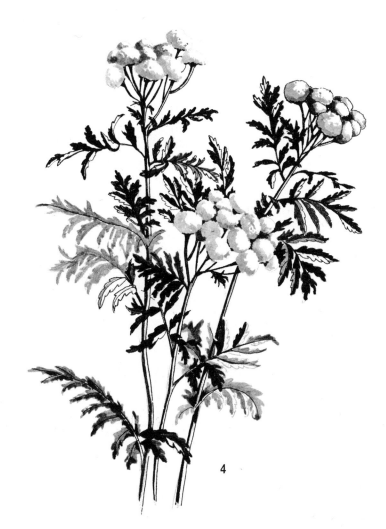

Drawing with a brush

For your first brush drawings you will require a fairly large and reasonably smooth sheet of paper. The surface must be absolutely flat, resting on a good drawing board or table top. Begin by placing the flat part of the nail of your second finger gently on the paper. Now move your hand so the nail glides easily over the surface of the paper. This is important as the second finger is to be the support for your brush. Place your brush against the second finger; bring your thumb across to secure it, finally bringing the first finger down on to the brush so it is held with thumb and first finger against the second finger. Now move the whole hand over the paper again as before, so the nail of the second finger glides over the paper - only this time you will be holding the brush.

Continue until you feel the hand moving freely over the paper. With the hand still, try moving the brush up and down with the first finger and thumb, keeping the second finger still. The object is to adjust the brush so that *only the point* touches the paper. Now dip the point of the brush into some black writing ink and make a long brush stroke by drawing your hand towards you; if the stroke is too thick, make the adjustment by sliding the brush up away from the paper with the first finger and thumb. By using your second finger as a support you will be able to draw, with practice, a thin even line.

Persevere until you begin to get reasonably satisfactory results. Then try making wavy lines, still drawing the brush towards you. Now try making some horizontal lines and free circles. Don't despair if you do not get good results at once. It needs hours of practice, so keep on;

Brush on rough paper,
black ink and water colour

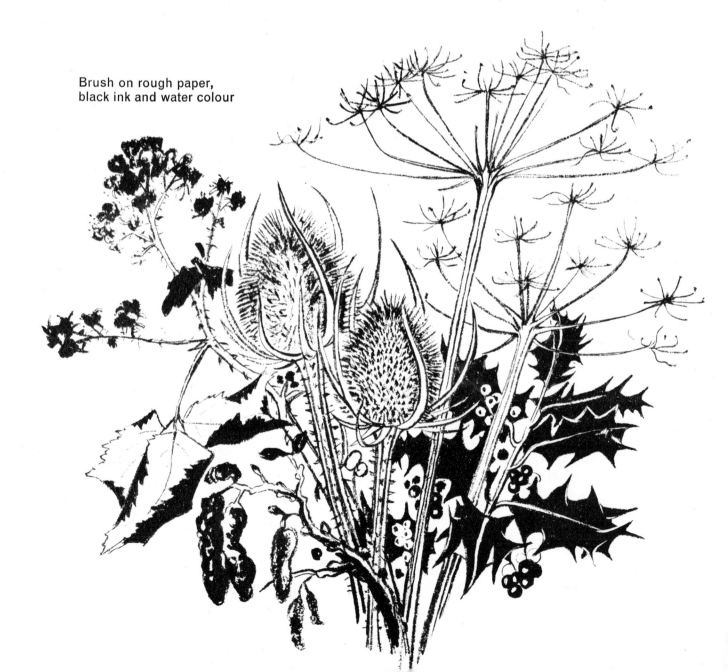

you will find the results very worth while. You will be learning one of the most difficult feats in painting: the mastery of free brush work.

Japanese and Chinese children are taught to draw and write with a brush; they spend years learning this art. Young Chinese artists are trained to draw lines first; only when they can do this are they allowed to draw twigs and, later, moving objects, like fish and birds. Try writing with a brush; if you are not too impatient you will find these brush exercises the greatest fun. Remember *you must draw with the whole arm*, moving your hand freely on the paper. Try drawing a twig; join another twig onto it. Relax. Particularly when you begin to draw an object. Keep the feeling you experience when doing practice strokes.

When you are able to draw clean, even, fine lines, try drawing a flexed line. This is one that begins by being thin but grows thicker; you do this simply by pushing the brush a little further down onto the paper, using the first finger and thumb to slide your brush a little down your second finger towards the paper. Try sliding the brush up and down so that you make both thick and thin lines. Now make thick lines using a slightly larger brush, sliding the brush up the second finger so you can thin a line down as you are moving your hand. Again don't

be depressed if you do not get good results at once; it's like learning to ride a bicycle!

The Chinese do not draw leaves by first drawing the outline and then filling in as we do: they paint each leaf with a single brush stroke, using a thin brush for grasses, and the long pointed sugar cane leaves they delight in painting; thicker brushes for large leaves, and very thick brushes for really large leaves. Such large brushes would be very expensive indeed; they are very difficult to come by in this country. Anyway we will be able to do a great deal with the brushes we have.

Try drawing a leaf by just letting the very tip of the brush touch the paper, then press down so that the full width of the brush comes into contact with the paper. Repeat these strokes and notice how the brush marks begin to look something like leaves. Keep on trying a variety of leaf shapes, long, short, fat and thin, and twisted or drooping leaves. When you have drawn many leaves in this way, take a thinner brush; try doing stalks and stems and see if you can join the leaves and the stalks. Begin to make some sort of a picture or design with these brush marks.

To begin with I suggest you do all this using black *writing* ink or *fountain pen* ink; remember you must never let the ink dry in the brush. Have a small jar or cup of water by you; rinse the brush when there

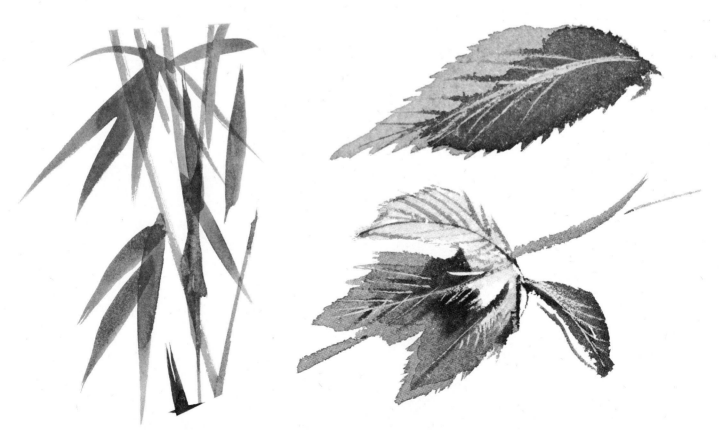

is a pause in your work. After you have finished, wash the brush with warm water and soap. Moisten the brush and rub it gently on the soap and rinse; you will see the ink coming out of the brush. Repeat the operation until it is absolutely clean. Lick the brush to a point and put it away in pointed form. Only very good sable brushes will work for this kind of drawing; squirrel hair, used in cheaper brushes, is lifeless. The hair should be soft to the touch, but springy and come to a good point. Test a brush when buying it by dipping it in water and shaking; if the brush is good it will come to a fine point of its own accord. A faulty brush tends to form two or even three points instead of one.

The Japanese and Chinese make their brushes with a hollow bamboo tube cap for protection. I have often wondered why we cannot buy these here. Your brush point can be damaged even if it is carried in a pencil box, so make a little brush holder from a small postal tube, so that you can carry brushes upright in your pocket. Brushes are expensive, and once they are damaged they are unsuitable for this kind of fine clean drawing.

Indian ink is intensely black and water-proof. This means that you can add water colour tones to your ink drawing, when dry, without disturbing the original line work by smudging. If you do not intend to add water colour use writing ink or moist water colour as a line medium. A small tube of lamp black is easy to carry and is easy on the brush. Mix with water to produce the desired black or grey. I mention this now because later I am going to suggest exercises in tone which will involve the use of blacks and greys, and moist water colour is one medium that you will be able to experiment with; thus you may be able to do two things together; to experiment with tones while continuing your brush exercises.

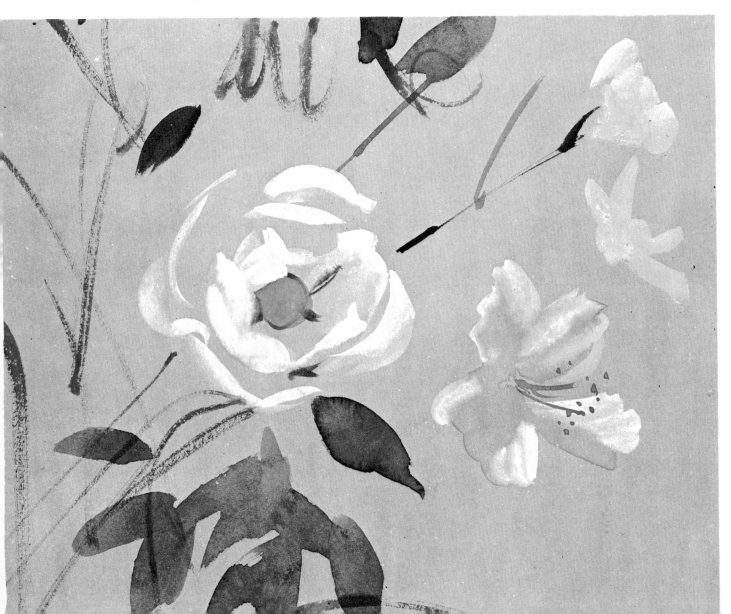

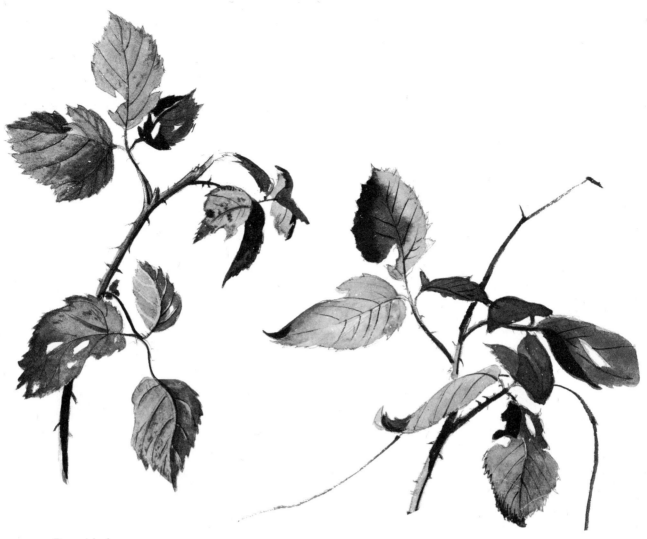

Bramble leaves,
line and wash water colour

Simplified tone

I hope by now you are progressing well with your brush exercises; that you are beginning to feel you are making real progress—and that as you do so you gain confidence: work becomes even more interesting and exciting.

When doing brush exercises in black you will virtually be drawing elementary forms in silhouette. As you draw you may find that some lines are greyer than others; it may strike you that the grey lines seem to be further back in the picture than the black ones. So we discover one of the principles of nature. Black appears to come forward; grey to fade into the distance. This happens in the general landscape when we observe: look at a street or a landscape, notice how the

darkest tones are in the foreground; how the tones fade to the light tones of the far distance. Artists call this Ariel Perspective; use this principle in your plant drawing. Now experiment: draw some upright lines in grey to simulate grasses growing, perhaps blowing in the wind; add further lines on top, this time slightly increasing the thickness of the line, and at the same time making it darker. Finally, finish up by drawing even thicker lines in jet black, to represent the grasses nearest to you. Consider the effect and see if the lighter and finer lines seem to go behind the darker ones, giving a stereoscopic effect of looking through a depth of grass.

Repeat this by drawing leaves instead

of grasses. Next try making simple arrangements on two planes in simple silhouette.

So far you have been drawing lines to represent the silhouette shape of the plant, as if you were viewing the plant against light. This process works well when drawing twigs and leaves; the fine and broad brush strokes simulate the look of these objects in an astonishing way. But this system does not work so well when one is attempting to draw a flower. Anyway, who ever heard of a black flower? So I will ask you to carry out another experiment.

First draw the stalk and leaves of a flower in black line, as you have been doing in your exercises. Then mix a fairly pale grey and paint the shape of the flower petals, as I have done. In fact you can begin by copying my sketch before drawing from the actual flower. Look to the flower for *outline shape only;* don't worry at this point about the other details you may be able to see in the leaves and petals.

Now you have been using tone in two different ways:
(1) To give depth to your picture by making some plants recede while others come forward.
(2) By suggesting the delicacy of a flower as seen in relation to its leaves and stalk.

So far you have treated the forms as simple shapes, now you are ready to experiment with the use of tone to suggest modelling by light and shade.

To do your next exercise you will need a simple plant form. Something rounded perhaps, or a simple flower head, a fairly large one for preference. Now view the subject in a strong light. Do this in the evening by using artificial light. Move the object in relation to the light and notice the various patterns of light and shade you can produce by lighting the flower first from one position, then from another. You will soon see that some lighting effects look better than others; that as you change the lighting so you get a slightly different conception of the flower.

Experiment observing the kind of light-

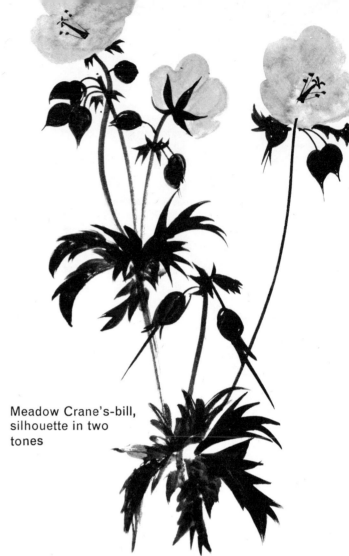

Meadow Crane's-bill, silhouette in two tones

ing you think best, then attempt to paint the flower or object in two tones only, simply by blocking in the area of shadow as a flat shape. Do not at this stage attempt gradations or 'merging' of tones.

First paint several views of the flower giving different lighting effects. Then compare the different results you get, asking yourself, 'Do these sketches look like flowers, do they convey the impression of flowers?'

I hope you will be surprised how this simple process conveys the impression of a flower. Next take a darker object like a leaf. Brush in the shadow in black; when this is dry paint in the deep tone of the leaf on the light side. Or, you can brush in your leaf in grey and add the black shadows afterwards.

Next combine the two, both flower and leaves. When you have done a number of free sketches along these lines you are equipped with enough knowledge to begin groups of flowers; to begin to make arrangements that will take you towards composing a picture.

Conveying texture

What do artists mean when they talk about texture? Imagine you are running your hand over various objects, first over something smooth like silk, then over something coarse and rough, like sacking. Now imagine handling something painfully rough like a teasle head or holly leaves which you know are painful to touch. 'Texture', applied to drawing, aims at giving the different 'feel' associated with various objects. How can we convey these kinds of 'feel'?

A smooth delicate wash will convey the feeling of the smoothness of a flower petal; sharp spiky lines the feeling of harsh or coarse textured objects. Remember your brush line exercises. Make a series of pointed lines; finely pointed at the tip but thickening as you increase the pressure on the brush. Imagine you are making spikes or thorns. Persevere *until you feel* the almost dangerous sharpness of the lines you make. Draw a line representing the stem of the wild rose, or a branch of bramble; add short spiky lines in the shape of thorns. Keep on until the thorns are so sharp that you feel that they would prick you if touched.

Think of various plants and imagine how they would feel to *touch;* try to develop the type of line that will convey this feeling. When you are in the country in winter collect some 'Old Man's Beard'; fix it in your window to see against the sky, then draw what you see, using very fine lines to convey the gossamer-like soft threads of the plant.

When mastered this will add another useful technique to your list of accomplishments.

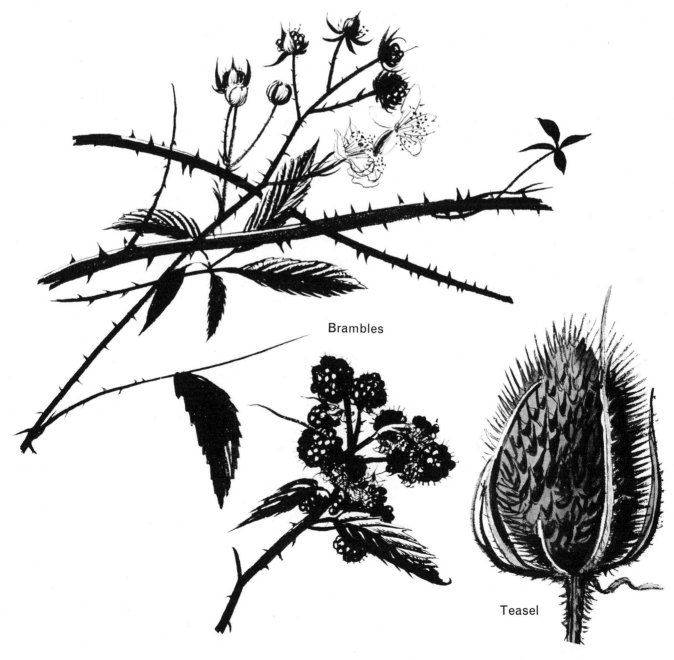

Brambles

Teasel

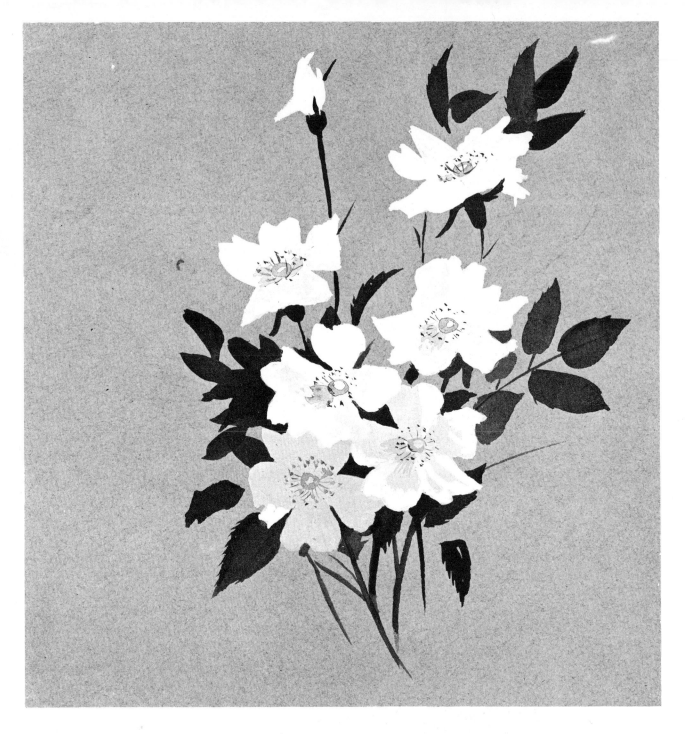

Working on a grey background

Both blacks and whites show up against grey - whereas only blacks show up on white; only whites on black: we now begin to combine them both into the same drawing. As a result the drawing process is beginning to have more of the qualities of a painting.

Select a mid-grey tone paper for this, half way between black and white. Work freely with the brush as before, drawing in the stalks and leaves in black; adding the flowers simply in white.

Grey makes by far the best background against which to look at your flowers, by the way; it shows up to the greatest advantage both light and dark tones. So make yourself a grey background board to set your flowers against: paint a piece of hard board or thick strawboard with grey distemper or emulsion paint.

A better way still is to use a soft board like sound proof board or Essex board so that tall and floppy plants can be supported by pins pushed into the soft board.

Counterchange

Counterchange means simply the juxtaposition of black on white and of white on black. These contrasts give a rich and full appearance to a drawing, adding interest and variety: thus we get continuity with exciting change.

The technique of counterchange is used extensively by the great painters; it is fascinating to look for the underlying counterchange patterns used in planning their work: light objects are set against dark and vice versa. Once you have become aware of this principle you will see that it is used everywhere, in modern and traditional art - as well as in designs used on fabrics, for advertising and display purposes.

Experiment by dividing your paper into two areas - making, say, a third of it black simply by painting it with Indian ink. Black water colour or poster paint will not do: they are not waterproof and will pick up and dirty the white when you overpaint. Take one of your most successful brush studies and draw it out again, making the plant forms overlap both black and white areas.

Now experiment with developments which will take you right up to the next stage - which is the actual composition of the picture. Begin to add half tone grey wash to parts of your white background. In other words, *begin to piece together* the conception of drawing on grey paper with the conception of black and white counterchange patterns.

The whole thing begins to be a bit complicated now - but is as a result much more exciting and interesting; it is also more difficult. You are like a juggler, who having learnt to throw one ball up and catch it (not very interesting to watch) now adds another, and yet a third and finally has five or six all going at once! He may drop a few at first; may even have to go back for the time being, juggling with one ball less, until he masters the process. Don't be depressed if a drawing goes wrong now and again. The great thing is to get enjoyment out of the work .

195

Composition

Composition is the arrangement and co-relation of the things making up your picture. Each artist must in the end find his own personal answers to the various problems confronting him: there are many opinions and ideas on the subject, but I will make one or two suggestions in the hope that they will start you off on an interesting adventure.

Begin by arranging small groups of flowers against a simple grey background. Lay your grey background board flat on the table or floor, with plants and flowers on the surface. Experiment by arranging them in different ways - trying to see them not so much as they are, but in the style you wish to draw them.

Try to bear in mind what you have learnt from the previous exercises. Arrange the lighter flowers against the darkest leaves so the whiteness of the flower is enhanced by contrast of tone. Avoid arrangements that lead to confusion; ensure that complicated plants like Marsh Mallows are shown against a simple background; avoid at all costs getting two intricate plant forms in a position where one is seen in front of the other, making it almost impossible to see the essential shape of either.

Each plant leaf and flower has its own individual shape - each has a position which best shows it to advantage: part of the artist's job is to make nature easier to see. Everything in your composition must be placed so that the final painting becomes *simple, clear and easy to understand*. If the background at one point does not show a plant or flower to its best advantage, cut out a piece of black or white paper to a shape that can be slipped behind the plant to sharpen the contrast.

When you are satisfied with the arrangement make simple rapid sketches, drawing broadly and freely as you have already done when practising brushwork. Composition sketches should not be too large - one should avoid getting lost in

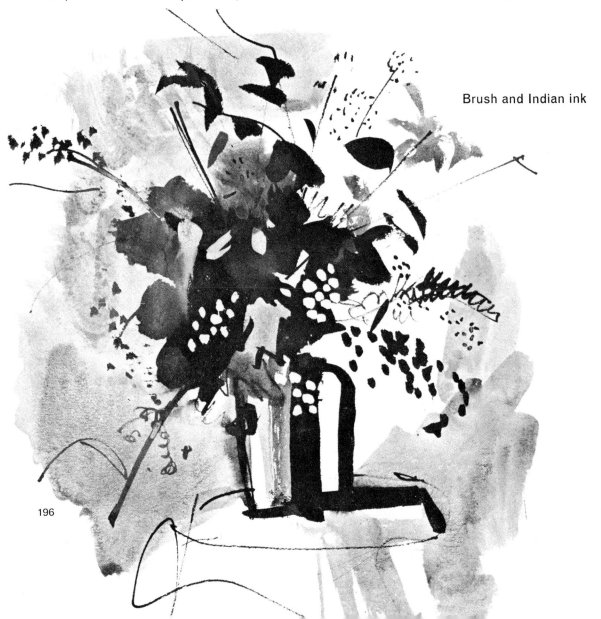

Brush and Indian ink

196

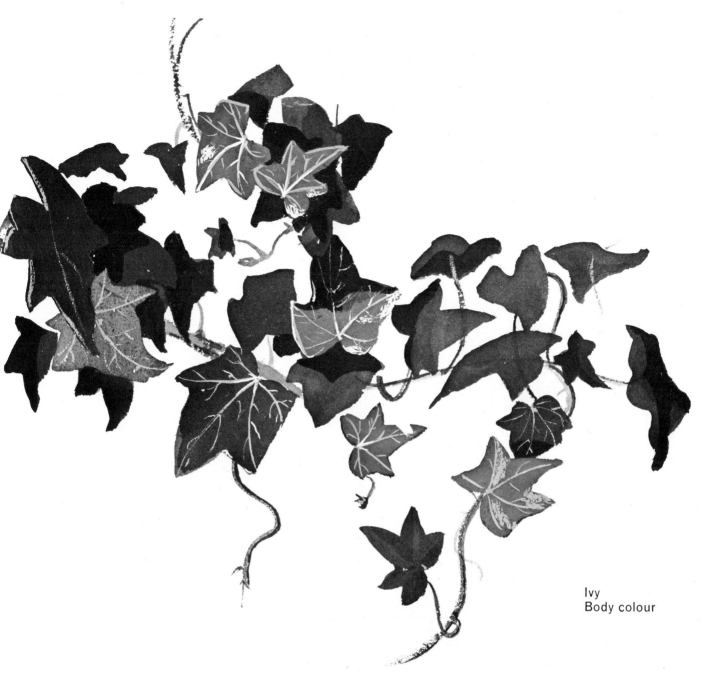

Ivy
Body colour

too much detail at this stage - go for the broader shapes and tones.

Next try sketching an arrangement from imagination and memory. Then try to place the flowers and plants in position following your drawn arrangement.

Having come so far you might now like to try your hand at a more ambitious kind of composition showing wild flowers in their natural surroundings. I think that you will soon find that it is advisable not to attempt complicated backgrounds; you will have greater success if backgrounds are kept as simple as possible. In fact it is a good idea to tailor the background to fit the flowers rather than the reverse.

Art is different from other subjects of study in many ways. In arithmetic there is a right and wrong answer; correct and incorrect procedure; whether or not your sum is right is not just a matter of opinion. But there is no neat correct formula for making a work of art. It would be stupid of me to try to tell you that this or that way of painting a picture is the *right* way. What I have done is to tell you what I have learnt painting my own pictures, and leave you to decide whether you wish to use any of the methods I have used.

As a flower artist I am commissioned to do many different kinds of work, from painting flowers to decorating pottery and

197

fabrics, to the execution of book illustration and advertisements, as well as painting pictures to hang on peoples' walls. Each job has its own special problems; each has to be tackled in a different way, but whatever the problem I always rely to a very great extent on the sketches and studies made directly from real plants and flowers, both in their natural setting and in my studio.

It is a fascinating study, the drawing of wild flowers, and I hope when you begin that you will get as much pleasure and enjoyment out of it as I do.

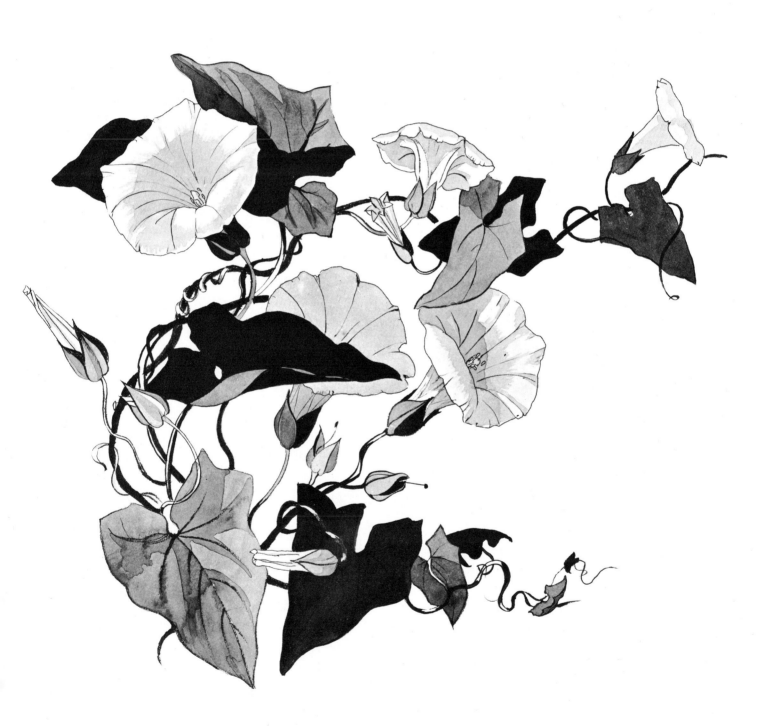

Trees
Colin Hayes

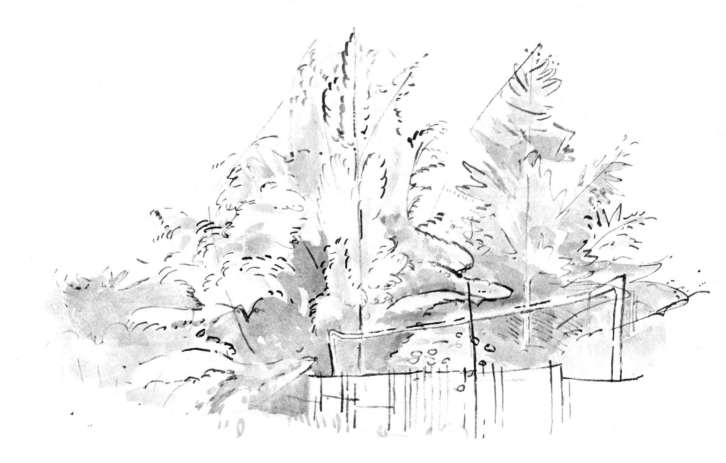

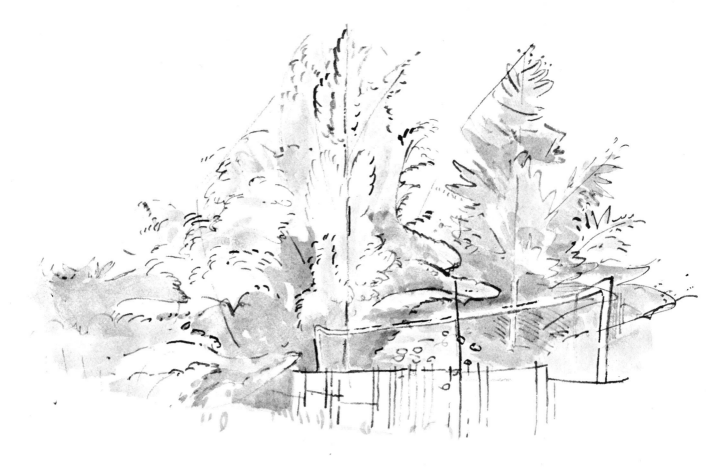

Trees look quite obviously different from figures, houses, animals or chairs. Anybody who sits down to draw one may well feel that there is some special way of doing it, for trees (they differ from each other enough, let alone from anything else) are pretty daunting objects at first sight. What are the special secrets?

I have to start by saying that the secrets of drawing trees are, in the main, the secrets of drawing. Indeed, I must ask the reader to bear with me in curbing, for a page or so, his enthusiasm for trees; I am really trying to save him time in the long run.

It is not much good, for instance, telling people to begin drawing trees by reducing them to cubes, cylinders and cones (as is often suggested) if they cannot draw cubes, cylinders and cones with any assurance. But the ability to represent such simple objects in depth is the departure point for drawing anything, and this means we must try to understand clearly the functions and powers of at least some of the marks that can go to make up a drawing.

When Constable or Rembrandt made their magic-looking representations of trees in pencil or pen-and-wash, 'magic' is what many people regard as the whole process, as if the means by which these drawings were brought about were mysterious and inscrutable. And yet the magical element in master drawings lies in their superior intelligence, authority and sensibility, and it is this last which defies ultimate analysis. The actual means are usually perfectly clear if we go to the rouble of sorting them out.

Now this is no place for a History of Drawing. It is enough to say that Constable, looking at an actual elm, had more marks meaning more things at his disposal than had a medieval illuminator drawing a flat conventionalized apple tree of Eden. As most readers will feel that Constable's idea of a tree's appearance is more like their own than that of the 12th century, it is worthwhile to wonder about some of the marks which go to make possible what we think of as representational drawing. I would like the reader to follow me in gathering a few basic devices to stock his draughtsman's equipment.

How to Start

The simplest form of drawing equipment is a line and its simplest form of use is the ideograph. Ideographs were used as a rudimentary form of writing, when all that was required was to convey a general idea. 'A line round an idea' that makes its point needs no elaboration. Look at a 1 inch to the mile Ordnance Map. You will find that it recognizes two kinds of trees, a kind of double-barbed arrow, or a clover-leaf.

The map does not mean that there is a tree looking like one of these shapes at such and such a point, or even that there is one tree. It merely tells you of the presence of trees, conifer-type and deciduous-type.

Nevertheless it is a sort of drawing, and worth mentioning because it shows in a rudimentary way how drawing is a language which has to be accepted and understood.

In order to represent an individual tree with some degree of realism, we must enlarge the vocabulary a little. With an inadequate vocabulary you will find yourself using a line to say what you know about trees instead of what you can see about them.

Some tribal societies do this intentionally, for symbolic purposes. They may know that a summer tree is covered with leaves (1), or that fish are covered with scales (2). But to them branches and backbones are more elemental properties of these objects. This is a perfectly reasonable attitude, but it is not quite what we need here.

However it does not to do despise symbols, because except by slavishly copying

(1)

(3)

(4)

(2)

every leaf in Nature, we must always symbolize to some extent when we draw a tree.

Symbols begin clearly to talk the language we want when they start overlapping (3). A tree in an Indian miniature might look something like this (4). The parts are flat and formalized but there is an intimation that depth exists.

But lines can be made to mean more than this. If we put a line round the observed shape of an actual tree as accurately as we can, we shall find that we now have what is in effect a silhouette of an object, not a symbol for one. (Though look at master drawings of trees and see how they seem to retain the feeling for symbolism, however remotely.)

A silhouette line is the first active step towards realism; it shows what your intentions are.

I shall call a line a 'contour' only when it is consciously used to describe a surface or plane seen edgeways on. Contour lines can transform themselves into exposed surfaces.

At this stage I am going to summarize these points, and add some more, by inventing a curious landscape.

Let us imagine that we are sitting with pencil and paper out of doors. In front of us are three objects, a box and a large beach ball both quite near us, and in the middle distance (so that it appears about the same size) a cone-shaped tree.

Diagram (5) shows the simplest thing we can do to describe the situation - which is to put an outline as accurately as possible round the outside of the objects and note where the horizon cuts them.

These are silhouettes. They do not tell us anything about depth or solidity.

We can help ourselves towards depth by moving our position until the objects overlap (6), as in our Indian miniature.

The objects are not yet solid, but there is the suggestion that one comes behind the other.

This suggestion is enhanced still more by allowing the front silhouette to break the line of the one behind it (7).

But how are the objects to be made solid with lines?

(5)

(6)

(7)

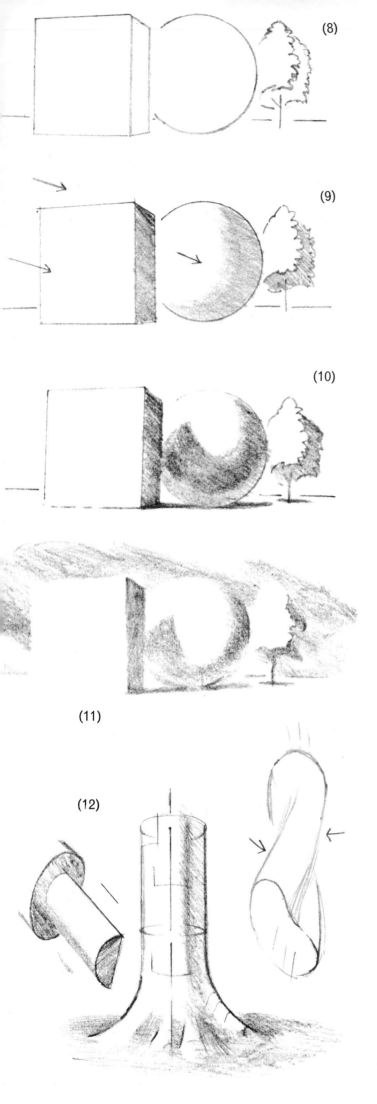

(8)

(9)

(10)

(11)

(12)

If we turn the box so that we can see another side (8) we can suggest that it has three dimensions; and we then see that the tree too has a front and a side. But we have done nothing to help the beach ball.

Now is the time to notice that the objects are illuminated (indeed they would be invisible if they were not). On the grayest of days solid objects disclose light and shade (9). With this we can give form to the beach ball and enhance that of the box and the tree.

We have now collected a number of devices - the silhouette, the overlap, the broken silhouette, and the shadow on one side of an object.

Now let us command a sunny day and we shall see that we have another sort of shadow, the *cast shadow* (10). This helps to explain the relative positions of cube and sphere and the fact that all the objects rise from the surface of the ground. You will see that some reflected light from the ground strikes back into the shadows. Before I can release you from this monotonous landscape I must introduce a storm cloud (11). Some of the outlines we have relied on so far are now suggested by the explanatory pattern of the shadows. It is important to notice that the background tone merges in places with the shadows on the objects.

Here are a few more 'devices'. It sometimes happens that 'sectional' lines, equators as it were, exist round objects like tree trunks, and these can be very useful in explaining their solidity (12). But they should be used with discretion; to invent them where they do not exist is a somewhat debased form of drawing.

A soft edge to a shape usually gives the feeling of a form gently curving out of view, where a sharp line corresponds to a sharp edge in nature.

Remember however that the insides of shadows soften everything - edges, lines and contrasts.

Simple Ideas of Structure and Growth

A knowledge of human anatomy can help the artist to draw the figure. A tree is a living functioning thing too, so that it is a good idea to know a little about its growth and working. But remember that many great artists have got on very well with a very limited scientific knowledge; some of them would say that it is possible to know too much about objects in a specialised way, so that you find yourself drawing with preconceived ideas instead of from observation.

A tree lives by attracting air and sunshine with its leaves. These combine with the substances drawn up from the ground through its roots, trunk and branches to provide food for further growth, and this act itself maintains the circulation of sap in summer. A tree is designed, therefore, to catch light and air through its leaves in the summer, and each leaf strives to present itself to the light. Because of this trees which appear from the outside to be solid with leaves are in fact comparatively hollow of leaves in their interiors. The trunk is, as it were, both a pillar and an artery, which diminishes in size and strength upwards, as its twin tasks lighten. Its roots serve both to draw in food and to provide an underground foundation for the tree. Trees grow bigger, as everyone knows; but their outer skins are not as elastic as ours. They crack, die, but remain as bark protecting the more delicate wood underneath.

This is all very elementary and well-known, and of course whole books far longer than this have been devoted to the scientific subject of tree growth and anatomy. That is the danger: let us stick to the simple things which will help us to begin, not hinder us.

We know, then, that trunks get thinner, and that leaves congregate usually towards the outside air and light. Are there any more 'visual' rules which can be relied on?

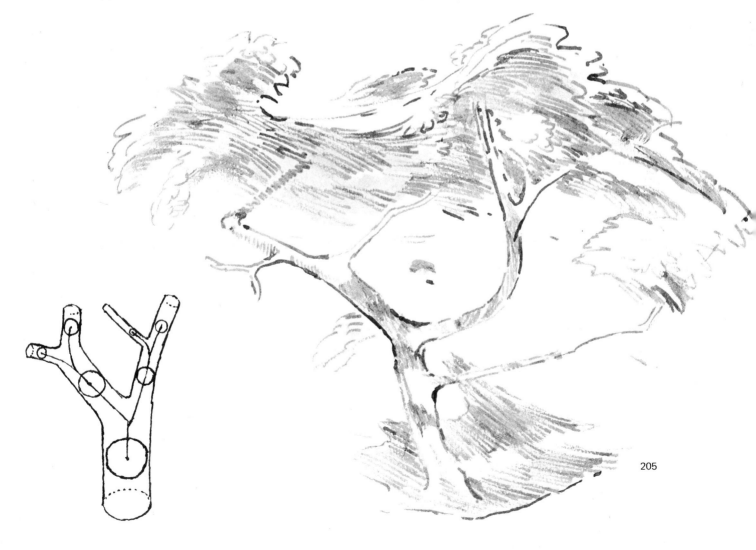

Trees vary so much from species to species, and from one example to another of the same species, indeed some are so prone to deformity, that I hesitate to use the word 'rule' about the following points in a strict sense.

This however is a 'working proposition' - the trunks of trees do not usually become thinner in an arbitrary way until they are finally dissipated into branches. The area of the cross-section of a trunk is reduced by the similar area of the branches which successively grow from it. As branches divide up they reduce themselves in the same way: this principle gives you a clue to estimating thickness of trunks and branches - particularly in winter trees.

Upward spiral growth is a common feature of plants, and not least of trees. It is more evident in some species than others. Among trees which commonly show a pronounced spiral twist (helical, properly speaking) are apples, pears, horse chestnuts and sycamores. As trunks tend to grow in this way, so do branches tend to spring from trunks rather in the way of the spokes on a spiral staircase.

Is there any sort of order to the intervals at which branches spring from trunks, and from each other? In some plant forms a natural proportion recurs time and again which the ancient Greeks called the 'Golden Section' and used in their architecture.

You will find trees in many Renaissance paintings being made to obey this interval, for reasons of design. Do not expect to find trees in Nature dividing up according to this neat law; they are too individualistic. Nevertheless some kinds of trees display a visible tendency towards the 'Golden Section', notably conifers.

With the devices and information we have gathered, it is time to face the problem of developing an actual tree drawing from a simplest beginning, stage by stage.

Developing a Tree Drawing Stage by Stage

How solid is a tree?

Most of the space occupied by a tree is clearly air. But it is best to begin by considering this space as a solid bulk with a top or point, sides, and underneath. This helps us to appreciate the tree form as a unit. We can knock holes and hollows into it later. Some trees are regular and compact, and so make this easy. Others send isolated branches and twigs out through the 'skin' of this solid.

How to begin a drawing depends on the subject, and what you want from it. There are no hard and fast rules, and while I have said 'consider this space as a solid', it is the mental process that matters. I do not mean that you should necessarily begin by constructing such a series of perspective boxes on the paper, but it will help you get into the habit of feeling their presence. The following page sets out a procedure of the sort that might be followed, in drawing an acacia.

Action

A draughtsman must discover that solid objects possess the quality of 'action', even though they are not in movement. A tree's action is that of upward growth, while its branches search outwards, resisting the force of gravity. It is a safe rule to look first always for the 'action' lines. These 'lines' are simply a searching on the paper for the tree's living design.

You will find that the trunks and branches of most trees dart up and out in alternating straights and curves. Look for the straight lines of action. (A drawing all curves is usually weak, as the tree would be.) Then search for the 'silhouette' round the 'action' in very broad terms. You will find that it too curves and straightens, and presents you with a few simple directions.

We have been discovering the 'feel' of the tree as a flat pattern on the paper. Now we may begin to think of its solid bulk and here I have likened the tree to a sort of beehive. I have of course thickened

the relevant lines to show what I am talking about: they can be kept quite light in the actual drawing and will take their place without having to be rubbed out. If you look at the foliage and compare it with this simplified conception you will find that some of the lines of leaves suggest where there are in effect 'sectional lines' round the tree. The tree hints at what the parallels of latitude and meridians of longitude on a globe make plain: seize on these hints. Remember another thing about globes. If you can see one pole inside the silhouette, you can't see the other. This is likely to be true of the tops and underneath of trees. The more you develop this idea the more the action line of the trunk will begin to take its place as an 'axis' through the middle of the mass.

Light and Shade

One of the things about the light and shade on a tree that often puzzles people to begin with is the fact that the whole tree usually looks dark against the sky. There may seem at first to be little difference between one side of a tree and the other. Only the 'holes' and the underside are obviously dark. Nevertheless except in a very flat gray light the difference is there to be found. Try comparing the 'tones' (or degrees of light to dark) with the ground rather than the sky, which you must mentally reduce in tonal value (as painters have to). Tilt your head and look at the tree sideways on. The unfamiliar view will reveal things you have not noticed.

First of all find which side of the tree

as a whole is the darker. If you have the light behind you, both sides will darken off as they turn away from the surface facing. You will notice this more clearly by looking at another tree in the distance, where the small scale simplifies these points. The underside is in shadow.

If you have some watercolours try on another piece of paper to wash in the general masses of shadows to see what sort of a flat pattern they make. Best of all try this on some very thin paper so that you can trace your washes over your line drawing. (If you make a brush study like this, to use and throw away, it will probably be worth keeping.) Refer this pattern to your tree drawing and you will find that it represents the shadows on the under-side of the fronts of the leaves: your sectional lines will tell you how the main shadows 'go'. Some of the shadow pattern will be where you can see right through to the inner surface of the tree's opposite side, and this is usually darker. Now we can look at what happens to the trunk, and how it enters shadow as it thrusts up into the tree. The action lines of the drawing emerge here and there as

branches.

Now that we have arrived at the main substance and structure and have given our drawing a sense of light, it is time to look once again at our tree's silhouette. Our original general silhouette is probably half obscured by now, but we must allow it to go on controlling the main shape, or the drawing will lose punch and character. However, we can see that the edge of the tree is made up of small 'actions' just as the whole tree is made up of large ones. Groups of leaves form a pattern of movement which continue across the drawing and form the edges of smaller overlapping shapes inside the drawing.

An important thing to notice is that once you have introduced the element of light you will rarely be able to put a line like a wire right round a shape. It will nearly always disappear into shadow or behind another line somewhere, and this is where the line breaks.

I have supplemented the drawing with a wash of tone, and put in the cast shadow of the tree to relate it to the ground. Simplify light and shade. The whitest

paper and the blackest indian ink will give you only a fraction of Nature's tonal range, and you must accept this fact. My advice is to choose four or five degrees of tone ('gray') from light to dark, and stick to them. The varied tones of Nature must be made to fall into one or other of your chosen categories.

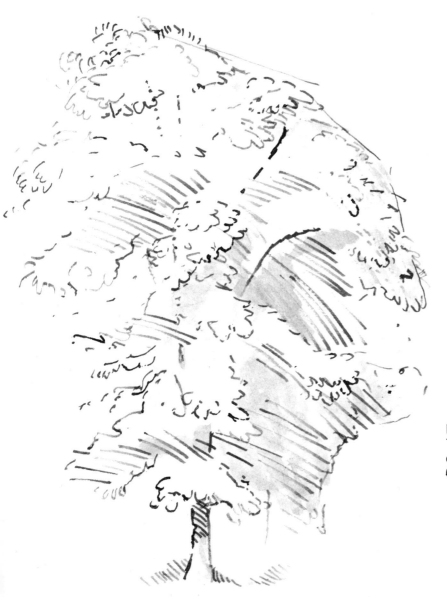

Reed pen and wash on cartridge. These simple tones unify the drawing and give it bigness. 6½ x 5 inches

Using Detail

How far should you take a drawing?

It is a good idea, when teaching yourself by practice, to take a drawing a little further than you easily can, for in this way you learn. Maintain your interest as long as you can. But stop the moment you have lost it; otherwise you will only kill the drawing.

Drawings usually founder on misplaced detail. Nobody can tell you finally what to put in a drawing and what to leave out; but you may be sure that details are at their most valuable when they are contributing to an explanation of the main form. These, too, are the details which most forcibly suggest other similar ones. Look at a Rembrandt landscape drawing carefully and you will be surprised at the extent to which it is composed of acutely selected and carefully drawn detail. You may expect to find such details, for instance, at moments where larger forms join together - trunks and branches. Certain details seem to help express the decorative character of a particular tree very clearly, but be wary of decoration for its own sake.

A particularly important detail, and the most commonly neglected, is the shape of a gap or 'window' through a tree, or between one tree and another.

There is a fascination in drawing individual leaves and twigs, as we shall see. Sit almost under a tree and a single leaf may be a powerful element in your drawing. You are certainly likely to draw a tree

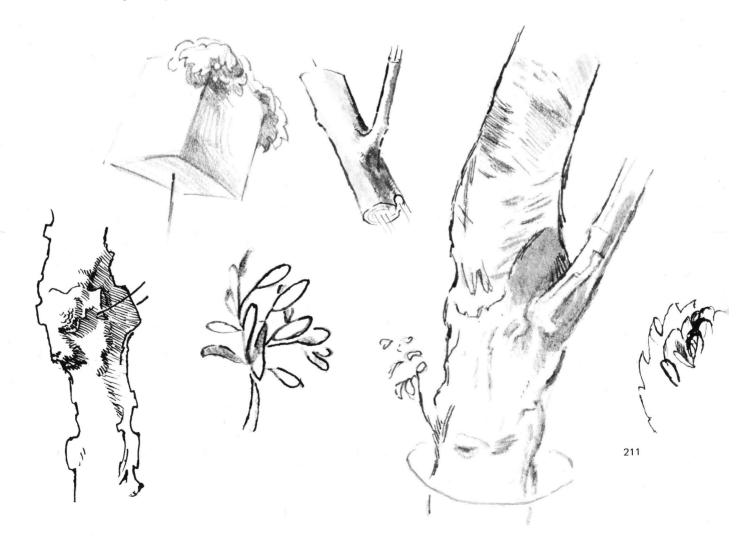

211

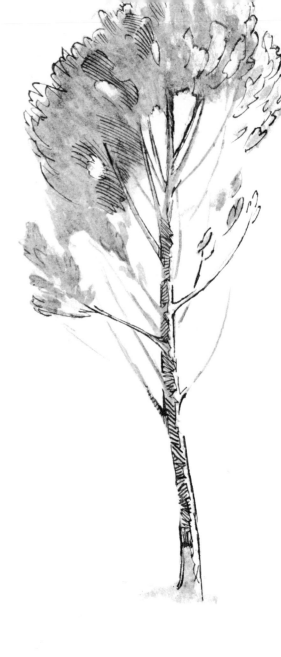

the better for knowing what shape its leaves are.

But there comes an optimum distance between you and the subject after which the single leaf is an act of self-deception; you cannot really see it, and you are either letting your observation slacken, or you are becoming a conscious symbolist.

Don't draw what you can't count - at least not if you are a realist. This is a piece of old advice, but I believe it marks the moment at which you must realize you are looking at groups of leaves, not single ones.

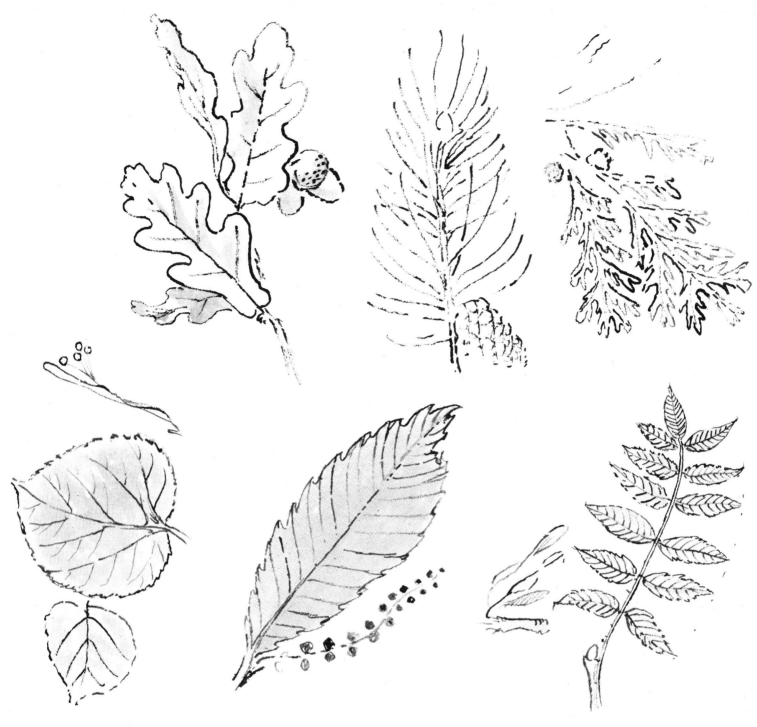

Leaves

It may be a mistake to draw leaves which you cannot count. Nevertheless the single leaf of a species sets the character of a group of those leaves, which in turn help to make up the character of the whole silhouette of the tree. This is why I introduce a few leaves, before I come on to the entire trees to which they belong.

An ash leaf is long and slender. Because it is really a series of leaflets making up one open leaf it is particularly decorative. There are usually about six pairs of leaflets, with an odd one at the end, to each whole leaf. They group into compact, heavy arabesque clusters. The twig is correspondingly strong to bear the weight.

A sweet chestnut leaf is a large individual, nine inches or so long with serrated teeth and catkin flowers hanging from its base in early summer. Its clumps of leaves, very compact and ornamental, give this tree in full leaf an exceptionally pattern-like texture.

The lime, by contrast, has a round smooth heart-like leaf and delicate slender twigs. The leaves characteristically overlap and combine into larger, but lighter

213

and more scattered, groups than on the sweet chestnut.

The common oak possesses the most familiar of leaves. They grow very thickly on the twig, often in tight, bunched groups, which are associated with the dark 'windows' between them.

Here is a quite different sort of leaf -

the Scotch pine. It is a conifer whose leaves last over two years. Their long thin needles splay out round the cones and go together to give the tree's spiky Gothic silhouette.

And finally the cypress whose fronded leaves make their tight, drooping, column up the straight trunk.

Silhouettes in Winter and Summer

This section I intend as a short 'Heraldry' of trees.

Learn to recognize, if you do not already, the way in which most trees signal their identity in summer and winter. Like heraldic devices on shields, which were, at least originally, meant to be recognizable from a distance, so trees are symbols of their own species. If you know what tree you are drawing you will not minimize its characteristics.

We have seen the leaves. Now let us look at five of these trees as a whole.

The Ash is both strong and graceful. Notice its straight bole and elegantly curving branches. The downward glide, ending in the consistently upward hook, is characteristic. Its twigs make a heavy network. Clothed in summer its leaf groups descend in small graceful canopies.

Ash

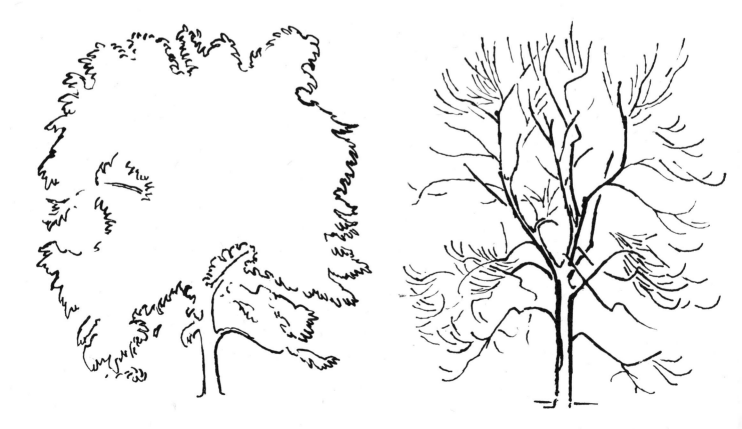

Lime

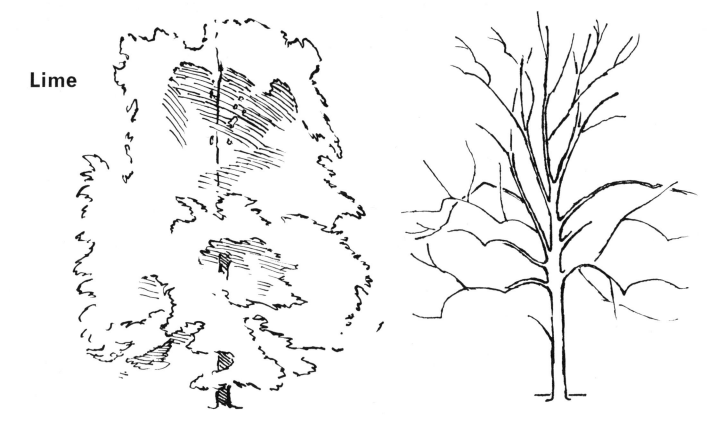

The winter Chestnut is not so gainly, its thick trunk often dispersing itself so abruptly near the summit that it seems out of proportion. Its branches grope out with elderly angularity like the oak; it is a somewhat formidable looking tree in winter. In summer its leaf groups combine in cumulus-like masses to transform its character.

The Lime by contrast is even more elegant and slender in appearance than the ash. But it can be very tall, and its trunk is often thicker than you may suppose at a glance. Typically, its lower branches fan out almost horizontally while its upper branches hold in towards the vertical axis of the trunk. In summer this structure is often indicated by great gaps in the foliage half-way up, giving a view of the inner vault below the roof.

Chestnut

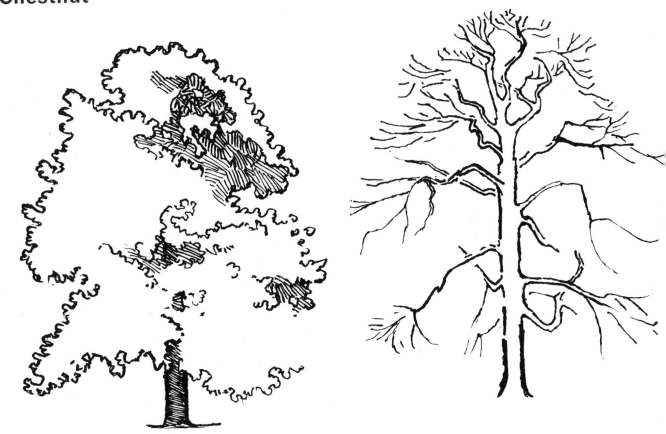

Plane

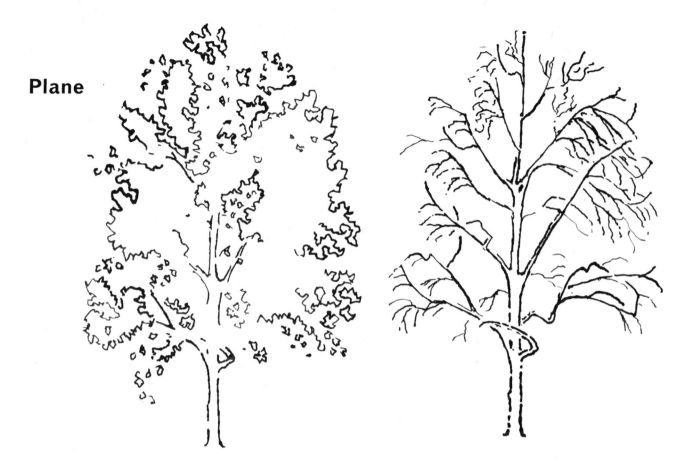

The resilient London Plane is among the happiest of urban decorations. While its scaling, flaky bark is its most familiar characteristic, its shape is also unmistakable. The straight, well proportioned bole separates into a kind of elegant disarray of slim branches and twigs. Its sparkling summer colour is an ideal foil to bricks and mortar.

The Oak in winter is the most formidably naked of trees. From its short wide bole, it sends its enormously heavy branches (almost trunks in themselves) writhing out and up in a series of tortured but powerful gestures. The tightly bunched twigs with which these branches terminate carry closely packed bunches of leaves in summer.

Oak

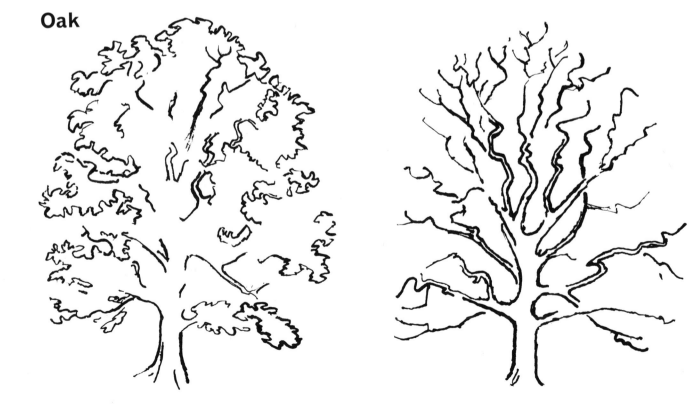

Trees in relation to each other

Few people want to learn how to draw trees so that they can produce endless isolated tree studies. Trees are gregarious and it is their varied association in the landscape that makes them really fascinating subject matter. Once we start looking at them from this point of view trees become at once more of a problem and more of an excitement.

What are some of the problems? Straight away there is a negative one. While we have necessarily been considering 'the tree' at close quarters, trees in the mass or in groups are, almost by definition, some distance away. Now distance makes things easier in some ways. The essential shapes present themselves much more readily, and we are spared a lot of confusing and demanding detail. But drawings which have merely avoided certain problems are likely to be boring - unless they have met others. In drawing woods and clumps of trees it is almost a problem in itself that we can get

away with doing very little and apparently achieve some rather clever looking results. But they may not be worth much!

Yet there are plenty of things to be considered. First of all there is the matter of tonal recession. Out of doors, tonal contrasts rapidly diminish into the distance, although it is not always immediately apparent. Varieties of circumstances may make distant patches of shadow look black when really they are a pale gray. One safeguard against 'digging a hole in the distance' is to remember what I said earlier about making a simple tonal arrangement and sticking to it. When you have decided what tones you are going to use you have made a start, but you have still to sort out all the different degrees of light and shade in front of you. I was once, as a student, given some advice which I have always found helpful. Do not, as seems the obvious thing, try to decide the tonal value of a shadow by comparing it with a light tone. Instead,

Reed pen and thinned ink, 5½ x 8 inches

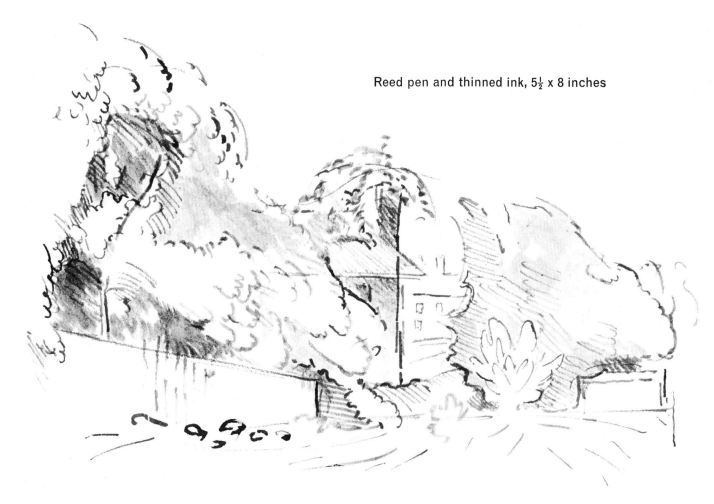

compare it with another and perhaps darker shadow. Compare, that is to say, darks with darks, half tones with half tones, and lights with lights. You will be able to sort out your tonal values more quickly and subtly, and you will not finish a wash drawing with the distressing discovery that a shadow in the left distance has got hopelessly out of gear with the right foreground.

Another problem with trees in mass is to find a coherent design. I have not embarked on this topic yet. Single trees which are carefully studied 'from the whole to the part' will go a long way to designing themselves: they are in their own way logical structures.

Groups of trees, woodlands and copses conform to some order, too, for they are dependent on the lie of the land; but the order is much more difficult to see. Yet it is still a matter of discovering the action. I have tried to show what I mean in some of these accompanying landscape drawings.

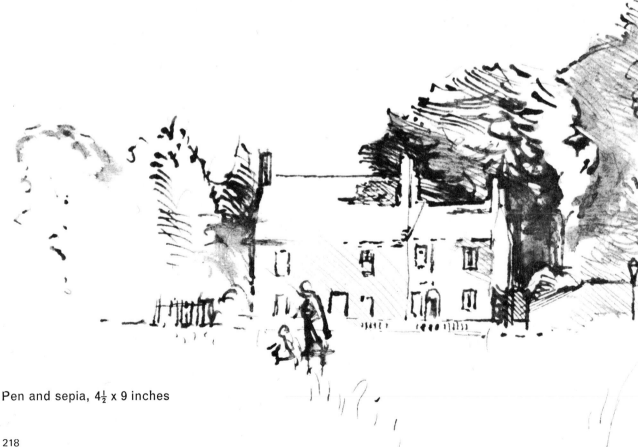

Pen and sepia, 4½ x 9 inches

218

3B pencil and watercolour, 4½ x 10 inches

The nature of the terrain, its flatnesses, ridges, undulations and hollows will always set up an underlying rhythm to a wooded landscape; and, as I have already mentioned, distance helps us here. But it must help in a positive way. In the distance you will see compactly presented the sorts of rhythm and massing which are difficult to sort out in the foreground. Nature has a way of hinting at a kind of formal geometry and it is necessary not to impose contrived designs on it, but rather to impose the order which it possesses already. But Nature will seldom do your selecting for you: it is for you to decide where to place your horizon, where the limits of your subject are to reach in the picture.

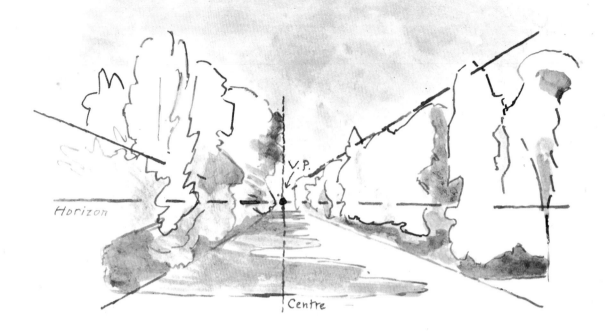

It will not have escaped notice that I have said nothing of Perspective methods as an aid to drawing. To this omission I must plead simple lack of space and refer the reader to the separate section on the subject.

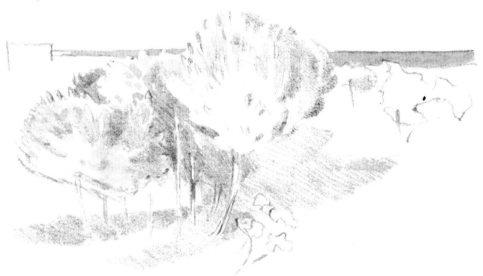

Pine trees, 3B pencil and wash, 4 x 7 inches

Ink and watercolour on cartridge, 5 x 7 inches

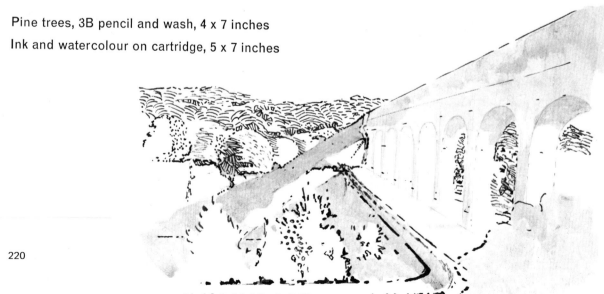

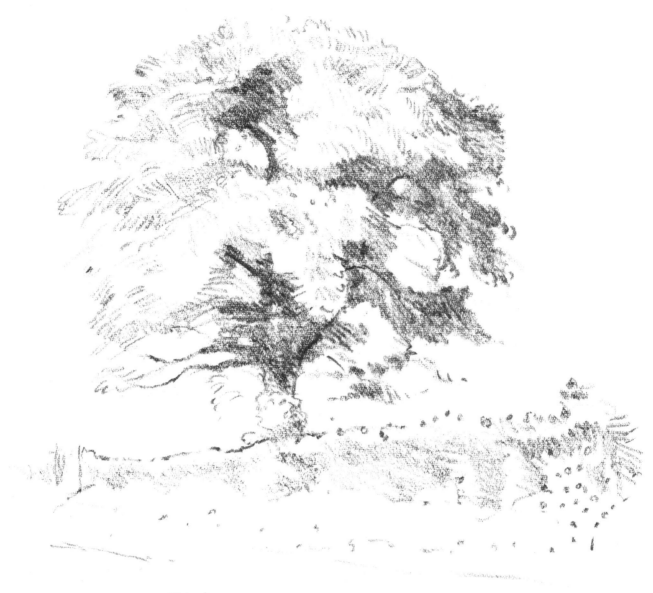

3B pencil on cartridge, 7 x 5½ inches

Banana plantation. Brush, reed pen and ink, with wash, 4 x 8½ inches

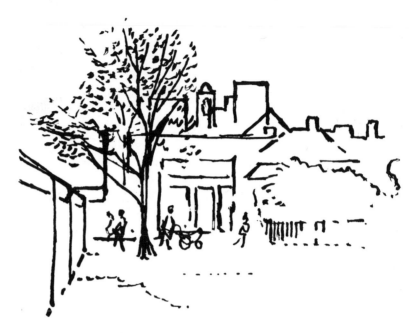

Reed pen and indian ink, $4\frac{1}{2}$ x $5\frac{1}{2}$ inches

Olive groves near Granada. Reed pen and ink, 4 x 8 inches

Pen, watercolour and coloured inks, 8 x 11 inches

Summing Up

A section which has no further pretensions than to introduce some of the basic problems of drawing trees must inevitably leave out far more than it contains. But drawing is a matter of 'first things first'; if I have named and illustrated only a few specific trees, I hope I have put the reader in the way of learning about many more for himself. It is true that I have mentioned neither the locust nor the monkey puzzle; but the principles of drawing these trees, so different from each other, are the same as those of drawing an oak (so different from either). It is important to stress that, though your attitude to drawing may remain consistent through the rendering of many varieties of tree, there is no reason why this consistency should not express the utmost contrast of character

between each kind. Contrast of character is something that the artist can only acquire a feeling for by practice: he will achieve this more quickly by the habitual practice of observing contrast. If you are drawing an elm and cannot see what makes it so peculiarly elm-like, turn your back on it for a few minutes and make a rapid drawing of some other tree if you can see one, a beech or a walnut. Turn back to your elm and you will have a few moments when its characteristic proportions, movements and groupings of foliage announce themselves with startling clarity. These are moments to seize on in drawing; get down what is fresh in your mind, and no matter if the results are a little crude or messy, they will have the force of conviction.

Remember that trees do not grow out of the air against blank white backdrops, though it is often made to seem so in drawings of them. It is not necessarily enough to scribble 'study' at the bottom of your paper and suppose that this absolves you from looking beyond the silhouette of your ash or your cedar. If you expect your tree to look 'alive' you are more likely to succeed if you give it somewhere to live, and few drawings are harmed by at least some indication of the ground - and background - of the subject.

I have written with a view to helping those readers whose interest in drawing is in the broad sense representational, and the suggestions I have made are directed towards the graphic explaining of actual visual experience. I would like to end by saying that of course this is only one aspect of drawing, and a comparatively recent one at that, where 'Nature' is concerned. Some maintain it has already had its day and to those whose object is flat decoration most of what I have said may seem irrelevant. But it may be that the artist who aspires to embellish wallpapers and fabrics with leaf and tree motifs will find the drawing of these curious things before nature a necessary basis of design. He may envy Renaissance Europe and the old Orientals their grand inherited traditions, but their pattern-books, alas, have been thumbed out of existence long since.

Animals

Maurice Wilson

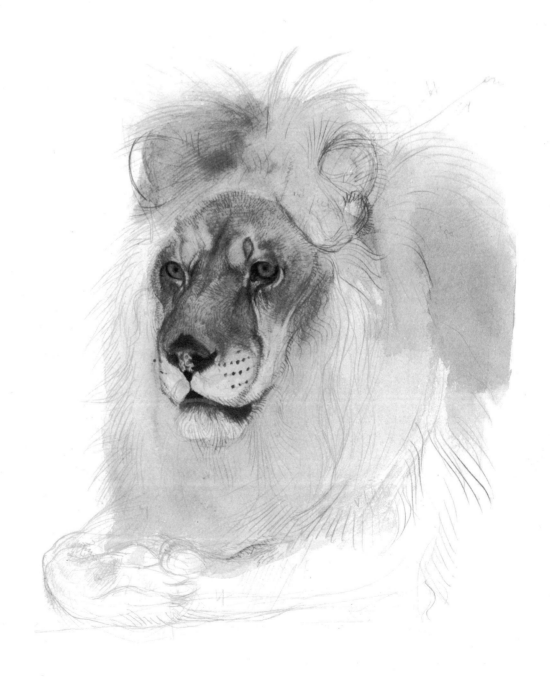

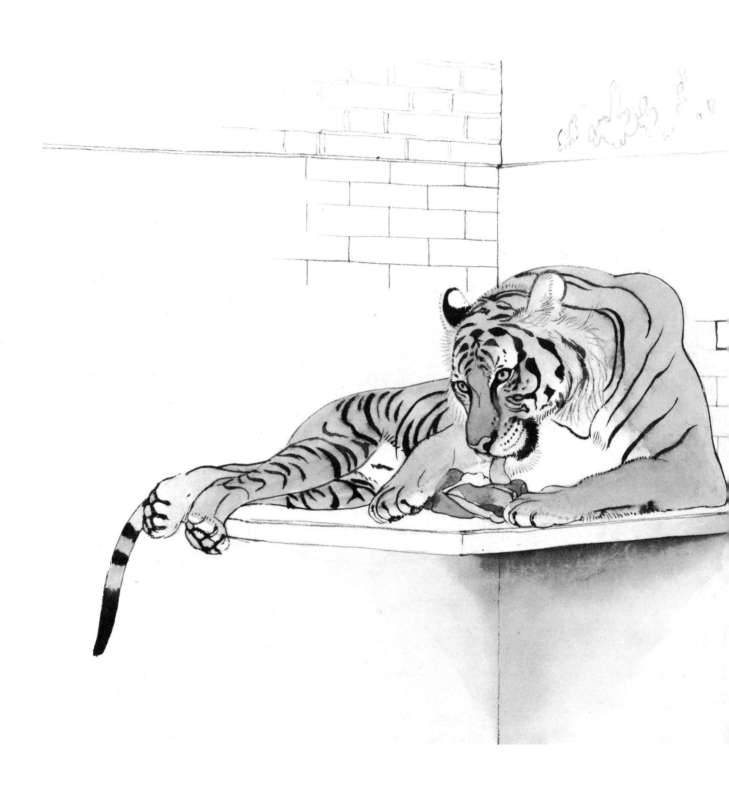

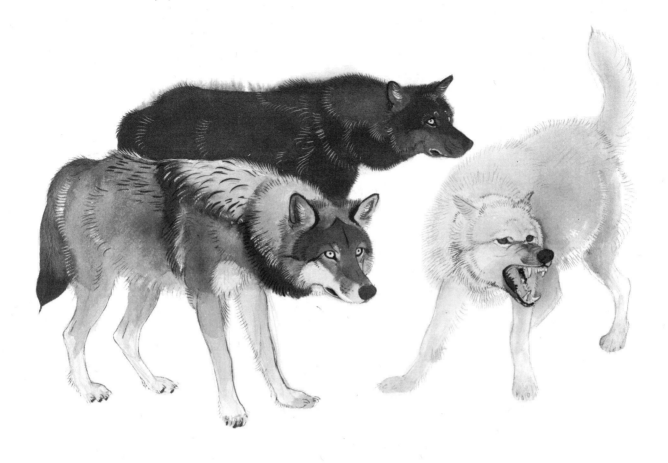

Animal Drawing

Though we have decided to divide drawing into categories according to the subject - animal drawing, portrait drawing, ship drawing and so on - in fact there is only drawing. The good draughtsman can draw anything he sees before him. However, we may have special interests, and for practical purposes special understanding of the subject is helpful. Especially when what is required is not only the appearance of the subject but some special point of construction and action of an elusive or intractable subject which we need to watch and study before we actually begin to draw.

In Europe in the past the portrayal of the lower animals has been greatly neglected. This must have been from lack of interest rather than from lack of ability, for very great artists who have shown by their consummate draughtsmanship the hu-

man figure have merely dabbed in the animals most perfunctorily, obviously not bothering to observe their forms.

In this book we will concern ourselves only with the higher backboned animals, the mammals other than ourselves, and with reptiles. For drawing these, as with anything else, the first essential is to look at them and to draw and draw and draw, perceiving the solid forms, understanding the principles of their construction and using lines as the boundaries of these forms.

Drawing is not mere map-making of the scene before us, nor can we expect absolute stillness.

Particularly testing are those models who appear to keep quite still but gradually change position. Such models are ruin to those who merely draw what is before them at a particular moment.

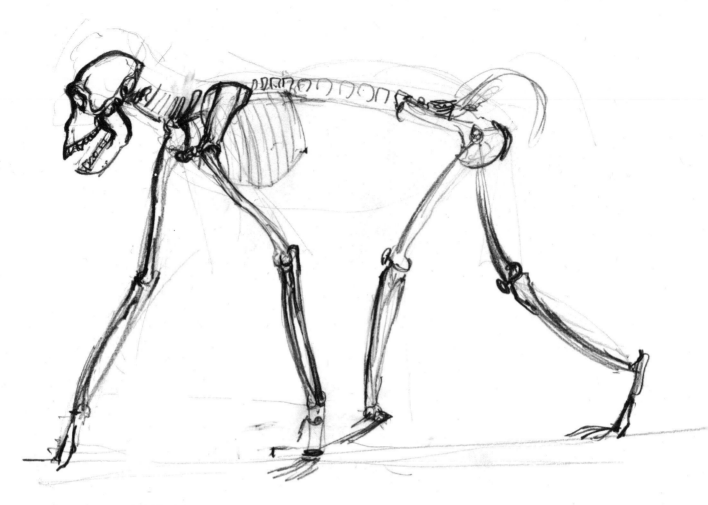

Pig-tailed Monkey.

Simple Anatomy

An understanding of the basic principles of anatomy is important particularly when dealing with animals in action. All the vertebrates have much in common, and the mammals a great deal indeed. Most of the differences are of proportion, hairiness and colour rather than of construction.

A mammal may be considered as being composed of several sections. A firm head with a movable jaw, a flexible neck, then the more rigid dorsal vertebrae each with a pair of ribs jointed on, the whole forming a rather inflexible rounded box - the thorax. Next comes the flexible lumbar section where most bodily bending and twisting takes place and where the organs of digestion and excretion are. A relatively soft and stretchy part, the only part, in fact, which can shrink and fill out from time to time. After this comes the completely rigid pelvis, and finally the tail which varies from our own completely enclosed coccyx to the long grasping organ of some of the climbing animals.

To the thorax are attached the fore-limbs which should be seen as beginning not at the shoulder joint but at the inner end of the shoulderblades, and, where they are present, the collar bones. Except at the inner ends of the collar bones no part of the forelimbs is jointed directly to the central skeleton.

On the other hand the hindlimbs are jointed directly to the pelvis by a strong, deep ball-and-socket joint.

Study the skeleton of the pig-tailed monkey in the drawing above; it has all the basic mammalian forms well developed as well as a clearly recognizable likeness to mankind.

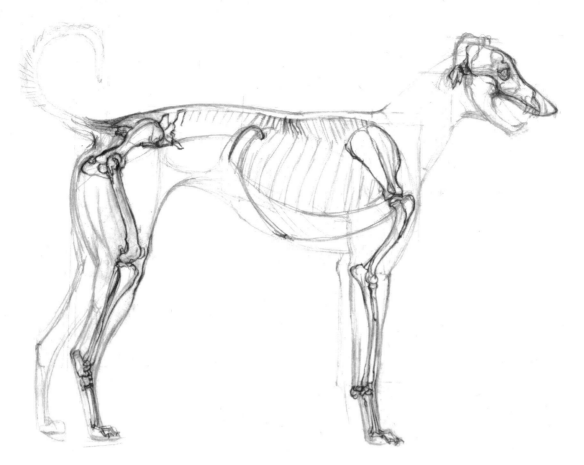

In fitting a skeleton to a complete animal never forget that the skeleton must fit the whole animal, never the other way round. The flesh and skin does not form a kind of coastline any old distance from the bone, but has a different relationship to bone in different parts. Over various bony knobs and ridges there is only the thickness of skin, sometimes with a little fat. In other parts there is the thickness of muscle and other organs. A little prodding on oneself or an agreeable dog will demonstrate this. Typical places with only the thickness of skin are the ridge of the nose; the cheek arches; the collar bones; a line from the elbow to the wrist; from the kneecap down the shin to the ankle, and so on. These are the places where on a thin person there is a projection; on a fat one a dimple or depression. Because skeletons are the durable part of our bodies, like sea shells, we are apt to regard them as the fundamental part, whereas this is not so: the life is in the

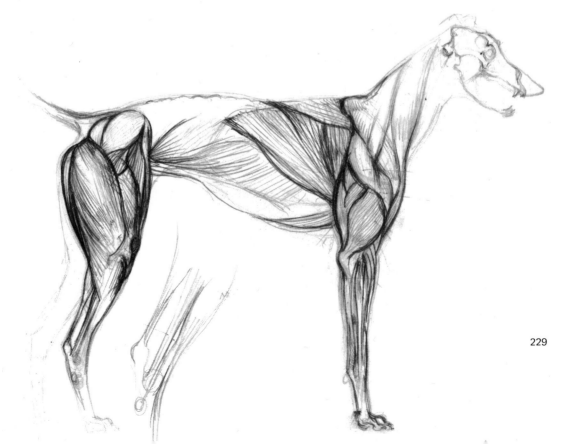

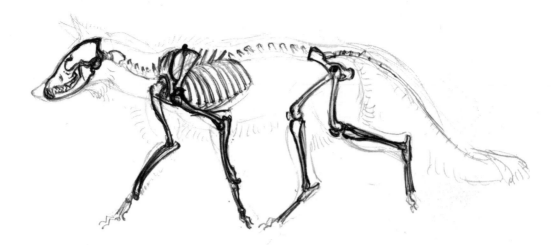

soft parts. There are many waterborne animals almost without any hard parts.

Bones provide framework and support; all movable parts are worked by muscles, all of which exert their power only by shortening. They also thicken, but this is only incidental to the shortening. They are attached to the bones by tendons which though flexible are not elastic.

The forelimbs of mammals consist of a flat shoulderblade - some animals with strong freely moving forelimbs also have a collar bone, the outer ends of which form the shoulder socket; the upper arm bone; and then the forearm, which consists of two separate and parallel bones, allowing the hand to swivel about in some animals, but which in others are welded together to bear weight.

The hand parts have been modified, sometimes drastically, to meet special need. Fast running but rather inflexible animals like deer have only two fingers, and the wrist is known as the knee.

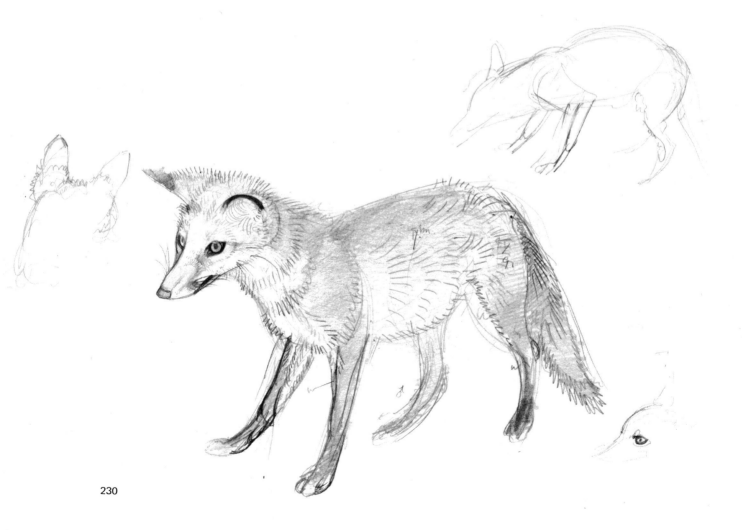

230

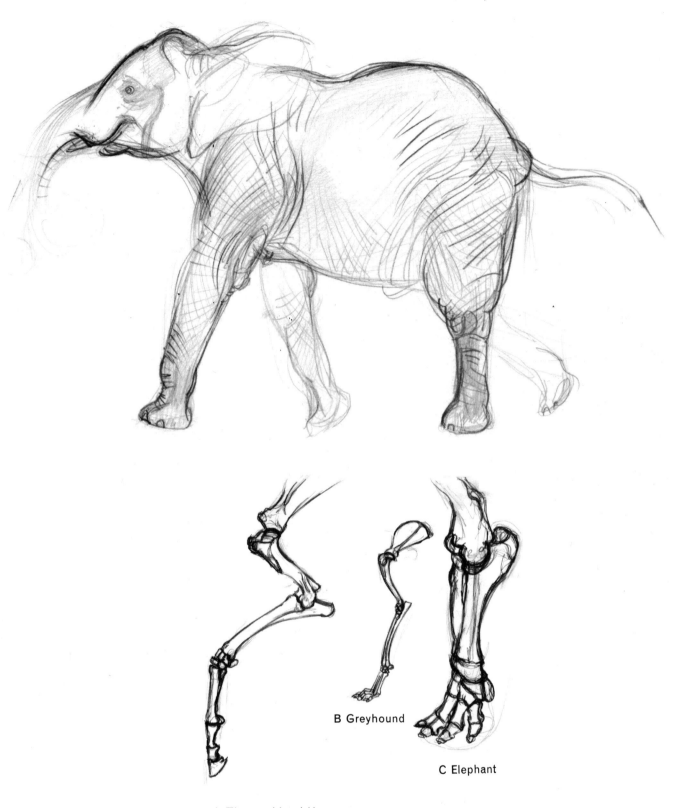

B Greyhound

C Elephant

A Thoroughbred Horse

The hindlimb is basically similar, but there is a distinct heel, known as the hock in quadrupeds. The upper limb bone is jointed directly to the central skeleton and only pivots from there. A slight extra fore-and-aft movement is given to the hind limbs by a side-to-side movement of the pelvis, and in galloping there is also a distinct up-and-down pelvic movement which considerably increases the length of the stride.

Quadrupeds such as horses and cattle have necks which lengthen as they lower their heads, due to the vertebral column being diagonally placed within the neck.

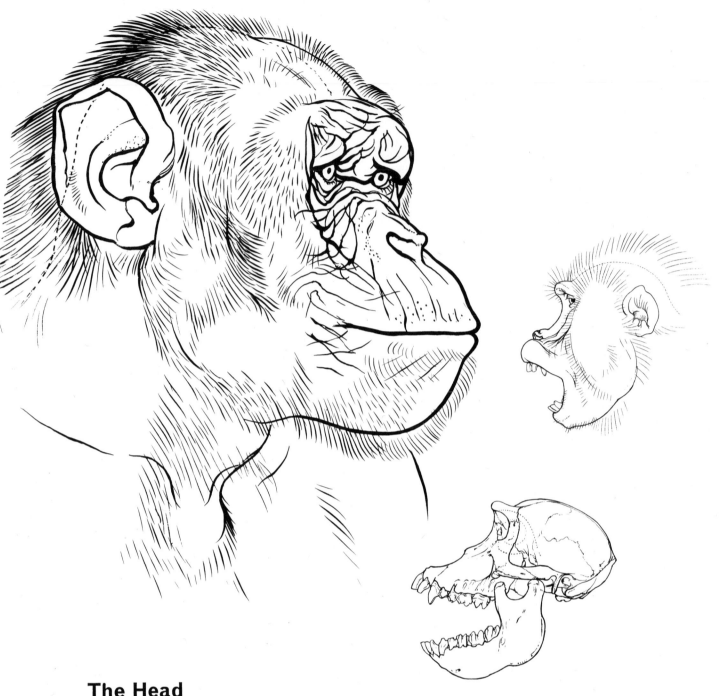

The Head

The bony structure of the mammal's skull
is rigid, formed of many bones welded to-
gether. For convenience it may be divided
into the cranium or brainbox, the upper
face with the upper jaw, and below this
the movable lower jaw, the joint of which
is just before and slightly below the ear-
hole. In many animals, particularly car-
nivores, the jaw simply swings up and
down, pivoting on this joint. In many
others, including ourselves, it actually
pivots from a spot lower down so that the
joint dislocates, coming forward as the

jaw opens. It does not go back as far as
one might expect. We can see and feel
this on ourselves by placing a finger on
the knobbly part just in front of the ear:
the knob comes forward appreciably as
the jaw is opened.

Though in fact heads are rarely quite
symmetrical, nevertheless for purposes of
drawing we may assume that they are and
apply to the head the ordinary rules of
perspective.

The eye should be regarded as a nearly
globular form swivelling about in a socket,

the framework of which is entirely or partially bony. Therefore what we see on the surface should not be considered as a mere flattish mark.

If it is not properly drawn no amount of clever tricks with highlights and so on will put it right. The eye itself is, of course, incapable of any expression whatsoever; expression derives from the surrounding parts such as the eyelids.

Animals' eye openings are rounder than ours, but not always as round as they appear. This is because the 'whites' of many animals' eyes, notably apes and monkeys, are darker than the iris, thus making the eye look bigger and rounder than it is. This is particularly noticeable in the gorilla, which has a blackish face, dark brown irises and almost black 'whites' circling the iris, although the black merges

into white further out. Sometimes this dark part is so narrow that it gives the effect of a dark ring round the iris.

In many primates a fold of skin obscures the upper eyelids: this fold may be seen on the chimpanzee on opposite page.

The projecting outer ears of mammals are peculiar to them. They vary from the little thing on a sea lion to the elaborate movable organs of the bats which may be furled almost to disappear. Most pointed-eared animals can direct them forwards, sideways or backwards, according to which way they are listening and in response to emotion; such ears are generally far more sensitive than the higher primates'.

Although the main part of the ear moves about, the ball-like formation close to the skull remains always in exactly the same place.

Drawing Hair

With the exception of the whales all normal mammals have more or less hairy skins. This hair may vary from a fine dense fur, very protective against cold, to the long, open, coarse hair of animals in hot countries. Extra coarse hairs with nervous equipment at the roots grow near the mouths of many lower animals.

Hair grows in particular directions on different parts of the animal. In general it tends to grow in a backward, downward direction, with an upward inclination on

the back of the forearm. There are various whorls, radiations and convergences elsewhere, which should be observed carefully for there are many individual variations.

Long hairs may be indicated by lines with brushes of size 00 or 0, according to scale of work, taste and roughness of paper. On rough paper size 00 might be too fine unless each brush stroke be slow. These lines need to be drawn carefully but firmly and cleanly, following the direction of the hairs of the subject. This is very important. There should be no hatching or anything which could be taken for badly drawn hair.

Soft fine fur may be painted by damping the paper and then putting on the paint, not too dark, in one go. Blot where it is a little too runny. Do not have the paint too wet or it will spread out of control over all the damp part of the paper, which when once it dries will leave a sharp edge difficult to eradicate.

When a not quite so soft edge is needed, put in the paint and then wet the paper afterwards. If one side of the wash is to be sharp-edged and the other soft, wet only the side to be graduated. If waterproof Indian ink is to be used the procedure is the same but control is more difficult. It is a good idea to do all the preliminary sharp lines in waterproof Indian ink, adding the washes in water colour afterwards.

On many animals there are lighter outer hairs on a darker ground. These can only be put in with opaque or semi-opaque col-

our. Those who believe in using only semi-translucent washes of pure water-colour can only give a general impression, though perhaps a good one. But so much consists of clean light or white marks on a dark ground that such abstention is rarely justified. What are we to do about white whiskers often so obvious and expressive?

In the apes the upwards direction of the

hairs on the forearm is very pronounced. It may be seen at its extreme on the young orang-utan on page 235. It is not certain why this should be so. One explanation is that they hold their arms above their heads in rain, but a recent observer who watched them closely in Africa for months never saw them do it once. They just got wet. The chimpanzee below and the old goat above were painted largely in line with Indian ink and a fine brush. The graduated tones were obtained by wetting the paper and dropping in the water colour, blotting up quickly with a lightly squeezed out brush wherever the water colour spread too far.

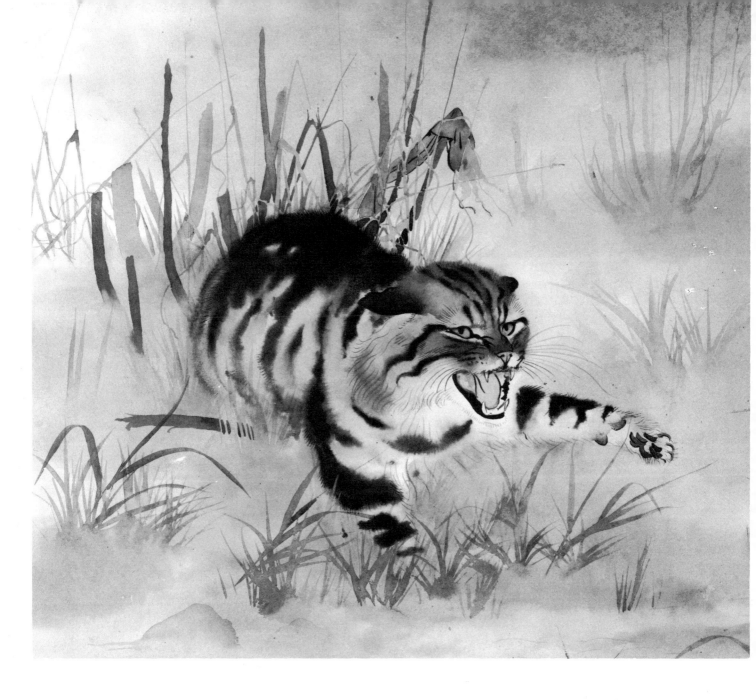

Backgrounds

We may approach the painting of an animal, or, for that matter, anything else, as the study of the creature itself, by itself, or in its natural environment. While we may properly portray a captive animal in its cage or enclosure, to show the same animal in the wild might be very unsound, for captive animals, especially certain kinds, are commonly much slacker, though not necessarily more unhealthy physically, than wild ones. We might as well draw an athletic performance, say a marathon race, using as a model a flabby man who has never walked, much less run, beyond the nearest bus stop.

Generally one should make studies, even if only the quickest notes, of the animal in its environment. Only rarely can one invent a grouping or a setting and succeed in making things look natural. Careful studies of details on the actual site are necessary. Put in only what one knows to belong if it is to be a naturalistic portrayal.

237

Here the graduated tones were obtained by wetting
the paper and dropping in the water colour, blot-
ting up quickly wherever the colour spread too far

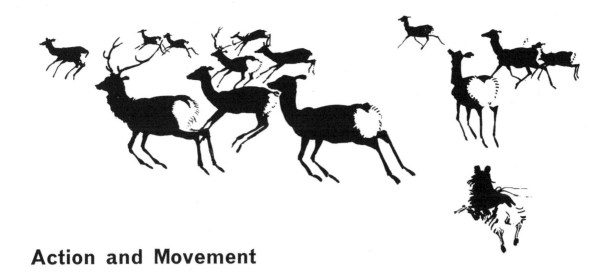

Action and Movement

The movements of an animal are very exactly ordained. In walking and running there is a set order of positions, varying somewhat with different animals and groups of animals. These have been incomparably well shown and described by Professor Mugbridge in his books of photographs in series of the movement of animals. These should be carefully studied but not slavishly copied, for not all the positions actually assumed really suggest movement; many are far too fleeting to be perceived.

It is the uncomprehending copying of these and other photographs of animals in action which causes the absurdities of

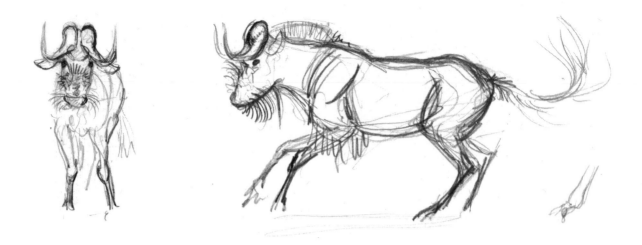

so many of the popular horse paintings which though photographically correct are unsound visually. As wrong visually as the rocking horse position of the old sporting prints the artists so decry.

In walking and trotting it is incorrect to think that legs simply go to and fro alternately, though sometimes old fat dogs do walk with both legs of the same side going to and fro together, slightly dragging the feet as they go.

Though the primary guide to drawing animals in movement must be observation of the live animals, it is as well not to depart too far from the photographic positions.

Photographic prints should be cut from publications and carefully filed and studied: they will prove to be an invaluable reminder of details.

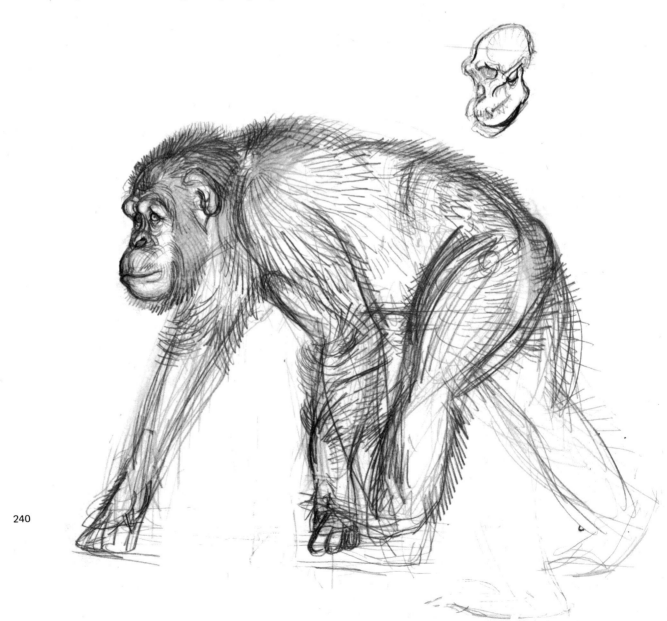

The primitive foot is placed more or less flat on the ground, but for purposes of speed, with some sacrifice of nimbleness, many animals have risen more and more upon their finger tips, the feet (or hands) becoming modified to suit such a position.

Lemurs and all the American monkeys walk upon the flat palms of their hands. The Old World monkeys largely walk upon the flats of their fingers, the palms of their hands being vertical, in line with the forearm, although when climbing they grasp the branches ordinarily.

Old or Zoo specimens often walk with their palms flat, but this is the result of captivity and can be compared with our fallen arches.

Chimpanzees and gorillas walk upon their knuckles, thus achieving greater length of forelimbs without sacrificing the grasping ability of the hand.

Elephants have a gait peculiar to themselves: the amble, or fast running walk, said to be fast enough to put a human runner in danger.

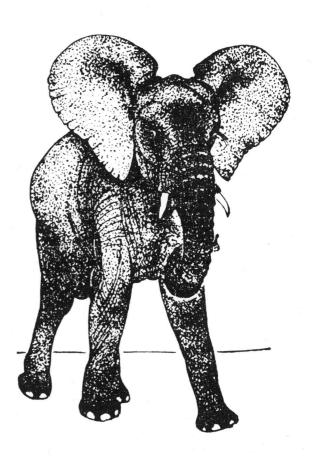

A drawing in brush and ink for newspaper reproduction made from the pencil drawing below

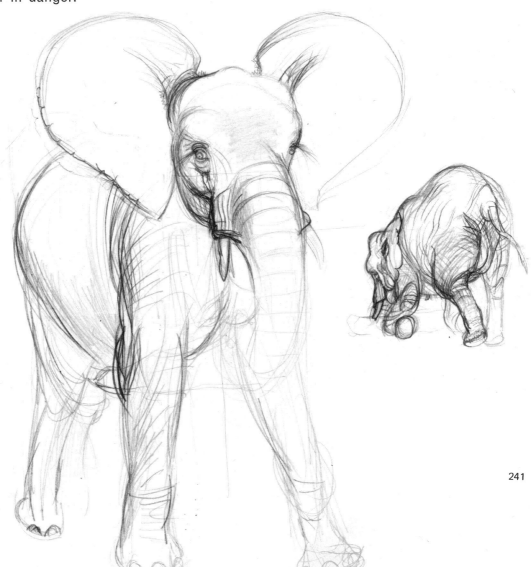

241

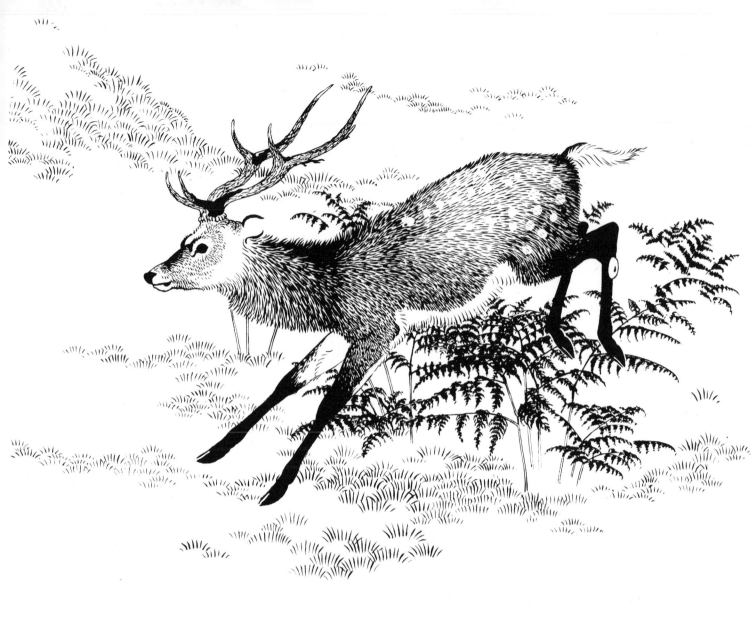

Materials

Experiment with as many different materials as you can find, with thin and thick brushes, different kinds of paper, pen nibs and pencils. The illustrations to this section have been done on a wide variety of papers and in many different mediums. The drawing of the rhinoceros, for instance, opposite, was made for what is known as line reproduction, for which *all* marks on the paper must appear as full-strength, sharp-edged marks, or not at all. Pictures with graduations and tones can only be reproduced by photographing them through a screen. This resolves the tones into little dots of varying size - they may be seen easily in newspaper photographs.

The rhinoceros was first drawn in lightly in pencil, then inked, and lastly the white parts were added in opaque white. If any further work is required on top of the white areas of paint, black water colour should be used, and put on cleanly: If it is worked about it will smear.

A graduated tonal effect may be obtained by the use of a black waxy crayon, in addition to the ink, on slightly rough paper such as Whatman not (or cold) pressed 75-pound hand-made paper. But never try to clean it up with an india-rubber: it should not be rubbed at all.

When drawing in line be careful not to confuse clear sharp lines with accuracy, for this is often done. A clear downright statement in pictures, as in words, is often mistaken for precision and truth; the most badly observed rubbish, if sharply and minutely drawn, is all too often acclaimed as dead right.

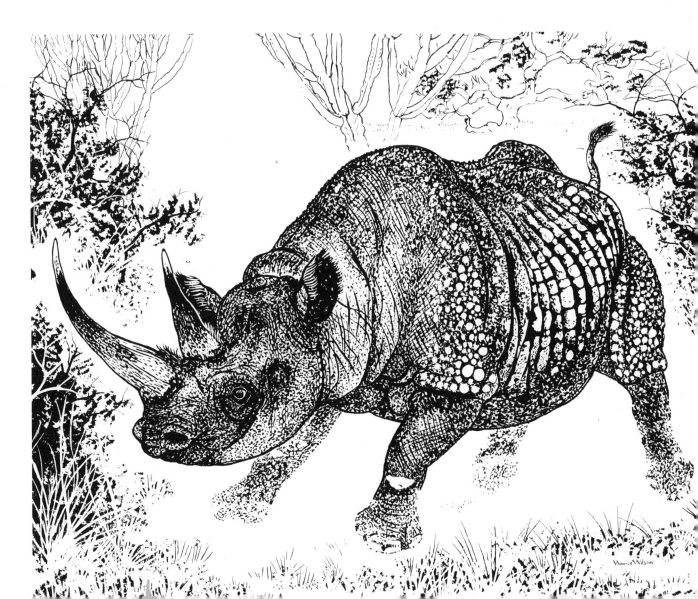

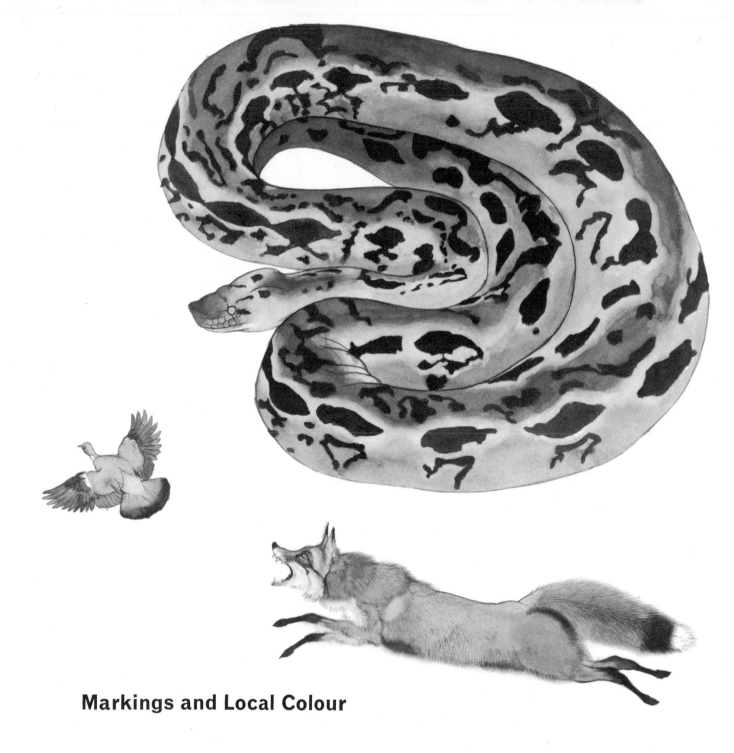

Markings and Local Colour

Unlike birds and reptiles, a positive bright colour is rare in mammals. Monkeys provide most, if not all, of the few exceptions, the red nose and bluish cheeks of the mandrill, the bright red faces of healthy Japanese and other stump-tailed Macaques, among others. But the range of subtler colours and tones is tremendous: the rich crimson chestnut of the Malabar squirrel, the yellow-toned coat of the tiger which is not clear yellow but yellow with much grey and brown in it, are only two instances.

These colours cannot be made in one wash, for the effect of one colour partially showing through another is often quite different from that obtained by mixing the two colours and putting them on in one go. Pale pinky flesh colour often shows through a darker pigment in the outer layer of skin, or simply dirt.

Even so strongly marked an animal as the tiger is not patterned by simple black stripes: there are many soft edged parts, especially, in the lower parts of the body. The face, too, is surprisingly brown. You

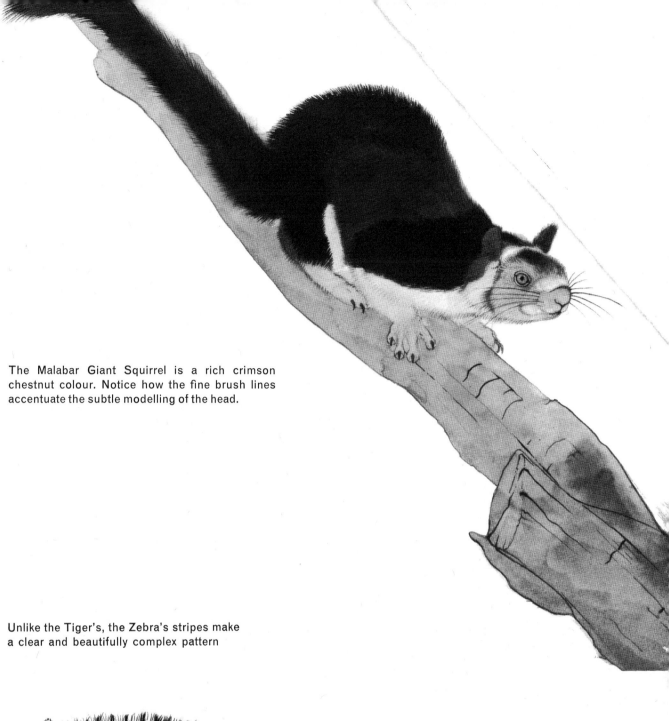

The Malabar Giant Squirrel is a rich crimson
chestnut colour. Notice how the fine brush lines
accentuate the subtle modelling of the head.

Unlike the Tiger's, the Zebra's stripes make
a clear and beautifully complex pattern

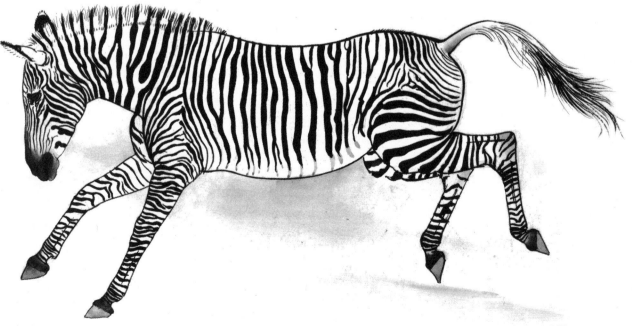

can hardly spend too much time looking and observing.

Examine and enjoy other artists' paintings and drawings of animals: the remote cave paintings, the superlative Bushman rock paintings of Africa, the glorious Dürer animal drawings, particularly the famous hare. Search too for reproductions of the innumerable superb Japanese and Chinese animal paintings, for they are among the most vital and beautiful work that has ever been done.

Many reptiles, like the lizard above, are vividly patterned, with colours, knobs fringes, spikes and other enrichments which make them scarcely credible. Although the little ones are inclined to rush about jerkily, they do keep very still indeed for considerable periods, thus simplifying some of the problems of drawing them, and only move off down a hole when one has nearly finished.

This is another picture of Japanese Deer. Here the soft fur has been painted by damping the paper and then putting on the paint, blotting it up where it is a little too runny. A line drawing of the same deer appears on page 242. Notice how the markings have been treated in each drawing.

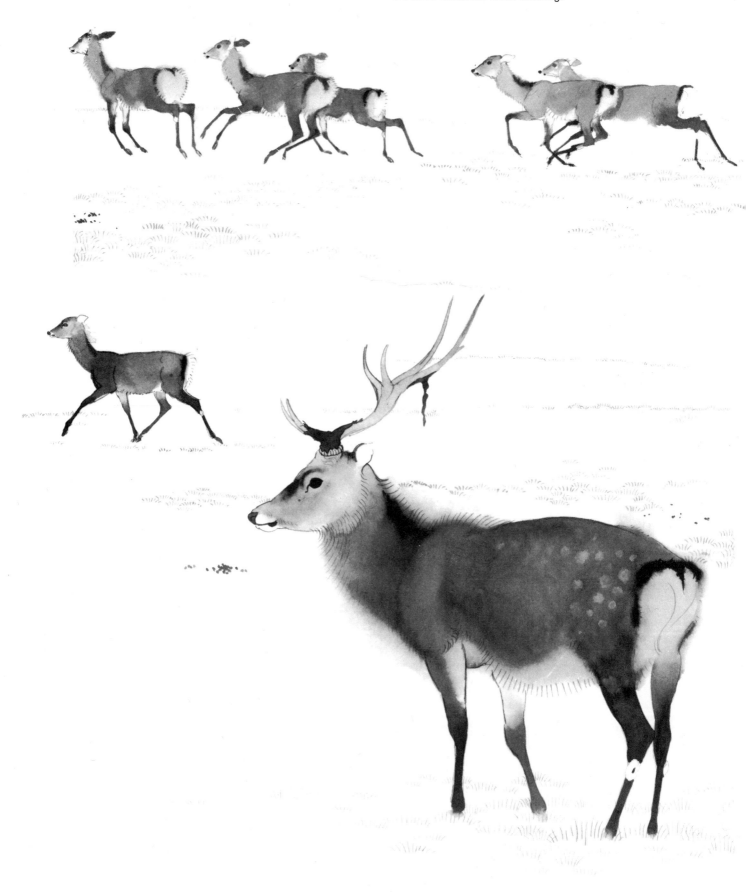

Tasmanian Devil

Alpine Marmot

Crab-eating Monkey

You can hardly spend too much time looking and observing. Try to see every subject as an individual. These drawings were made on handmade Whatman paper with an HB pencil and are almost twice the size as they appear here

248

Summing Up

There is little one can say to conclude but to emphasize the necessity of constant study. See every subject as an individual. There is no such thing as *the* tiger or *the* chimpanzee, any more than there is *the* man. In Natural History there is what is called the type specimen whose principle qualification to rate as such is the earliness of its description, and merely a description in words at that.

It might be, and often is, an unrepresentative specimen of the bulk of its kind. This is all very well as a method of classification, but we should never forget that classification is not as exact as some would have us believe. Many animals can be defined obviously and indisputably, like lions and tigers. But there are too many animals which merge inconveniently and imperceptibly with other kinds. To classify them is like trying to contain a stream within wire netting: one has only to stand before an aquarium tank studying a few mackerel for a little while to know them apart by their faces and expression.

Do not take absolutely for granted the views of accepted authorities: their views, though usually correct and valuable, are commonly limited. Never forget that the

most ignorant of shrimps shows more about shrimp behaviour and shrimp appearance than the best authority; it is common for scientific people to spend hours wading though books to learn what something *should* look like even when the actual creature is to hand.

Nevertheless knowledgeable advice and criticism from several people who really know what they are talking about is of enormous value. It is surprising what appalling gaffes one can make even after examining a creature for hours. And in drawing a wild animal in its natural setting considerable knowledge is needed.

Finally one should never forget that unless one is on the spot and sees the actual creature, no matter how sound the work is, or how imaginative, it is a reconstruction.

Birds
Maurice Wilson

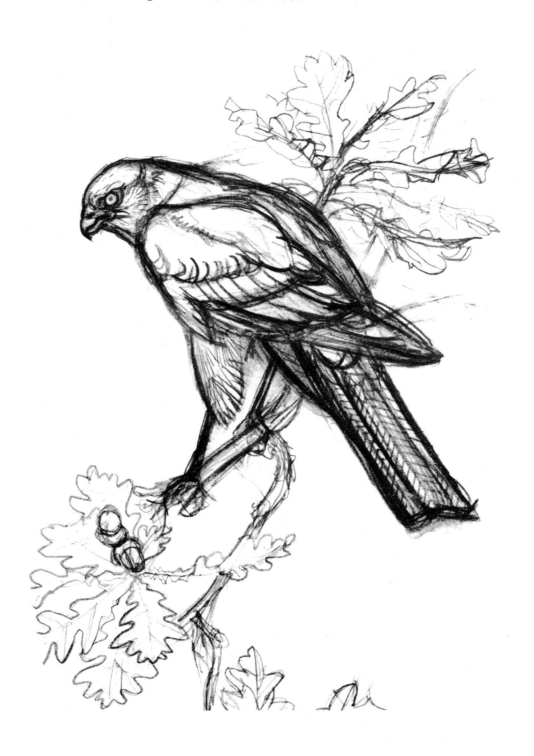

Basic structure

Birds possess the same basic structure as other vertebrate animals, but they are so visibly distinct that they are a study in themselves. The thick covering of feathers is utterly peculiar to birds. Their variety of pattern, colour and form, sometimes fantastic and often combined with coloured skin, wattles, combs and warty shapes, is practically infinite.

Apart from the huge running birds like ostriches, birds are the most highly evolved of the flying animals. Purely as flyers, they are by far the most efficient of all. Damaged flight feathers can be regrown, whereas damage to a bat's wing, for example, is more likely to be permanent and perhaps completely incapacitating. Certainly the extinct flying reptiles would have been far more vulnerable, for their wing membranes were extended by a single finger.

The covering, or contour, feathers provide a most efficient protection from cold and wet, and in aquatic birds a completely waterproof one; so that birds may be found from the tropics to the furthermost Polar wastes.

Their beautiful appearance and the charm and loveliness of their voices have too frequently led them to captivity. They are creatures to whom movement and an intense rate of living is essential, yet they are commonly kept in cages inadequate even for a sleepy tortoise.

But the captive bird does offer the otherwise rare opportunity for close, prolonged study. Besides exact and careful drawings, make endless quick sketches noting attitudes, details, angles of the head, the delicate balance of the body on the legs, and the sudden movements.

Some movements are alike in all birds -

253

practise drawing a particular bird well, and your drawing of other birds will also improve. Thus you will train your eye to measure proportion accurately and to observe the pattern of the plumage.

Remember that in all drawing, it is the form within, and defined by, the lines drawn that matters. If we lose sight of the form, we merely produce indifferent maps in line.

Fast prolonged flight or, for that matter, any flight at all, calls for great physical strength - as those who have tried the various pedalling or flapping forms of man-powered flight would doubtless testify. In birds, the whole structure is adapted to serve this purpose.

The bodily skeleton is a light, rigid framework from which spring the principle muscles of flight, the great breast muscles that pull the wings downwards. The muscles that raise the wings are also attached to the breast, so that the weight may be kept low. The holes through which the tendons pass act as pulleys. But all this power is bought at the expense of suppleness.

A long, flexible neck of many vertebrae

254

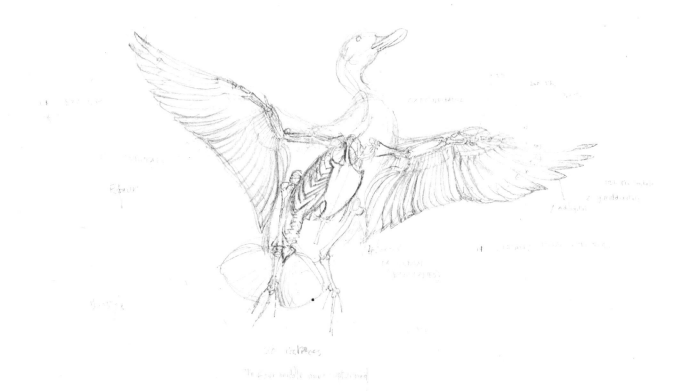

compensates for this lack of bodily mobility. While this is obvious in storks and other long-necked birds, even apparently neckless birds, such as owls and robins, have long slender necks, the flexing of which gives the illusion of lengthening or shortening.

Structurally the legs are similar to ours, although the thighs tend to lie alongside the body and do not show at all on the surface. The slightest flexing or extending shortens or lengthens the legs appreciably.

The forelimbs are completely specialised; the forearm and hand together form-ing a framework for the attachment of the primary and secondary flight feathers on which flight depends. Unlike the clothing feathers, these are attached to the bones in a row right up to the elbow, and both their upper and lower surfaces are exposed to the air stream. The surfaces of the tail feathers are exposed in the same way.

Covering the base of the primary and secondary feathers is a row of firm feathers of medium length, attached to the skin and overlapping in the same way as the flight feathers. Then there is another row - the major coverts - which in many birds overlap the other way. These

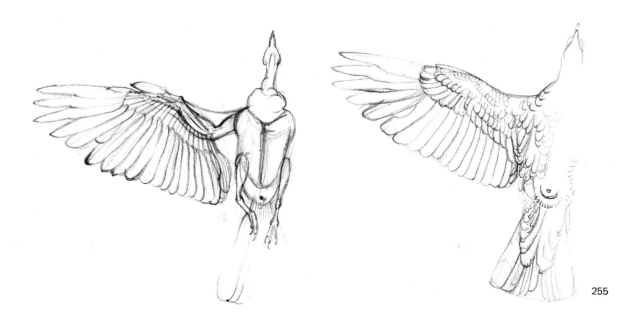

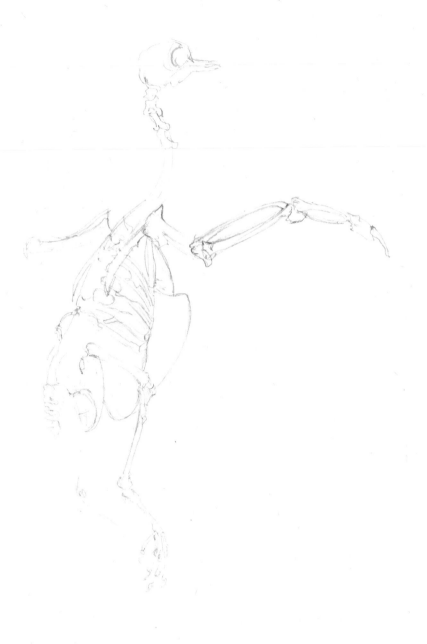

are known as the reverse coverts and are very distinct on the wings of small perching birds.

The flight feathers always overlap - the outer and forward ones under the inner or hinder ones - thus presenting a continuous surface to the flow of air during the main, and downward, stroke.

Inevitably they overlap the wrong way for the less forcible, but nearly equally important, upward stroke, a stroke which is much more than the mere returning of the wing into position for the next downward stroke. Birds like the kestrel and, particularly, the humming bird exert nearly as much lift with their upstoke as with their downstroke while hovering in still air, because their wings flap horizontally rather than up and down. Birds which cannot move their wings in this way are unable to hover.

Finally, a fan-shaped group of feathers acts as a kind of closure to the gap between the flight feathers and the body.

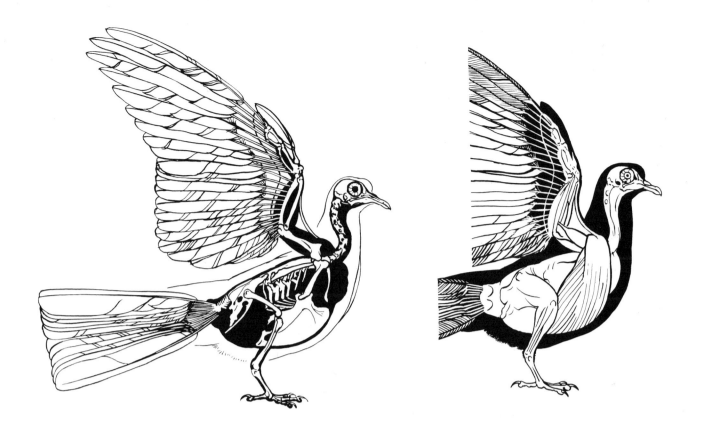

The thumb is separate and has a few small flight feathers attached, which may be seen clearly in flight. So also can the abrupt narrowing of the outermost primaries in some species so that the tips stand out like fingers and act as slots which assist the flow of air.

The main thing is to note carefully for yourself all these points when drawing live birds, because there are many ex-ceptions to this overlapping of feathers. In American vultures, for instance, the feathers are not reversed and even within families of birds such as the crow, there are variations.

Do not go by what you have seen in drawings, for this is one of the things about which many excellent artists have been careless. Even stuffed birds have their feathers rather muddled up.

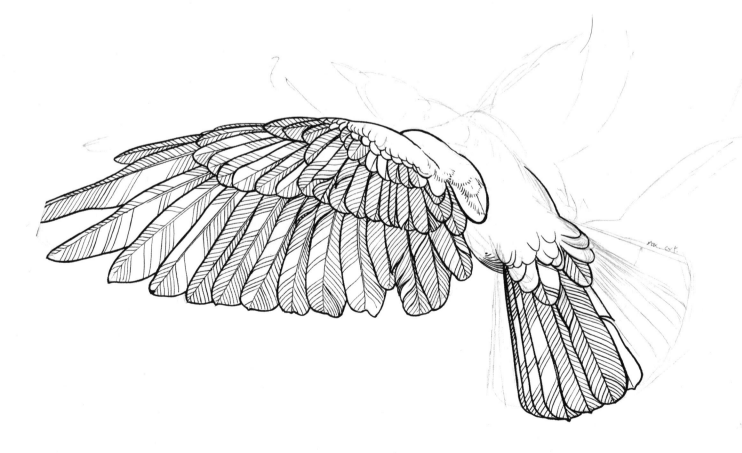

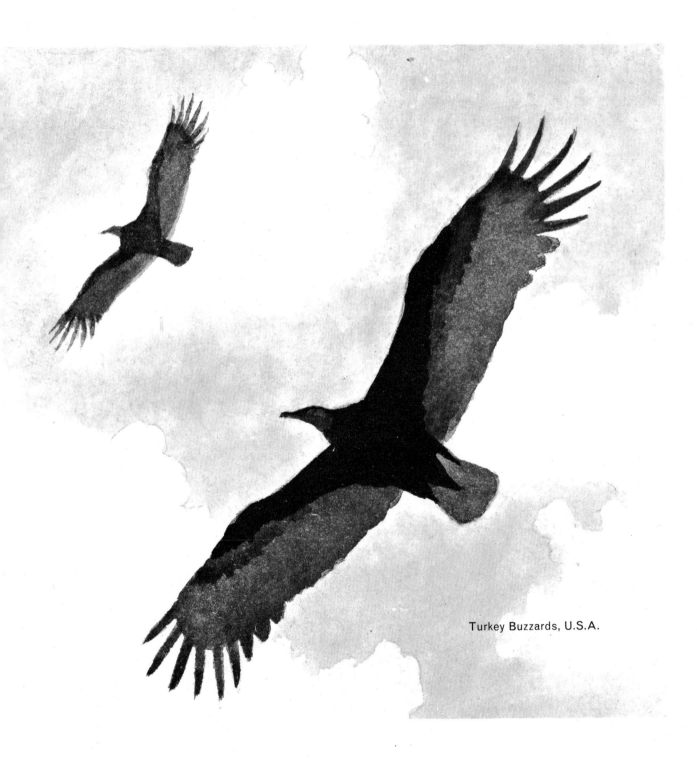

Turkey Buzzards, U.S.A.

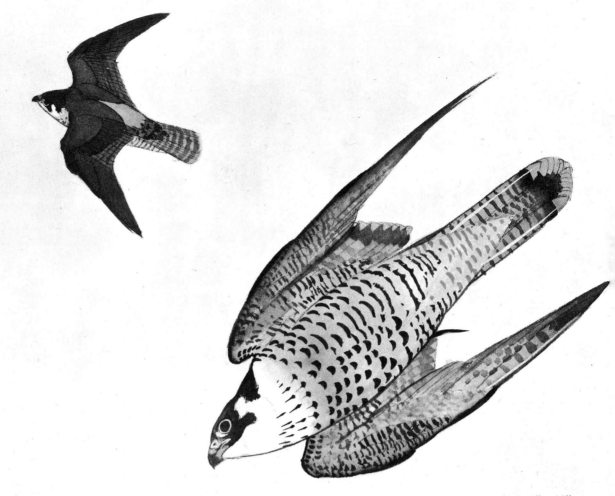

Indian ink and watercolour, 6" x 8½".

Flight

True flight implies that the flyer can rise unaided from the ground and sustain himself in the air. Gliding is a different and altogether simpler matter - before creatures adapted to free flight, they must have been able to glide as, indeed, many creatures still only do today. Gliding must start from a height, the glider travelling downwards - at least in relation to the air. If the upward currents of air rise more quickly than the downward glide, the creature may, in fact, soar in actual relation to the ground. The modern sport of gliding works on this principle - the air, passing by suitably shaped wings, presses up from below and sucks up from above.

In level flight the obvious movement is the up and down beat of the wings; it is the angle of the outer part of the wing that provides the forward movement. This applies to all flying birds, but the way of life of the different species accounts for the endless variety of bird forms.

Birds which spend much time on the wing, will have long wings and less (and lighter) breast muscles, so that they are efficient gliders. An extreme example is

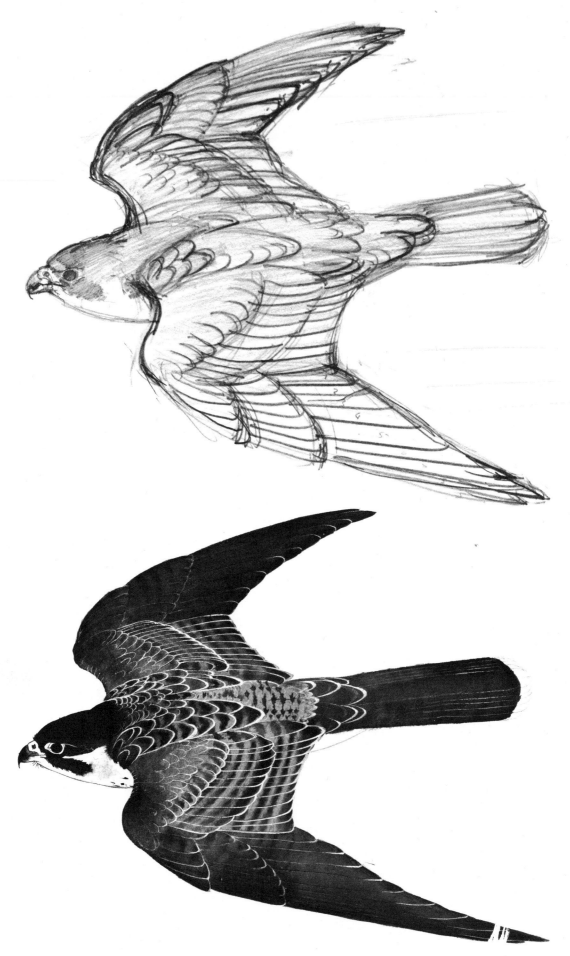

Peregrine Falcon. Pencil on cartridge paper, 6'' x 8½''.

the wandering albatross, which glides on its long wings - the greatest span of any living bird - over the great southern oceans. So specialised a glider is it, that it cannot rise from the deck of a ship unless the ship is heading into a strong wind.

Another example, and one of the heaviest of the gliding birds, is the condor. Like vultures they glide about the sky for hours, taking advantage of any upward current by small, economical wing strokes, until one sees a faltering or dead animal upon the ground, when he will swoop - to be followed by distant fellows who will have been watching each other as vigilantly as they watch the ground, just as human searchers for, say, blackberries, mushrooms, or even gold, will investigate the vicinity of an apparently more successful searcher.

Like vultures, condors cannot lift prey with their feet. And like them, they have more or less bare, scrawny necks - an advantage when the head has to delve into the messy interiors of large, dead animals.

Many other birds glide well, but the smaller ones need to flap more.

At the other extreme is hovering. To hover, the bird must be able to turn the upper arm bone freely backward, so that the wing may flap vigorously backwards in a horizontal direction, helped by an upward inclination of the body. During hovering in still air, the wings move to and fro horizontally - the upstroke giving lift as well as the down, or forward, stroke.

Many birds hover, but the less perfectly they do it, the more laborious it is; so they will fly slowly forward through the air, turning into what wind there is, while appearing to remain stationary in relation to the ground.

The kestrel, known also most descriptively as the windhover, is the most familiar European hovering bird and is very similar to the North American sparrowhawk. Less often seen is the nightjar.

Barn Owl attacking a rat.
Indian ink, watercolour and body colour on handmade cartridge paper, 8½'' x 10''.

The Head

Whether their necks are as long as giraffes or as stubby as whales, most mammals have seven neck vertebrae. Birds often have many more, thus giving their necks great flexibility. Owls, with their deep covering of feathers, appear to be able to swivel their heads right round.

Lumps of food may be seen descending in thin or bare necked birds. Conspicuously so in ostriches which, contrary to popular belief, are likely to become ill, or even die, if they swallow anything but food or the small stones needed for digestion.

A bird's head is very specialised. Most of the large brain is concerned with co-ordinating the many manoeuvres of flight. Though some species show definite intelligence, the 'intelligence' area of the brain is not highly developed, though birds are probably not as blindly automatic as many biologists would have us believe.

The eyes are large and separated from each other by a thin sheet of bone. Instead of the rigid cranium and upper jaw skull of mammals, to which is hinged the lower jaw, birds have several moveable bones jointed to each other. The upper jaw is not fixed immoveably to the rest but is raised to some extent when the beak is opened. This is very noticeable in ducks and geese, while parrots have

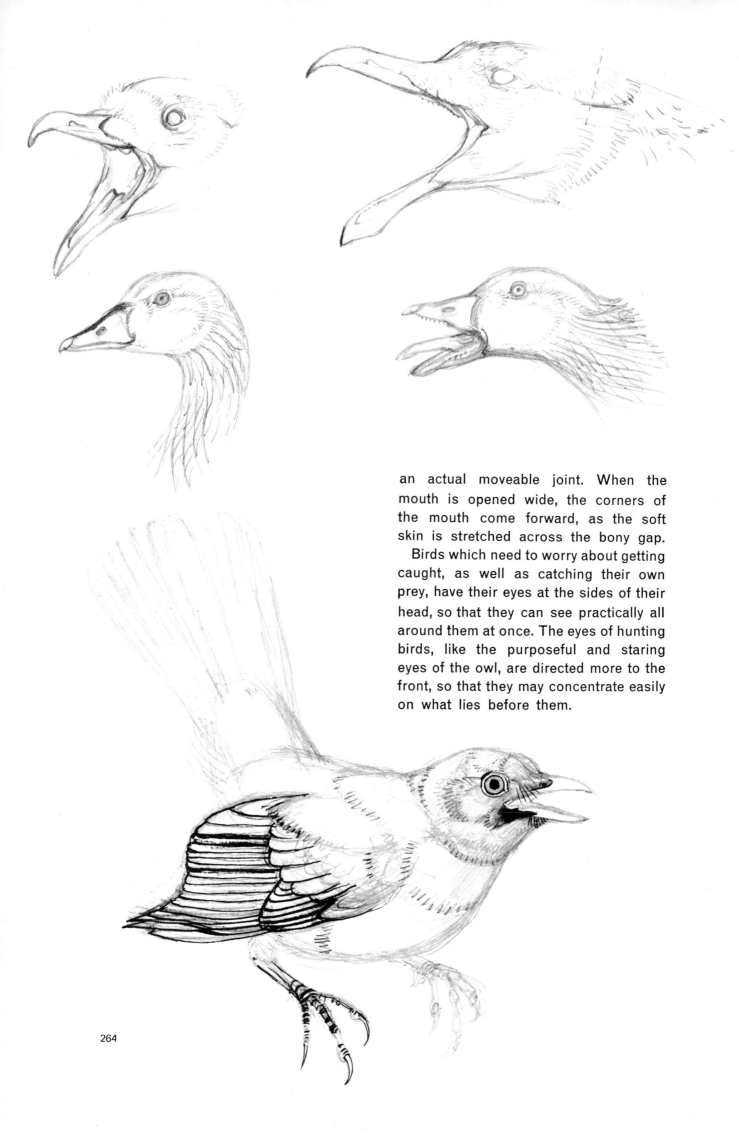

an actual moveable joint. When the mouth is opened wide, the corners of the mouth come forward, as the soft skin is stretched across the bony gap.

Birds which need to worry about getting caught, as well as catching their own prey, have their eyes at the sides of their head, so that they can see practically all around them at once. The eyes of hunting birds, like the purposeful and staring eyes of the owl, are directed more to the front, so that they may concentrate easily on what lies before them.

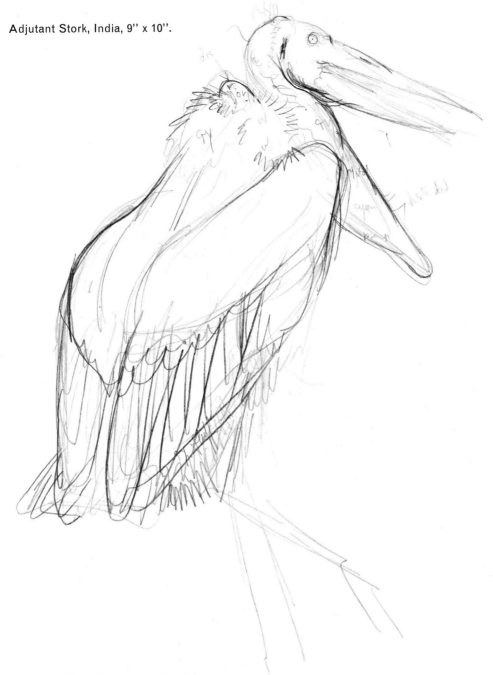

Adjutant Stork, India, 9'' x 10''.

Hindlimbs and Feet

Because the forelimbs of birds are given over completely to the exacting necessities of flight, all handling has to be done by the beak and, in some species (notably parrots), by the hind limbs.

In the majority of birds, three toes point forwards and one, the first toe, backwards. This hind toe arises well to the inside of the leg. In other species - toucans, parrots and owls - it is not quite so far back; it can come well forward. The lower leg is, in fact, part of the foot.

Feet vary from the tiny niggling things on which plovers teeter about to the great grasping hooks of the eagle; from the webbed paddles of many swimming birds to the camel-like brackets of the ostrich.

The number of phalanges in the toe increases from two on the first (the hind toe) to three on the inner forward toe, four on the middle toe and five on the outer. In some species, the hind toe is greatly reduced or, to all intents and purposes, absent.

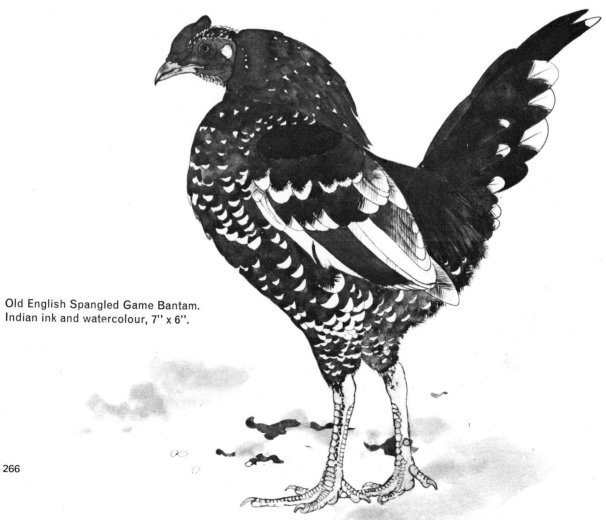

When birds perch upon a thin twig, the outer and inner front toes wrap around the twig, but the long middle toe hangs down.

In drawing live birds, one of the main things to bear in mind is that the heel, or its functional equivalent, must be below the centre of gravity. This is generally rather far forward of the apparent bulk of the bird, because the body is short and dense and what projects at the back is a mass of feathers having very little weight.

Old English Spangled Game Bantam. Indian ink and watercolour, 7'' x 6''.

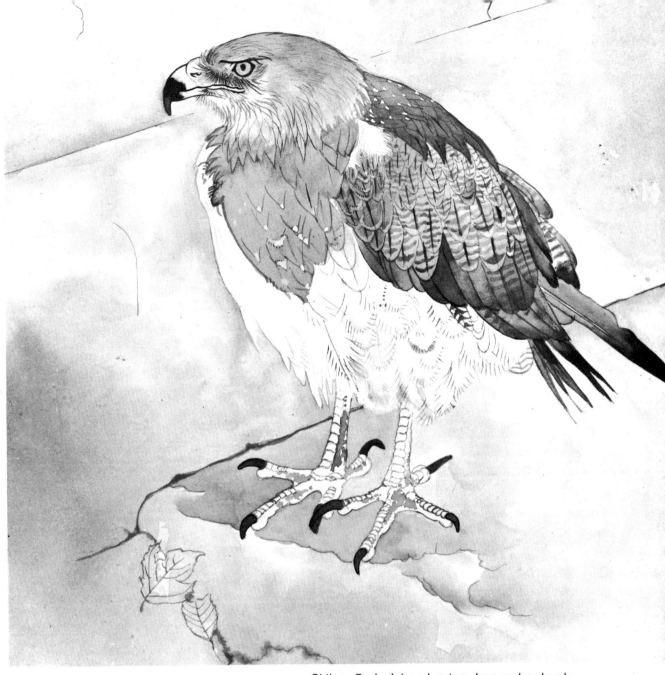

Chilean Eagle. Ink and watercolour on handmade cartridge paper, 9'' x 8''.

The peacock is the most curious example of this unexpected point of balance. Many artists, particularly those who work from dead specimens, fail to place the feet correctly; many old drawings show this error, often in an extreme form. It is particularly obvious in the works of Audubon, who generally drew from dead birds and though one of the most magnificent recorders of feathers, patterns and other details, generally failed to bring his birds to life.

The thighs are normally flexed, so as to be part of the compact body of the bird. This flexure may be changed, so that the visible legs lengthen and shorten as though telescopically. Some birds have pads beneath the joints of the toes, others have them beneath the phalanges. Look out for this and notice also the scaling. Some birds have a row of large scales like ridge tiles along the upper surface of each toe and two rows up each side of the front of the so-called leg, while others appear to be clothed in a mass of small scales.

In many birds, this leg is feathered down to the toes; in some - owls, for instance, and some birds such as the ptarmigan that live in cold climates - even the toes are covered.

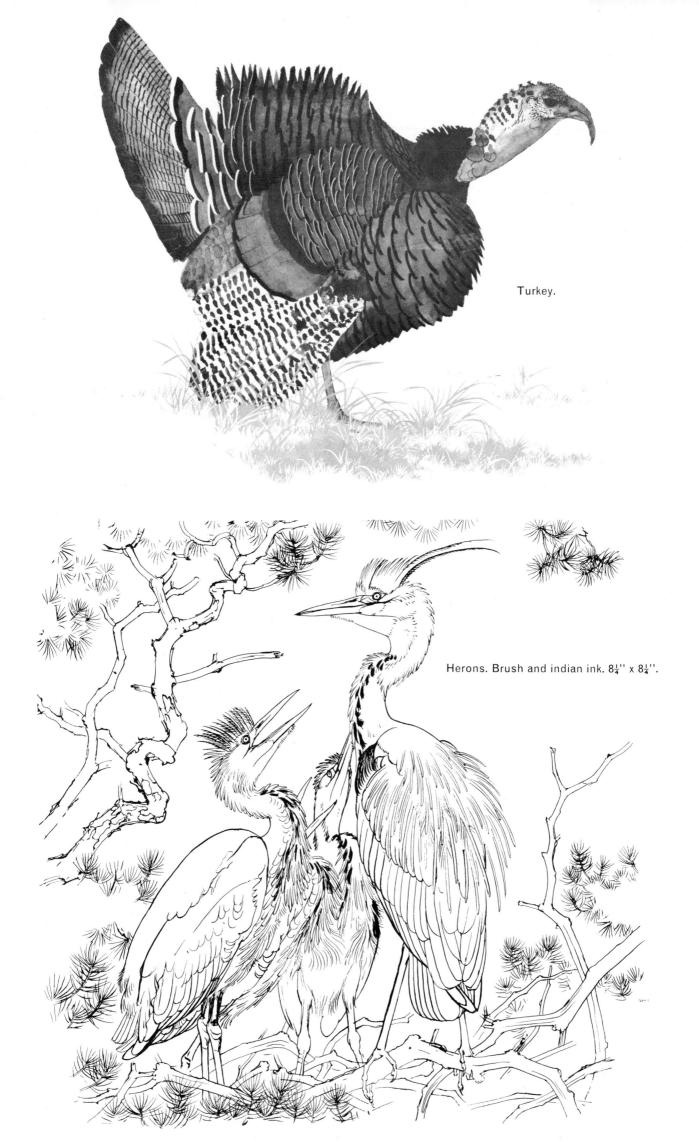

Turkey.

Herons. Brush and indian ink. 8¼'' x 8¼''.

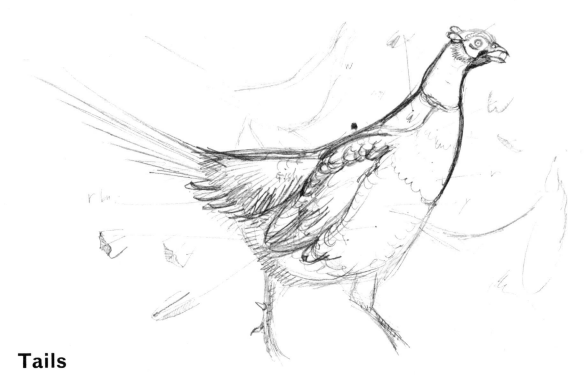

Tails

Birds have extremely short, bony tails (the 'parson's nose' of poultry is a good example), to the end of which are fastened, side by side, the tail feathers. These vary greatly in length and usually amount to twelve, which overlap from the centre outwards in two sets of six each, one of the middle pairs overlapping the other asymmetrically. Their shapes should be observed very carefully. The bases are covered by an orderly row of covert feathers in a similar way to the wing.

While the tail feathers vary in length from the short tails of the owl and plover to the long one of the pheasant, there are many instances of pseudo tails: feathers

Leghorns. Pencil on cartridge paper, 5'' x 7''.

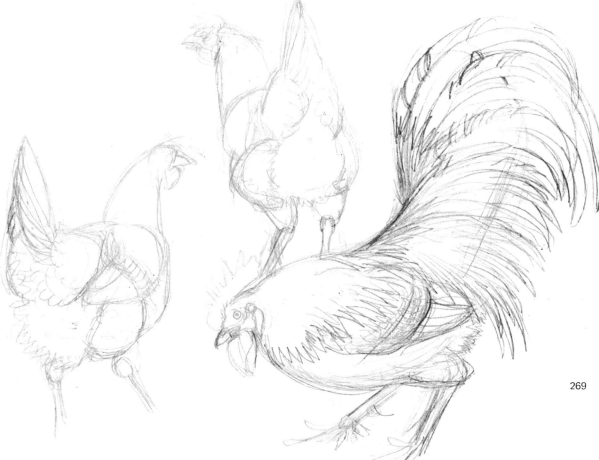

269

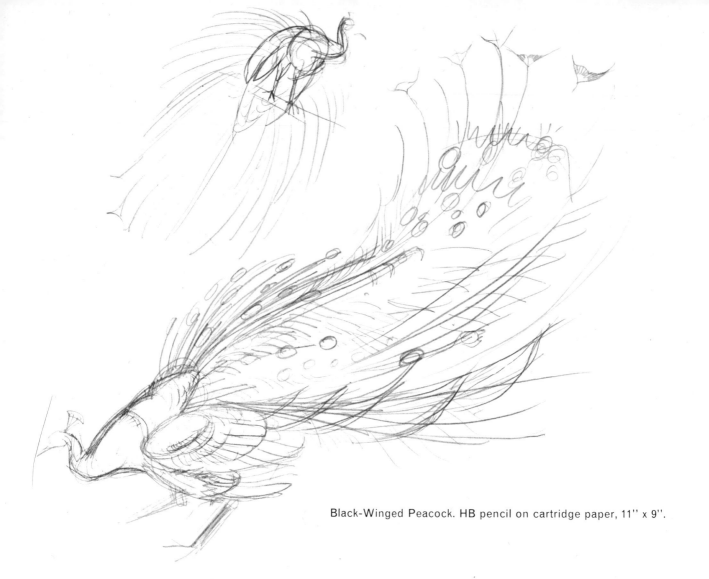

Black-Winged Peacock. HB pencil on cartridge paper, 11'' x 9''.

belonging to other parts which extend beyond the actual tail. Perhaps the best known are the spectacular tail coverts of the peacock, whose genuine, somewhat chicken-like tail may be seen from the rear when the glorious sham tail is spread.

Another instance is the male chicken - again the real tail, similar to the hen's, may be detected beneath the cock's feathers. The elongated inner wing feathers of the Demoiselle Crane can also be very deceptive.

Black-Thighed Hornbill. Indian ink on cartridge paper, 4'' x 5½''.

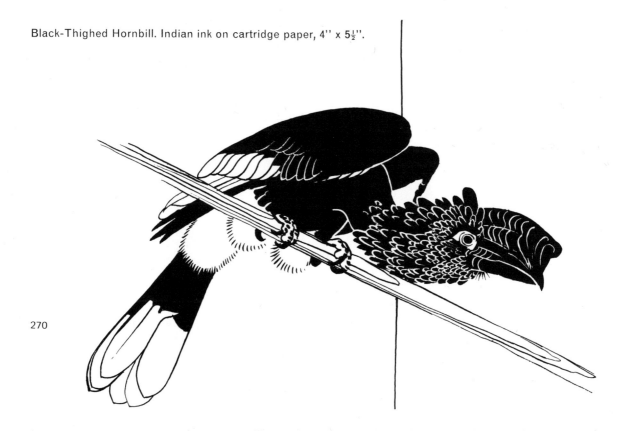

270

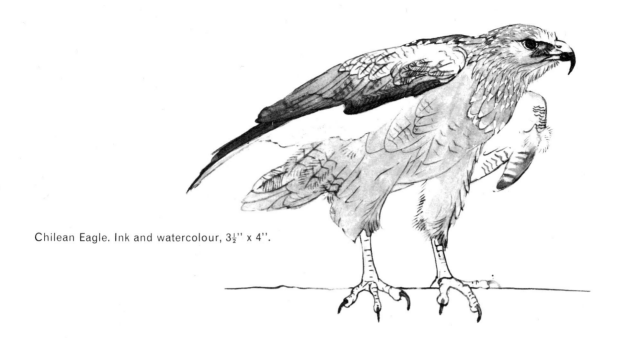

Chilean Eagle. Ink and watercolour, 3½'' x 4''.

Displays

Many birds vary seasonally in their plumage. All moult. Most shed their feathers a few at a time, so that the bird may continue to fly - if looking somewhat ragged - throughout the moult.

Geese and ducks, however, shed them all at once and so have to spend a period during the summer flightless.

During the mating season, birds have what is called a display. This varies from the great spreading of the fan-like tail coverts of the peacock to the marvellous performance of the various birds of Paradise; from the bowing and bubbling of city pigeons to the prancing and flapping of excited cranes. Out of season, pseudo-displays are also a habit of some species.

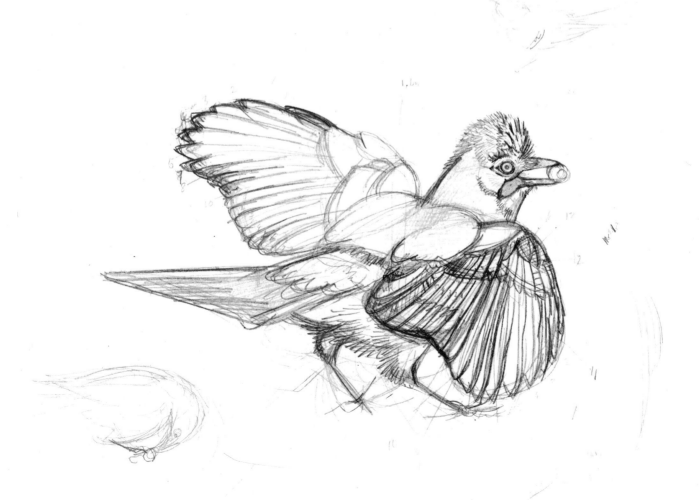

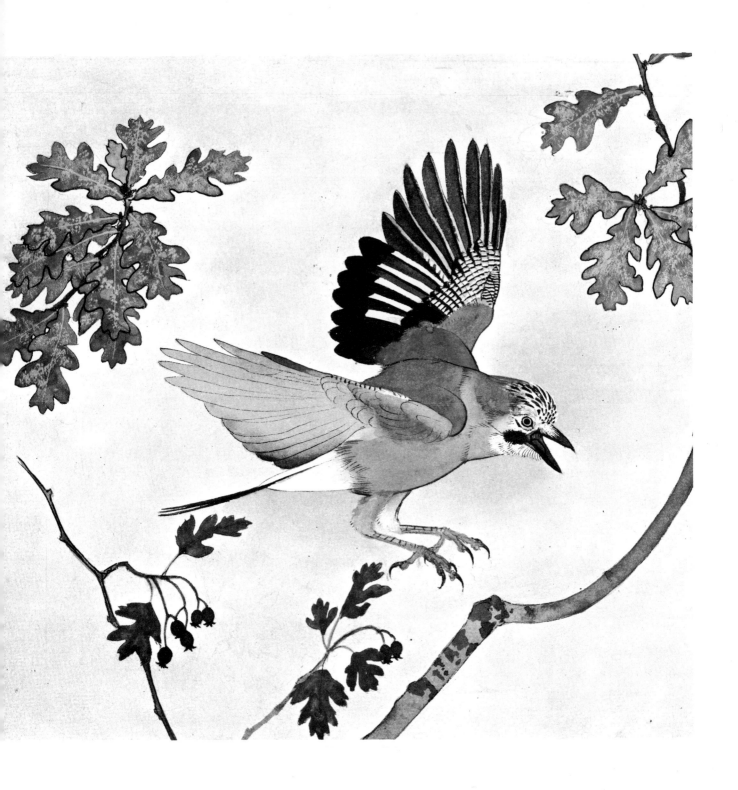

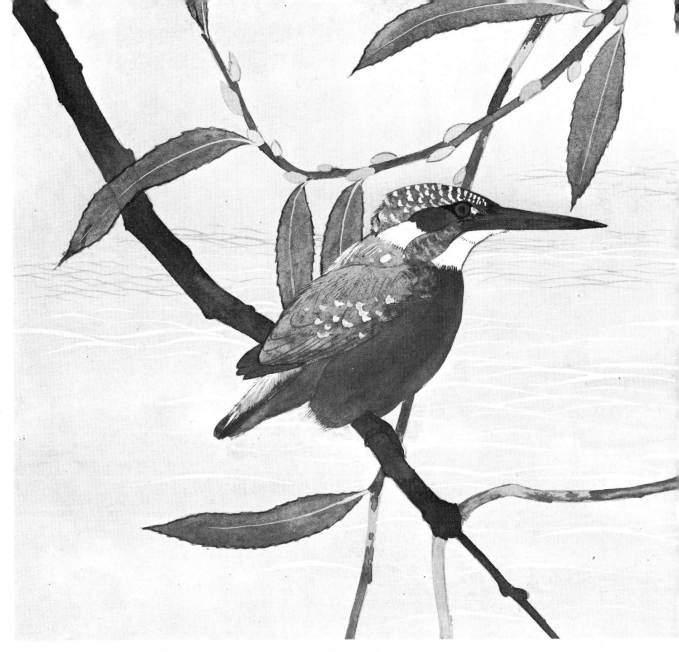

Kingfisher. Watercolour on handmade paper, 9" x 9".

Colour and Markings

There is almost an infinity of colours and patterns in birds. To the artist, the most rewarding are those with colour in masses, though the boundaries of each area of colour should be observed very closely, for they do not necessarily conform with the groups of feathers. Bars or other patterns on each feather are extremely difficult to draw, because collectively they sometimes give rise to speckly patterns or stripes. And the trying thing about these patterns is that if they are drawn carelessly, they look wretched; to draw them accurately and properly is exceedingly laborious - if one succeeds at all, one is only left with a speckly brown bird. For patterned birds like the partridge and the owl, there is much to be said for an impressionistic treatment, based on the vitality and character of the brush strokes.

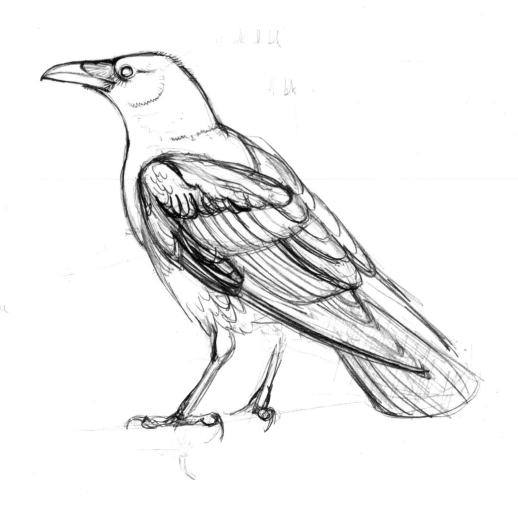

N. American Crow.
HB pencil on cartridge paper, 6½'' x 8''.

Particularly rewarding to paint are the great darkish eagles, with dark feathers defined by paler edges, huge and distinct flight feathers and smaller contour feathers merging into a strong dark mass.

Brilliantly coloured birds set other problems no less rewarding to solve. Where freshness of colour is desirable, as for the kingfisher on page 273, clear watercolour is recommended, using opaque colour only where light overlaps dark, or for fine light detail such as the pale heron's feathers on page 280, or the grasses on page 276. Never add layer upon layer or opaque colour will flake.

A carefully considered pencil drawing is the soundest base for a watercolour. The final drawing may be made with a fine brush and waterproof indian ink, so that colour can be flooded on without fear of running or smudging. A brush as fine as a number O or OO is ideal for detailed studies on smooth surfaced papers; rougher papers and broader treatments require larger brushes. Always buy the best brushes you can afford and never let paint or, above all, indian ink dry in them.

Ordinary cartridge paper is ideal for pencil work; the handmade papers are better for colour. For a pale or white subject, a tinted paper is excellent. Put in the darker areas first - but don't get them too dark - then add the lighter areas, leaving any very dark or fine details until last of all. The herons on page 280, are an example of watercolour on tinted paper.

Large smooth washes are very difficult to handle so, if possible, divide the area

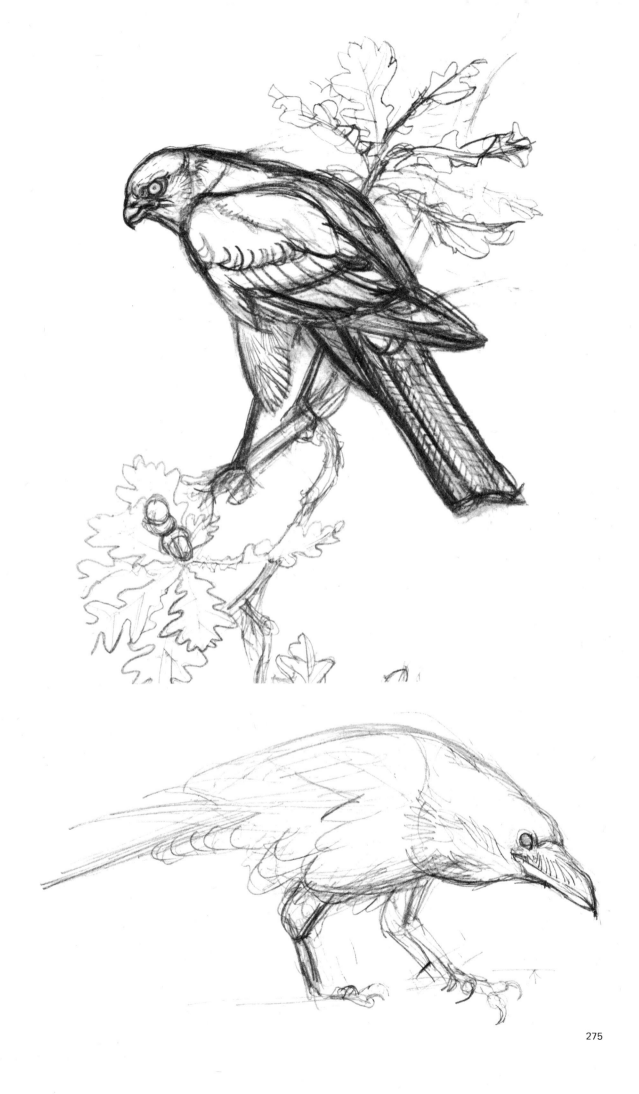

to be covered by painting to a natural edge such as the horizon, or a line of rocks. When this is dry, add the next area. With practice, you will discover the correct angle at which to tilt your paper: too steeply, and the paint will run too quickly; too slightly, and it will gather in maddening little pools.

Make up more colour than you think you could possibly use, put it on with a large brush and never touch a partly drying wash. A carefully placed twig, some grasses or pebbles will help to camouflage the line at which the washes meet.

Yellow Wagtail, Western Europe. Ink, watercolour and body colour on handmade cartridge paper, 7'' x 11''.

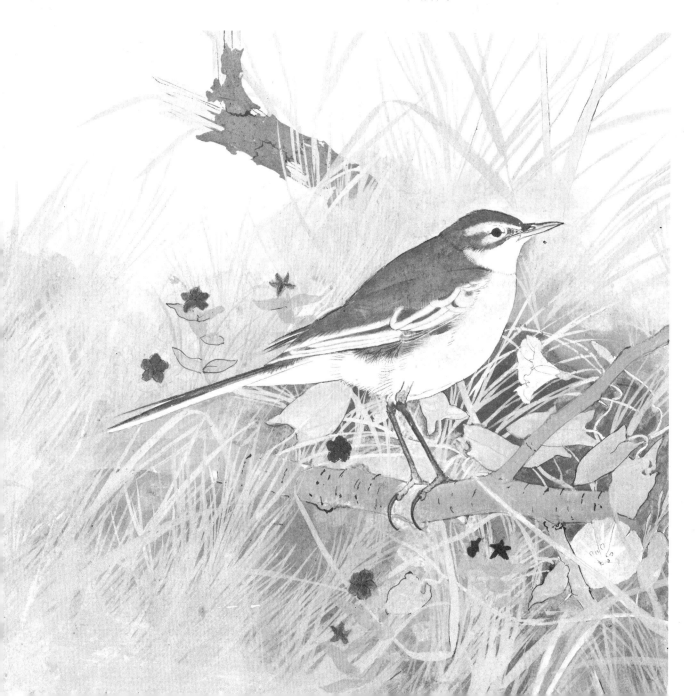

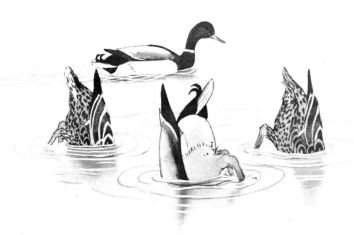

Ducks and Geese

Geese, ducks and swans are a beautiful group, well adapted to life partly on the water. The majority are strong fast flyers, but some are unable to fly at all. In spite of being such strong flyers, the bodies of many domestic breeds are so heavy, that even a small increase in weight or diminution of wing and muscle power will prevent them from flying altogether.

Geese, when swimming, appear to float high in the water; diving ducks swim low. All swimming birds float with the base of the neck partially submerged. A moment's reflection shows that this could not be otherwise, but common neglect of this has produced a distressing number of paintings of ducks and geese looking as unconvincing as plastic toys.

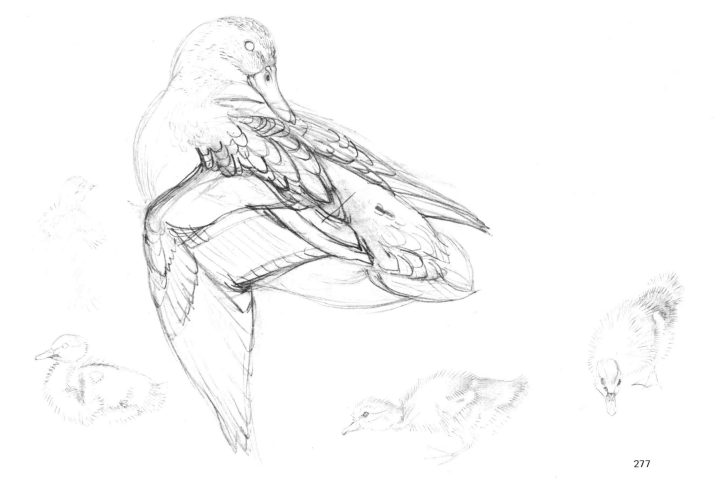

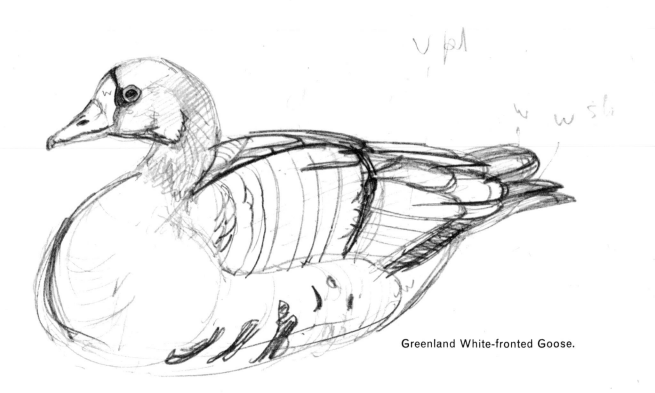

Greenland White-fronted Goose.

Diving ducks swim on the surface with alternate strokes; underwater both legs paddle in unison. Waterfowl from many parts of the world may often be seen in public parks, summoned at will by no more than a handful of bread, thus saving the naturalist and the artist many a fruitless journey overseas in search of rare species.

Geese have beautiful and distinctly marked feathers, which are both a joy and a problem to paint. There is a great deal of delicate graduation on the individual feathers, as well as on the bird as a whole.

To get these graduations of tone into your drawing, wet the part of the paper to be painted and then drop in the paint, blotting it up quickly on one side with a lightly squeezed out brush. Repeat the process until the exact graduation is achieved. Use opaque colours for this - suitable mixtures made up of Chinese or titanium white.

Herons. Watercolour and white body colour on grey paper, 11" x 11".

Lesser Snow Goose.

Summing-up

Watch and draw live birds constantly and, whenever possible, wild ones. Make little scribbles continually, noting positions, angles, attitudes and groupings of as many different kinds as you can.

Only very rarely can even a related bird be adapted for the portrayal of a different species. Take, for instance, the rook and the crow. The crow is a little bigger, its beak more massive; the older ones do not have the bare patch of skin by the eye. Even so, they are extremely alike, lying dead - but how very different in posture,

voice and habits they are when alive! So keep on observing and working from live creatures all the time.

Crows, which are fairly common and large enough to be studied easily, are among the most useful birds for the purposes of study because they are so generalised in form. So, too, is the approachable and common pigeon, dead specimens of which may be obtained easily from a farmer or a dealer in poultry.

Ornithological books can be valuable, but not as complete evidence because the

illustrations are commonly made from preserved skins. And though the drawings may be done by excellent artists, such illustrations are in fact only restorations, not statements of fact.

Photographs are valuable sources of information about appearance, details and action, but they really only help the student who is thoroughly familiar with the live creature. Otherwise he will copy blindly.

Copy from nature, not from books or photographs! Drawing birds, like watching them, is an open air, sunlit occupation requiring hours of patient observation and constant study. The more you know, the more you will want to know, both about the life of birds and the art of drawing.

Field-glasses are helpful though clumsy to use - by the time you have fumbled for them the bird may have flown - but you should carry pencils and a small notebook with you everywhere. Enjoying the beauty of birds in their natural settings can make life richer; so too can the pleasure of drawing. Let the two together take you out into the woods and fields, to the seashore, the mountains and the zoo, as well as into your own garden.

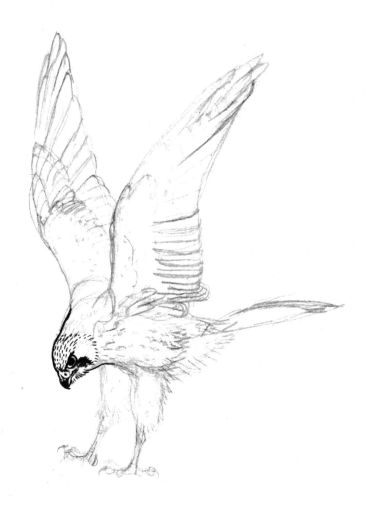

Ponies

Norman Thelwell

Line and wash

In the course of my work as an illustrator and cartoonist, I have drawn almost every subject under the sun at one time or another, or so it seems to me: human beings, animals, machinery, landscape and architecture, roller coasters and rockets, parrots, planets and pigs. I have been asked many questions too, such as 'Where do you get your ideas?' and 'Do you get paid for your drawings?' But the most frequent question is 'How do you draw those ponies?'

Why ponies should be singled out in this way I am not sure, and the simple, truthful answer 'The same way that I draw anything else' does not seem to satisfy anyone.

It is not easy to answer this question more fully on a street corner, or on the telephone, or even in a letter. I'm not all that sure that I shall find it easy to write about it either, but I am going to try.

There are no short cuts to drawing well, just as there are no short cuts to doing anything worth-while, but it is interesting to know how other people go about their work, and sometimes it is helpful. I hope that these pages may be helpful to you.

'That's *one* Christmas present she won't break in a hurry.'

What is a pony?

Well, it may surprise you to know that in many ways he is very like a human being. Look at the diagram below.

You will see that he has a skull, a rib cage and a pelvic bone, and so have we. These are all joined together by his spine in much the same way as ours.

He has an extended spine which forms his tail, of course, but we also have a tiny tail which does not show on the outside.

Let us think of our arms as front (or fore) legs. His fore legs are connected to his rib cage by flat sheets of muscle which hold his shoulder blades in place. His hind legs fit into hollows in his pelvis, making a smooth ball and socket joint. This is true of us too.

At first glance his hind legs look very different from our own, but they are really very similar. His thigh bone is shorter in proportion, but it is otherwise much the same, and although his knee is high and close in to his body, it is constructed much like ours and works in a similar way.

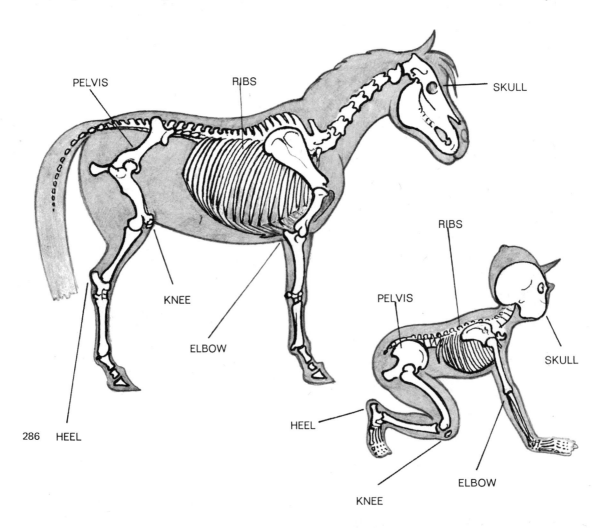

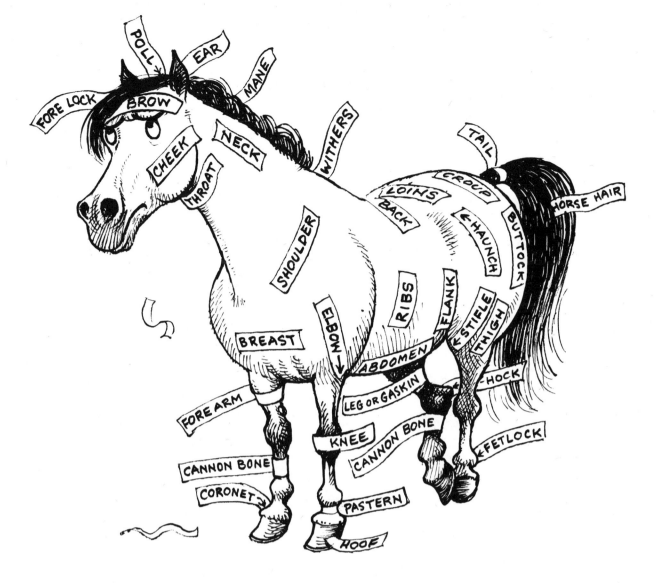

We have a shin bone below the knee, and our heel and toe bones are connected to this. A pony also has a similar bone below his knee to which his heel and toe bones are attached. It is important, when thinking about how ponies move, to remember that this joint is really his heel. Now a rather interesting thing happens; we have five sets of toe bones, all rather short and each with a nail at the end. A pony has disposed of all but the centre toe, and this has become very big and strong, and his toe nail has become very useful indeed for walking on and for kicking other people's ponies.

If we now look at our 'fore' legs, the story is much the same. We both have shoulder blades which slide smoothly against our rib cages. A pony has an upper arm bone like us, but shorter and thicker and held in against his side so that his elbow joint is tucked in close to his chest. Our lower arm has two bones, his only one; at the point

we often wrongly think of as his knee, he has no knee cap but a series of little bones very like those in our wrist.

It is odd to think that if we put our pony wrongly at a jump, he is likely to fall on his wrist. But this is so, and it explains why this joint is so easily damaged by a bad fall. If it were really his knee, then he would have a knee cap to protect it.

The fore legs of a pony finish off in a similar way to his hind legs, but he has developed a strong finger at the front to match the strong toe at the back.

So there you are. Whether we like it or not, we are all a bit horsey.

Feeling like a pony

This comparison of the structure of a pony and of ourselves is not only interesting but very important if we wish to draw ponies. We can only express ourselves well in graphic form if we have a real feeling for our subject.

To draw a pony convincingly we must identify ourselves with him. We must walk, trot, canter and gallop as he does, at least in our minds, and try to understand what it feels like to be put at a high fence when we don't want to jump. Then perhaps we will get our expressions right when we knock it down and fall on our wrists.

We must show his feelings in our drawings mainly by facial expression, but remember that his face is very different from ours, at least as far as most of us are concerned. When we give him expressions which are really human ones, we must be very careful indeed not to destroy his character as an animal.

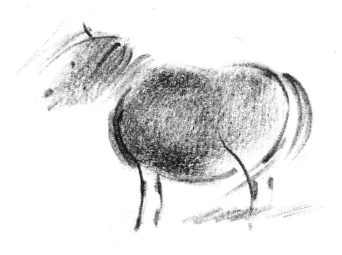

Lithographic crayon

Line and wash

Unfixed fountain pen ink and wet thumb

Pencil and Indian ink

Materials

As with most things about drawing and painting, there are no strict rules about materials unless you are drawing for a magazine, book or newspaper. If you are, then you must make it your business to find out from the editor what materials you are allowed to use. If you use the wrong ones, it may not be possible to reproduce your work in that particular publication and the editor will not be pleased.

Most drawings are done in black Indian ink with a pen, or sometimes a brush, on a good quality white paper or fashion board. This sort of work is clear and easy to print, and Indian ink is very black and does not smudge. I do not use Indian ink if I can avoid it, because it tends to thicken quickly in the bottle and on the nib when you are drawing, and this can be a great nuisance. I also

dislike bottles of ink because they are so easily knocked over and they tend to distract one from the job in hand.

A fountain pen is an ideal drawing instrument, if you can find one which gives you a wide variety of line and will run smoothly on the paper. There are a number of makes of black fountain pen ink which will give a good black line and not clog the pen as Indian ink would certainly do.

It must be remembered, however, that fountain pen ink will smudge if roughly handled, and some editors do not like it.

If you are drawing purely for pleasure, then you should try any materials that you can get hold of. You will soon discover those that suit you best, and you will have no end of fun trying different paper surfaces with inks, chalks, crayons, pens and paints.

A closer look

We have seen that in some respects a pony is not unlike ourselves.

In many ways, however, he is very different, and if we are to make him look convincing on paper we must find out more about him.

This we must do with the aid of a sketchbook, the most valuable piece of an artist's equipment. Take one with you wherever you go, and draw in it as much and as often as you can.

Draw horses and ponies at shows,
grazing in fields and standing in stables; anywhere and everywhere that you can find them.

If they are moving, then make a lot of quick sketches on the same sheet, going from one sketch to another and back again as the animal changes position.

The best way to learn how to draw is by drawing, and by doing it as often as possible. Do this with ponies and horses and you will learn a great deal and improve your draughtsmanship at the same time.

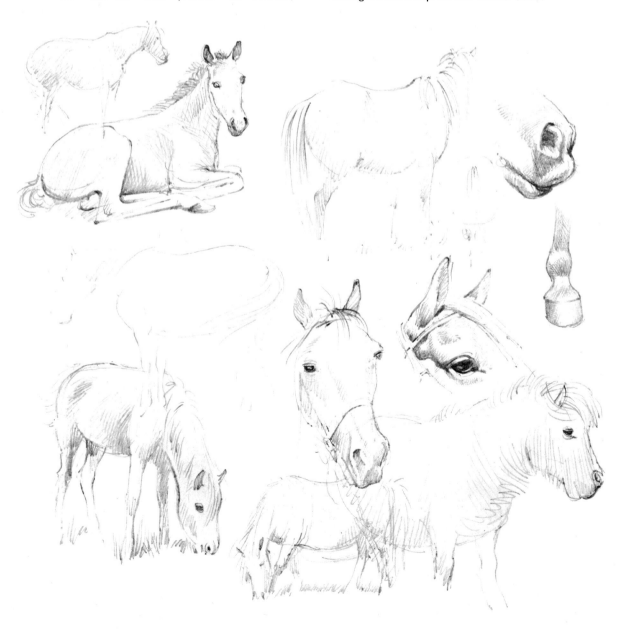

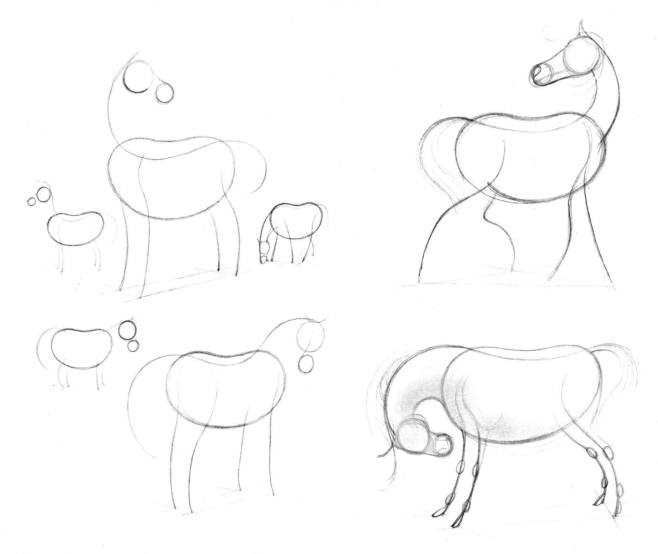

Getting down to work

Although it is most important to draw from life whenever possible, to improve both one's drawing ability and one's knowledge of horses, there is of course no question of using models directly when creating one's own personal equine world. This world is a personal one, and within it we may do whatever we choose provided that we achieve the results we are after. One's imagination and invention will influence the way one interprets nature on paper. Everyone draws differently, just as no two people use quite the same handwriting.

One's style of drawing will develop naturally from a combination of technical ability and imagination. Don't try to force yourself into a style or manner of drawing. Let it develop in its own way. It is a great help to look at other people's work and to learn from it, but it is fatal to be influenced too much by the work of one particular artist. If you copy another man's work, you can

never produce more than a pale imitation.

However, you must make a start somewhere, and knowing how other people go about their work can be very helpful in setting you off on your own particular road.

Start drawing by putting down the general mass and proportion of the animal and arranging it in a convincing manner.

This is best done by thinking of the body as a bean or kidney shape, the head as a sphere with a smaller one beside it, and the limbs as flexible wires attached to the bean. Another and most important flexible wire joins the head to the body, passing beneath the upper surface of the bean and ending in the tail.

Thus you have a simple horse puppet which can be drawn quickly and easily. Its lack of surface detail is a great help at this stage, for you can devote your full attention to proportion and arrangement.

You can play about easily with these few simple shapes until you are quite sure you have the sort of action you require and the type of animal you want, whether long and thin or short and fat.

It is at this stage also that you must think of the human beings who may be included in the drawing. The best horsemen try to ride as if they were part of the horse. Balance between horse and rider is not only essential in real life, it is vital also in drawings. Never think of the rider separately from the horse.

The rider must never be an afterthought

For the human figure use an egg shape for the body and a smaller sphere or egg shape for the head. Flexible wires will represent human limbs in the same manner as for the pony.

When drawing figures of any kind, it is important to think about the area of ground on which they stand, otherwise they may look as if they are unstable or falling over. In the case of four-legged animals it is a help at this early stage to join the feet together with light lines to make sure that they appear to be standing solidly on the ground.

to be added later if you feel like it. Horse and rider must be thought of together and drawn together right from the start.

In the same way that you can use a few basic shapes for the horse, the human figure can be represented in a simplified manner. This enables you to work out the relative proportion and position of the rider in relation to his mount right from the start.

The body of a horse fits roughly into a square. The black lines show how the head length compares with other parts of the body. Some

There are certain rules about how one should sit on a horse, but these vary in different parts of the world. The cowboy, for example, does not use quite the same seat as a show jumper, and a jockey does not sit like a huntsman. Such details should not be ignored, but you can often get more fun in drawings from riders who have lost contact with the saddle altogether.

idea of average proportions helps us to make variations of the truth with knowledge of what we are doing.

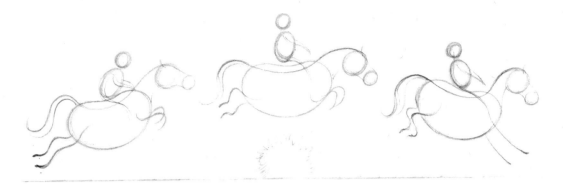

Into action

Movement and action are essential ingredients of a satisfactory drawing. Even if you are drawing a pony which is standing in a more or less static position, there must be a flow of line through the picture to give it life.

You may be creating a phantasy world of your own which does not conform in many ways to real life, but it must nevertheless be a world which is vitally alive in its own way. Indeed you should go further, you should try as an artist to give extra emphasis to the particular kind of movement and action you wish to show.

The feeling of life and speed may be helped at a later stage by the addition of certain details such as flying stones and earth, or a cloud of dust, but by far the most important thing is the arrangement

and pattern of your figures on the paper and the first flowing lines on which the picture is built.

Not only is it a mistake to draw detail in the early stages of a composition, but you must not even think in terms of detail. Your whole concentration must be on the movement you wish to express. In the case of animal drawing, the most important single line is often the one which runs from the tip of the nose, over the profile of the head, along the neck and down the back to the end of the tail. Once this line is established, all further lines of action should be in sympathy with it.

The lines of movement do not apply to the pony only, of course. If a rider is present, he is just as important in suggesting action and flow. Not only his action but his

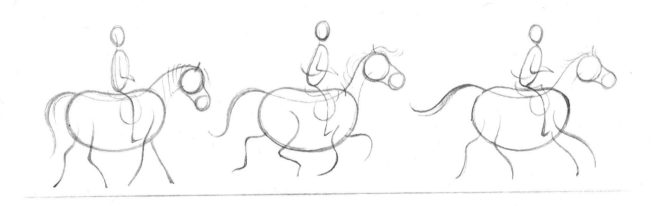

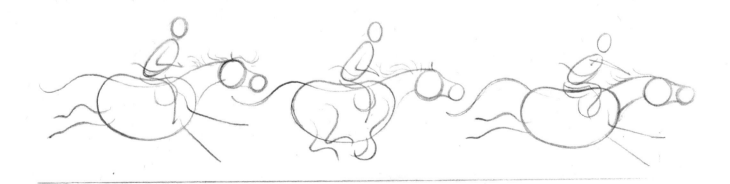

whole figure must be part of the design of the picture to achieve a satisfactory result.

A first-rate rider in action will of course be nicely balanced on the horse, but when we are making pictures we are concerned not only with the relationship of rider to horse but with the balance of the picture as a whole. We may well be making a drawing where the rider has lost his balance and has achieved anything but a happy relationship with his mount. Nevertheless, both horse and rider must make a happy and balanced shape and pattern on the paper.

With your puppet figures you can work out all these problems long before you get involved in the drawing of any details, and it is less discouraging at this stage if you fail a number of times before you get the effect you are after.

Giving him his head

So far we have represented both humans and animals as puppet figures in the simplest form. We have played about with these figures and seen that they are the real bones of our drawings. I hope that you will appreciate what fun may be had with a few bones.

Now we must consider the construction of the pony in more detail. The two spheres which we used to represent the head are a good basis for more careful construction. Draw a line down the centre of the head from the poll between the ears to a point between the nostrils. This will help to get a balanced shape, and a further line crossing it about one third of the distance from the top will ensure that the eyes are drawn level. Another shorter line can be drawn across in the same way to fix the position of the nostrils.

Try to make drawings from nature of heads and parts of the head as often as possible. This will help you to understand the construction of eyes, nostrils, ears, mouth and so on, but in addition you must practice drawing the head from memory in order thoroughly to assimilate what you have learned. Photographs can also be a great help, because although they may not be so useful in developing drawing techniques, you can at least sit comfortably and study them at times when you may not be able to study the living animal.

Do not draw constantly from photographs, however. Drawing from nature is always better, even if more difficult, both from the point of view of learning to draw well and of learning about horses.

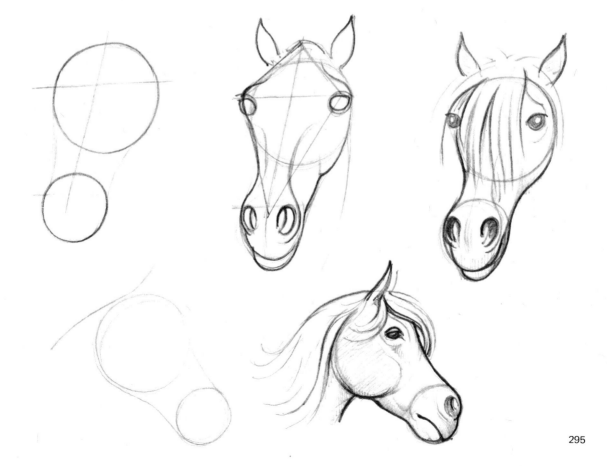

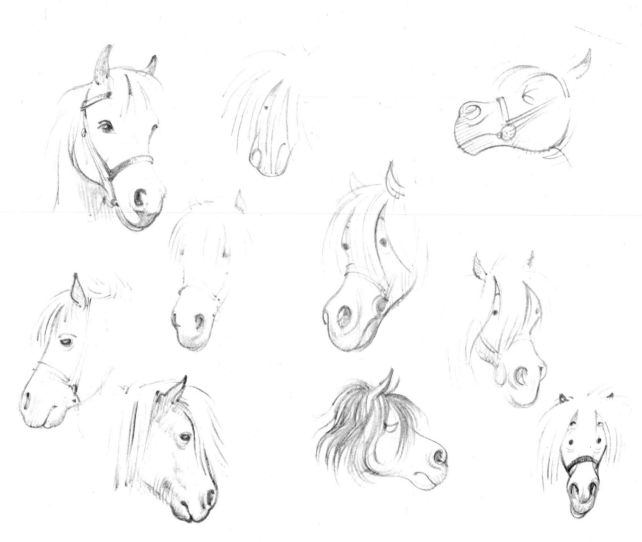

We can create expressions on the face of human beings in a remarkable way by the use of a few very simple tricks. Up-turned corners to the mouth will express happiness, pleasure or self-satisfaction, whilst a downward curve will express sad-ness, annoyance or anger.

The way we represent the eyes as dots, or circles, or slits will also express a great deal, and the position and form of the eye-brows can have quite surprising effects. When we combine all these in their various forms, we have an endless variety of facial expressions which are the stock-in-trade of the cartoonist.

In showing the feelings and emotions of ponies, and indeed of any animal, the same method can be used. Remember, however, that animals are not human, even if humans are animals, and they cannot laugh or cry in real life. Although in the world of our imagination we can make our animals be-have exactly as we choose, yet we must beware of taking things to the point where we destroy their essential animal charac-teristics.

Compared to the human version, the nostrils of horses are large, mobile and very expressive. The value of nostrils in human expression is to some extent limited by their relatively small size and lack of mo-bility, but in the case of the pony they are one of the most valuable points to seize upon because they are so characteristic.

Pony tail

The tail and mane of a pony are very important indeed, not only to him for flicking off flies and keeping them out of his eyes, but also to us when we come to draw him.

The way the hair flows or hangs can suggest a great deal about the creature. It can be a valuable indication of his emotional state or medical condition, or just of his mood of the moment. Its texture and position can also help greatly in suggesting external conditions such as wind or rain or the irritation of insects on a hot afternoon.

They can also help very much in suggesting speed, movement and actions of all kinds, because the loose hair is so mobile by comparison with the more solid parts of the body. This contrast between the hair and the rounded, solid form of the body and legs is also very important in that it gives us most useful textures and patterns to play with in our drawings, and makes our pictures more interesting, varied and pleasing.

A dark tail and mane on a lighter pony or lighter hair against a darker body can produce the most pleasing pictorial possibilities, whilst the hair texture itself can produce the most interesting contrast with the glossy surface of a well groomed animal or the varied materials of riding clothes and tack.

Bandaged tails and plaited manes are also interesting in shape and pattern and add to the endless possibilities of picture making.

297

Legs to stand on

The sequence in which a horse moves its legs when in motion is very difficult to follow and to understand by simply watching horses in action, particularly when they are moving quickly.

If you look at old sporting prints, which are drawings made before the invention of photography, you will see that although man had been closely associated with horses for hundreds of years, he did not fully understand their action, particularly at the gallop.

The result was that galloping horses were represented as having their legs stretched out in front and behind in the stiff unnatural manner of a rocking horse. The invention of photography changed all this. By taking many individual pictures of a horse in action, from the walk through the trot and canter to the gallop, it was soon possible to study the natural sequence of leg movements and to understand them exactly.

The slow motion camera has made this even easier to follow and to understand, and you should take every opportunity of studying the movements of horses from photographs. However, although photographs show the correct movements, they do not always appear to do so, and certain individual photographs may not suggest smooth movement and action at all. It is up to you to learn and then select from the knowledge acquired. It is more important to give an impression of rhythmic natural action than to worry too much about reality.

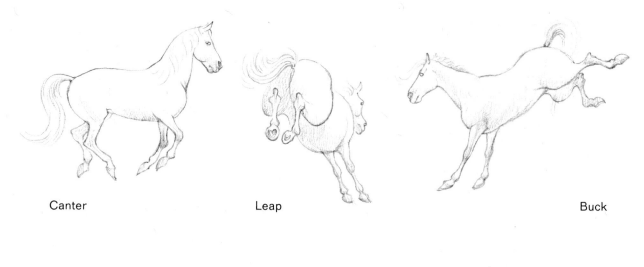

Canter Leap Buck

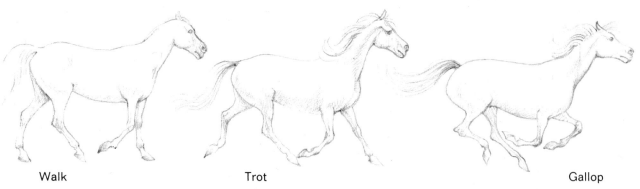

Walk Trot Gallop

Riding country

However well you may draw animals, if they are set in an unconvincing background the results will be disastrous. Whether the surroundings be detailed and full of interest, or the briefest suggestion of space, the drawing must never be skimped.

We have already seen that the sketchbook is our most valuable asset in acquiring knowledge of ponies and of improving our drawing skill. It is just as invaluable when it comes to the drawing of landscape and settings of all kinds.

You may wish to take all kinds of liberties in the creation of your pictures, and there is no rule which says that your backgrounds must be realistic in treatment. This is a matter for each individual to work out for himself and to interpret through his imagination and invention.

Your imaginative efforts are, however, unlikely to be convincing unless they are based on sound knowledge and careful drawing.

Notes should be made at every opportunity of anything and everything which may be useful to you, from mountains to molehills and from trees to grasses. Your sketchbook will become an endless supply of patterns, shapes and textures which will be most useful when making pictures.

Unless you are lucky enough to have a natural feeling for perspective, it can be a complicated subject of study and we do not have the space to go deeply into it here.

Before we leave the subject of background, it should be said that photography can help us just as much here as in learning about horses themselves. We may not wish to confine ourselves to drawing horses in the limited localities in which we live or

'It's so sordid Charles - having to meet like this.'

'He knocked down the last fence - with my foot.'

travel. The world is a big and varied place, and even in this modern world it is not easy to journey to the prairies of America to draw cowboys or to the steppes of Russia to get backgrounds for Cossacks. Even if you are lucky enough to travel widely, it is unlikely that you can go everywhere where there are horses. It is very useful, therefore, to make a collection of photographs and clippings from magazines and newspapers of interesting backgrounds and settings.

The Australian out-back, the inside of the big top at the circus, the hunting country of Europe or the pampas of South America - any of these settings and a million more may be the backgrounds you require. Use photographs for reference, but *never* neglect drawing from life in your sketchbook.

Horsey people

In spite of the fact that men have been falling off horses and being bitten by them for countless ages, a bond of friendship exists between them which is astonishing to say the least. So complete is this link, that it is difficult to think about horses without also thinking about horsey people. These types are even more numerous, if anything, than the types of horses, and they are rich material indeed for our purpose.

Show-jumping arenas are not only full of them but are also surrounded by them. There are the competitors themselves, from the red faced sporting colonels to the tiny enthusiasts who must be lifted into the saddle. There are the spectators who watch them, from the doting mothers to the critical connoisseurs, and all are fascinated by everything from the winning of a rosette to the breaking of a collar bone.

The hunting field provides a rich vein of characters to explore and use, and so do the dealers, horse doctors, blacksmiths, riding mistresses and equitation experts of all kinds.

The race courses are crammed with horsey people, from the jockeys and stable lads to the elegantly dressed racegoers and down-at-heel tipsters.

There are cowboys and gauchos, cavalry soldiers in richly elaborate uniform and circus performers in spangled tights. And of course many others.

Many of these people we can meet and get down in our sketchbooks, but others we cannot, so again we must make use of photographs and pictures of all kinds.

Even photographs cannot tell us much about the horsemen of early days, the knights in armour, the mounted hordes of Ghengis Khan, the Crusaders and coachmen, but other artists have gathered the information and reconstructed the clothing and trappings, and this is one way at least in which history books can be fascinating.

On form

It is the effect of light falling on to objects and being reflected off them again that makes them appear solid. To achieve an effect of solidity and mass in your drawings, therefore, you must first decide from which direction the main source of light is coming. Surfaces facing in this direction will obviously be light, and those facing away from it will be relatively darker.

In most cases light will be reflected back again from the ground surface and other objects on to the darker surfaces of the object you are dealing with, and this helps enormously to show the three-dimensional form. By fixing the main direction of light, you can also work out the size and shape of the shadows which will be cast by an object on to the ground and on to other objects nearby.

Most objects in your drawings will have surface texture of one kind or another; hair, cloth, stone, brick, leaves, grass and so on. Use these surface textures not only to record facts but also to give variety and interest to your picture. When suggesting these materials in a drawing, do so carefully and in the right places and the textures themselves will produce tones and shadows

Fountain pen drawing from Thelwell's Riding Academy

which will make the drawing look solid and three-dimensional.

We have touched briefly on perspective in the geometrical sense earlier, but there is another aspect of perspective which must be dealt with. This is sometimes referred to as 'aerial perspective' because it is concerned with creating a sense of space and distance between objects in a drawing or painting.

We have all noticed at one time or another (particularly when looking across open landscape) how objects far away from our eyes appear not only smaller but paler in tone than objects in the foreground. Strong lights and darks and colours merge gradually towards grey as they get further away. This is due to the increasing amount of air between the objects and our eye.

It is relatively easy when using colour or washes of tone in a picture to suggest this illusion of space, but when only black line is being used it is harder to deal with.

The effect can, however, be created by the relative weight of line used for objects in a picture. Foreground objects should be drawn with a relatively strong, bold treatment. Objects in the middle distance should have a lighter touch and thinner line, and if any solid blacks are used at this distance they should be kept to a minimum. The far distance will be suggested with a finer line still, and no solid blacks used at all.

It also helps if some white paper shows between the linework of the objects in the foreground and the finer lines of distant objects, so that they do not quite touch each other.

The finishing line

It may be of interest to take a problem of illustration and work out the stages necessary to arrive at a finished drawing.

In this case we wish to illustrate a situation where a child has neglected to pay her fee or 'cap' for a day's hunting, and the hunt secretary is keen to collect his dues.

We are creating the characters, so it is up to us to decide how they will behave. Before we can think about composition, we must decide how the secretary will get to grips with Sandra and her money.

He could perhaps put the hounds on to her. That's an idea! But in order to get a pack of hounds into the size of page we are allowed, we would have to make our main characters rather small. He must obviously run her to earth because we know her - and so does he - and she will be deaf to any sounds she doesn't want to hear. When he catches up with her, how will he stop her? No lasso in the hunting field. But wait! That handle on his hunting crop will hook nicely round a field gate, or most other objects when necessary. His problem is solved - now for ours.

We want to tell the whole story in one picture. The chase, the closing in, the moment of truth. We have made a start. Let us continue.

Stage I

In the passage above we have set ourselves a problem and have decided what we are going to draw. Now we must work out our composition. At this stage we are not concerned with detail remember, but with finding a design which will put over the facts clearly and in as interesting a way as possible.

First, make a number of little drawings of the situation on rough paper. Try different angles and points of view but keep your sketches small, bold and simple. Work on them until you feel you have tried all the approaches to the subject. Then choose the one you like best and think about it very carefully.

Stage II

Now we must make a full size drawing of the composition chosen, but before we do so we must think about possible changes if these will improve the design. We must think about movement and balance and change anything which was not quite satisfactory in the first sketch.

The legs of both animals made much the same sort of pattern, so we have changed the legs of the pony to add contrast and variety and also because the pony now gives us another stage of the galloping movement (exaggerated, of course) and adds to the feeling of progressive movement. Both riders wore the same kind of hat. Changing one of them adds variety of shapes. The direction of light and main tones should be considered at this stage.

Stage III

Some artists like to trace their preparatory drawing off on to a clean sheet of paper before doing the finished work. I find it less tedious to redraw it if necessary, but this is a purely personal matter.

The important thing is to enjoy working on the finished drawing; have fun with it, or it may look tired and overworked.

The object should be to make it look as fresh and spontaneous as possible, however much toil and effort may have gone into its creation.

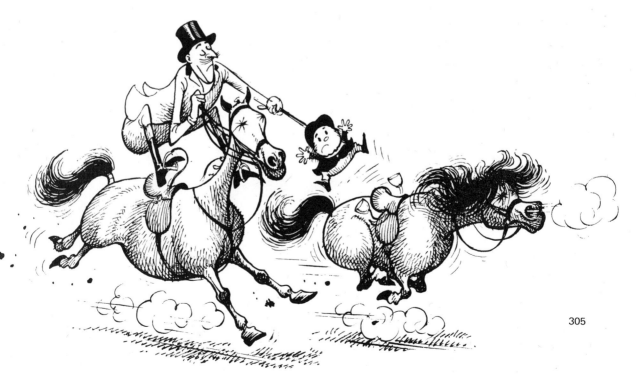

305

Summing up

This section has been about drawing ponies; in fact it has been concerned mainly with how I go about drawing them.

However, on reflection I am sure that in many ways it would have been very similar if I had been asked to write about drawing cows or pigs or monkeys. The main principles of drawing apply whatever subject one happens to be concerned with.

The fact of the matter is that there are no rules in the strict sense of the word for producing a picture. It is unlikely that the prehistoric hunters who painted on the walls of their caves worried over much about rules, yet their pictures have an effect as satisfying and delightful in their own way as anything which has been done since.

The thing that matters ultimately is the drawing, rather than the methods used to achieve it, and no two people will go about it in exactly the same way, which is why pictures and picture making is so endlessly fascinating.

There are, however, certain principles which are helpful in putting young artists on the right lines, and I make no apology for repeating some of them.

Knowledge is never wasted, and the more we can know about a subject the better. Those cavemen may not have cared much about rules, but there is no doubt whatever that they knew the subjects they painted very well indeed.

Study your subject then and use every possible means of doing so. From photographs and books and from the work of other people, but most important of all, from personal contact with the subject and by drawing from life.

Remember your sketchbook. It is the most important piece of equipment. Using it will teach you about your subject and teach you about drawing.

It is pointless to try to do with pen or pencil what a camera can do much better, but this is no excuse for lazy, inaccurate drawing. However inventive and fertile your imagination may be, your pictures will be better if based on careful observation and careful draughtsmanship.

Learn from the work of other artists by all means, but do not try to produce the same pictures. At best you can only be a clever mimic. Your own personal interpretation of a subject is the only one which will have any real meaning and life of its own.

Experiment with materials. Again, there are no rules unless you are working for publication in a certain paper. What will excite one person may bore another. The very nature of materials will suggest new fields of interest and exploration. Materials for drawing and painting are infinite in their variety nowadays, and it is well worth trying anything you can afford.

Remember, however, that the most delightful results are often achieved with the most restricted materials, and that the limits set by a given material may often add enormously to the visual pleasure of a piece of work.

Drawing is hard work but it is also absorbing and delightful work. Whatever you are working on, enjoy it. Your delight will show in your finished work, and those who see it will share your pleasure.

Cartoons
Michael ffolkes

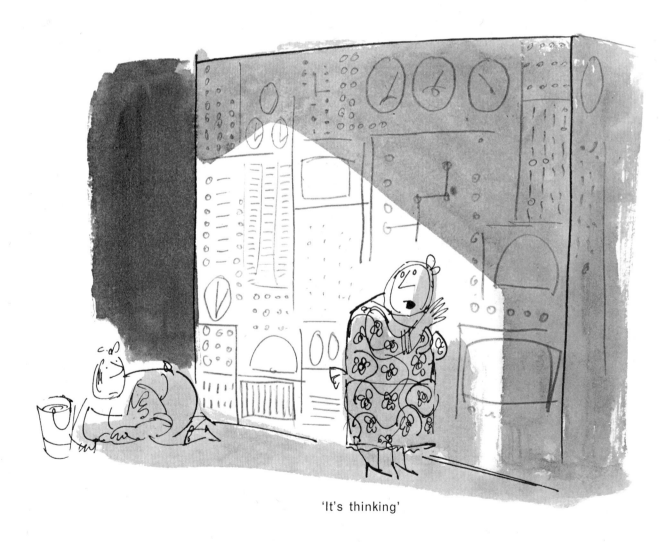

'It's thinking'

Most cartoonists submit 'roughs' before committing themselves to the finished drawing. In this rough (8''x 10'', pen and ink, pencil and wash) the basic problems of composition and light and shade have been solved.

Fig. 1. The Editor as he is popularly imagined

Fig. 2. The Editor as he really is

'Where do you get your ideas from?'

Every cartoonist is asked this question and there never seems to be a good answer. From Outer Space, perhaps.

But let us assume that you are lucky enough to have an original sense of humour and would like to know how this can be turned into a cartoon. This book has been written with an imaginary Editor always in mind, for however agreeable it may be to draw for one's own private pleasure, it is twice so to see your work

ACTUALLY REPRODUCED

Before turning to how this magic state can be achieved, let us look first at what the cartoonist is. He is a story-teller, in pictures, and his whole quality depends on whether he has a good story to tell and an interesting way of telling it. The stories are short and they should be told easily and suddenly. The drawing should appear to have arrived on the paper as naturally as a conversation.

As the Romans say, 'The sign of Art is to conceal Art'. However much blood, sweat, toil and tears have gone into your work the final result should appear natural and spontaneous. It won't always succeed but this must be your aim. Only the artist should know how much he suffers!

The Right Lines

We shall begin with the human face. A very few lines can be made to convey exact expressions.

Drawing the face from the front, back or side starts with an oval. Draw a dozen blank ovals and fill them in with dots for eyes and a mixture of straight and curly lines for noses, mouths and ears. By raising the corners of the mouth, the face will smile. By lowering them it will grow sad. If the eyes are wide circles the face will stare and other lines will make it wink or sleep or gaze tranquilly back at you.

Above these the eyebrows add enor-mously to the expression. Raise them for a quizzical look or surprise and drop them for anger or concentration.

In achieving the more delicate shades of expression you will find your own face and a hand-mirror a great help.

As you go on drawing, these ovals can be broken up into many more complicated shapes but the essential way of achieving facial expression will not alter.

Another way of completing your character may be to use tone on the face, from the faint blush on the young lady's cheeks on page 314 to the deep purple glow of a furious brigadier.

Tinker Tailor Soldier Sailor

Rich Man Poor Man Beggar Man Thief

A Sense of Proportion

The head must now be attached to the rest of the body. In cartooning the normal human proportions are changed. Most adults' heads fit into their bodies between 7½ and 8 times, but as a cartoon drawing is concerned to simplify the world we see, even apart from producing a comic effect, the head is usually enlarged so that it fits into the body only three or four times. (There are exceptions to this.) This makes for a more compact figure whose actions can be compressed into a smaller space. Always a good idea when considering that Editor of ours!

Now begin by making a dozen drawings based on the proportions below and on the oval shapes on the next page. Try to create a different man or woman on top of each of these dummies. Children, of course, grow their heads first and bodies afterwards so their proportions are even more compact. Pretty girls we will turn to later. Vary the heights of your characters, also their stance. The human figure, however curiously shaped, generally manages to balance: in drawing standing people make certain they really stand on their feet. There's a lot of fun to be had with feet. Tailors try to make dummies of us all. Emphasize the parts

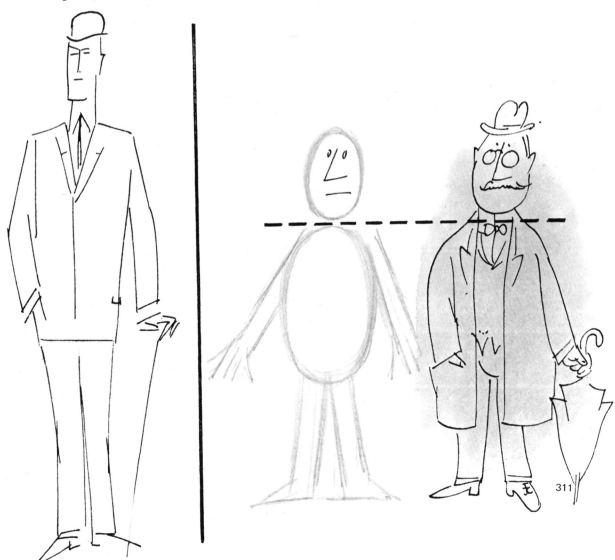

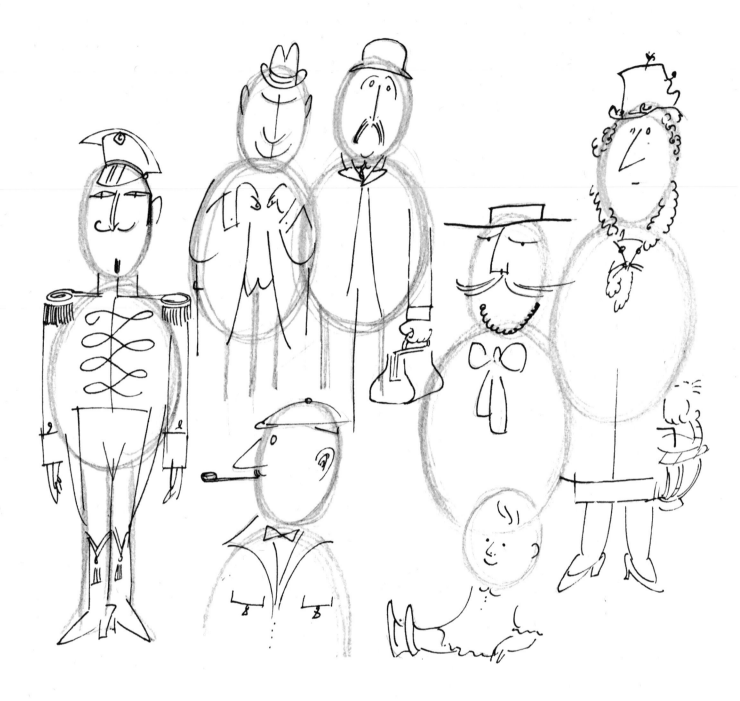

of the body they cannot hide: cuffs, collars, ties and socks.

For the creation of a wide range of characters you must accumulate a large assortment of theatrical 'props' to help them dress the part.

Hats
Suits and Shoes
Moustaches and Beards and all kinds of hair
Umbrellas and Walking Sticks
Glasses
Gloves

Hearing Aids and Buttonholes
Pipes and Cigarettes, etc.

By varying the characters' dress and optional extras many recognisable types can be developed, a fundamental step in making your audience believe in the fantasy world you are trying to create.

Don't hesitate to destroy any drawing that hasn't worked out. Much better to start all over again with the greater knowledge of your problem that the first attempt provides.

Action!

The young artist tends to draw in straight and stiff lines but the cartoon character must live and breathe convincingly in his own world. As we have said, the cartoonist is a story-teller in pictures and he must be able to choose the right movements and gestures for his story.

Let us forget those upright tailor's dummies and make a few random lines on the paper. Now develop these lines into people bending to different tasks. A drooping line may suggest an old woman clutching her stick. A crescent can be translated into a weight-lifter or a sergeant-major. Act the part yourself. Feel the correct way to move your characters' limbs by taking up their positions.

It is perfectly fair, in fact often desirable, to over-emphasize and distort some part of the anatomy to make a dramatic point.

By animating your characters you add enormously to the vitality of your drawings and this will communicate itself to your audience.

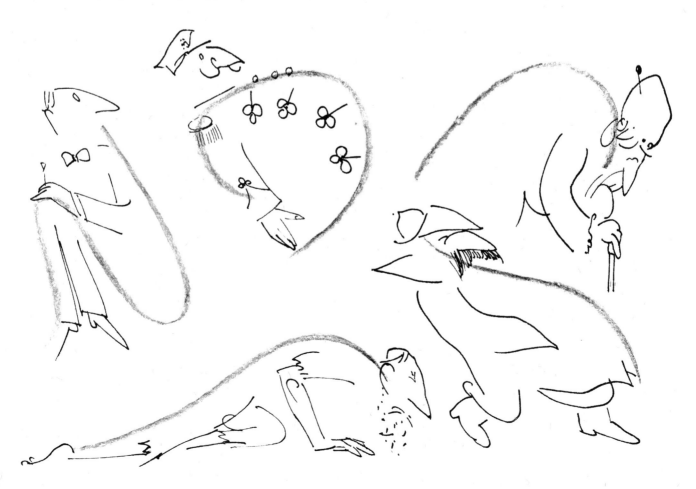

The Ladies, God Bless Them!

One unquenchable source of humour is the battle of the sexes, so we must be able to draw both Adam *and* Eve. Of course, this can be reduced to repeating the male figure and adding long hair and a skirt; but properly speaking, women are a complete subject on their own.

It may be more difficult to create a wide variety of character when drawing women as you are denied the opportunity of adding moustaches and beards and briar pipes. To balance this, however, one may employ lipstick and eyelashes, so perhaps there is not so much difference between the two.

Men's fashions have remained fairly static for the last fifty years but women's clothes are continually changing. Some awareness of contemporary hairstyles, hats and hem-lines will help to bring your characters to life, undoubtedly a help to please an Editor who is always looking for the comic artist with an exact eye for present-day absurdities.

Simplicity Itself

No, this doesn't mean drawing cartoons, which can be quite complicated and difficult. The simplicity refers to the need to make the clearest possible statement of your characters, their background and their dilemma.

Avoid all unnecessary detail. Make the focal point of your picture stand out. Refrain from filling every corner with objects or shading. If four fingers and a thumb seem too many to manage reduce them to three fingers but keep the thumb. (Walt Disney's animal characters were always drawn in this way.)

The drawings on the opposite page were made the same size as reproduction but this is a personal matter. Few artists produce originals actually smaller than the size they will appear in a magazine, though there are some. Most of us prefer to work larger, but the scale of the drawing does not mean that it must contain a lot more information but only what is relevant to the situation you are describing. Train your hand and eye to put down on paper rapidly recognisable situations like these in the fewest possible strokes. One significant detail is worth far more than an uncertain clutter of lines that don't really describe anything. Make dozens of small pictures like these, drawing directly in pen and ink so that the pen becomes a natural drawing instrument and not something that can only be used to work painfully over carefully prepared pencil lines.

One thing in particular to remember. Your audience must be in no doubt as to who is speaking, so open the character's mouth.

Ideas

Humour is beyond simple analysis but here are a few sub-headings. There are lots more.

Matrimony (wife and rolling pin)

Exaggeration (well, exaggeration)

Understatement (polite surprise at an avalanche)

The Reverse of the Usual (man bites dog)

The Disaster (banana skin, loss of trousers)

The Impossible (flying pigs)

The Situation We All Recognise (lost collar stud)

The Saucy (wrong bedroom)

Animals Behaving Like People

People Behaving Like Animals

At some time or another you are likely to produce ideas that come under all these headings, but this should happen by chance. Artists don't get up in the morning and say to themselves 'Today I will think up some terribly funny stuff on the subject of the Situation We All Recognise'. It just doesn't happen that way. Thoughts merge into one another, an idea takes on various unclear shapes,

appears to be captured, but too often gets away. It is disconcerting or encouraging, depending on how you look at it, that the air in an artist's studio is throbbing with funny, saleable ideas, invisible like germs in water, until by some chance or insight, one of the lovely things is caught and written down on the back of an old envelope.

When is an idea not an idea?

This is a great conundrum and it may be our friend, the imaginary Editor again, who will solve it for you.

Often the artist is quite misled about the quality of his ideas. Certainly they can seem far less funny once the first sweet rapture has passed.

No-one can be taught how to be brilliantly funny but he *can* be discouraged from being positively unfunny. On this page are a few situations that have been done to death. These are some of the clichés that make Editors sigh deeply, at the very least. It is not actually impossible to find some new and worth-while variation on these themes, but the chances are small and there are so many other paths to pursue.

The Desert Island
The Bed of Nails
The Psychiatrist's Couch
The Raft
The Magic Carpet
The Optician's Card
The Measles

Finally, there is the question of Bad Taste. Of course this is a matter for each individual conscience, and some jokes may be in undoubted bad taste and make everyone laugh like mad. But there's a line to be drawn somewhere and our Editor will draw it if you don't.

The Constant Sketchbook

It will seem an obvious thing to say but the way to learn to draw is by constantly drawing. Draw everything and always carry a sketchbook. Some people are blessed with magnificent visual memories and can conjure up anything from a watering-can to a Boeing 707 without difficulty. However, for most of us it is essential to take notes and the sketchbook habit becomes a MUST.

When drawing people try to make yourself invisible as not everyone enjoys being watched. (The great draughtsman Toulouse-Lautrec drew in his pocket!)

Of course it isn't enough to study people. A hall-stand can also have a unique character. A whole day can be spent in drawing all the articles in your own or a friend's home from a regimental tie to the lawn-mower. The artist's mind

'*I'm starting hay-fever*'

(7'' x 11''. Pen and ink and wash)

must be stocked with all the appearances of the visual world, for the more he sees and remembers the wider his range becomes.

The sketchbook habit will develop your aptitude to note things down quickly. No matter how rapid and scribbled your notes may be they can provide the spring board for your memory to re-create something seen once and otherwise lost. What may be the merest shorthand to an onlooker may contain the bones of a future drawing for you. Visual notes do not have to take the form of a blueprint or catalogue to be of value.

Remember, if you aren't quick *enough* your quarry will have gone. In finding the most explicit line to record an event you are at the heart of being an artist.

Picture Library

To amplify the information being collected in your sketchbook it is useful to keep a file of newspaper and magazine clippings of any visual reference that may be of interest. Knowing that somewhere in that large pile of old journals is buried just the picture you require can be most frustrating. Cut everything out as it comes along and file the material away in appropriately titled folders. After a time you will have acquired many pieces of paper and sub-divisions will become necessary and numerous. Also collect picture books as far as your pocket will allow and between the three sources of information (your sketchbook is still the most important) you will be able to tackle quite diverse subjects.

The purpose of all this is not merely to reproduce line for line the piece of reference but to borrow from it certain facts and shape them to your own imaginative needs.

319

'I don't care what's up there, I'm not going!'

(13'' x 10''. Pen and ink and wash)

Setting the Stage

In a sense the cartoonist is the complete theatrical manager. He chooses and dresses the cast, paints the backcloth and furnishes the stage.

So far we have learned to create individuals taking up their positions in backgrounds containing necessary objects, and observing them from a fixed position.

The next step is to decide precisely what their positions should be and how their setting should be arranged. Just as in the first stages it was important to avoid straight lines, it is now as important to avoid the obvious and symmetrical.

Your actors do not have to occupy the centre of the stage and they certainly should not be the same height as the furniture. Don't arrange them like nine-pins. The purpose of composition is to create movement and space in your picture and all the powers of your imagination will be required to invent interesting but balanced designs.

The most important weapon in your armoury is the white paper you leave untouched. It creates light and space and the shapes that are formed *between* objects can be just as satisfying to the eye as those of the objects themselves.

Again it is a good idea to imagine yourself as part of the picture, being able to touch the chairs and tables and shake hands with the gentleman with the drooping moustache.

Point of View

So having created our players and considered their positions on the stage, we must now place them in their proper settings.

To do this requires a large repertoire of sofas, lamp standards, coffee tables (and coffee pots), doors, dados and desks (see 'the Constant Sketchbook').

Visit country houses open to the public. If you have a television set make notes from the image on the screen. Plays are acted in carefully planned sets comparable to the ones you will try to create on paper. Drawing these backgrounds will bring you to the problem of perspective, a complex subject which must be simplified here. The principle to remember is that everything above the eye-level slants down towards it and everything below slants up towards it. The place where these lines converge is called a vanishing point.

One or two vanishing points will suffice to build most settings and the diagram on the opposite page contains the essential elements.

The important thing is to decide on your eye-level. This may grow quite naturally from the story you are telling, bird's eye or worm's eye view. To give a sense of large scale, as in a museum or palace, you must look up. Looking down will make things seem smaller. In general most artists observe their worlds from the human eye-level, that is about five feet above the floor.

'I'm not sure we haven't taken a wrong turning somewhere'

(7½'' x 11'')

'Do you ever get the feeling our flag's fallen off their map?'

(7" x 11". Pen and ink and wash)

All Shapes and Sizes

The people whose job it is to put magazine pages together often welcome a drawing of unconventional shape because it allows them to build their type in and around it and so create variety.

We have seen already that in the name of simplicity distracting and unimportant details can safely be omitted. With the considered elimination of ceilings and walls that have no part in the story new shapes will emerge. Of course some jokes cannot be told in one picture and then the action has to be sustained over 5 or 6 smaller ones. This is the strip cartoon that can wind its way at will over the page, always providing the reader knows where it starts and stops. These moving cartoons make a pleasant change from the static situation but require from the artist a certain amount of discipline. There

must be a real continuity from one picture to the next.

One small thought about sizes. It is usual for an artist to work somewhat larger than the reproduction size. Half as large again ($\frac{1}{2}$ up, as it is called) or twice size are the usual ratios, and the reducing process always seems to improve the qualities of the original. Of course some artists need to make the drawing the size of table-cloths; for them a reducing glass becomes a necessary item of studio furniture.

Nowadays quite thin lines can be reproduced; but too many of them create a spidery effect. A published cartoon has to stand up on the page against all sorts of competition. So don't be too shy and retiring in your drawing.

Watercolour

Although a few simple lines and solid blacks can often perfectly well convey the essence of a cartoon idea, this is not the end of our resources. Many professional cartoonists brilliantly exploit the painter's world of light and shade and with the vastly improved quality of half-tone reproduction in modern journalism we must examine the more complex technique of watercolour.

The successful handling of this medium requires much practice. There is only room here for some simple rules.

The accent must be on water. This allows the paint to show off its lovely qualities. If heavy matt effects are required, use poster colour. Preserve as much as possible the white ground of your paper. It is this that gives the washes their freshness and transparency.

Always work from light tones to dark. Plan ahead. If the area to be covered is large, moisten it first with clean water.

Mix enough colour for your needs because of the difficulty of matching tones.

Watercolour dries lighter than it appears when wet on the paper so allow for this.

The ideal brush is a fairly fat one that comes to a perfect point.

Constantly refresh the water-pot. Keep plenty of blotting paper handy. You will need it for removing excess water and for toning down tints. A small sponge is also very useful. Provide plenty of rags for wiping brushes (and possibly yourself).

Determine the source of light. Everything turned towards it will be lit and objects turned away will be in shadow. Although it may not be necessary to follow a careful lighting plan throughout the whole picture, on no account should there be an absolute contradiction of the natural laws.

To intensify the dramatic content a bold stroke may be used to introduce

'Where did you take that damned plank from?'

(9" x 7". Pen and ink, pencil, wash and felt nibbed fountain pen)

323

'Isn't that young Miss Taylor who had
the corner table by the bougainvilleas?'

(6'' x 6½'')

a silhouette of almost unrelieved darkness. If the shape is going to be such an important element it should be well designed.

The training of the hand to obey the eye takes time, so try not to be in too much of a hurry to arrive at a personal 'style'. This will come out of your *own* solutions to the problems of drawing. Interest yourself in other artists' work, of course, even to the extent of dissecting them to see how they work. But the way a person draws is as revealing as an autobiography, and it is essential that an artist's style should be his own particular way of saying things and not borrowed ready-made off someone else's peg.

'All right. I'll allow you to
play the stroke again'

(11¼ x 9''. Watercolour, pen and ink)

Production Line

Let us follow the development of a cartoon from the first scribble to the final signature.

It may be necessary to try different compositions. Do your early drawings on a large lay-out pad. The thin paper allows you to trace each stage from the preceding one as often as required. This repeated drawing will make you more and more familiar with the problem and the last version should be the most fluent. Preserve each succeeding drawing as there may be some early thought that might otherwise be lost in the changing process. A good idea is to arrange all your drawings side by side to judge whether or not you are going in the right direction.

When the basic arrangement has been settled, transfer this onto a clean sheet of paper by blacking the back of the sketch with a 6B pencil or by placing a sheet of red transfer paper (not carbon) between the two surfaces. Before proceeding to pen and ink, pencil in any undecided parts of the design. You must be clear in your mind about the details before making marks that cannot easily be removed.

Now the lines are drawn and the solid blacks filled in. Start again if the drawing is not working out properly. Irritating hours can be wasted trying to save a poor start. Overworked drawings (and paper surfaces) are disagreeable both to you and everyone else.

When the cartoon is complete add your signature. This should not be too large and tricky; complicated ones are out of fashion. Place it with care, even as part of the composition.

Let us look now at this graphic development of an idea, stage by stage, over the following three pages.

The subject; rats, a sinking ship. Not sinking fast enough, perhaps.

Now the deck slopes about right. Froth the sea. Those rats don't look right.

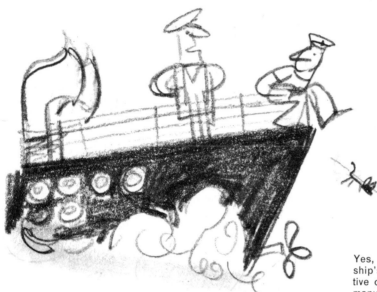

Yes, that seems to be a better composition and the ship's detail is coming along. Perhaps a bit of perspective on the rail would help, though we don't want too many facts. Make hull pretty dark and dramatic!

This sailor... Not really simple enough. Too many arms and legs. Try a different position altogether. Why not have him diving off?

What to do with the officer's legs? They must make a different shape to the sailor's. If the sailor is showing only one leg in profile, the officer should show two, for contrast. Try to get officer-like stance. Makes sense too, because he'd keep his balance better this way. (Remember to have fun with propeller.)

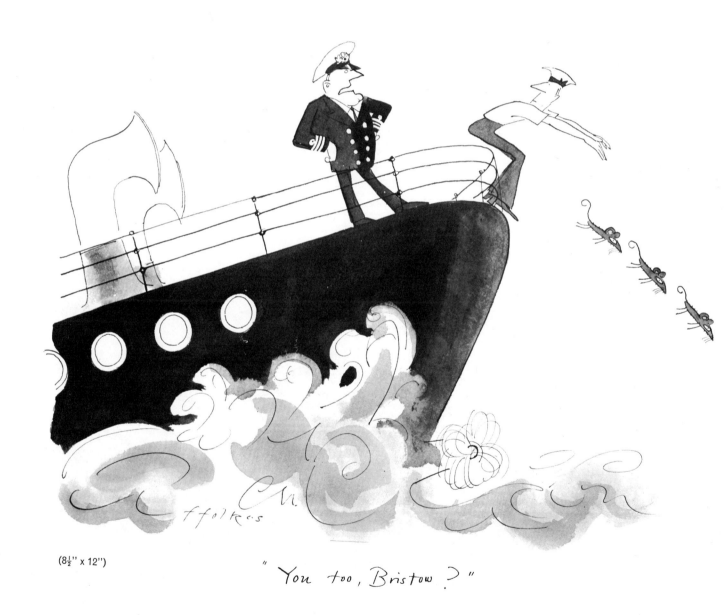

(8½" x 12")

"You too, Bristow ?"

A Good Likeness

To be able to draw your friends is a useful social gift though a good caricature is not always appreciated by the sitter.

As always in cartoon drawing it is important to choose and exaggerate the essentials in creating character.

A long nose: Make it longer.
A weak chin: Show no mercy.

Look for the deviations from the vertical and horizontal remembering that nobody has two eyes set perfectly symmetrically in their heads and that few noses are straight.

If you are ambitious and the drawing is to include more than the face, observe carefully everything that contributes to this one unique person. The way he dresses, hunches his shoulders, holds a cigarette.

In particular note the hands which con-

tain the essence of their owner's personality.

Here we have Henry Willoughby who tends to be rather plump and untidy. He has a pointed, tip-tilted nose, a curly upper lip and a chin that runs back into

his neck rather too quickly. His ears and eyes are small and perhaps his most noticeable feature is the way his hair, which is neither light nor dark, flops over his forehead. He has an Adam's apple.

Having looked at Henry rather closely and decided which of his features to concentrate on, we start with the basic shape of his head, forcing it into a more extreme version of the truth. The profile (and caricatures need not always be profiles) takes shape on the scaffolding of the first lines. However much his face may be distorted it must still resemble Henry, and in fact a good caricature may be more like the person portrayed than he is himself. And so to the final details, that little tuft of hair at the back, his hand perhaps, and the expression on his face when poor Henry sees what you have made of him.

329

The Animal Kingdom

If they aren't actually talking away in the centre of the picture, animals are frequently discovered lurking behind armchairs or large clumps of hydrangeas.

As with the caricature of humans, the important thing is to try and capture their precise qualities. The crocodile is cynical. The chimpanzee is knowing. The cow is placid.

A visit to the Zoo or your local Natural History museum, indeed many visits, will prove most rewarding.

Drawing animals allows many opportunities for inventiveness. Fur, scales, feathers may suggest new textures and techniques but once again it is the overall shape that counts. Exaggerate this in the same way we have learnt to treat the human figure, who is after all only a particularly interesting member of the animal kingdom. As the drawings show complete shapes may be built up over simple ovals and triangles.

(Crayon, pen and ink, pencil, felt nibbed fountain pen and wash)

330

'Catch!'

(4'' x 8½'')

New Worlds to Conquer

The cartoonist can create a world of infinite marvels. Everything that can be drawn may be the subject of a cartoon, so don't be limited to the drawing-room when you can visit the Moon and Ancient Rome, and why spend all your time concerned with coat lapels and trouser turn-ups when you can try your hand at ostrich feathers and winged sandals?

The more intelligent and informed the artist the more interesting his stories will become. It is no exaggeration to claim that comic artists have influenced the attitudes of their own generation. Certain cartoons have become classics and are constantly quoted as the quickest way to convey a particular point of view. James Thurber's famous joke about the host telling his dinner guests that they will be amused by the presumption of the wine he is serving them has made it impossible for many people to think of wine (or some hosts) in quite the same way again. No doubt you will think at

'Personally, I don't think she's sea-worthy'

(7½'' x 10''. Pen and ink)

once of half a dozen favourite cartoons, and for each new generation there will be some drawings that say something new and wise that cannot be said in any other way.

Humour is based on resemblances and contrasts, the unexpected relationships between subjects not previously thought of being related at all. Such as wine being presumptuous. Something that appears most matter of fact when spoken in Suburbia may sound quite differently on the lips of Julius Caesar or Captain Bligh or the White Rabbit. And perhaps if we think hard, there is another reason for Napoleon tucking his hand into his waistcoat that no-one has ever considered before. What really passed through Cleopatra's mind when she picked up that asp? What happens to the apple that fell on Sir Isaac Newton's head? Perhaps *you* know.

Dear Editor

Behind his vast mahogany desk sits the Editor while waves of drawings flood down on him. To win his attention and separate your own work from this sea of paper you must take care in its presentation.

The customary start is to send a selection of your best ideas, say between six and ten, to the magazine or newspaper of your choice. So that the Editor can see that you are capable of completing an accepted idea it would be wise to work up one or two of your drawings to the completed state and label them accordingly. Protect them between sheets of cardboard and attach to your polite letter sufficient stamps for their safe return. Don't explain any of the meanings of your drawings in the letter. If it isn't self-explanatory the idea just shouldn't be sent. Editors have no time to waste on detective work. Discriminate carefully in what you send, as a poor impression is made by including feeble material only to make up the number.

Smartness and cleanliness in presenting your work will count in their favour and the effect is further improved by their being cut to a uniform size. Each drawing should bear your name and address on the back and the use of a rubber stamp will save you a lot of time here.

The market is large as many dailies, weeklies and monthlies buy drawings, and by studying them diligently you will discover their tastes. Fashion in humour changes subtly every ten years or so and you must keep a weather eye on what is being done at this moment. Old collections of past cartoonists may teach you a lot about drawing but little about devising saleable jokes.

And now the great day dawns.

The postman hands you your returned packet of drawings and one of them has the magic pencilled inscription . . . OK. Please finish.

Complete the drawing on good quality paper or board, allow a generous margin all round and if there is a caption, write it in pencil or blue ink - not black, as this may mean the blockmaker will include it on his block.

And, of course, keep sending more ideas.

So you are a cartoonist. Some of you may be courageous or foolhardy enough to take up humorous drawing as a full-time occupation but many people with other interests draw in their spare time and are content to appear occasionally in print.

There has always been a demand for funny pictures and no doubt there always will be. Just as long as there is someone left who can draw and someone left who can laugh.

Ships

John Worsley

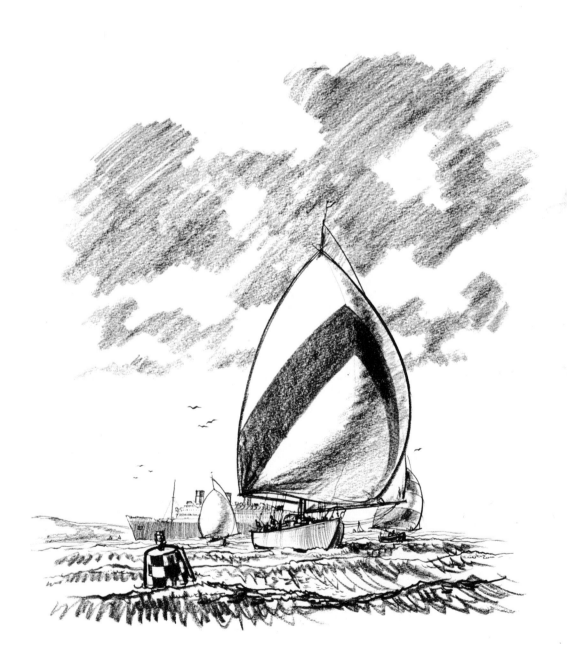

Making Ready

The sea is impersonal; if you fight against it you will lose; only if you use its forces can you win. This is the fundamental understanding of a good seaman, and the law governing the construction of a well found ship. Ships, with their ancient history, are a rewarding life's study. Their construction and function over the ages has depended on the materials available and the skill of the men who built and sailed them.

When we draw ships or parts of ships, and things to do with the sea, we must realise first that they are functional; the more we can understand their function the better will be our drawing. Nature, with her physical laws, must always be paid the greatest respect. Woe betide the mariner (or the artist) who forgets this.

The size of this section limits us to essentials, particularly over the highly technical side of ship construction, and sailing. However, I shall try to cover the ground, or should I say sea, in the simplest and most general way, concentrating on visual effects and appearances.

The pace at which science advances today constantly produces new materials, principles, and sources of power, but there remains always the unchanging nature of wind and weather and the aloofness of the oceans, with their currents and tides, storms and hurricanes. Man, whether he invents sails, steam, diesels, jets, hovercraft, hydrofoils or submarines, must obey rules if he wishes to move across or through water.

There is no place for 'abstract' or 'action' painting when drawing ships and sea. A ship is a mathematical thing, and although its shape may have many subtle curves, they have been arrived at mathematically; it is these curves that give it its beauty. It is also a solid thing; this is the real contrast between it and the elements around it.

335

Propellor of the 'Queen Mary' in dry dock. 2B pencil on very smooth paper.

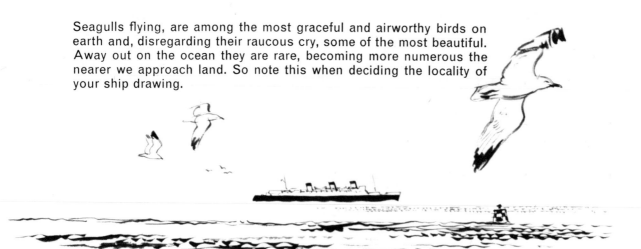

Seagulls flying, are among the most graceful and airworthy birds on earth and, disregarding their raucous cry, some of the most beautiful. Away out on the ocean they are rare, becoming more numerous the nearer we approach land. So note this when deciding the locality of your ship drawing.

When drawing ships, make sure that the drawing has this feeling of solidity as against the liquid naturalness of the sea and the airiness of the clouds and sky. The general shape is of prime importance too, so make sure of this before tackling the details. At sea they tend to look smaller than they really are, owing to the vastness of the sea and sky; whereas in harbour or alongside one feels their full mass. It is for the same reason that the moon appears so much larger when viewed low down behind a landscape.

In this section, when I wander occasionally into the realms of mathematics and science, remember I write very generally from the standpoint of drawing and how things appear to the eye. So let us now make ready for sea and the drawing of ships.

Seeing the Sea

Let us first examine the visual qualities of the element in which ships sail, that is, water. How to make it look wet? Wet things are invariably shiny and reflect. You may say that there are many things that do not seem to look shiny when wet, such as a coarse fabric, or a blanket. The reason for this is that their surfaces are broken up by the fibres or texture. Each fibre is shining but in a different direction from its neighbour, resulting in a million tiny reflections in all directions cancelling each other out. Water, being as one might say 'pure wetness', must therefore be 'pure shininess'.

Unfortunately, we come upon a snag here, as it is also transparent. If you stand at the edge of a flat calm swimming pool with a dark bottom, and look straight down, you will see right through the water. There may be a little reflection from the sky or a bright light above, but the main effect is one of transparency; you see the dark of the bottom. Now let your eyes move slowly up towards the far end.

Reflections

45°

Penetration

There comes a point at an angle of sight of about 45° when the quality of reflection becomes stronger than that of transparency or penetration; you begin to see only the reflection of the sky or whatever is at the other end.

Although this is not absolutely scientifically correct, it can be a good formula for the artist; if we assume that the change over from penetration to reflection is a definite line, we evolve a method of depicting water which will give the desired appearance. So, together with keen observation, we are half way there.

Now, if there are waves on the bath, you will get alternate penetration and reflection as your line of sight on each wave passes across this 45° point. The dark patches will be the transparent areas, where you see deep into the water, and the remainder reflection. Study the drawing below.

If the waves were geometrically regular at right angles across your line of sight you would see straight horizontal streaks diminishing in thickness to the distance, like those in the drawing on the left below. But, as nature abhors a straight line, the waves are wavy across as well; although not so much. So what you actually see is the effect of the drawing on the right below.

The white is the reflection from the sky and the dark the transparent part. In the distance, no part of the wave surface is 45° to you, so you see through the water no more.

Theory Practice

If we now put a boat at the far end of our bath, it will be reflected in each wave in the same way. The more wavy the water, the longer will be the broken reflection. BUT ... if the water is *very* broken it becomes like our wet blanket with millions of reflections from all places at once, cancelling each other out and giving a dull all-over sameness.

Theory Practice

So when drawing or painting a ship on the sea, try to decide what state the water is in. LOOK ... and analyse where the reflections are coming from, then your ship will appear true and the water will look like water.

This drawing, made with a 4B carbon pencil on cartridge paper, is of a modern trawler in a very calm sea. In this case the main reflection is slightly broken by a light local breeze, giving a line of small wavelets which again pick up the light of the sky. These can be put in with small flecks of white paint, but should be kept very regular. An alternative method is by dragging a sharp penknife point across. Note the dark area of penetration in the foreground. Practise making simple drawings of this kind.

Running into Rough Water

In a rough sea, as I have said before, because of the very broken water you will get hardly any clear reflection but, instead, strong shapes of waves. The whole effect must give a feeling of anger and violence. There will be big troughs; your ship will be 'shipping it green' as the mariners say. Each massive wave must have that feeling of great weight. Keep the wind direction uniform. Very probably large pieces of your ship will be blotted out by areas of white foam, so don't be afraid of doing this, if necessary with chunks of white paint.

The drawing will be more interesting for the contrast between the dark hull of a ship and these breakers, and, of couse, she is unlikely to be on an even keel.

Try drawing heavy seas in this way, using a dark soft pencil on very smooth paper. Work as swiftly and as busily as you can, 'feeling' your way along the crests of the waves as you draw.

These are drawings of the 'Kon-Tiki', the famous balsa wood raft that made the perilous voyage across the Pacific Ocean from Peru in 1948. The more you can understand the construction of your subject, the nearer you will be to getting a feeling of authenticity. Make separate studies of details first, to make yourself familiar with a ship before starting on a drawing.

These drawings were made with a 6B pencil, often using the side of the pencil for the broader strokes.

Sunlight and Shadow

The simplest form of drawing might be called the silhouette; and this certainly gives very clear and strong information. With the addition of flecks and lines to indicate the sea we soon have quite a complete drawing, as of the modern British 'Daring' class destroyer above. The silhouette reversed also gives an interesting effect.

Below we have the Royal Mail Lines ship 'Aragon' against a storm threatening sky.

The above show the value of simplicity in drawing and the importance of the whole shape. I have drawn them with indian ink and a brush, with the addition of a very simple grey wash. The addition of further detail will enhance and complete, but should not be overdone.

Strong sunlight, on the other hand, although very valuable for giving detail and strong shapes within the whole, tends to break up the drawing, and this should be watched. An example of this is when the sun is high overhead, such as in the tropics, when an interesting strong shadow appears under the bow flare of a ship. Indicated in the drawing at the bottom of this page of the British India Lines ship 'Barpeta' are cloud shadows on the water behind the ship and in the foreground. Although the clouds are not actually drawn you know that they are there. The strong foreground has the good effect of giving the ship a kind of frame, making it more interesting.

Our ship (in this case a tanker) is now in one of the cloud shadows herself, so we make use of the silhouette once more. Big cloud shadow patches across the sea make for an interesting picture and exciting composition. Once more, I cannot stress too much the value of really looking.

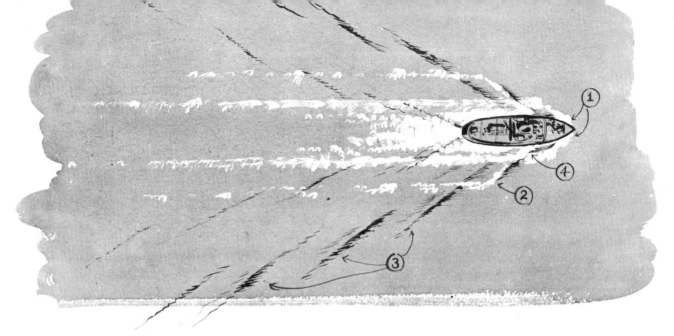

Wash and Waves

As a ship moves through the water, it makes a wash or disturbance to the surface. This has a definite and standard pattern. There is the initial bow wave, and subsidiary smaller waves which are best illustrated by the drawing above. The first bow wave breaks over itself after a few yards and leaves parallel lines of foam either side (1). From the air this gives the shape of the wash pattern. A few yards out and astern these waves repeat themselves but seldom break. When they do break they leave two lesser white foam lines outside the first (2). This process is repeated in a rolling motion further out and astern on either quarter until they finally dwindle away to nothing (3). These waves are the most obvious, being regular and uniform; each forms from the one before; they are the ones that do the damage to small craft if a big ship steams too fast through confined and crowded waters. Inside the parallel area of disturbed water, wave patterns are less distinct, as the water is generally foaming and white.

There is, however, a second noticeable wave about a third along from the bow, which is the root of our second repeat bow wave and in line with it (4). From there astern the water remains generally disturbed until the actual stern, when another

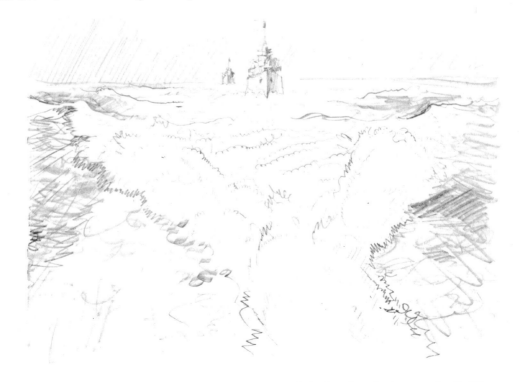

This is a drawing of the violent stern wash of the leading destroyer of a flotilla in line ahead. See how both this and the wash of the next ship astern relate to our wave diagram.

V formation occurs, starting with the violent turmoil from the propellors. This all looks rather geometrical; but we are drawing a physical phenomenon and nature has a way of following strict laws. If you *know* what is going on in your seascape, you are half way to drawing it well.

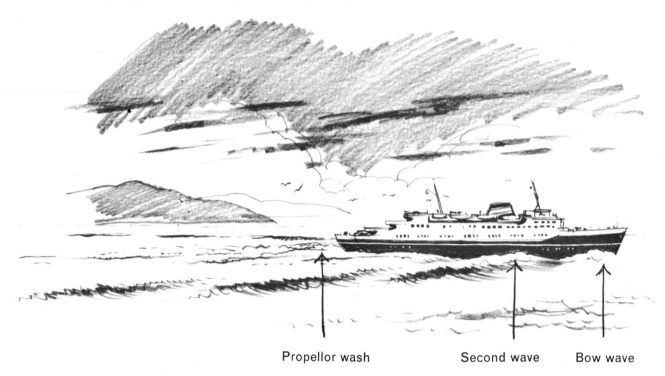

Propellor wash Second wave Bow wave

Above is the modern Danish Ferry 'Princesse Anne-Marie' at full speed showing the same wave formation on page 341 from the side. I have stressed the dark hull particularly, to give added strength and contrast to the white foam. I drew this about twice the size it appears here, on very smooth paper with a 4B carbon pencil. Carbon pencils give an intense black line but tend to smudge easily unless sprayed with fixative. Notice how the dark horizontal clouds add to the impression of speed. Many of your ship drawings will contain large areas of sky so study cloud formations at all times and make notes in your sketch book as often as you can.

Ship Shapes

The hull shape of a ship is both subtle and complex, primarily determined by the necessity of streamlining. To know why it is shaped as it is will be another step towards drawing ships well.

In the air, or under water, the most efficient shape for speed and ease of passage, is the shape above: a parabolic curve forward, tapering away to nothing aft, with the fattest point one third along; a shape with slight variations, invented by fishes ages ago.

So why not make all ships basically this shape? Here we come to a difficulty; where the air and the underwater meet at the surface, the ideal shape is strangely different.

342

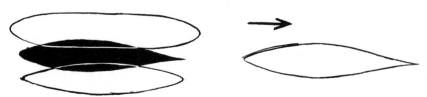

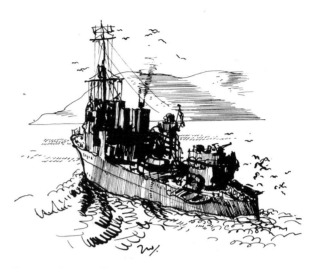

Older ships (left) tended to slope outwards towards the waterline. You can still see many ships that do this. Yachts also have this 'fatness' so that they remain a streamlined shape even when heeled over.

It has to be sharpened considerably forward in order to cut the water, and the widest point moved further aft to give the most efficient passage. The drawing below, opposite, shows this ideal surface shape.

Above the surface other adjustments also have to be made, the most marked being the need for a good flair at the bows to fend off heavy seas. So the perfect ship should be our first parabolic shape under water, the second one at the surface, and back to the first, plus bow adjustments, in the air. A difficult juggle, one might say!

This is what most modern ships' shapes very nearly are, although they stray away from it to a certain extent for other practical reasons. Ships' sides, above the waterline, are vertically parallel for most of their length, to facilitate mooring alongside. The outcome of this is the basic hull shape drawn below.

When drawing in the tone or shadow on a ship's side, the best effect is obtained by making the strokes up and down as above, at the same time varying direction to emphasize the changing subtle shape. Notice how the fine pen lines shape the hull in the drawing at the top of the page. A broader nib was used for the outline, and the blacks were put in with a brush. Always use a variety of pens, etc., when drawing in ink.

343

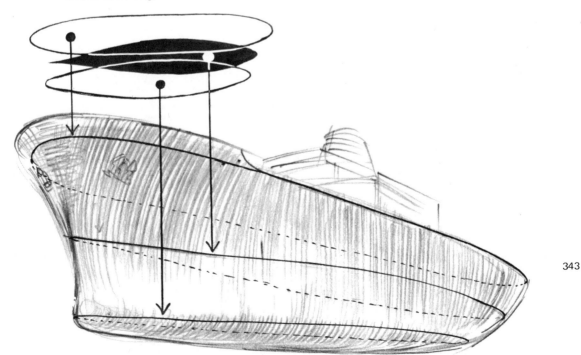

Weight of Ships

A ship or boat floats *in* the sea, not *on* it; it has weight, or, for the more scientifically inclined, specific gravity, and displaces its own weight of water. So when you draw a ship, think of its size and weight; a big tanker, fully loaded, really does 'sit down' in the water.

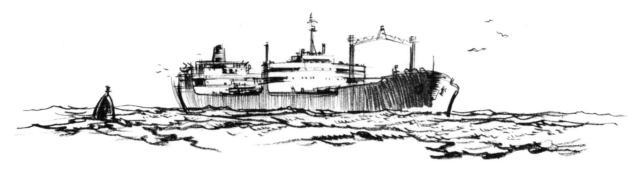

'World Beauty', Neptune Shipping Corporation.

Never let them appear to float on top as one sometimes sees them drawn.

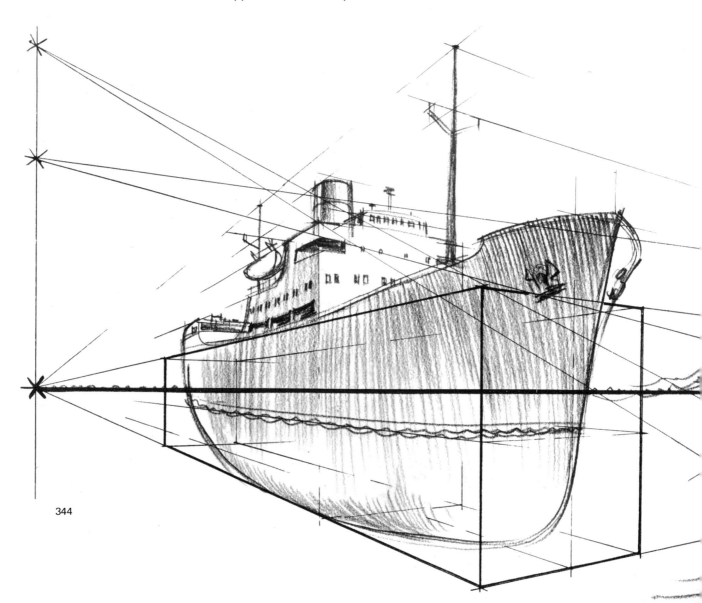

344

Putting it into Perspective

As in architecture, particular attention must be paid to perspective, and the same simple rules apply. If ships were built absolutely rectangular, their perspective would be comparatively simple, as in buildings.

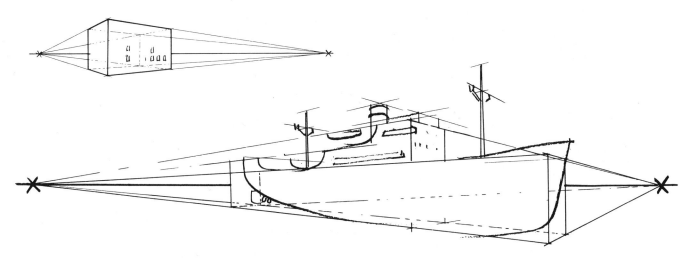

As we know, however, they have very subtle curves, and these have got to be allowed for, and the rigid perspective lines adjusted.

Study the drawing below. It is an attempt to fit a simple ship into a rectangular box. Not only do the decks curve fore and aft, being high each end, but also athwartships like the camber on a road! It is quite a mental exercise to understand how the curves do behave and still conform to the basic perspective.

This is not, however, the complete problem. If the ship was permanently on land or in absolute calm water, we could stick to these rules and be safe, but now we must take into account the rolling and pitching motion of the sea, which has the effect of moving both vanishing points up and down irrespective of each other.

Take a ruler and try juggling with the two vanishing points; it is an intriguing exercise, and helps a great deal in understanding the appearance of ships in a rough sea.

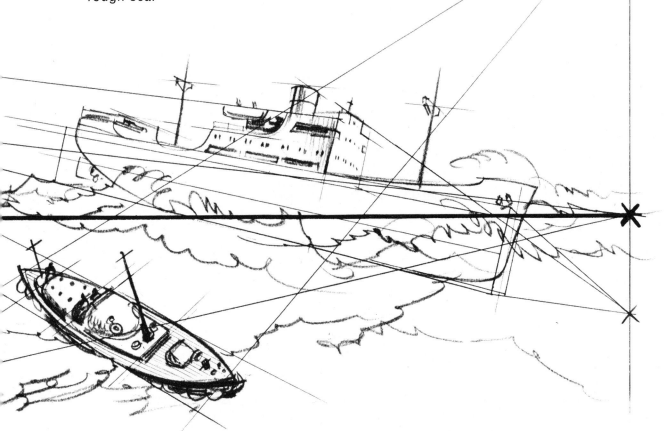

The drawing of sea is always difficult, but try and let your pencil feel its way over the waves, often with a jerky motion like the lapping of water, and don't be afraid of a good dark line for the 'penetration' areas.

One of the reasons, I believe, why there is not more and better marine painting and drawing, is that the elements themselves are a frequent obstacle. Wind and weather are constant enemies, but if you have the paper on your drawing board, or book, firmly held with some good elastic bands, and do not have it too large, you will find you can soon control it. Dress is a point worth attention when working outside. Make sure you are going to remain warm enough. It is surprising how cold one can become when concentrating on a subject and oblivious of the weather. Those old-fashioned mittens with no fingers can be good friends. They may feel awkward at first but you'll soon get used to them.

Composing a drawing

There is a theory that in a given rectangle the important and most immediately observed points are at the intersection of lines dividing it into imaginary thirds, and that any important object should be placed at one of these four points. This seems to be a most satisfactory planning arrangement. I have drawn it, as you can see, above. With seascapes the horizon is usually 'comfortable' when placed either one third or two thirds up the picture, with a single ship at one of the points. Try this for yourself, on the lines of these little drawings. Let's add a squall to the first drawing, taking up another third on the left. With a little darkening in the foreground for balance it still looks right. The small black is equal in 'weight' to the area of tone.

Composition, which is another word for arrangement, is largely a matter of sensitive balance. Never have all your 'weight' on one side.

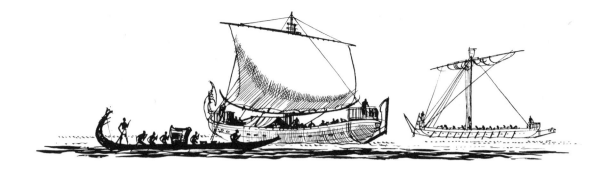

Ancient Ships

On these next pages are a few examples of ships from the past, which will indicate only a few of the fascinating variety to be found if you are interested. I have drawn this first page in pen and ink in order to show the quality of this medium.

Do not be afraid of using occasionally a good thick line; it gives strength to a drawing and also contrast against the thin lines of rigging, shading, etc. Above are three examples of Ancient Egyptian ships. One point to note in all those ships with one big square sail is that the yard or spar, being rather long, was always made of two pieces lashed together in the middle; this should be indicated in the drawing. The modelling of the hulls should, as before mentioned, be made with vertical strokes to emphasize the shape. Again, do not be afraid of strong cast shadows, as in both the Roman ships below. Remember you are making a drawing, not a diagram, and shadows give realism.

One must keep in mind their whole character, always remembering that they had to sail, and therefore the proportion of hull to sail must look right and they must 'sit' in the water. Models of old ships were frequently made with their hulls much too small in proportion to their sails, and would obviously capsize; so if you are drawing from a model, check this point.

Let us now set about drawing a Viking ship, or perhaps two in convoy. They had a single square sail, like the 'Kon-Tiki', and therefore could only sail before the wind. First we must make sure of the relationship between hull, mast and sail. The mast

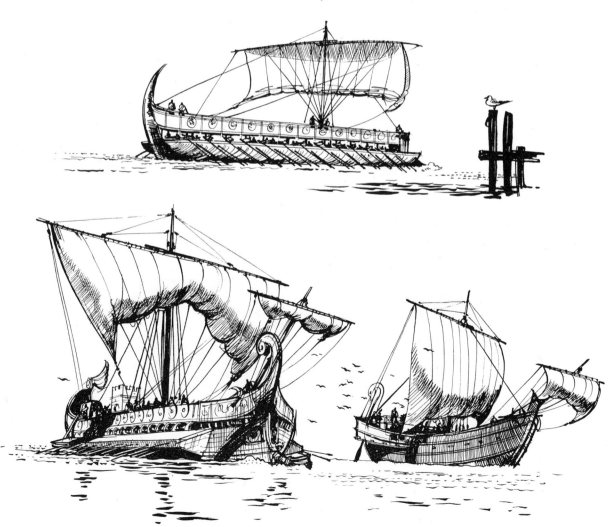

height was just about half the ship's length, and by making sure of this we will avoid having too much canvas, and making her look topheavy.

The first pencil lines to put on paper are those at the top left. Compare them with the final stage of the drawing below. Notice how it is controlled by these few lines. Get them right, get the amount of movement you want into these first construction lines and the rest of the drawing will be plain sailing. Practise drawing simple curves like these until you can draw them easily and swiftly.

The drawings at the top right are the notes we made as we worked out the details before starting. The fierce dragon's head will decorate the fore peak-post. We *must* understand its construction however 'roughly' we intend to put it in.

The wind, in our drawing, is coming from astern, and the lighting is about 45° top right. The darkest part of the shadow on a sail is where it first passes into shadow. The diagonal lines on the sail were reinforcement for the weak sail material. They reinforce the drawing, too.

There was a theory in those days that the correct ratio for building a ship was for the beam to be one third the length, making them rather too fat by modern standards. This meant that they could hardly sail at all to windward, therefore, always draw any flags or pennants flying forwards. For this reason the Captain and officers always lived right aft so that they got the fresh air first!

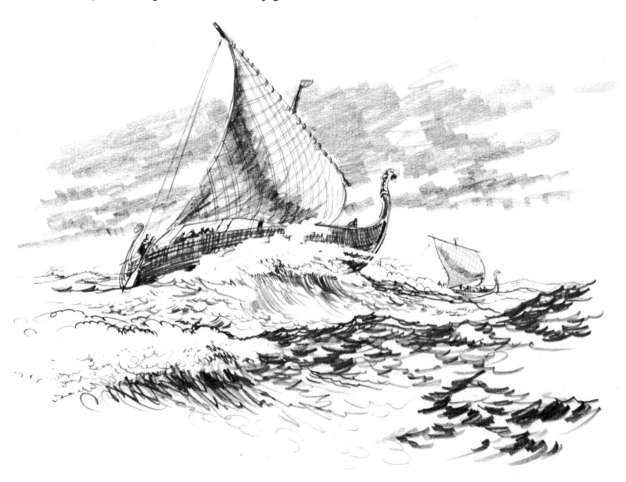

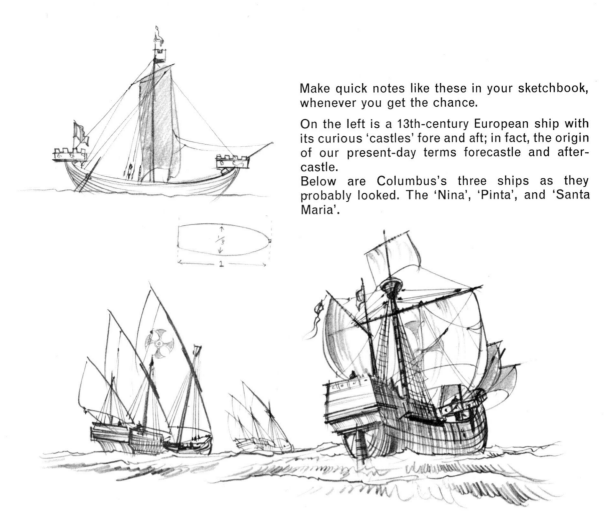

Make quick notes like these in your sketchbook, whenever you get the chance.

On the left is a 13th-century European ship with its curious 'castles' fore and aft; in fact, the origin of our present-day terms forecastle and after-castle.

Below are Columbus's three ships as they probably looked. The 'Nina', 'Pinta', and 'Santa Maria'.

The drawings on the last two pages have been treated quite simply in order to give a clear idea of their construction. The history and study of the infinite variety of ships can be a fascinating hobby, and from research in museums and libraries many interesting drawings can be made.

Let us now make a drawing of the famous 'Victory' in line ahead, giving a broadside. Once more a clear understanding of the construction of the ship must come first, and I have shown (below right) with a few lines the approach to this. Note how the lowest sails (foresail and mainsail) are unexpectedly smaller than the ones above them (lower topsails).

Your first few construction lines are important, so don't rub them out. If you consider they are inaccurate, as I said before, they will be a guide for your subsequent correct ones, and if they are not too strong, will not intrude on the final drawing.

Now to the sails themselves; they are large and heavy, so *feel* this as you draw. They must hang and crease, not flutter; my actual size drawing on the next page I think gives this feeling. The completed drawing (page 350) was drawn with a 6B pencil, and the ship was 9" from mast to waterline.

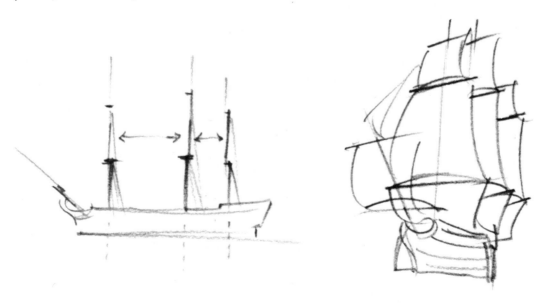

Here is the completed drawing. The side of the 6B pencil was used extensively for the smoke and turmoil of battle. Although one cannot distinguish a great deal of detail, remember I am trying to give an impression of thunder and struggle. The heavy darks under the sails on the upper deck give a feeling of drama, and the general business of the drawing, action.

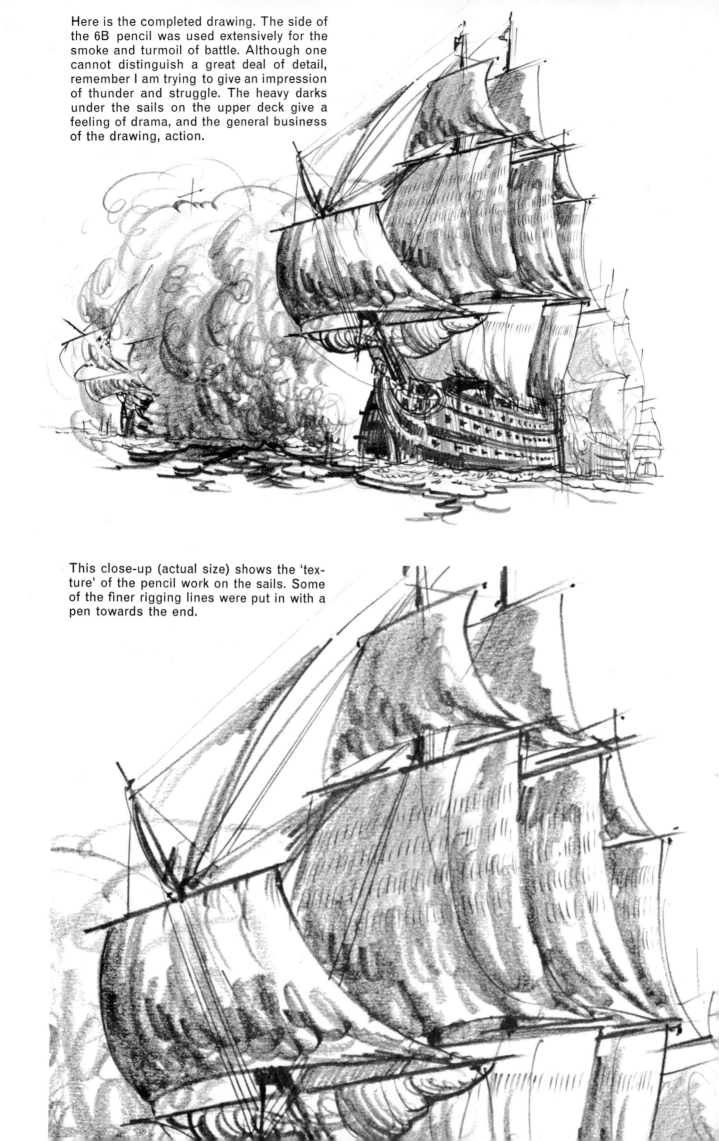

This close-up (actual size) shows the 'texture' of the pencil work on the sails. Some of the finer rigging lines were put in with a pen towards the end.

The Great Tea Clippers

The romance of sail is now history, but the great names of the old Tea Clippers of the 1860's and 70's 'Ariel' . . . 'Taeping' . . . 'Thermopylae' . . . 'Cutty Sark', live on for those fond of the sea.

Drawing these ships does require study, as their rigging was infinitely complicated, and the more one can learn of this the better. General shape - proportion - lighting - weight are again the first points to consider. A big ship never heels over in the manner of a small yacht, except in exceptional hurricane conditions; so always give it the dignity it warrants. Decide early on the setting you wish to have her in - rough sea - calm sea - at anchor with sails furled, etc. There always seem to be more ropes and lines than one expects, and to give a feeling of too many is better than too few. The upper deck always appears to be full of bits and pieces; and the larger the ship the more these seem to be; this applies to steam ships as well. The larger the ship, the smaller, relatively, are the various parts. A block will be more or less the same size for a small ship as for a big one, and the size you draw it and other similar fittings will govern the impression of size you wish to give.

Often in adventure films, models of ships are used, and they always look like it! The reason is the relative sizes and weights of things near each other. A model of a sailing ship in a tank will always look too small for the size of the waves, the sails will not hang as if they had weight, and the rigging will probably look too thick; and she will bob about, which a big ship never does.

The 'Cutty Sark' was one of the most famous of all Tea Clippers. Note the difference in the sail proportions compared with the 'Victory' opposite. The mainsail (1) now becomes the largest sail. Next above are smaller sails (2) and (3), then we have a larger one again, the main lower topgallant (4), then two more smaller ones.

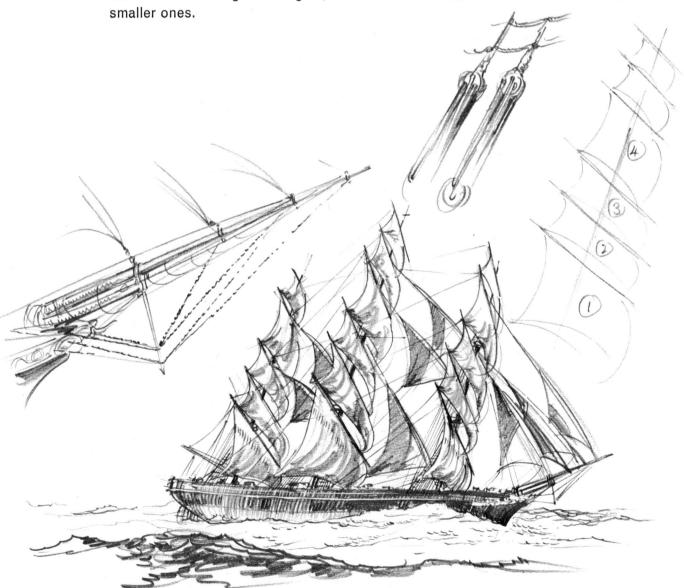

Modern Sailing Boats

As before, the more technical knowledge acquired the better, when drawing modern boats and yachts.

In old sailing ships the 'standing rigging' or shrouds and stays were always the thickest ropes because they had to take the most and permanent strain; today steel wire is used and is the same average thickness as other lines. Try and 'feel' the strength required for any particular rope or part of a yacht, whether it be a shackle, chain cable, capstan, rope, etc., and then it will take its proper place and proportion in the whole. It is difficult when discussing rigging not to embark on a long and detailed manual of seamanship. The artist would be best advised to study this field from one of the specialist books on the subject. In passing, however, a point to be noted is that ropes, except in very rare cases, are always layed (that is, wound) in a clockwise direction away from you. They should also be coiled down clockwise, so that the coil when looked at from above coils away anti-clockwise.

There are certain parts of a yacht which the uninformed tend to leave out of a drawing, but which are general to nearly all sailing boats and give a drawing authenticity. At the foot of this page is a typical twelve metre yacht, together with a numbered key to the various essentials. Note perspective in this drawing. All thwartship lines on deck and the spreader lines would meet at a vanishing point somewhere top left, well off the page.

(1) Spreaders
(2) Burgee
(3) Battens
(4) Reefing points
(5) Sail construction and seaming
(6) Navigation light holder and or light
(7) Fore stay plus sail fastenings
(8) Runners. The lee runner must always be slack
(9) Stays
(10) Ensign
(11) Pulpit

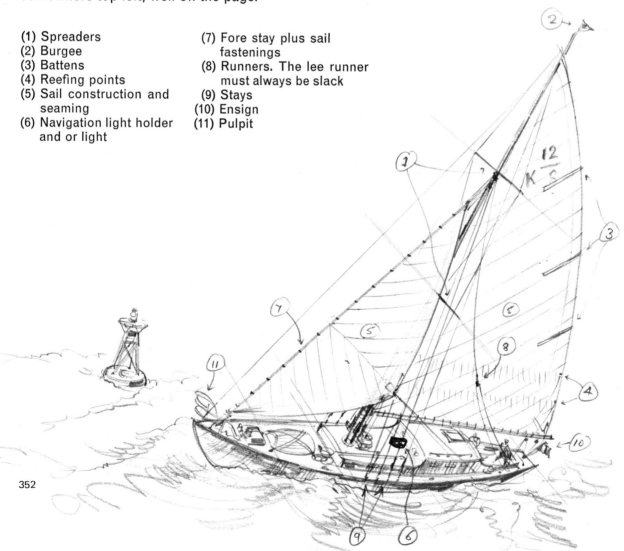

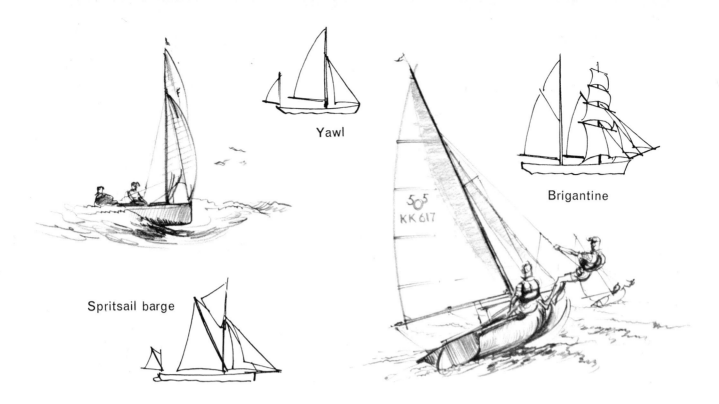

Yawl

Brigantine

Spritsail barge

Like all small things (animals, children, birds) the dinghy (an Indian word meaning small river rowing boat) seems to have a delightful lack of dignity; they bob about, weigh very little, and if they have occupants, remember the considerable effect of their weight. Sailing dinghies have a way of sailing at very acute angles with the occupants leaning far out on the windward side to keep the boat balanced, and some larger, though still small, racing yachts are fitted with what is called a trapeze, enabling one of the crew to swing his weight well out over the windward side.

Yachts racing with full spinnakers are always an intriguing sight and a pleasure to draw; and modern spinnakers are made in many and various colours and patterns. Remember a yacht under mainsail and spinnaker will be running before the wind, so make sure that the wave formation is at right angles to the boat's course, and ensign and burgee both blow forwards. The drawings of various other rigs on this page, may help you in making drawings of your own. Try putting some of them into very rough seas!

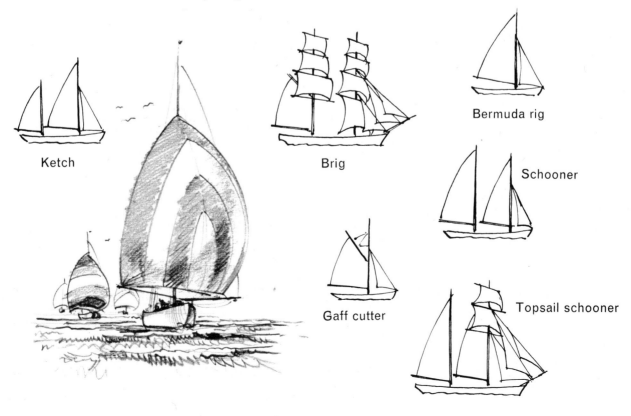

Ketch

Brig

Bermuda rig

Schooner

Gaff cutter

Topsail schooner

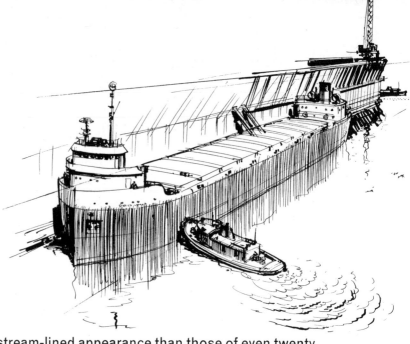

Modern Ships

Ships today have a much more stream-lined appearance than those of even twenty years ago. The foremast is frequently the only mast and is placed on or near the bridge, for convenience in hoisting flag signals and mounting radar. Some cargo ships, however, still have what appear to be several masts, but in fact are samson posts for supporting their derricks, and will not be so tall as a mast. Funnels have also been stream-lined and are not necessarily parallel sided; and sometimes, as in the 'Rotterdam' opposite, are constructed in an entirely new shape. In the case of some big passenger liners like the 'United States' and 'France' strange wing-like projections have appeared on them. These are there to create updrafts and prevent the fumes from descending onto the after end of the ship. Bridges have become very stream-lined, sometimes with long cantilevered wings to them. Lifeboats are to be found carried lower down the ship's side than before, as in the 'Oriana' and 'Leonardo da Vinci' below.

A considerable amount of original thinking goes into modern ship design, which is frequently governed by a specialist trade; so when looking at a ship, try to assess what her work is; it will often explain various oddities about her.

The pen used for the above drawing of a Canadian Lakes grain ship was a Gillott's 170, a good general nib, both strong and pliable. A few light and simple construction lines were drawn first with our 2B to act as a guide; then the drawing was made quite freely in pen and Indian ink.

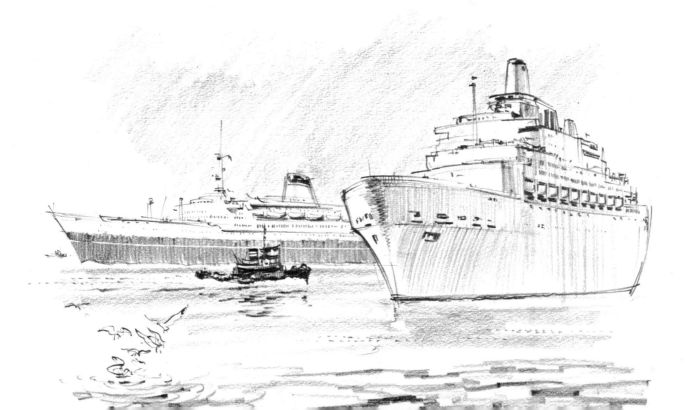

Drawings like these are helped by the inclusion of details suggesting a special moment in time. A tug busily at work or seagulls fighting over a fish give interest and third dimension to a picture. See how the tug sets the 'Leonardo' back; how the gulls bring the foreground nearer. This was drawn with a 2B pencil, 9" x 15" on cartridge paper. The modelling lines on the hull of the 'Oriana' emphasize its unusual shape.

Always endeavour to draw freely, keeping your face well away from the paper, so as to see the drawing as a whole. Concentrate in the early stages on the main big shapes, as in the first-stage drawing above of the Dutch ship 'Rotterdam' below. My first line was across the centre to establish the waterline; then I felt for the solid thickness of the ship's beam with the full fat shadow on the front of the bridge (lighting from the left).

The tug shape came next; making sure of its size and nearness in relation to the bigger ship. The close-up of the tug is the actual size of the original drawing, and you can see the value of *suggesting* detail rather than ponderously putting in every rivet.

The 'Rotterdam' (Dutch). The completed drawing. Notice the single streamlined mast on top of the bridge and the two tall streamlined funnels aft.

Harbours, Jetties and Yards

There are so many things going on in a dockyard, that unless the perspective and close relationship of ships, cranes, trains, warehouses, etc., is kept mathematically close, the drawing will be in danger of becoming disorganised. So a common horizon for vanishing points for all the various objects in the drawing is essential, as you will see in the drawing above.

Add as much detail as you can in order to give the drawing a busy and natural appearance; always put some figures in somewhere; a drawing like this without figures gives the feeling of a dead world or perhaps that everyone is on strike! Seagulls are always somewhere in sight.

Apart from these points, hard work and observation are the essentials, remembering at the same time to keep your main masses of foreground, middle distance and background a uniform strength of drawing, and your lighting from the same direction for all objects.

Dockyards and seaports sometimes appear inaccessible to the layman but I have always had encouragement and certainly no obstruction, from Port Authorities, who are always willing to issue passes to people wishing to draw or paint in their docks and yards. Usually, however, it takes a few days to obtain a pass, as your request has to go through the proper channels.

The perspective and construction lines shown on these two pages are particularly necessary, because when we get involved in drawing harbours and jetties with their many and varied buildings, cranes and other objects, unless discipline is maintained, these become unrelated to each other. The horizon and the various vanishing points become very important, and if drawn in soflty, can either be rubbed out afterwards or overwhelmed by the stronger work in the final drawing.

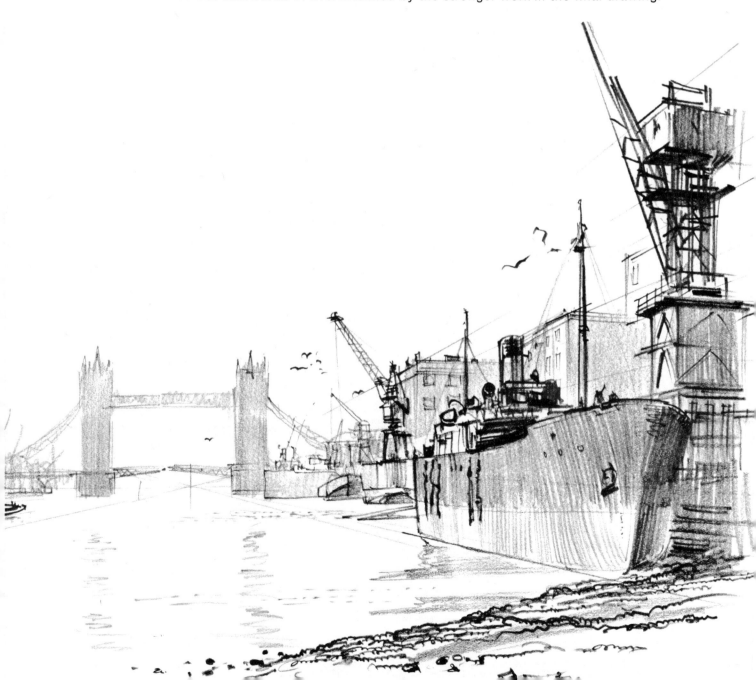

To round off

In order to draw the sea and ships you have to go to them, often having to battle against wind, weather and general discomfort. So when, in the process of drawing, a gust of squally wind, and probably rain as well, prevents you capturing a particular scene, regard it as a challenge!

Many a time I have been trying to draw when away sailing. The wind will be blowing, the yacht tossing, and just at the most interesting moment I have received a face and drawing book full of spray. Add to this the likelihood that the skipper suddenly decides to go about or set another sail and the fainthearted will wonder whether this drawing business is worthwhile.

Other problems occur on docksides and jetties. You settle down nicely, with a perfect view; the results are beginning to appear. Suddenly you find yourself in the path of a hardworking crane! You move to let the monster by only to find it now completely hides the view. These, and other hazards are, alas, the marine artist's lot, so it is worth cultivating a philosophical outlook and an anticipatory eye for the likely future movement of your subject and the objects surrounding it.

Interested spectators are seldom aware of their ability to distract. To make yourself oblivious of them needs a little practice, especially when they breathe down your neck, but you will soon learn where to look for suitable hiding places.

Throughout this section I have stressed the importance of understanding the construction and function of the things you draw. The ideal artist should really have an infinite knowledge of all things, which is obviously impossible. However, by training himself to observe and by acquiring a sense of endless curiosity, he will get some way towards this and also have the pleasure which is the result of effort.

Buildings
Richard Downer

Square in Florence 4B pencil drawing on bank paper, 16'' x 14''

Learning to See

Have you ever really *looked* at the house you live in? The aim of this section is to give you an approach to drawing buildings; to arouse your sense of awareness; to help you in training your eyes to observe the varied architectural structures that make up our cities, towns and villages. Once your eyes are looking, and are *really seeing*, practice will enable you to put down what they see on paper, by means of pen, pencil or brush. When you can achieve discipline of both eye and hand working together harmoniously, you will find the exercise exciting and satisfying; you will begin to achieve on paper what your mind's eye has already seen.

Drawing is not easy; in fact it is hard work. Do not worry if you do many drawings that prove disappointing, or even some that go wildly wrong. If you are using your mind, and your powers of observation, as you draw, you will have learnt *something* whatever the result.

Enjoy what you are doing. If things go wrong you can always start again the next day. Houses have an advantage over other subjects in this book: they remain your models for as long as you wish, so there is no need to hurry.

Not all the drawings you will see in this section were drawn actually on the spot. Some were made at the drawing board from sketch book studies and notes.

The first drawing in the section was sketched at a café table in a square in Florence. The drawing across pages 376, 377 was also drawn on the spot, so was the one across pages 382, 383. The drawing of the Sacré Coeur, on the other hand, was made at the drawing board from notes and sketches made in Montmartre. Both methods have their advantages. Drawing on the spot gives greater spontaneity and architectural atmosphere. Drawing at the board gives greater control over your subject, more time for consideration, and freedom from interruption. You should aim at doing both.

Street scene in North West London. 10'' x 14''. Drawn with an ordinary fountain pen on thin cartridge paper, from an upstairs window

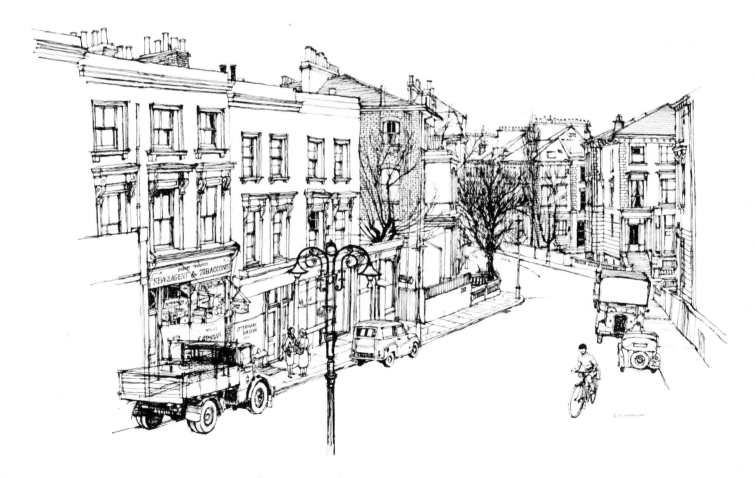

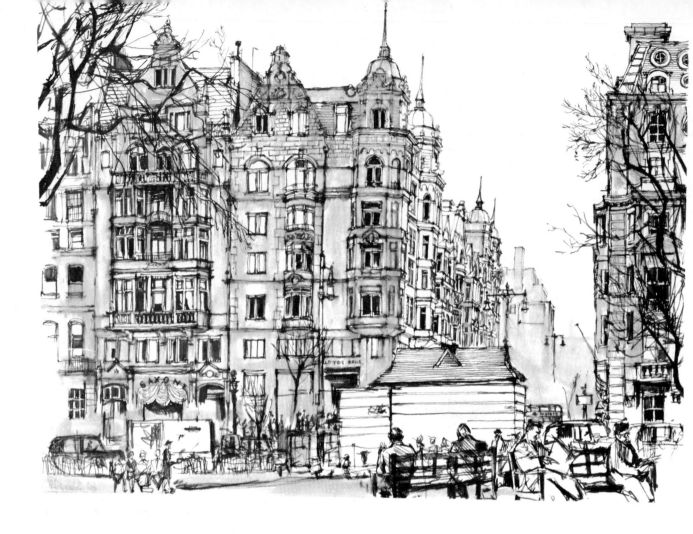

Fountain pen and wash drawing on layout paper, 19" x 12".
Here the main buildings were unified, and the pen line softened
by the addition of a light wash.

The first and most important thing about drawing buildings is to realise that what
you intend to draw should interest you as a subject. It should be something that
really excites you when you look at it, something that has plenty of interest in the
way of shapes and textures, or something on which you feel you, personally, can
comment. It is often necessary to spend as long looking for a suitable subject as
you spend on carrying out the actual drawing. Once you have decided on your
subject, and on the best view-point from which to draw it, think carefully about
the medium in which you intend to carry it out. Allow your subject to dictate this
to you. You may feel instinctively that the best result will be achieved by using
pencil, or pen and wash, or a simple fountain pen.

Therefore, when you set out to do a drawing, always have a variety of materials
with you, so that you can use whichever medium the subject seems to demand.

One problem you will inevitably come across is that of onlookers. To draw
buildings it is usually necessary to go out, in most cases, into the street, among
the people and the traffic. You will naturally feel inclined to look for a vantage
point where you will be away from the crowds. This is all very well, if you can find
exactly what you want, but don't allow the presence of people to persuade you
away from a good position and so prevent you doing what could have been
a good drawing. With a little perseverance you can achieve concentration. You
may find, as I have, that this atmosphere helps a drawing.

It is good practice to carry a small sketch pad about with you. Making rapid

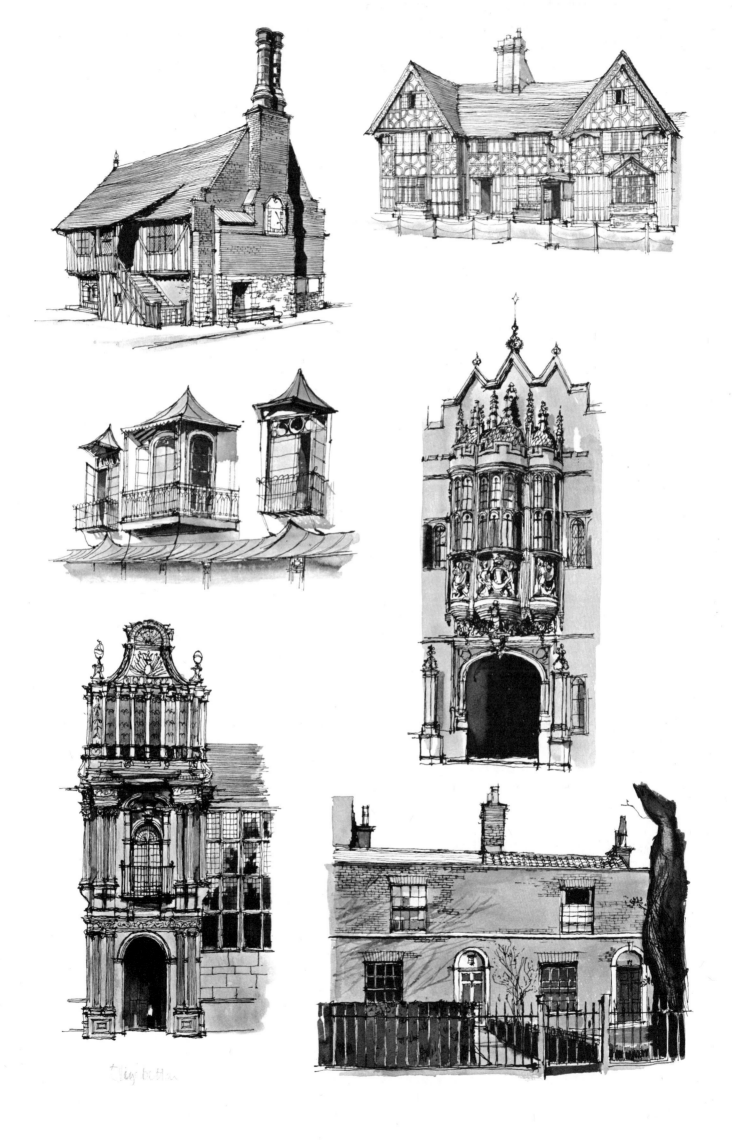

notes, and sketching everything that interests you, will develop your ability to draw. A series of small sketches will often help you to decide on the best position from which to do a drawing.

It is sometimes helpful to make written notes on the drawings in your pad. Don't be afraid of spoiling what you have drawn; notes often add interest to a sketch and will help you to remember the scene. After all, what is the purpose of this sketching? It is not only to improve your drawing, but also to enlarge your knowledge of architecture, and buildings of all kinds, and to collect a small personal library to which you can refer at any time.

A basic knowledge of architecture is, of course, a great help as a background to drawing buildings. Study books on architecture at your local reference library; better still, begin building a small library of your own. The more you draw the more you will want to know. Wherever you go you will derive pleasure from being able to identify the periods of the buildings correctly.

This increase in knowledge will stimulate your interest in your subject and will add enormously to your enjoyment of drawing. Enjoyment nearly always 'shows' in a drawing: drawing houses should be fun.

By architecture I don't mean knowing only about the great architectural 'periods'. Learn as much as you can about 'regional' architecture and housebuilding materials, so that as well as recognising the style you will also know *why* houses in different parts of the country are built in the way they are. Houses tend to 'grow' out of the ground on which they stand. Where there is limestone under the ground, the traditional building material will be cut stone; where there is granite the houses will be made of granite. Give particular attention to, and sketch as often as you can, the *details* of houses you see. Quick notes, both drawn and written, are sufficient: this will be your own building material for making drawings of houses. File them carefully.

Building a Drawing

Building a drawing is a matter of balance; one area of weight has to be balanced by another. This is all part of selecting your subject matter and should be considered carefully when choosing your vantage point. This building process is called 'composition'; it is the arrangement of all the various elements inside the intended shape and size of the drawing. In drawing still-life subjects the problem is easy; all we have to do is to arrange the objects to our liking. But to arrange buildings to our liking we have to do all the necessary moving about. Make a rule

about this: instead of beginning work on the first view which pleases you, search for two or three alternative vantage points before deciding from where to make your drawing.

Always, before you draw a line, think hard about what you see. Even the most complex subjects can be reduced to simple terms. Look at the drawing shown below. This may seem to you a complex subject, so I have reduced it to simple terms in the pencil drawing at the top of this page. As an exercise, try reducing similar scenes to a few main construction lines like this. Do them quite small, no bigger than the one above.

Haymarket, London. Pen, indian ink and wash drawing, 18'' x 15''

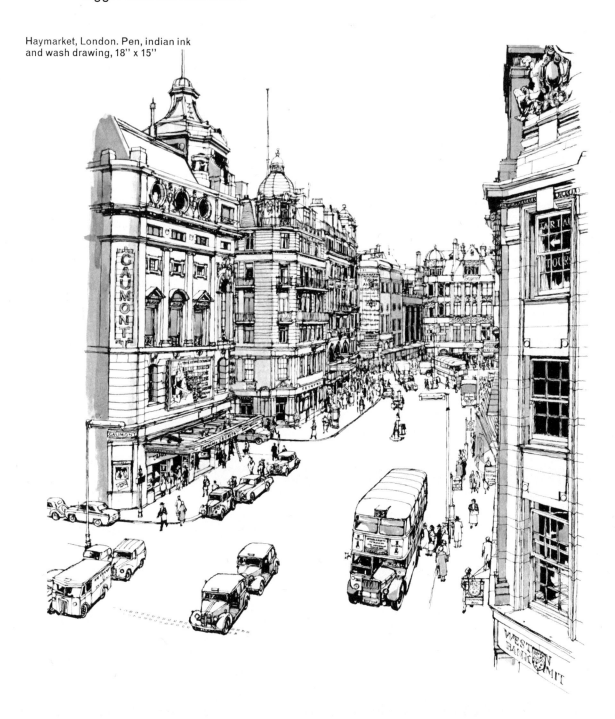

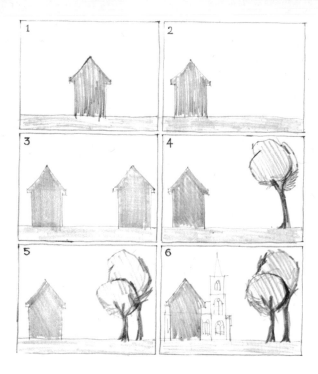

In the first diagram we have balance in its simplest form: the house is central; the white spaces on each side of the house are equal. A point to remember here is that a tall building in the middle should always be placed slightly off centre, as in the drawing on page 360. The second diagram is too one sided for balance; some weight must be added to the other side, so we place another house within the rectangle. Balance is now perfect; in fact, diagrams 1 and 3 are 'equal'.

Now let us replace one of the houses with a tree. Still balance is maintained, but now 'interest' has been increased. A second tree in diagram 5 adds further interest. Lastly, if we add, say, a church, as in diagram 6, not only is balance and interest maintained, but the composition now has a *focal point*.

Let us see how this works out in practice. Below are two 'compositions' of drawings appearing elsewhere in this book. In the top one the projecting railing on the right balances the building on the left. This composition is related to diagram 3. In the other drawing the placing of the dark tree adds interest and balance, as in diagram 4. By placing your finger over the railing or tree you can *see* how the balance is upset.

After some experiment 'balance' will become instinctive. A window cut out of a piece of card (above) and looked through with one eye closed, will help you in arranging a composition, or you can use your hands as I have shown in the drawing below.

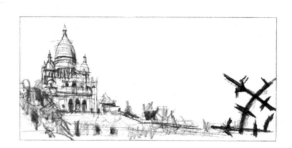

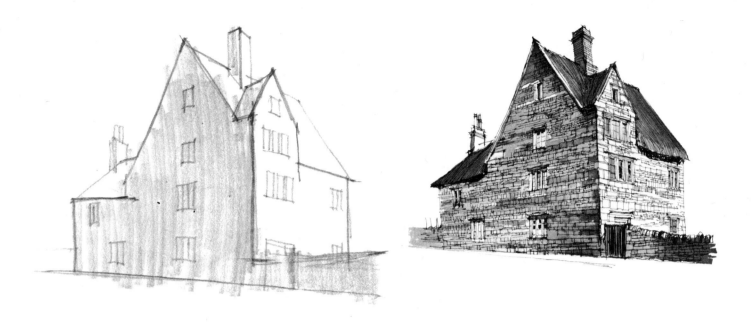

The composition above presents no problem: the house is 'central'. Concentrate first on tone and shape; consider them as one. Build up the main construction lines and masses of tone very simply and broadly, first getting the 'shape' correct in perspective and proportion.

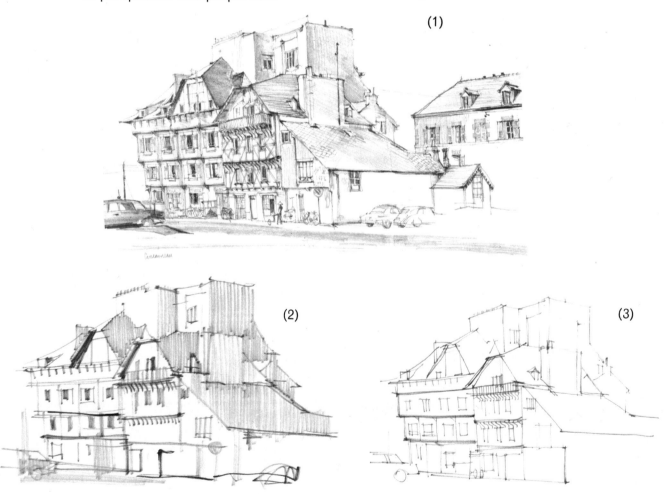

(1)

(2)

(3)

When looking at groups of buildings (1), half close your eyes so that you see no details at all; only shapes (2), or areas of tone. The *outlines* of these shapes are the main construction lines (3). These are the first lines to draw.

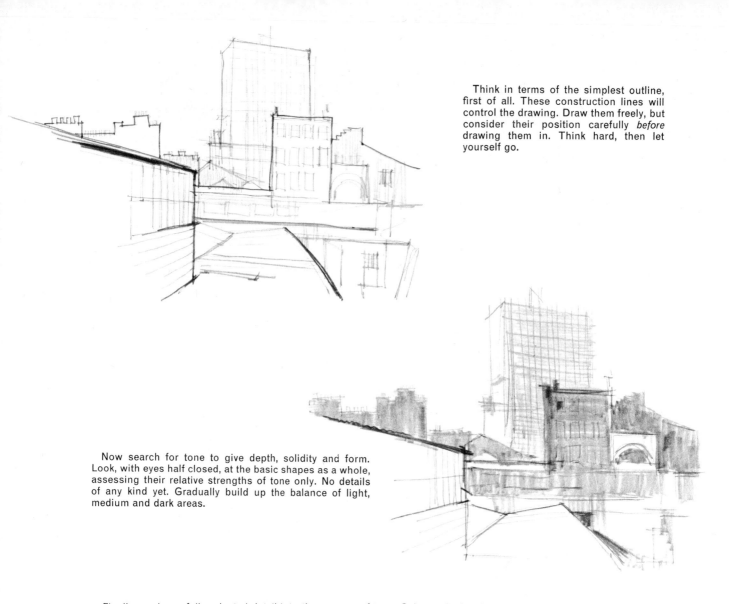

Think in terms of the simplest outline, first of all. These construction lines will control the drawing. Draw them freely, but consider their position carefully *before* drawing them in. Think hard, then let yourself go.

Now search for tone to give depth, solidity and form. Look, with eyes half closed, at the basic shapes as a whole, assessing their relative strengths of tone only. No details of any kind yet. Gradually build up the balance of light, medium and dark areas.

Finally, work *carefully* selected detail into these areas of tone. Select only detail that adds atmosphere and character to the drawing. Use whatever there is in the composition to guide the eye into the drawing. Notice how the lines in the foreground do this.

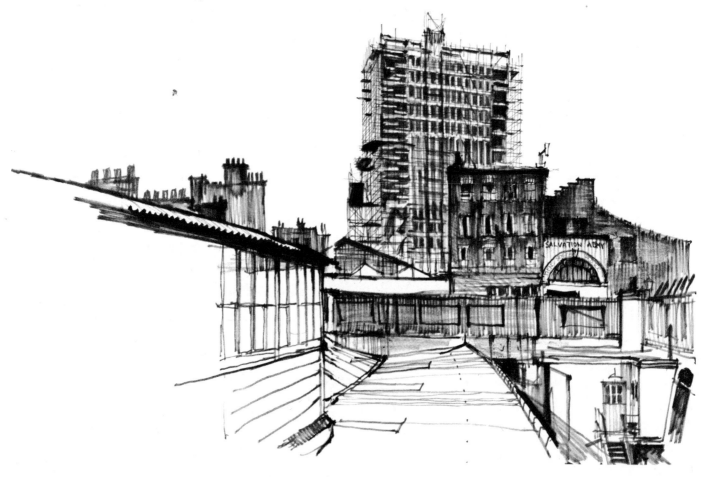

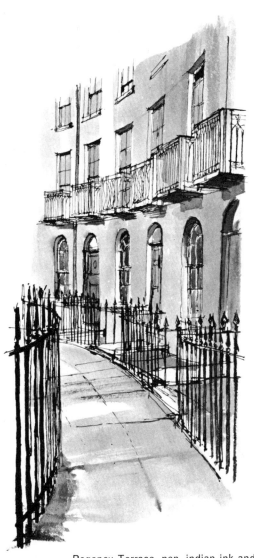

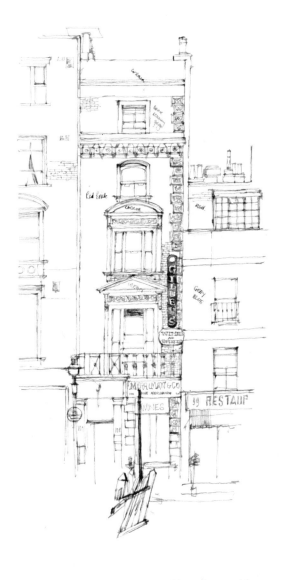

Regency Terrace, pen, indian ink and wash, 8'' x 3½''

Details of the front of a building, drawn with a fountain pen in blue-black ink

Technique

Technique can be described as a means of using a medium, or mediums together, to produce a certain style or effect. The use of pen and wash, for instance, is a technique.

By technique I do *not* mean you should produce a collection of clichés or tricks for drawing certain objects. Too many people have developed their style of drawing in this way: they have a set way of doing a chimney stack, or of rendering trees in the distance, or even of adding texture to the foreground. How uninspiring it is to see a collection of such drawings. I feel this is not true drawing but a means of making a pretty picture, which has no depth or feeling. You must realise as early as possible that you should draw *what you see*, not what you think you see. This is all that true drawing is, really; training yourself to see accurately and then putting down on paper, without any false representation, what you have seen. A good test, if you feel you may be falling into this trap, is to place three or four drawings together and see if there is any particular object among them which is drawn identically.

There are no set rules about which *medium* to use. If you feel you can make a better drawing by using bootblack and brush go ahead and do so. So don't limit yourself to only one or two mediums; experiment with them all. Only by having a wide range of techniques at your command can you select the one most suitable for a particular drawing.

You may find a rough surfaced paper and soft black crayon, or conté crayon an exciting method of working. You may find, as I do, that the felt-nibbed fountain pen is useful for quick sketching and for catching the atmosphere of a building. I have included examples of many techniques in this book.

Style is a word often confused with technique. What does it mean, and how is it that one artist has developed a manner or style that distinguishes his drawings from all others?

A sincere individual style cannot be taught; it can only develop naturally and slowly. It cannot be forced, because it springs from the quality of mind *behind* the drawing. So do not worry about it at this stage. Keep working and it will come to you as your interest in drawing develops, as your knowledge of your subject matter increases, and as your hand becomes more practised.

This drawing of the Sacré Coeur (8½" x 20") is an example of what is known as the 'dry brush' technique. Use a fairly rough paper for this and either indian ink (with no water) or black poster paint. Make sure you haven't got too much paint or ink on the brush, then 'drag' it across the surface of the paper. This will give you a medium tone into which you can work. Also try using a dark paper, or black, if you like, with white poster paint. A very satisfying effect can be achieved this way.

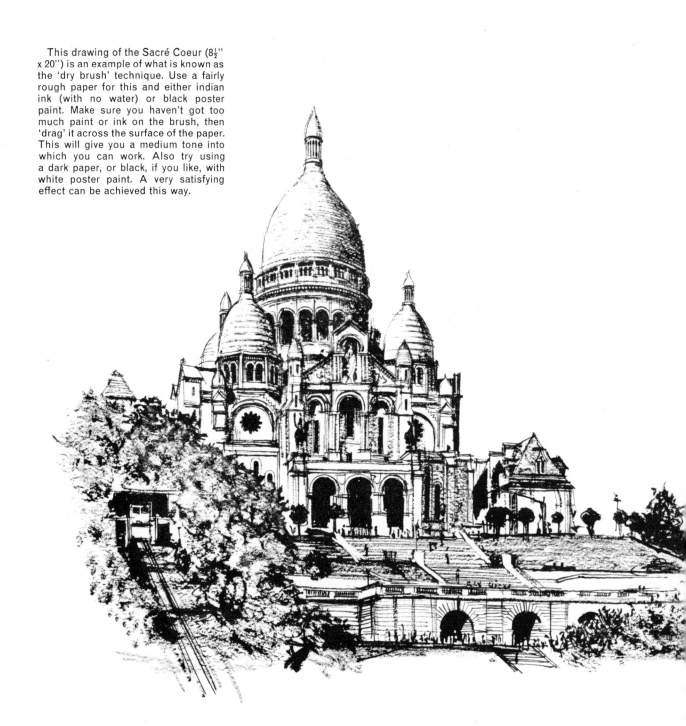

In this drawing I have used a variety of different materials to give it the atmosphere I wanted. Wash, body colour, pen and indian ink, fountain pen and pastel. There are no set rules about what to use; use anything you like.

This is a free and rapidly
made drawing of a corner in
Paris, done in fountain pen and
blue ink on bank paper, 10" x 9".

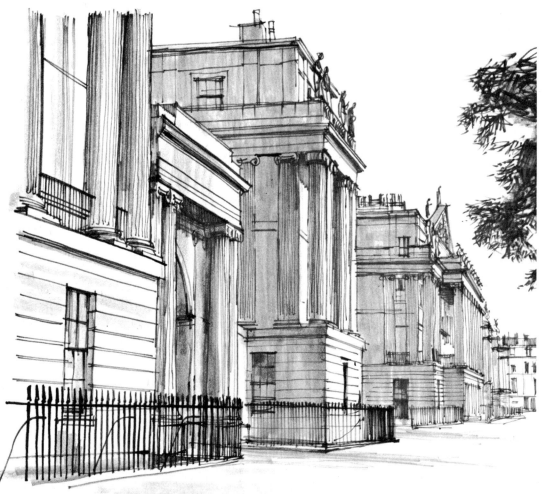

This drawing was made entirely with a felt-nibbed fountain pen on bank paper, 12" x 14". Felt nibs of various sizes and shapes can be fitted to these pens, which are extremely useful for broad, simple treatments, emphasizing size and mass in buildings.

Sometimes you will want to enlarge a sketch you have made on the spot. This is how to do it.

1. Divide your sketch into equal sections, or squares, both horizontally and vertically. It is important that the sections are all exactly equal.

2. Draw the same number of equal squares, both horizontally and vertically, on the paper you are using for enlargement. Each square will, of course, be larger than those on the sketch.

3. By drawing line for line, taking one square at a time, you can now build up the enlarged picture. As long as you copy line for line you cannot go wrong.

4. Draw the guiding lines in lightly so that they can be rubbed out when the drawing is complete.

5. You must be prepared to put as much as you can into your original sketch or you will find the enlargement disappointingly empty on completion.

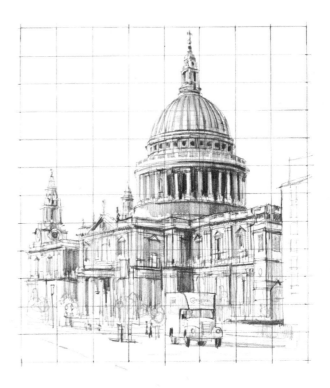

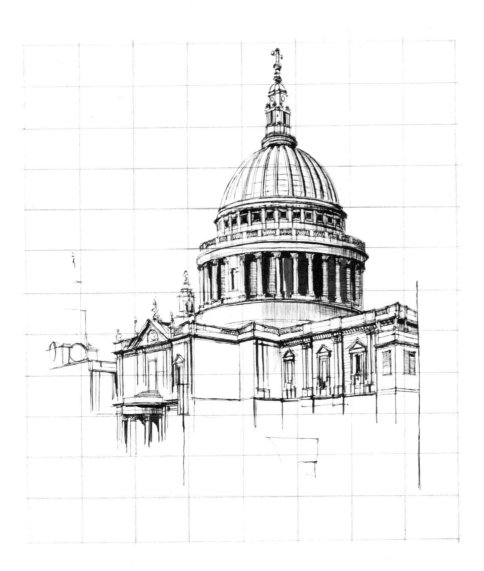

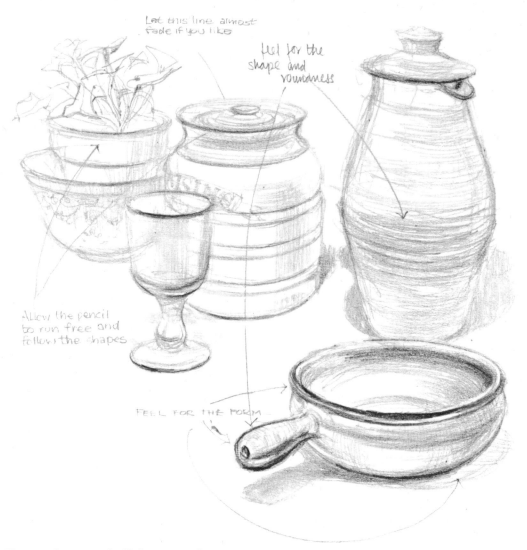

Let this line almost
fade if you like

feel for the
shape and
roundness

Allow the pencil
to run free and
follow the shapes

FEEL FOR THE FORM

Depth and Dimension

Getting 'depth' into your drawing will seem difficult at first. While correct perspective, such as the way the buildings and roads 'vanish' away from you, is important, 'depth' can also be increased by varying the weight of line in a drawing. Basically, the rule to apply is this: the nearer the object the heavier you should draw it.

The following exercise, which you can carry out at home, will help you in understanding and solving this problem. Set up a still-life composition of, say, a jug, a glass and a pot or two. Make an interesting grouping of them. Now draw them as a whole, remembering that you are going to draw the jug, or whatever is nearest to you, in a *stronger line*. The object furthest away will be drawn in lightly. At the same time try to *feel* your way round the objects as you draw. Try to feel the space between the front of the jug and the back of it, even if you cannot see the back. If you apply what you learn from this exercise to the drawing of buildings you will give the buildings greater solidity; you will show how the walls recede; you will give your drawing depth. If you are making a wash drawing or shading with pencil the sensitive use of graduated tone will also help to convey depth.

Whatever the subject we are drawing it is made up of a foreground, a middle distance and a background. It is the middle distance that is so often the most difficult to draw, especially if the subject is a landscape without objects in the composition. Objects are needed to give a sense of proportion; the most helpful of all are things we know the size of already, like the traffic in the Haymarket drawing on page 365.

This diagram shows how the drawing on the right has been broken down into separate areas of foreground, middle distance and background. It will help you to see how each area has been treated in a different weight of line. The drawing below has been 'seen' in this way, too. Try doing this. Start with a fairly simple scene and concentrate solely on making your drawing 'go back' by this method. I think you will find it helpful; after a while you will find you do it instinctively. Using two or three different grades of pencil may help when you first start.

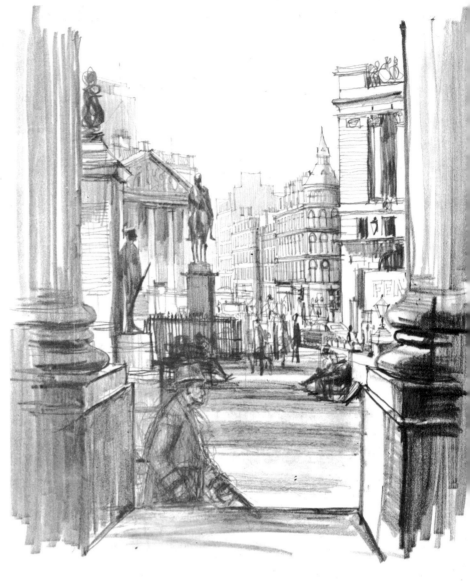

375

Detail and Texture

An appreciation of detail and texture is a great help in composing a drawing; it can give added interest to the composition and help the observer's eye to move easily round the picture. Texture can be defined as the pattern made by various materials used in building. A row of windows on a large building in the distance, for example, will give a texture. Detail is not quite the same thing, although the two together certainly give a pattern.

When walking in a town or village, or even when travelling in a bus or train, look out for differing textures; notice the different effects of texture given by the varied materials used in the buildings - brick, stone, flint, tile, slate, thatch. Notice pattern too and imagine how you would indicate these differences in your sketch book.

Opposite there is a drawing made with the fountain pen mentioned earlier. Can you see what excited me about this subject before I put pen to paper? Look at the varying texture and pattern in the buildings. Look at the brickwork. But notice that the tall building to the left has been deliberately kept clear of brickwork. Why? Because, had I added it there, the drawing would have become monotonous.

Composition can be 'imposed' on a drawing, however complex, by simplification, by the subtle emphasis of main construction lines and by the elimination of all detail in carefully selected areas. Here the central area has been left bare and texture has been confined to the perimeter, a reversal of the usual process. Notice how these

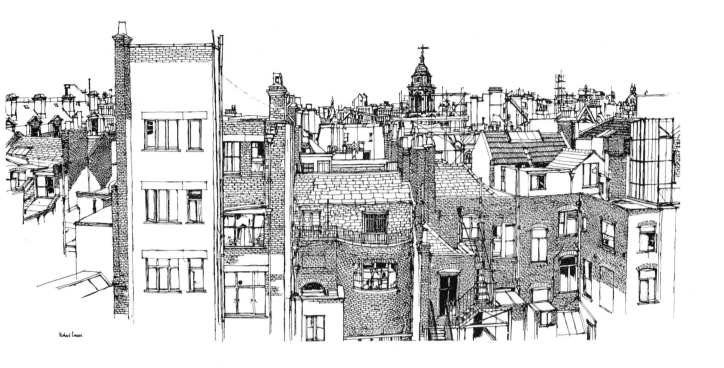

areas of 'texture' send the eye back into the centre of the drawing, and how the air conditioning system is 'balanced' by the lines of the flat roof leading in from the bottom right hand corner. Detail has only been suggested: the drawing is quite free, as you can see from the treatment of the chimneys in the foreground.

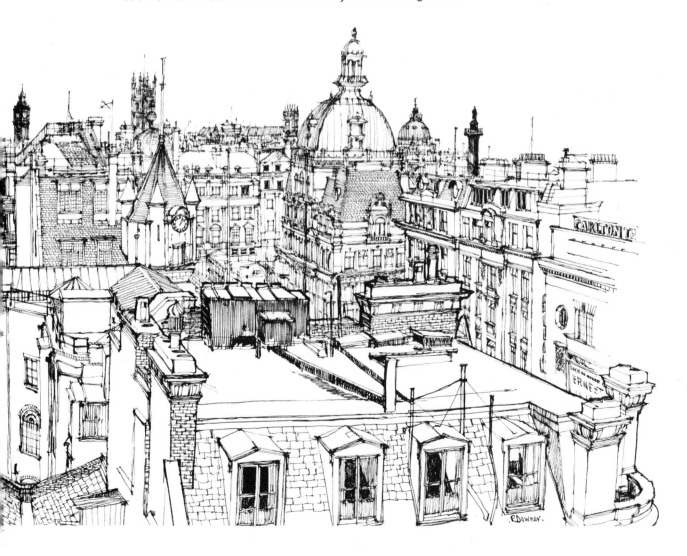

This rule of selection has been applied in the same way to the large drawing across pages 376, 377. There I have left a bareness in the foreground. Let me explain the reasons for this more clearly. They are most important to grasp.

When we draw a subject we are recording what we see and putting it down on paper. But we do not want to record it *identically;* the camera does this. We can do more. We can *select* from the subject the things that interest us and leave out what is unnecessary or that which confuses our design. We want the observer's eye to wander round the drawing at random, enjoying everything he or she sees. Composition goes far in achieving this; detail and texture, used intelligently, does the rest.

Take another look at the drawing across pages 376, 377. Notice how the detail varies from one area to another. You might say to yourself: 'Well, the brickwork was there for him to draw.' Yes, but so was the patterning on all the other buildings. The area I have left undrawn in the centre is terribly important; it acts as a resting place for the eye before it goes off in another direction. It also does the job of stopping the composition from becoming too monotonous in detail and texture.

You must also learn to be selective in this way.

From this drawing I have taken a section to illustrate objects and shapes which group together to form pattern and texture. Look at the wonderful shape the air conditioning system on the roof makes. Notice how important a part it plays in the whole composition. This detail is reproduced the same size as the original drawing which was drawn in fountain pen and black ink, 9'' x 26''.

Looking at the drawing as a whole you may well say to yourself, 'I haven't got the patience to do all that detail.' Believe me, if you can persevere, you will find drawing very rewarding and satisfying.

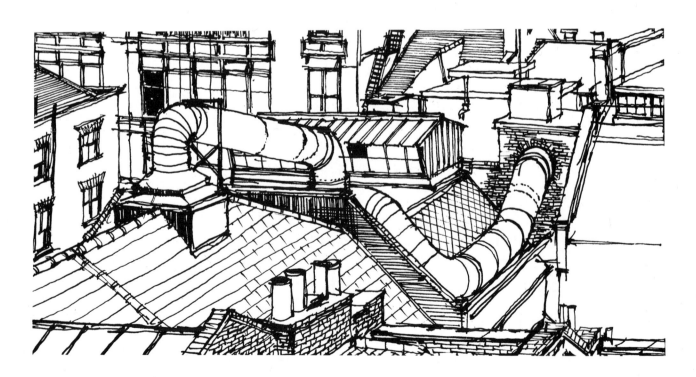

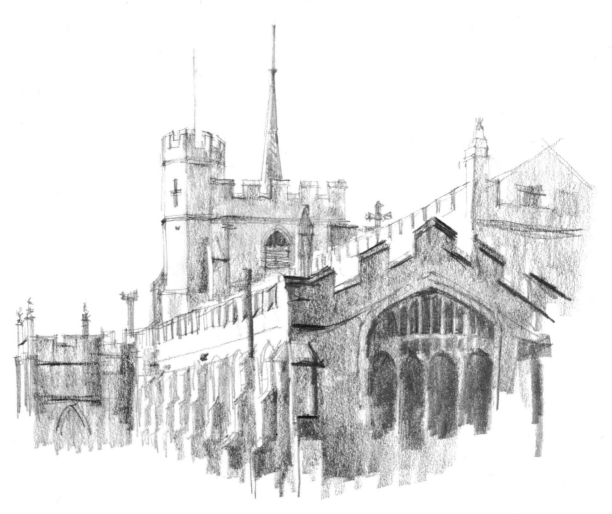

Chisel, or flat leaded pencils, with which this drawing of Hitchin Church was made, are useful for putting in large areas of tone. For quick impressions and in working out composition they combine particularly well with a felt-nibbed fountain pen. Sharpen the lead as you would a chisel and use them like a flat brush.

Sunlight and Shadow

Shadows cast by buildings in direct sunlight can produce an interesting effect. The drawing above is a study in shade with very little line work in it at all; the sun, in fact, was almost opposite me as I worked. It shows how tone can give depth to a drawing and pull it together as a whole. From the start this shadow is seen as the important element in the composition. When drawing a subject such as this, try putting in the shadow first of all. Use a chisel pencil quite loosely; do not worry if you do not get the exact shape of the shadowed area; allow yourself freedom. By doing it this way the result will be more spontaneous. Then start working into the drawing with a sharp pointed pencil and search the form for detail and texture.

It is important to differentiate between tone and shadow. They are not the same thing. Shadows in a drawing can be in different tones, darker or lighter, and so can colours.

Early evening shadows can be very useful in a drawing. If you find it difficult to get the shadows in before the sun disappears, you can complete your drawing earlier in the day and at the appropriate time go back and quickly put in the shadows with a chisel pencil, or brush and wash.

The difference between tone and shadow is illustrated on the left. Suppose for a minute that the roof and the walls of a house are exactly the same colour. Now the light from the sky would make the roof *lighter in tone* than the walls - House (A) shows this. However, roof tiles are usually darker in colour and tone than the brickwork or stone of the walls. House (B) in the illustration has the darker roof because *the colour*, not the tone, has been drawn. In fact, you have to decide carefully before you start a picture which is colour and which is tone.

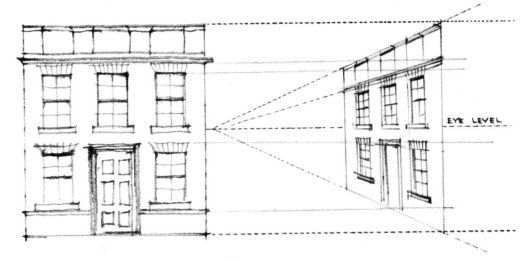

Perspective

Perspective is simply the art of making buildings and objects decrease correctly in size as they recede. We know from observation that things look smaller in the distance; with perspective we show this fact on paper, so that our drawing 'looks' right.

The drawing above shows, first of all, a house as we see it, standing directly in front of it. In this case we are not concerned with perspective; there are no planes going away from us. Directly we look at the house *sideways* we begin to see it in perspective. The lines we know to be horizontal and parallel, the lines of the roof, the windows, the pavement, *all* begin to converge towards the horizon, or eye level. All horizontal lines above the eye level will slope *downwards* in the right direction, all those below will slope *upwards* to meet at the eye level.

What is the eye level? It is an imaginary line drawn horizontally across the subject at the level at which our eyes see, when we are looking *straight ahead*. You will be surprised at times by how much these converging lines slope, so measure their angle carefully.

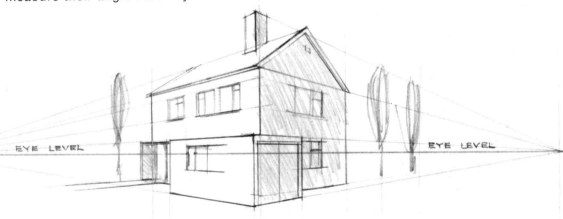

These drawings show the same house viewed from different heights, or eye levels. Above we are looking at it from quite low down; below, from a position higher up. Notice how the change in eye level alters the angle of the various 'horizontal' lines, which meet at the two 'vanishing points'.

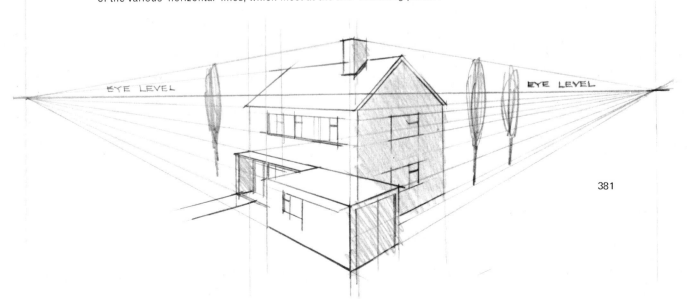

381

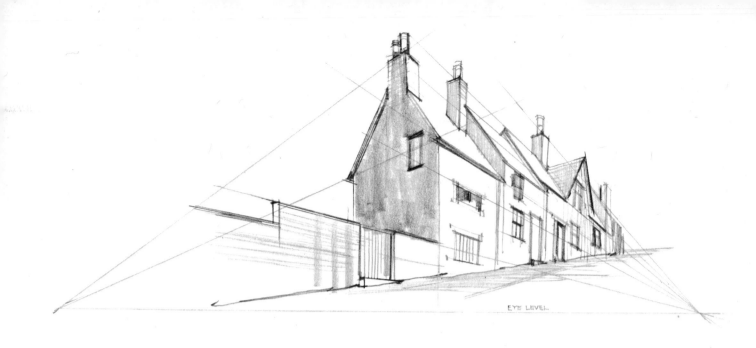

EYE LEVEL

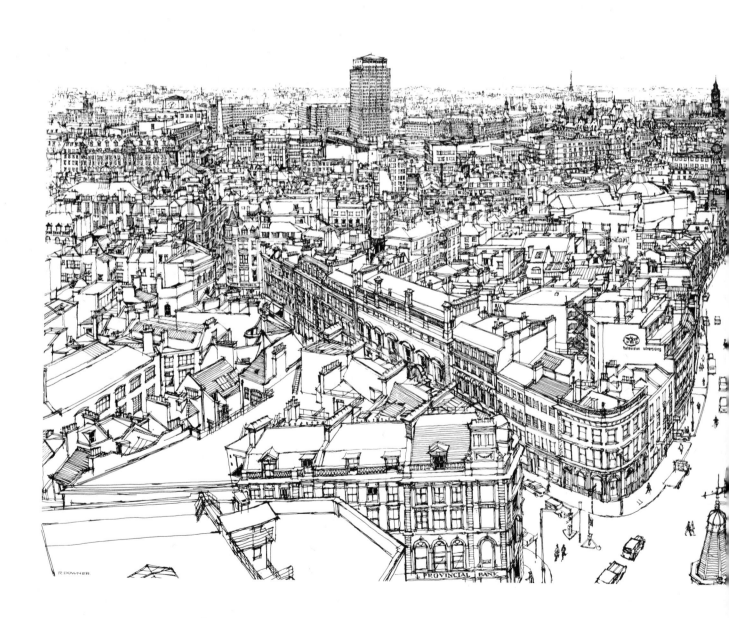

R DOWNER

PROVINCIAL BANK

Buildings on a hill may seem a problem at first, whether you are looking up the hill at them, or down. Remember, *wherever* you are, your eye level, or horizon is directly in front of you as you look straight ahead. The 'horizontal' lines of buildings *below* this level will slope upwards towards your horizon; the 'horizontal' lines of buildings *above* you will slope downwards, as I have shown in the drawing. In both cases they meet at the vanishing points.

On the right I have drawn a circle and arch in perspective to show how the same simple rules apply.

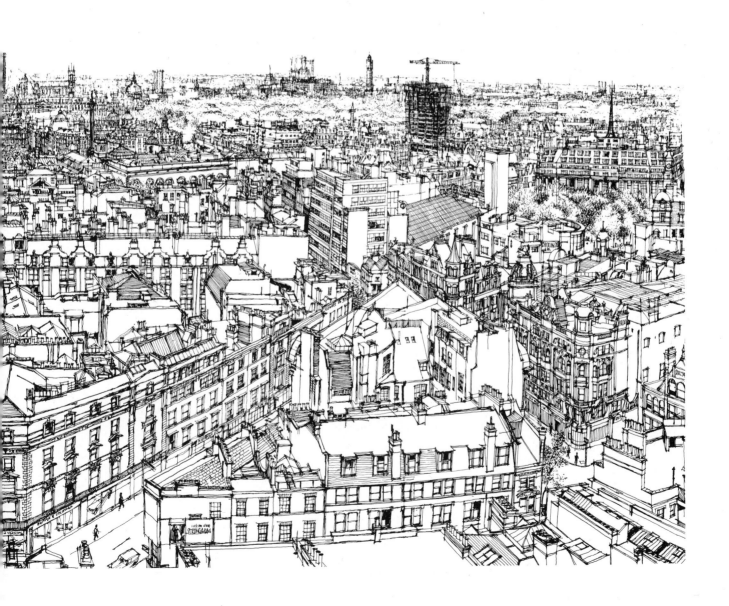

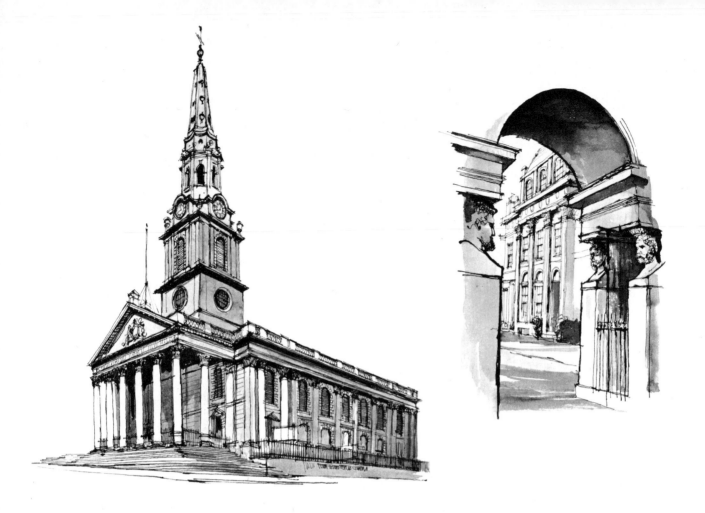

These two drawings show perspective unobtrusively applied. Never allow the rules (or the ruler) to 'control' your drawing. Think of perspective as a useful aid: too rigid an application of the rules only produces hard and lifeless drawings.

The drawings were made with pen and indian ink. Watered down indian ink was used for the wash, but be careful using this: it dries quickly and once it's dry it cannot easily be altered.

With the panoramic view of London, which covers the two previous pages, I conclude this section, because it seems to me to sum up in one drawing much that I have said elsewhere about perspective, composition, detail, texture, and the use of varying weights of line.

In it the eye level is the horizon. Towards this line *all* the horizontal planes diminish and converge, however much they wander on the way. The composition is based on balanced areas, built up on each side of the important street that runs through its centre, and which leads the eye at once *into* the drawing, where it can begin to wander at random. Areas of *selected* detail and texture save the drawing from monotony, and the use of varying weights of line help to give it depth.

There is nothing 'difficult' about a drawing of this kind: it was made simply as an exercise in perspective and proportion. Among the drawings of buildings I hope you will make, do some purely as training exercises. You will learn more from these than from anything. But whatever you draw, *enjoy* drawing it: your enjoyment will show and give pleasure to others, too.

384

Perspective
Hugh Chevins

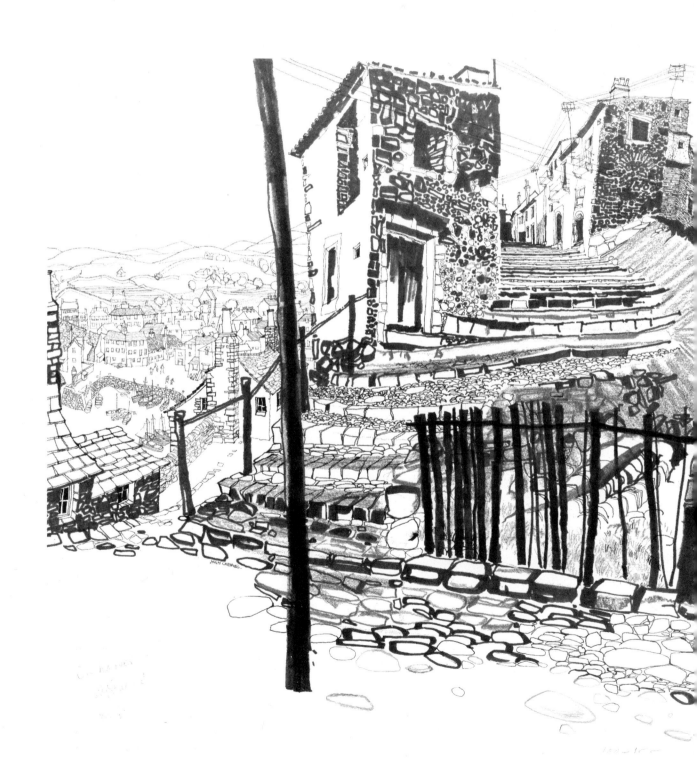

386

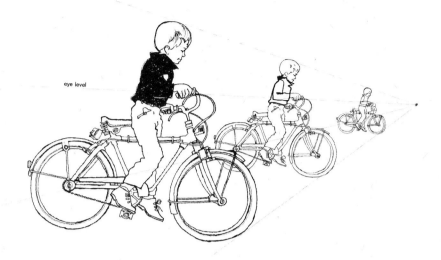

eye level

The simple principles of perspective

Perspective is the representation upon a single plane surface of objects occupying differing depth positions, in such a way that the scene appears natural to the eye.

In making a perspective drawing it is necessary to draw (1) a base line indicating the lowest limit of the picture, (2) a horizontal line representing the horizon of the picture from the same angle of vision, and (3) a vertical line drawn from the base line to the horizontal, meeting this at what is called the point of sight. This point often comes in the centre of the picture, but it can be either to the right or left, though always on the horizontal line.

The base, horizontal and vertical lines form the skeleton of the perspective.

All parallel lines when extended will, if the drawing is correct, meet at one point, which is called the vanishing point. This is not necessarily within the limits of the picture. It may, indeed, be far outside them.

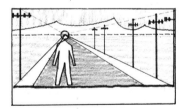

Base-line The lowest horizontal line upon which the whole of the picture is constructed.

Eye-level A true horizontal line of vision varying according to the height of the individual.

Horizon The line at which earth and sky appear to meet.

Vanishing Point The point at eye-level to which all parallel lines appear to converge.

In capturing a scene on paper, the most important things to remember are the relative sizes and positions of the subjects making up the picture. Their differing densities are quite easily portrayed afterwards by filling in the basic skeletons which we draw, to show curves and modelling which would otherwise not be apparent. The simple rules for the basic constructions are shown in these cartoons.

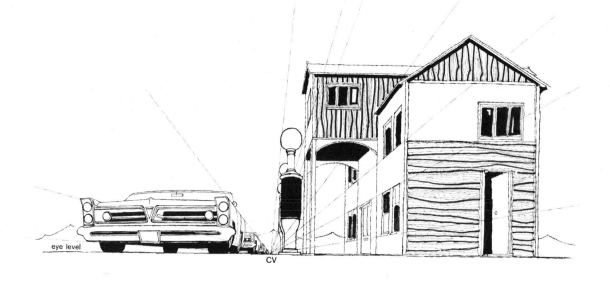

eye level

CV

The vanishing trick

How often do we say that a thing appears to vanish into the distance? The explanation is easy to understand if we consider for a moment how the eye views receding objects. The row of cars below, each of the same length, is being observed by the eye. The length of the nearest car is estimated through angle A.

Although the brain knows that the cars are of the same length, the eye sees them through successively smaller angles the further away they are. It is plain then that if the row of cars stretched to infinity, the angles of vision relating to each of them would get smaller and smaller until they were so minute that the eye could not detect them. Hence the vanishing trick!

Now let us look at the cars from two different eye levels. The point at which both cars and building disappear from sight marks the horizontal line of vision, or horizon — our normal level of sight.

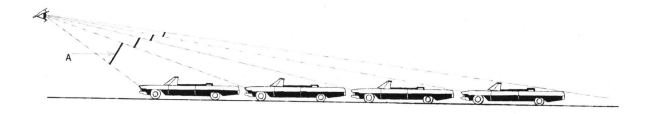

A

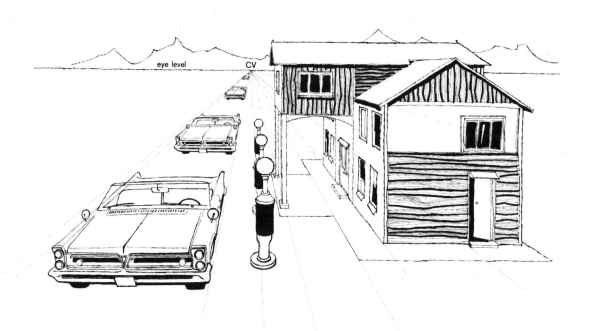

eye level CV

What we see

So far we have only referred to the principles of perspective and to the so called vanishing trick. Now we must try to understand what is known as the cone of vision or the limit of the eye's view. One of our first problems is: what are the limits of the pictures to be? When looking in one fixed direction, the eye has a certain accurate range of vision in a circular view. The limit of vision is known to be within a cone of approximately 90°, but in drawing it is limited to 60°, as shown above. Any objects outside this 60° cone of vision are not seen quite normally and are therefore distorted, like the distortion which we sometimes see at the edge of a photograph.

The two drawings above show a group of buildings in perspective with the cone of vision represented by a circle. In the first one the buildings outside the circle appear distorted, but in the second one, sketched from further away, the whole scene is contained inside the cone of vision. The first technique is often used in picturemaking to give the subject a much more dramatic appearance. Your cone of vision position must always be considered in relation to the effect needed in your drawing and the nature of the subject.

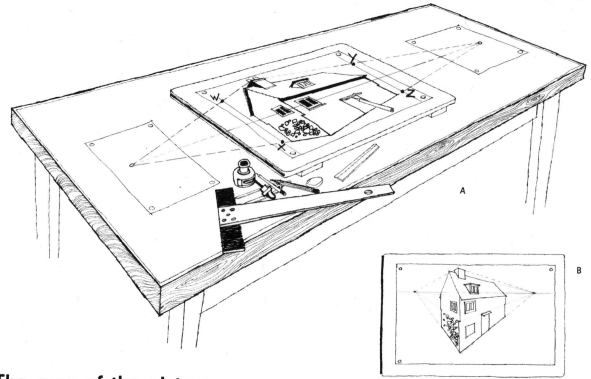

The area of the picture

When we draw some subjects, the correct vanishing lines may extend to points well beyond the area of the drawing-board. It will often be accurate enough to cut short these lines at the points W.X. and Y.Z. but, in cases where the vanishing points must be accurately determined for a very care- ful assessment of perspective, they can be located by pinning additional pieces of paper to the table, as shown (A), and then continuing these lines to their conclusion.

If the vanishing points are kept within the area of the picture the perspective will be grossly distorted, as they are in (B).

Demonstrating scale

It is interesting to discover how we see in perspective. The human eye can roughly estimate such things as depth and width, but finds it difficult to estimate accurately how far away an object is, unless at the same time it is able to compare the object with something familiar.

In the drawing (i) the eye sees a tower,

(i)

(ii)

but cannot judge its distance or size as there is nothing else near to make a comparison. We are all familiar with a postbox, as it is an everyday object and we know roughly its size. If the postbox is placed next to the tower (ii) we can then immediately estimate the size of the tower.

How often have you seen a painting of cliffs, or rock at the seaside? Sometimes it is difficult to judge their size, but if suddenly you notice a person standing at the base of the cliff-face you immediately appreciate the height, distance and size of the objects.

Measuring lines in perspective

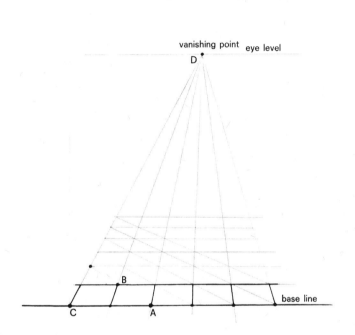

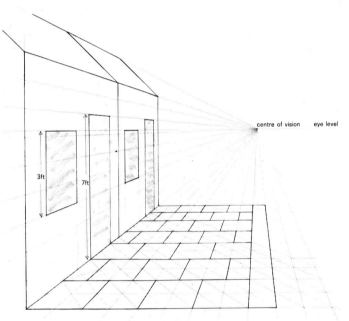

The simplest way to understand measuring in perspective is to begin by imagining a tiled floor vanishing into the distance.

Let us assume that the tiles are 1 ft. wide and draw the fore-edge of these on the base line of our picture to a scale of 1″ = 1′. We then arrange the eye level and the vanishing point, and connect these base points to the vanishing point as shown.

Next, we draw a horizontal line above the base line to represent the first row of tiles. To get the following rows of tiles vanishing in perspective, all we have to do is to draw a diagonal guide line from A

through B and on until it crosses the line C to D. Where it crosses this line C. D. we draw another horizontal line to represent the next row of tiles.

This can be repeated until there is a sufficient number of tiles.

From this basic knowledge, one can develop far more ambitious scenes, such as the row of chalets with the pavement in front. To get the correct height of the doors etc. use the same scale of 1″ = 1′. Mark off in the same way on a perpendicular line at the edge of the picture and draw all these lines to the vanishing point.

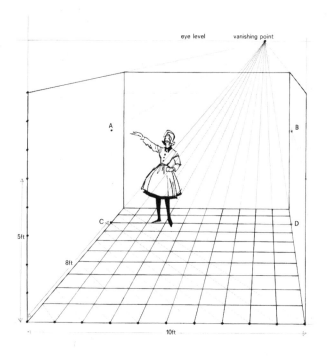

In the opposite picture the same method of marking a horizontal and perpendicular scale is used. To show a woman 5' tall standing 8' back in a room, mark off ten tiles on the base-line and also mark equal points on the perpendicular line, as before. Establish the vanishing point, draw grid lines from the scaled base-line to this, and also a line from 5' on the perpendicular line to this vanishing point, as illustrated. We then draw the tiled floor, to our set scale, and the eighth row back is where she will stand. Draw a vertical line from this 8' baseline onto the 5' perpendicular line to the vanishing point and lightly draw the box A. B. C. D. The figure placed anywhere between the horizontal lines of this box will be in the correct scale to her position in the room.

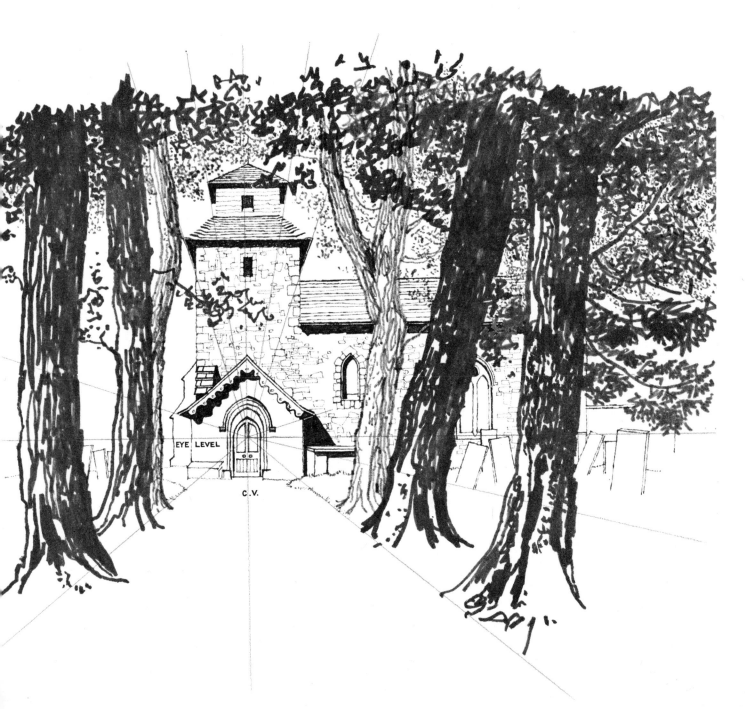

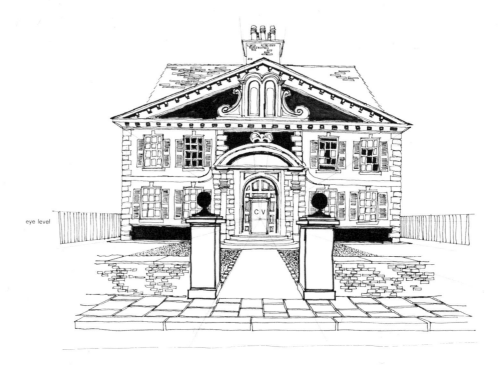

eye level

Simple front view perspective

To put it simply, there are two perspective views: parallel or front view and corner-wise or angular perspective. In parallel perspective the vanishing point is always in the centre of the picture, with the main masses of the object facing the artist. In the drawing of the house above, the lines of the front do not vanish, but the lines of the other sides vanish to the centre of the picture on the eye level.

In the drawing on page 394 imagine that you are standing in the middle of a straight, level street of houses. If you stand upright you should come to about three-quarters of the way up the doors, so we have now found out the eye level of the scene. Let

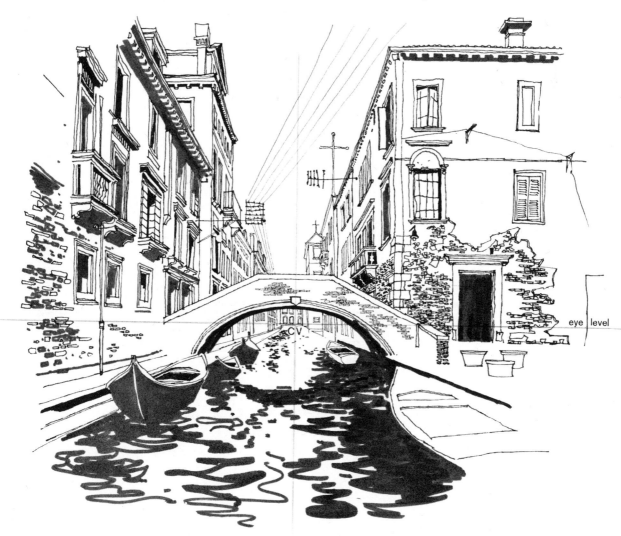

eye level

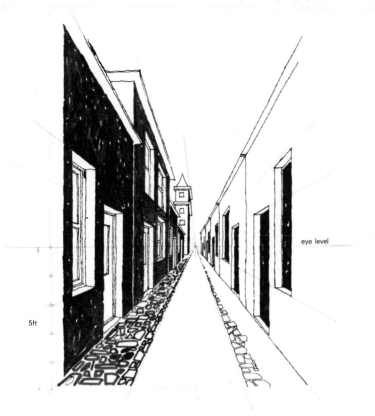

5ft

eye level

us assume that the artist has an eye level of five feet. This is marked by a scale at the side of the picture. Connect this to the centre of vision by a line which then becomes the base of the houses. A perpendicular line from eye level to anywhere on the ground line of the houses is therefore bound to be five feet. The measurement of the doors and windows going back into the distance can be made by the same method discussed in 'Measuring Lines in Perspective' (p 391). In that way, the rectangles of the doors and windows will all vanish in the correct proportions.

The same methods of measuring can be applied to any interior. If your room is ten feet across, divide the floor line into ten equal parts. Then if the height of your eye level is five feet, mark off five equal parts at the side of the room to the same scale as the floor. Next, put in your centre of vision point on the eye level and afterwards connect all the points with lines going to the centre of vision. Mark off the floor into squares as in the previous chapter. Using this as a scale, you can now put in any furniture you want to include.

The drawings of the church seen through a row of trees, the canal in Venice, and a room interior with people are introduced for you to study, as they illustrate some of the problems we have just discussed.

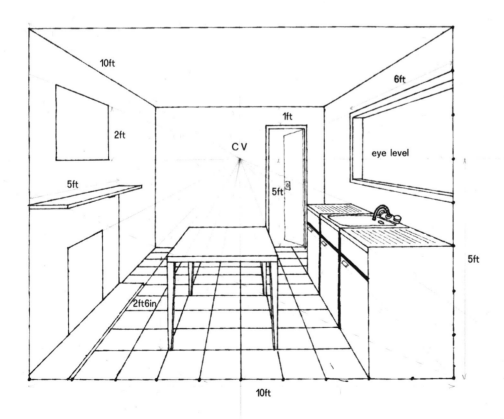

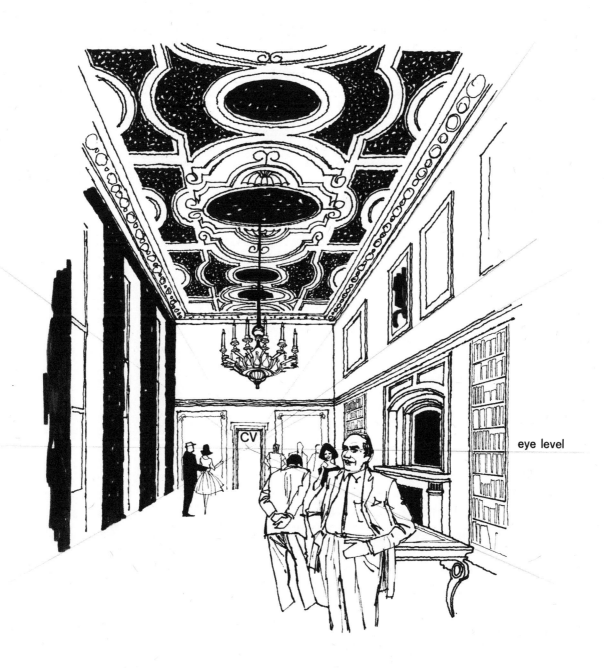

CV

eye level

vanishing point

Simple angular perspective

Angular or cornerwise perspective is simply a drawing in two-point perspective - a drawing using *two* vanishing points at eye level, one each side of the centre of vision. Notice the direction in which the lines vanish in this glimpse of a country church, and compare it with the drawing on page 392, which is in front view perspective.

It is important to draw lines in perspective accurately. If they are drawn carelessly and do not meet properly at the vanishing points, the building will not look right, as in (1) opposite. (2) shows the same bungalow in correct perspective.

As many deliberately introduced horizontal lines as possible have been included in the detailed interior (opposite, above) to demonstrate the simple principle of angular perspective. Once it is grasped, you can apply the principle to almost any drawing.

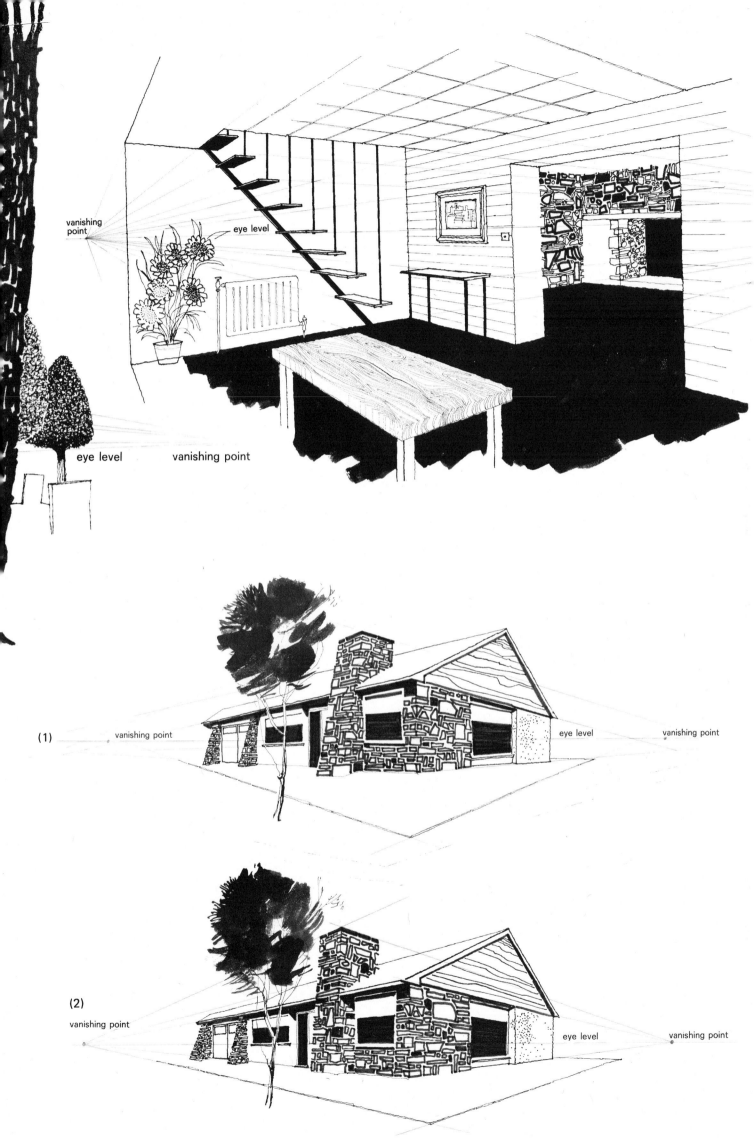

vanishing
point

eye level

eye level vanishing point

(1) vanishing point eye level vanishing point

(2) vanishing point eye level vanishing point

Curves and circles in perspective

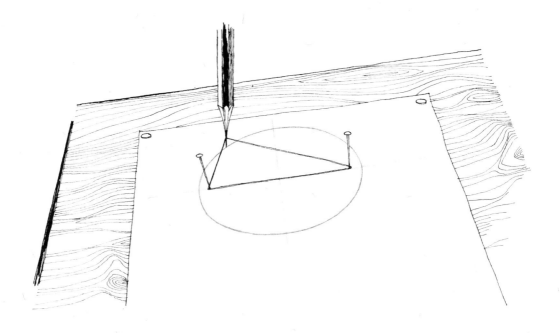

First I will show you a simple and quick method of drawing an ellipse. This is very useful where the drawing is only meant to be a rough sketch, but please do not misunderstand, it is quite an accurate method.

Place a piece of paper on your drawing board and stick in two pins upright, a few inches apart or just a little less than the required diameter of the ellipse. Take a piece of thread and join the ends to make a loop big enough to go round the two pins, with a little slack. Take a pencil with a long sharp point and put it inside the thread. Now hold the pencil upright and keeping the thread taut make a line right round the two pins. The shape you draw will be a true ellipse. When the thread is shorter the ellipse will be narrower; if you lengthen it, it will be much fatter and nearer to a circle. Take the pins out and if you want to draw the axis of the ellipse, the two pin holes will give you this - draw a line across them. This is important in drawing, say, wheelbarrows, carts or motorcars.

Another method of drawing the perspective view of a circle is to start by enclosing the circle in a square (see diagram). Draw a circle of the required size with a compass and put the square round it. Then from the centre of the circle draw the two diagonals of the square. At the points where the diagonals cross the circle, draw a line parallel to the edge of the square.

The next stage is to draw this construction in perspective. Take the points which I have marked A. B. C. D. E. to the vanishing point on the eye level. Next decide where you want the circles to start above the ground line and draw a line parallel to it - F. Decide where your distance point will be on your eye level, and draw radiating lines from this point to cross the lines A. B. C. D. E. This will be the diagonal of the square in perspective. Now it is only a matter of

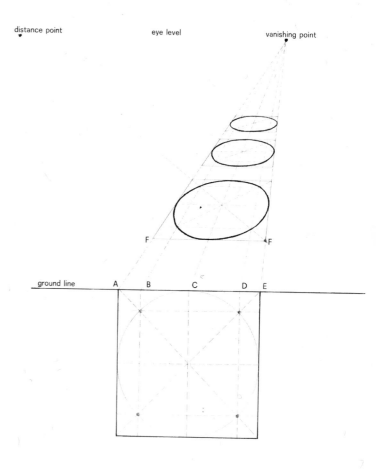

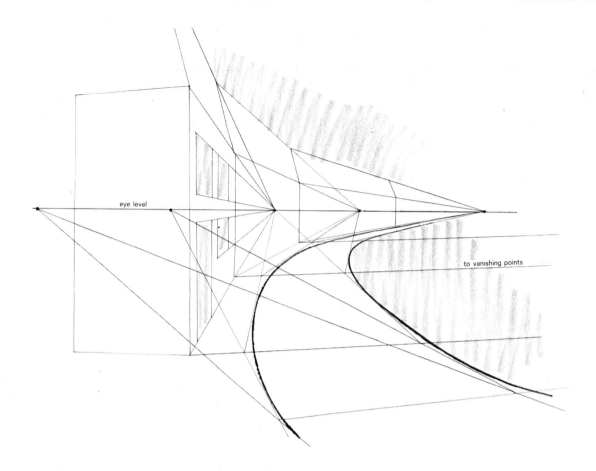

eye level

to vanishing points

drawing the ellipse through the points where the lines cross. You will be able to draw as many circles in perspective as you wish until they reach the eye level. The problems that we have discussed so far are illustrated by the ellipses in the selection of drawings shown. You might find this very puzzling, but after a few moments studying the diagrams, you will find it quite simple.

The curve of a road, for instance, may be constructed by simplifying it into a series of straight sections and then drawing a freehand curve through them. This is quite a simple problem which can be seen easily from the accompanying diagram. The drawing of a small town shopping street on page 414 has a similar problem.

Simple reflections

It might appear at first rather difficult to draw the reflection of an object, but the basic constructions are really very simple The main thing to keep in mind is that whatever the position of the reflecting surface, the reflection of each part of the object will be the same distance away and exactly opposite I hope that you will understand from the diagram above, opposite. You will see a box at the side of a mirror The mirror goes directly away from you, to finish at the vanishing point on the eye level. You can see that the reflection of the box appears to be at the same distance in the mirror as it is in front of it. This effect

is achieved by extending the perspective lines of the box to cross the line of the picture plane. Where these lines cross the picture plane measure off the lengths A. B. and repeat on the opposite side of the mirror. Then draw lines from these marks to the vanishing point. Extend the horizontal lines of the box to cross these lines. Now you can finish the drawing of the box's reflection.

Look carefully at the drawing on the opposite page of a dining room with paintings hanging on the wall. The position of the painting reflected in the mirror is arrived at in exactly the same way.

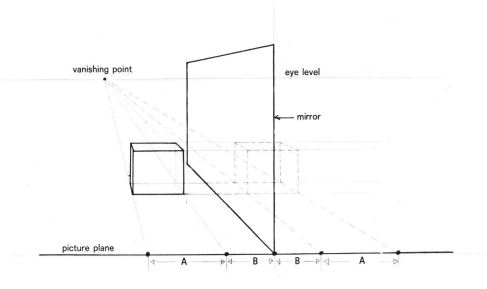

vanishing point

eye level

mirror

picture plane

A B B A

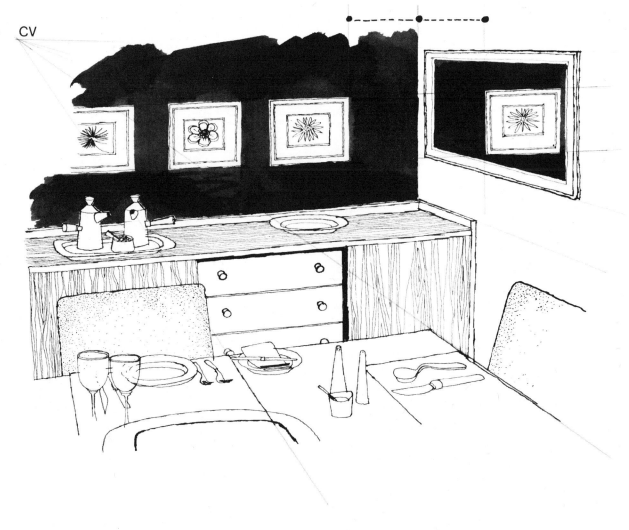

CV

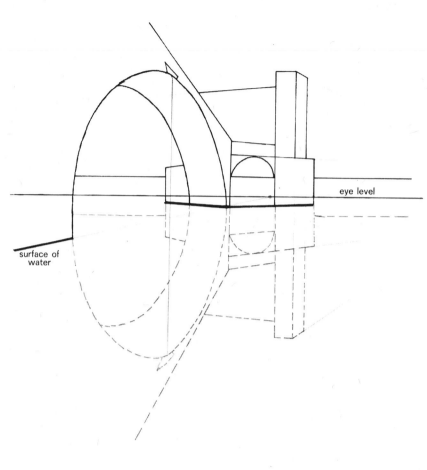

eye level

surface of
water

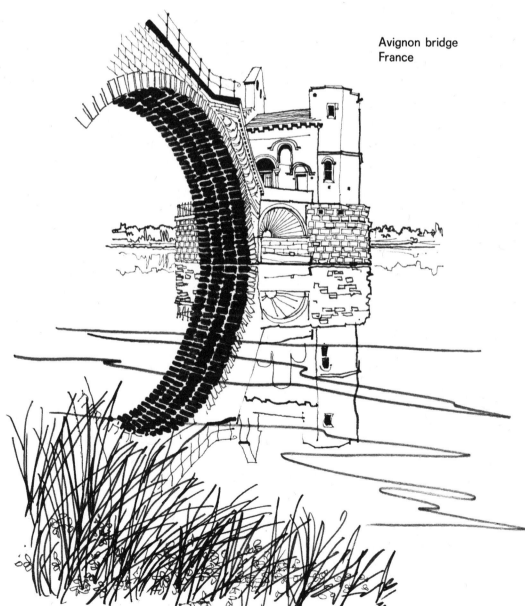

Avignon bridge
France

Reflections in a horizontal surface

This simplified drawing is of the Avignon bridge in France. Each line which touches the water's surface will have a reflection equal to its own length, so draw all the necessary verticals and then measure from the water's edge to the topmost point, and transfer this measurement to the vertical line below. In drawing the arch of the bridge, take a line from the top centre point, known as the keystone, and draw a vertical line downwards through the surface line of the water to an equal distance below.

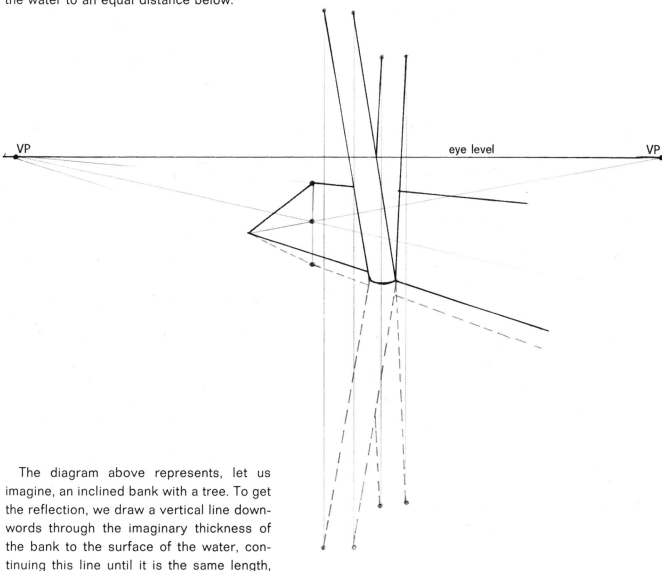

The diagram above represents, let us imagine, an inclined bank with a tree. To get the reflection, we draw a vertical line downwords through the imaginary thickness of the bank to the surface of the water, continuing this line until it is the same length, and connecting the slope of the bank afterwards. Exactly the same principle has been applied to the drawing over page of Thornton-le-Dale, in Yorkshire.

403

Thornton-le-Dale, Yorkshire

Some ups and downs

I shall try and explain the opposites (or the ups and downs) in perspective by a simple drawing of a girder suspended from a crane, seen first from above and later viewed from below. (see opposite).

The first thing to do is to determine the angle at which a line drawn through the length of the girder meets our eye level. One of the most useful ways is to hold a celluloid set square so that the girder can be seen through it. Make sure that the bottom edge is held in a horizontal position. Now mark the angle of the main line of the girder on the set square with a dot, as in

the drawing here, and transfer this to your drawing paper (A. B.). It is necessary next to find the angle of the section of the girder. Do the same thing again with the set square, marking the angle on the celluloid, and then transfer it to the drawing paper (C. D.).

As we now have the angles of the girder pin-pointed, the next step is to find out its true length. Take your pencil between finger and thumb, as you see in the drawing, measure off the length E. F. over the end section and transfer this measurement to the drawing. Keeping your thumb tight against the pencil, count off the number of times you

can get the length E. F. into the length of the girder. You will find, in this case, that it is approximately 3½. You have established the length of the girder in relation to the end section and with these simple visual measurements can complete the drawing. The drawing on the next page shows a gird-

er seen from above eye level. It has three main vanishing lines, but the best one for judging the angle is that which is marked A. B. Use your set square to find the angle of the girder in relation to its surroundings. Measure the end section in the same way with your pencil, E. F., and find the length.

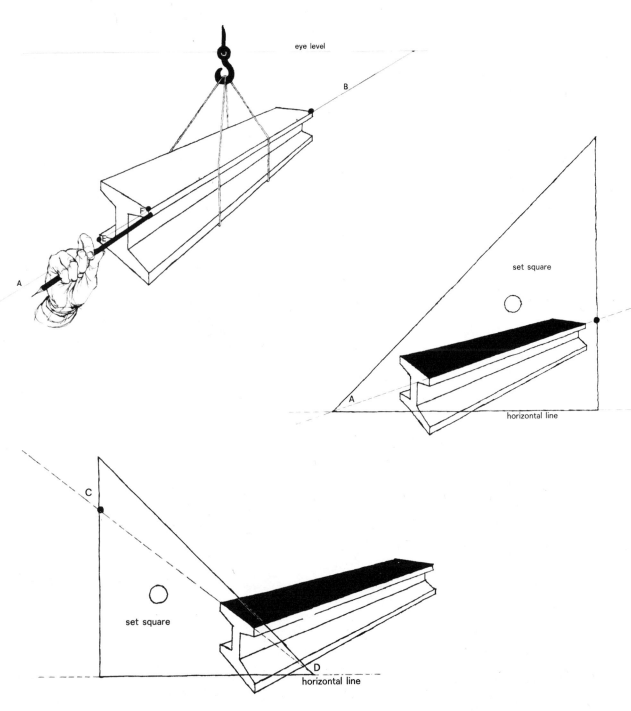

One can also measure the verticals H. to C., I. to F., and E. to J. on the same principle.

The same principles apply in these more visually exciting scenes, looking up and down a hill. The thing to keep in mind is that, whatever the angle of the road, the main lines of the houses (such as ridges, window sills) will always be horizontal. In perspective the street will vanish to a point above or below the horizon according to our viewpoint, while the horizontal lines of the houses will vanish to the horizon.

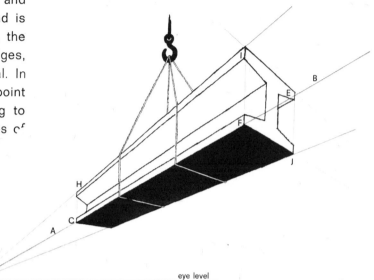

eye level

Shadows
in perspective drawing

eye level

to light source

VP

1

light

2

Shadows play an important part in drawing, as it is the shadow which generally makes the subject appear more solid and possibly dramatic. Shadows come either from the sun or from some artificial source, such as a light bulb. The following gives some ways of applying perspective drawing:-

Shadow of a curve

There are three kinds:

1 A straight perpendicular line onto a curved object.
2 A curved shape onto a flat surface.
3 A curved line onto a curved surface.

In the first diagram, we have a shadow thrown by an upright wall onto the flat ground and then round the curved object. This shape could represent a bridge or a curved piece of land. To find the shadow's position on the curved surface, extend an imaginary line under the shape. On this line place a number of dots. From the vanishing point draw lines to go through the dots and on towards the front edge; continue up the front with vertical lines and back along the top, to finish once again at the vanishing point. Draw vertical lines from the original dots, and where they intersect the lines on the curved surface, this will be the shadow's position.

to light source

3

Shadows from artificial light

Shadows caused by artificial light are usually larger than those caused by sunlight and therefore usually produce a more dramatic effect. An example is given in the accompanying diagram. It shows an interior of a room with a shadow thrown onto the floor from a standard lamp which is the light source. All the vertical lines throw a shadow which radiates from a point directly under the source of light. In the diagram it is called 'base of light'. To find the length of the shadow, take a line from the light itself, across the tip of each vertical line, and down to meet the radiating line. If the shadow goes up a vertical wall, carry on the radiating lines from the 'base of light' until it touches the wall, then continue the shadow up the wall, vertically, until it meets the line from the light source. As in all perspective drawings, constructions used for drawing shadows can be kept very simple. There are of course many methods and problems. The construction shown had been chosen to give a general example.

eye level

light source

base of light

Shadows coming towards the artist

Opposite, above we have the sun in front of us, so we know where the light source will be. We draw a vertical line from the light source to meet the eye level. This point will be the 'base of light', and the vanishing point of the shadows thrown by the vertical lines of the house. Draw a line from the light source to touch the topmost points of the vertical lines and continue until they meet the radiating lines from the 'base of light', shown by the dots in the diagram. Connect all these points to make the complete shadow. Study the diagram and you will see how easy it is to draw a correct shadow.

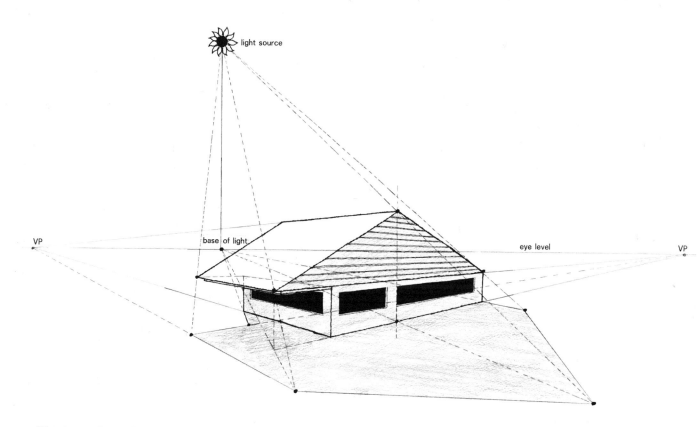

Shadows from behind the artist

As the sunlight is from behind the artist we will not be able to put the position of the sun on the drawing paper. However, we do know that the vanishing point of the sun's rays will be below eye level and also that the shadows are in front of us and will therefore vanish to a point on the eye level. To find the shadow's length, take an imaginary line from the sun, A. B., and continue downwards until it meets a vertical line drawn downwards from the shadow's vanishing point. This point is known as the

vanishing point of the sun's rays. If you put your imaginary sun high up in the sky, the vanishing point of the sun's rays will be quite low beneath the eye level and therefore your shadows will be short. On the other hand, if you want your shadows to be longer, put the vanishing point of the sun's rays higher or nearer to the eye level. I will not tell you any more on this subject as it will only confuse you. Study the diagram, then try a few shadow drawings of your own.

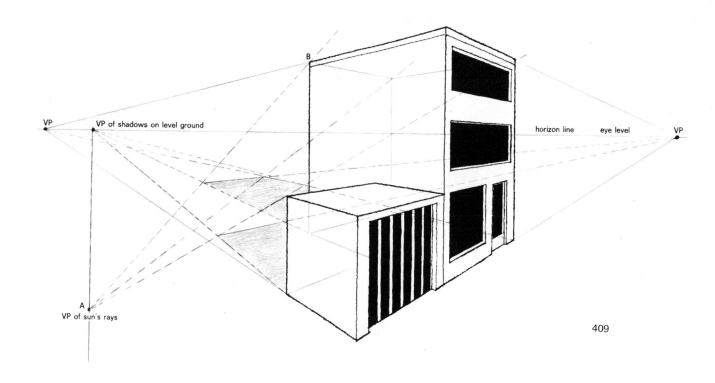

Materials

Very few instruments are needed for perspective drawing. In fact the fewer the better, as one should always draw the picture freehand, except for a few guide lines.

The first requirement is for pencils of various grades, from 6.B., the softest, to 6.H., the hardest (bearing in mind that H.B. is the ideal general purpose pencil), a pen and Indian ink and an eraser; do not overuse this, however, as guide lines can look very effective in the finished drawing.

A perspex set square is a necessity, pre-

ferably one of 45° with at least 10 inches on one of the sides.

Perspex French Curves are a valuable aid to drawing ellipses and irregular lines; they are shaped to a number of useful curves and, after a little practice, it is possible to draw a complete ellipse with minimum movement of the instrument.

Buy the best quality pencils and materials that you can afford and a scalpel (there are a number of excellent ones on the market) to keep your pencils perfect.

hill side

Perspective drawing
Stage by stage

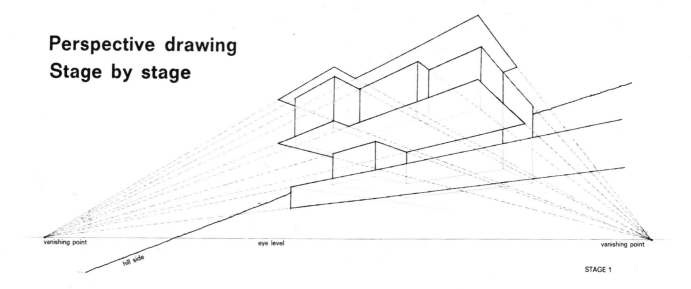

vanishing point eye level vanishing point

hill side

STAGE 1

Stage 1

Illustrated here are various stages in the perspective drawing of a modern villa I came across whilst touring along the Spanish Costa Blanca at Alicante. For the student of perspective this villa is of particular interest because, with its position on the hillside, it is well above eye level and therefore all the perspective lines converge downwards.

In the chapter on 'Some ups and downs' I described the easiest way to determine the angle of the best line from which to work; here, as with the girder, the same principles apply. Find this line and the others will follow. Keep to the basic shape of the villa and forget the details at this stage.

Stage 2

After the basic cubes have been determined through the correct perspective vanishing lines to the eye level, the next stage is to develop the shapes into a true representation of the villa, while still keeping the drawing in simple line. Develop the basic shape of the landscape and draw the steps leading up to the villa. You will notice that the steps start below eye level, so that the perspective lines converge in an upward movement, slowly levelling as they get near eye level. The drawing is now losing that uninteresting geometrical appearance and is becoming a picture.

STAGE 2

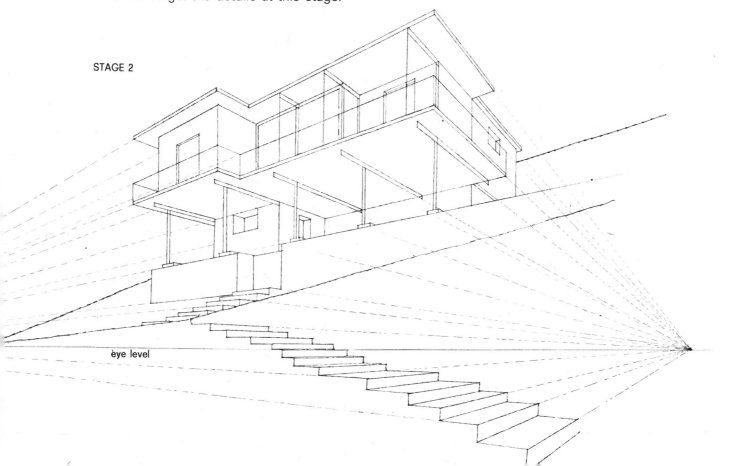

eye level

Stage 3

We are now at the most interesting stage, for it is possible at this point to add atmosphere. The introduction of local trees or bushes gives the villa true scale and also tells the viewer the type of area in which it is situated - a rugged and sunny region.

STAGE 3

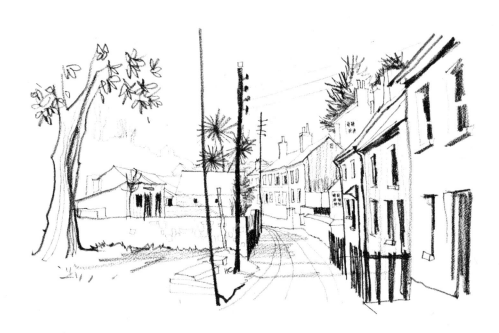

Putting perspective into perspective

A great deal could be written about the theory of perspective and the various methods by which it can be applied in drawing, but there are not many people these days who have the time or the opportunity to do a large amount of reading in order to acquire this knowledge. This applies more to the complete beginner, as he is faced with the difficulty of showing on a flat piece of paper or board the assemblance to the eye of three dimensional objects and scenes. Not many people have the ability to draw spontaneously in correct perspective. There are, indeed, a greater number who find it very difficult.

The aim of this section is therefore to help the reader to draw with a reasonable degree of accuracy, and these brief instructions

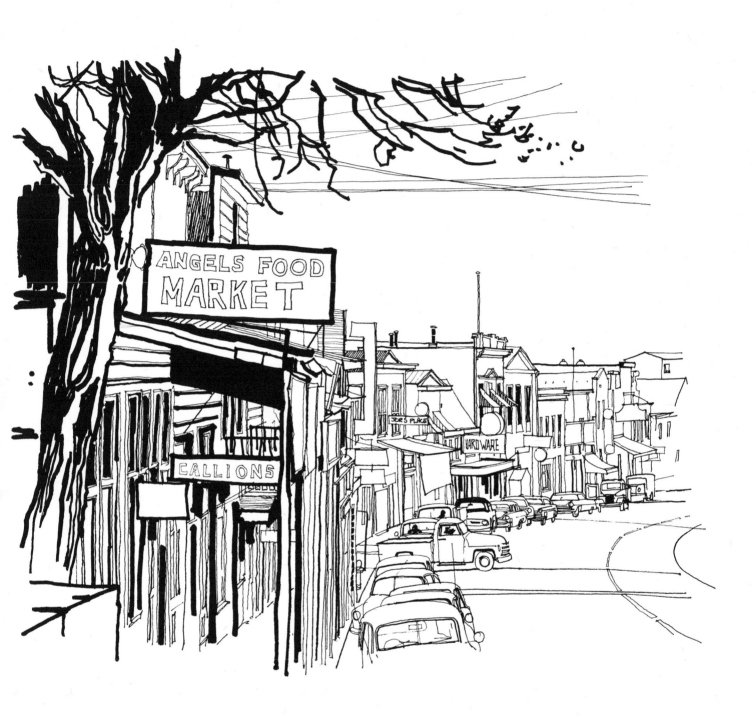

form a logical sequence to be followed. If each stage is taken carefully, the problems of drawing in perspective will slowly disappear. If the beginner, young or old, continues his study of the theory of perspective, which should at all times be supplemented by practical viewing of the country scene, for it is in this way that a good standard can be attained, he will see that it is not such a difficult problem. Perspective need not be a dull necessity in drawing; enjoy yourself, for it is a fascinating subject.

414